# THE LAUGHTER AND THE URN

*Other books by Laurence Whistler*

ON HIS ENGRAVINGS
*The Engraved Glass of Laurence Whistler* (1952)
*Engraved Glass 1952–1958* (1959)
*Pictures on Glass* (1972)
*The Image on the Glass* (1975)

PROSE
*The Initials in the Heart* (1964, republished 1975)

POETRY
*The World's Room: Collected Poems* (1949)
*The View from This Window* (1956)
*Audible Silence* (1961)
*To Celebrate Her Living* (1967)

ON REX WHISTLER
*Rex Whistler, His Life and His Drawings* (1948)
*The Work of Rex Whistler* (with Ronald Fuller) (1969)
*¡OHO!* (1947) *AHA* (1978) (verses to Rex Whistler's Reversible Faces)

ON ARCHITECTURE
*Sir John Vanburgh, Architect and Dramatist* (1938)
*The Imagination of Vanburgh and His Fellow Artists* (1954)

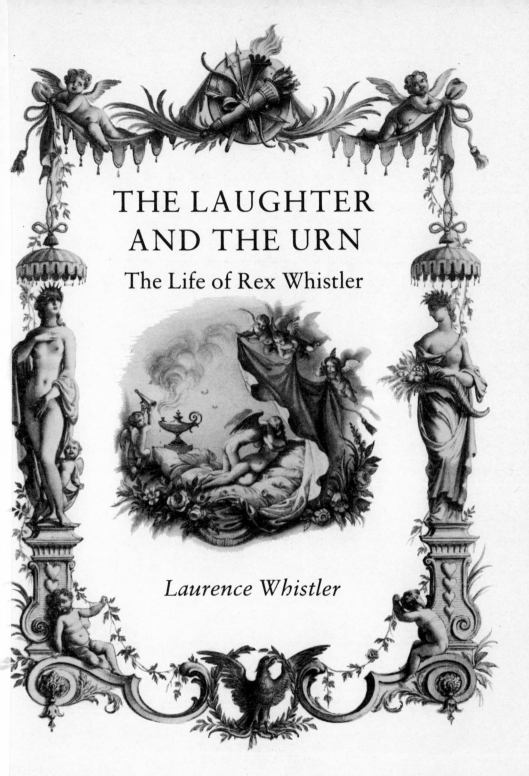

# THE LAUGHTER
# AND THE URN

## The Life of Rex Whistler

*Laurence Whistler*

WEIDENFELD AND NICOLSON · LONDON · MCMLXXXV

First published in Great Britain by
George Weidenfeld & Nicolson Limited
91 Clapham High Street
London SW4 7TA

The author at two by
the artist at eight,
1915

ISBN 0 297 78603 2

Printed in Great Britain by Butler and Tanner Limited, Frome, Somerset
Designed by Cinamon and Kitzinger

FOR

HENRY ANGLESEY

WITH LOVE

Laughter in the ballroom, in the bathroom,
in the bar-room – but the laughter is an urn.

(p. 104)

# Contents

List of Plates
ix

List of Illustrations
in the Text
xi

The Author's Gratitude
xiii

*The Narrative*
1

Notes
303

Bibliography
312

Index
313

CHRISTIAN·FIGHTS·WITH·APOLLYON

For a *Pilgrim's Progress* never completed, *c.* 1932

# Plates

*Between pages 114 and 115*
1. The Whistler family in the garden at Eltham, Kent, *c.* 1911
2. The artist's mother in 1898
3. Rex aged thirteen
4. At his table in 20 Fitzroy Street, London, *c.* 1927
5. Rex and Laurence Whistler in 1937
6. In the studio at 20 Fitzroy Street
7. With Lord Anglesey at Plas Newydd
8. With a painted trophy, *c.* 1939
9. With the crew of his Cromwell tank at Pickering
10. Censoring letters in a Normandy orchard, 1944
11. The artist's father lying dead, 1940
12. The author, *c.* 1931
13. William Walton in 1929 (original now in the National Portrait Gallery, London)
14. Arthur Waley at 20 Fitzroy Street (original now in the National Portrait Gallery, London)
15. *The Master Cook*
16. Discovered in the Cornfield, from *Gulliver's Travels*, republished by the Herbert Press, 1984
17. Sight-seeing in Lagado, from *Gulliver's Travels*
18. Design for curtain, *Le Spectre de la Rose*
19. Scene design, *Le Spectre de la Rose*
20. The girl's ball-dress, *Le Spectre de la Rose*
21. Mural at 19 Hill Street, London
22. *In the Wilderness*
23. Murals at Mottisfont Abbey, as proposed in 1938
24. Murals at Mottisfont Abbey, as carried out in 1939
25. *The Buckingham Road in the Rain*

*Between pages 210 and 211*
26. Self-portrait, over Regent's Park
27. Detail of the Tate Gallery Restaurant mural (by courtesy of the Tate Gallery, London)

ix

## Plates

28. The painted room at Port Lympne (by courtesy of Port Lympne Zoo Park; photograph by Angelo Hornak)
29. Bookplate for the Duchess of Westminster (by courtesy of The Hon. Lady Lindsay of Dowhill)
30. *The Vale of Aylesbury* (by courtesy of Shell UK Ltd)
31. *East Mersea Church*
32. *Girl with a Red Rose* (by courtesy of Lord Lilford)
33. *Laura the Drummer* (private collection)
34. Penelope and Angela Dudley-Ward (by courtesy of Mr and Mrs David Mlinaric; photograph by Angelo Hornak)
35. *Conversation Piece at the Daye House*
36. The dining-room at Plas Newydd (by courtesy of the National Trust; photograph by Erik Pelham)
37. Detail of the Plas Newydd murals (by courtesy of the National Trust; photograph by Erik Pelham)
38. Clavichord painted for Tom Goff
39. Curtain design, *Victoria Regina* (by courtesy of Mrs John Owen)
40. Design for Acts II and IV of *An Ideal Husband* (by courtesy of Mr John Cavanagh; photograph by Motley Books)
41. Design for Act I, Scene 2 of *Love for Love* (by courtesy of Sir John Gielgud)
42. "Allegory. HRH The Prince Regent awakening the Spirit of Brighton" (by courtesy of the Royal Pavilion, Art Gallery and Museums, Brighton)

# Illustrations in the Text

| | |
|---|---|
| The author at two | *page* iv |
| For a *Pilgrim's Progress* never completed | viii |
| From *Königsmark* | xiv |
| From *The New Forget-Me-Not* | 11 |
| Battle scene, drawn at the age of ten | 20 |
| Crucifixion, drawn at the age of five | 26 |
| Letter to Sir Edwin Lutyens | 47 |
| From *The Next Volume* | 81 |
| From *The New Forget-Me-Not* | 98 |
| "The Great Accident" | 126 |
| Reversible Face for Shell | 128 |
| From *Gulliver's Travels* | 147 |
| From *Gulliver's Travels* | 164 |
| From *Hans Andersen* | 181 |
| Temple Bar, drawn for Shell | 190 |
| From the artist's address book | 196 |
| Medusa, for the Guards Armoured Division | 227 |
| From *Hans Andersen* | 247 |
| From *Hans Andersen* | 258 |
| Letter to Edith Olivier | 272 |
| From *The Next Volume* | 302 |

# The Author's Gratitude

My thanks go again to the very many friends of my brother and myself, owners of his work and his letters, comrades in the Welsh Guards and others, who have helped so greatly in the making of this book. They are too many for all to be named personally, but I must mention three: Miss Rosemary Olivier, whose loan of her aunt Edith Olivier's unpublished journal, together with the previous copying out of all the main references to Rex, provided an indispensable thread throughout his adult life; Lord Anglesey, who devoted minute attention to the text; and Sir Rupert Hart-Davis who did the same, and characteristically copied for me all the relevant passages in Siegfried Sassoon's diary, on which he was working.

I also express gratitude, mine and my publisher's, to Shell UK Ltd and to Mr Ted Sheppard, their adviser, for sponsoring the sixteen colour pages. These commemorate my brother's early engagement by the Company to make humorous drawings, which included his earliest Reversible Faces.

We thank Mr Douglas Matthews, Librarian of the London Library, for providing the index.

*Laurence Whistler*

The Old Manor,
Alton Barnes,
Wiltshire.

Illustration for *Königsmark*, by A. E. W. Mason, 1942.
(Originals now in the Tate Gallery, London.)

*I*

IN THE LAST quarter of the nineteenth century, in two small vil-
lages of North Hampshire not far apart, there were two families of
eight children, composed of six boys and two girls, each as a group
conspicuous for better for worse in that uneventful countryside, and
each known to the other, although they were socially on different levels.

This part of the Hampshire Downs formed at the time an unspoilt
territory of gentle chalk undulations going on for ever, as it seemed;
high ground but not noticeably hilly, with big cornfields and pastures
crossed by ox droves, and with any horizon one might look at, far or
near, fringed with some long belt of woodland – a cool country, wide
open to the wind and light, yet also with a certain feeling of darkness
about it, derived from the yews by the roadside, and from its villages
of flint picked off the chalk and dressed with mellow red brick, or of
red brick and blue brick, and where the little dark casements had
diamond-shaped panes. Such was the landscape round Sherborne St
John, about three miles to the north-west of Basingstoke; though here
it was coming to an end with an imperceptible tilt in every stream and
river-bed towards the distant Thames. In fact the geological frontier
passed through the middle of that village, for here the chalk ended and
the clays began. A few miles to the east the hedgerows drew closer,
the flint walls disappeared, the parks of the well-to-do multiplied, and
the whole landscape began to gain the character, at once lush and
humdrum, of the Thames Valley.

In the western part of the village lived our grandfather John Whis-
tler, a builder and decorator, whose grandfather had met with an
untimely and dramatic end, hinted at by his rhymed epitaph in Alder-
maston churchyard: "Dear friends, do not lament my fall ...". The
*Reading Mercury* for 25 July 1825 tells the story:

Sat. July 23. This morning, about ten o'clock, as Mr Whistler,
Journeyman to Mr Joplin, plumber and glazier, of Aldermaston,

was cleaning windows [in fact, reglazing them] at Lord Falmouth's, at Woolhampton House, the round of the ladder on which he stood broke, and he fell near 30 feet: whereby one of his legs and four ribs were broken, and he was otherwise so dreadfully bruised, that he expired soon afterwards. He was a very industrious, sober man, and has left a widow and nine children to lament his loss.

The true story was this. A boy had taken the long, heavy ladder without permission during the dinner hour, and had let it fall. Too frightened to own up, he had replaced it against the wall of the house, as apparently sound. The cause of the accident remained unknown for about forty years when the culprit lay dying and wanted to clear his conscience. He sent a message to the family, but was dead by the time it arrived.

It was soon after the accident that the victim's son, John, moved south to Sherborne St John, where in the 1830s he provided himself with a home, named Wellington Villas in honour of the hero, and perhaps to signify his Tory allegiance. It survives: a pair of small red brick boxes in the final Georgian manner, semi-detached, but presently made one for a growing family; with the builder's yard at the back. Here our grandfather John would spend his whole life.

The name Whistler is not a common one; in the current telephone directories there are seven in this area and ten in central London. All Whistlers are said to have origin in what is broadly the Thames Valley between Watlington and Newbury, and the derivation is shown by mediaeval usage to be musical. A certain "Osbert le Wistler" of 1243 was a flautist; for in the same assize rolls the scribe has corrected a mistake, changing "William le Wyzelere" to "William le Vylur" – a fiddler or viol player. Presently the map acquired place names like Whistler's Farm, and Whistley Green. The rain flowing from the gutters of Wellington Villas into the Weybrook passed through Whistley Green on its way down the Loddon to the Thames. It was ancestral country, from which, too, the American artist, James McNeill Whistler, derived (see note).

As a young man in the 1860s our grandfather – the second John, just mentioned – took photographs of local characters and scenes, and was in touch with other pioneers of photography (see note). Then he married a Londoner, the daughter of a Camden Town saddler called Warhurst, meeting her when he was articled to the firm of Cubitt in order to learn the fashionable craft of graining (tricking up wood to look like better wood). He also worked at leaded lights in a long-standing family tradition, and at putting together stained-glass win-

dows'. Presently, as an owner of property he was second only to Squire Chaloner Chute of The Vyne nearby, if only a very distant second. Such were the Whistlers, modest craftsmen with initiative, who married into the families of other craftsmen, or of tradesmen and farmers; and with prosperity they seemed to rise a little in the social scale.

Mrs Chute thought they were rising too high. As the parson's wife she was sister-in-law to the squire, and required an old-fashioned standard of deference to The Vyne, and to the church that was a function of its empire. Therefore she called at once to complain to my grandfather when, passing three local girls in the road, she observed that only two of them had curtseyed to her – and that the young Whistler girl (though in fact without malice aforethought, being recently back from the slightly wider world of school) had not. It was a simple dispute over status. "No daughter of mine is going to curtsey to you, Madam!" John Whistler must have been fairly sure of his firm's goodwill in that neighbourhood.

To a contemporary no more sophisticated than they were, his children gave an exciting impression of high spirits and creative enthusiasm, and seemed unlike any other family. They painted and drew, sang, played music and acted, and supplied the church choir with a sequence of trebles. It was characteristic of John, when he restored the top of the church spire in 1885, to have his children with him on the scaffolding – at midnight, on New Year's Eve – singing the "Old Hundredth" around his new weathercock, to their own cornet and violin accompaniment; and to record the celebrations in a sealed bottle recently discovered up there. One brother painted murals of a sort all round a room at home, anticipating his nephew Rex, fifty years on. Most of them has serious ambitions. Two of the boys became schoolmasters and ultimately headmasters of private schools, though all the formal education they received began in the village and ended at Basingstoke, four miles away, where they walked every day up to the age of fifteen – after which a London BA and BSc. were simply achieved through private study. Exercise consisted of skating, fishing and bellringing, and very long excursions over rough roads on springless pennyfarthing bicycles. The family was much in demand for concerts, and would get up a play among themselves, paint the scenery, and take it into neighbouring villages.

Wootton St Lawrence lies two and a half miles from Sherborne St John, higher up on the chalk. Here in 1876 our other grandfather, Charles Slegg Ward, was inducted into his second living. He had been born in Battle in 1840; had gone to Emmanuel College, Cambridge,

where he had rowed in the eight – been inspired by his influential tutor, S.G. Phear, to take holy orders – and emerged a "muscular Christian" with an independent, well-informed, unoriginal mind; soon he was assistant curate to the Rev. Frank Storr at Brenchley in Kent. Storr was the younger son of the silversmith, Paul Storr (see note), who had made for him in old age a set of altar vessels; but by the 1860s that fine craftsman was no longer celebrated, his work in the Georgian manner seeming tasteless and outmoded. No personal memories of him were cherished by his many descendants, and not a trace of his talent was bestowed on any of them, at least until Rex appeared. Staying with her uncle at Brenchley Vicarage was Jessy, a gentle and weakly girl with violet eyes. From the day when his young curate entered the door, alert, manly and decidedly good-looking, it must have been thought that here was danger; and in fact a shadow of recollection survives that the family did not think him good enough for Jessy Storr. Few bourgeois families did think that of any young man who was not titled, or born to a "good" family, or at least comfortably off. The last two advantages were possessed by another good-looking young man who had been touched by the unalarming Jessy when she stayed at Finedon, his home – Digby Macworth Dolben, the poet and Etonian friend of Bridges. But he was heaven-bent on becoming a monk, and died by drowning soon afterwards.

> A little flower of love
> Is ours, without a root,
> Without the end of fruit,
> Yet – take the scent thereof.

Charles Ward was no poet, but he was bent on winning the girl of his choice and at least it could be said of him that, though penniless, he was a gentleman. In two photographs taken in the high-walled Brenchley garden he has evidently been accepted by the pensive girl at whose crinolined feet he is sitting. So they were married, and a daughter – our mother – was born, and christened Helen, but always known as Nell or Nellie.

Inducted at Wootton, Charles Ward set himself to get the Vicarage enlarged for a growing family, whose almost annual growth he accepted as an act of God. For architect he secured his wife's cousin, Basil Champneys, afterwards the designer of Newnham College, Cambridge, and the Rylands Library in Manchester, and from him acquired a new house altogether, in what was thought to be the style of Queen Anne, then emerging from contempt: that is, it had tall chimneys and many sash windows, but no symmetry. Making good use of an old

4

lime walk and yew hedges, he himself added many timber trees, and characteristically recorded them one by one among the baptisms in the church register. He thought big hollow walls were required for warmth, double doors for silence, ample shelves for his library – and for ease and convenience several servants and a gardener. He was also benevolent in the parish, and no bargainer. "I suppose it would be a matter of a £5 note?", he would say to an artisan, who, till then, had had £3 in mind.

Submissive Jessy was not very active in the parish, though liked well enough; for here there was no compulsory curtseying. Nor did mansion and parsonage enjoy the same oppressive unanimity as in the neighbouring village. Soon after they arrived a cross appeared on the altar. Worse, she was putting flowers beside it, and decorating for festivals: she was a great lover of these. Worse still, the church was now candlelit for evensong and the Squire, a wealthy man from somewhere else, never came to church again. Yet the Vicar always refused to be labelled either High or Low, never tried to convert his nonconformists, cheerfully introduced General Booth of the Salvation Army, when he came to preach. He preached very well himself, and with his capable mind and his gift for reconciling opposites seems designed by nature for a bishopric. But no preferment ever came. For in his study hung a portrait of Gladstone, and in the ultra-conservative diocese of Winchester he was known as "the radical parson". With poverty for spur, he began reviewing for the *Literary World*; he crammed backward boys for the Army. After talking to a stranger in a railway compartment about the lack of guide books for pedestrians, he took on southern England for *Baddeley and Ward's Thorough Guides*, researched with pedometer during clerical holidays. He worked late into the night. But it was no good, He would have gone bankrupt and lost his living, but for some arrangement with his creditors. The Whistlers knew of it, of course, and knew that he was pitied more than blamed, such was his popularity.

Meanwhile his sons ran happily wild, until any local misdeed was ascribed to "them Wahrd boys". Since he could not afford good schools, he tried to supplement the grammar school, or even educate them single-handed, but none of them read for pleasure, or had any intellect, or showed the least mark of descent from a great craftsman. They were manly and united and foolish – better bred than the Whistler boys across the fields, and more philistine.

Only his elder child Nell, born in 1870, rejoiced him. She was not intellectual, indeed rather silly at times, like his wife. She read poetry and history with him or with her governess, played Chopin and Men-

delssohn, played the organ in church, sang, wrote verse, did everything
gracefully that a Victorian miss of her station could be expected to do.
It was not in this; it was in herself, a certain "new every morning"
response that would make her seem to her children like an artist
*manqué.* She was tall, with almost auburn hair and very blue eyes,
wilful, rather vain, but the reverse of conceited or complacent; ani-
mated, but, alas, one of those who set firm before the camera from
selfconsciousness, so that always in her photographs she is cold and
severe and barely recognizable as our mother. Too feminine for a
tomboy, she would accompany her brothers into various scrapes, and
return with torn dress to plead their excuses before an irritated father.
Once, when about sixteen, skating near Sherborne St John, she fell
through the ice over a flooded field and was taken to Wellington Villas.
Beside the fire in Mrs Whistler's bedroom she was left alone with an
array of huge calico knickers and skirts that slid to her ankles, but
pinned herself in a red flannel petticoat and came down to a sumptuous
tea. That evening Harry Whistler drove her home in the dog-cart.

Born in 1866, he is said by a contemporary to have been the most
lovable of the Whistler children, and the steadiest. He was quiet-
spoken, not irascible like the others, yet not to be intimidated, resolute
rather than pugnacious, broad-shouldered, slightly under medium
height, with moustache and brown humorous eyes, a lover of merri-
ment and rudery. A friend, whose porch jasmine would never blossom,
returned one late evening to find it studded with little white flowers
neatly made out of cigarette papers. The sayings and anecdotes that
frequently came back to him in after years were those that Thomas
Hardy could not put into his novels, but they smacked of a similar
Wessex; and when I first read Hardy I seemed to enter the scene my
father recollected. In fact, the Hardys and Whistlers viewed it from the
same elevation, that of the village artisan employing a small number
of men. Though afterwards removed from that scene, Harry would
remain essentially a countryman all his life.

He was not as brainy as some of his brothers, but as musical, and
could have been a sound craftsman in wood. His brother John would
take over the business some day, it was assumed; for the eldest son
always did. He himself might set up in some other part of Hampshire,
or perhaps specialize in woodwork. But in 1888, with a father still
active, and with the spirit of enterprise stirring, John and Harry re-
solved to see something of the world. At that time British engineers
using British capital were rapidly extending the new railways of the
Argentine across the pampas. John took a job as a draughtsman on
the Santa Fé and Cordova line; Harry on the line itself, and presently

as superintendent of one section, putting by a good sum of money. Britons were popular because of the support we had given in the War of Independence, but there were tough episodes: brawls when knives were flashed, rides on the engine down the unfenced track when you might run into a crossing herd of cattle with a sickening noise of cracked bones and limbs thrown up beside the boiler. John married a Spanish girl – and died within a month or so of typhoid. Harry thereupon discovered that the Table of Affinities was inoperative there, and that he was not only not forbidden to marry "his deceased brother's wife" but positively expected to. A telegram from his father was timely, and soon Enrique Silvador, as he liked to call himself, was back – now the eldest son – and presently in charge of the firm.

In three years much had happened in nearby Wootton, though it scarcely concerned him. Nellie Ward had "come out", not, needless to say, at a ball of her own, but with some other girls of her age, at a Hunt Ball in Basingstoke Town Hall. Then there were dances at Manydown, Tangier and Malshanger; for her world was now the world of the small country house, overlapping to some extent the fashionable one in which she had no part; she had only once been to a London theatre. She danced well, and was much attended. But she shared a grief with her family. Hard on her father's bankruptcy had come the sudden death of his wife, worn out by childbearing. At the following Christmas dinner, when toasts were drunk, the family waited to hear if Mamma would be included – and she was, one more time, in a constrained voice. Then before eighteen months were up Charles gathered his children again and announced that he was about to remarry, the lady being Henrietta Shute of Yateley, affluent and thirty-five. By modern standards the interval may not seem inconsiderately short, bearing in mind that he was fifty, and could see no other end to money troubles. But the boys were dumbfounded. "We won't speak to her!", they said among themselves. Hetty Shute was plain-spoken, immensely conscientious, and had projecting front teeth that had been reconciled long since to perpetual spinsterhood. (Charles had them put right: she could afford it.) She was willing to take on this motherless family, and was as much to be pitied as they were. On arrival at the Vicarage she found her new drawing-room full of smoke which her husband could not account for, as his tall "Queen Anne" chimneys had never given trouble. The chimney pot had been stuffed with a wet sack for the occasion.

This family, once so closely united round a mother, was exploding like a several-phase firework. Two brothers read of an offer of work in America. It was at their mother's grave that Nell said goodbye to

them, unconsciously composing a Pre-Raphaelite picture. The jobs proved illusory, and they drifted apart, one to die of meningitis at the age of nineteen, robbed of all he had in a Mexican silver mine. For two younger brothers the South African War would give the means of escape. Nell alone, with her sweet nature, older and more sympathetic to her father's obvious needs, accepted a stepmother. But it would never be a happy household again, and she too went abroad, to Brussels for a stay of some length. She shone among the Belgian girls and at one ball introduced the informal English custom of sitting on the stairs between dances, which caught on in that circle. While there she learnt of her brother's death in Mexico, and was encouraged by her father not to wear mourning but enjoy herself. This was as well; for it turned out to be her last visit abroad, and all her fluent French would one day disappear for lack of use.

It was her brother Denis who at seventeen redirected her life, though intent only on his own designs. He was attracted to saucy Lena Whistler (the girl who had failed the curtsey to the Vicaress), and might have married her if the Boer War had not accounted for him with enteric fever. Harry Whistler was content to chaperone their meetings – especially when Denis volunteered to make it a foursome by getting Nell to accompany him down the ox droves in the long June evenings (Pl. 2).

How quickly Harry had serious thoughts of her he would hardly recollect himself. From childhood she had been his ideal, so he said, though of course unattainable. On his return from abroad he had done what was expected – proposed to the daughter of his father's best friend. But she refused him. He had then had some brief liaison with a Miss Huntley of the Reading Biscuits. All the same, he had hidden among the brambles at the crossroads on Rook's Down to watch Nellie cycle by on her new safety bicycle, to music lessons in Basingstoke. He was far from pushing now, or indeed on later evenings, when tactfully leaving Denis and Lena to take a different path, he strolled with her through scabious and vetch, through orchis and harebell, across the open landscape they both loved and knew from childhood.

At the Vicarage only the younger sister sensed what was afoot. "I will give you this box of chocolates if you don't ask me where it came from!" She saw Nell slip behind the limes to watch, when Mr Whistler called about the renovations. This he did rather often, with some pleasant talk in the study, where it seemed to him he had only to mention a subject for the Vicar to pull out the apposite book, always eager for new information himself, on the Argentine or anything else. The workmen showed praiseworthy despatch. "Harry Whistler is an

absolute brick!", exclaimed Charles at the dinner table. But the blush
and quickly-bent head of his elder daughter passed all unnoticed by
him and his impercipient wife.

What Nell saw in Harry was, to put it simply, a man. She had
thought little of the callow fellows in white ties who made up to her
at county balls, or of the dullards whom her father had prodded into
Sandhurst; and she was far too insular to have married a Belgian or
indeed any foreigner, except conceivably an American, whose country,
she felt, displayed English virtues with an exciting difference. Here was
an Englishman, strong, unassuming, pleasant-looking, though not as
strikingly handsome as his father, uneducated, but with a love of
beauty and of country ways, and some experience of the world – a
man of thirty now ardently in love with her, as she with him. When
after a year he proposed she was already twenty-six – this too was a
factor and she accepted him.

There followed two trying years of secret engagement, with a ring
accepted but not worn, before they could decide on action. Then the
Victorian rules began to be flouted in succession. There could be no
"asking for her hand". As his favourite child, Nell was more afraid of
hurting than enraging her father; but here was a first humiliation to
her fiancé, who did not lack moral courage, and would have braced
himself to ask for her. That would have been quite disastrous, and
after some debate, discretion prevailed. "Nell has the pluck of the
devil", thought her sister, as she heard her knock quietly on the study
door.

"Father – Harry Whistler has asked me to marry him, and I have
accepted."

"Don't *say* so!" It was a shock more devastating than the one the
Vicar had administered himself.

Pleasant to record that after much consternation and pleading this
sensible, forward-looking man made the best of it, that Nell was mar-
ried in white by her father, as of course she had always imagined,
before a nave packed out by two parishes, and that two local families,
who after all liked and respected one another well enough, were briefly
and awkwardly united in the clink of champagne glasses. Pleasant, but
alas, entirely fanciful. Charles Ward's liberal principles fell short of
such a liberating upshot by a lifetime of sustained class distinctions.

The charge of snobbery, though merited here, is often difficult to lay
with due weight because that discreditable impulse is often intermixed
with others, not bad, and even good. In itself it is not snobbish to
fear that your daughter is throwing away her chance on a man who is
not her equal in culture, and will not give her the companionship she

needs or the way of life she is used to. It would be pointless, as well, to apply the social standards of a later age. The current standards were still those that had governed a curiously similar situation in *A Pair of Blue Eyes*, except that Hardy's fictional Rector was more angered that an artisan's son should presume to claim his daughter, while this real-life Vicar was more pained. Ward's view of a "social" marriage in his church as out of the question was accepted all round: even the Whistlers are said to have taken no offence – though John Whistler might, but he had recently died, thus removing one awkward drawback. The Vicar felt humiliated. None of his children, not even precious Nell, ever did what he wanted. He must have concluded that he had failed miserably as a father; but the truth was partly that he lived in a tricky, transitional period. Fifty years back, he would have forbidden this marriage. Fifty years on, it would not matter. Forbid it outright he would not, if he could. But have any part in it himself – that was unthinkable.

Along the activated network of the Storr and Champneys cousins dismay was exchanged, and some perplexity. "... And Mr Whistler is only a builder!", wrote Basil, the now-eminent architect. Still, if the poor girl's mind was made up, she would have to be helped. The Vicar's stance made collusion inevitable. His first wife's sister, Fanny Storr, a Sister of Mercy, beloved by Nell as much as her dead mother, was no enemy of his; but she soon contrived a holiday at Betws-y-Coed where of course Harry Whistler would be staying too, and the couple could explore by themselves. For if Nell could be taken to Wellington Villas to make friends with warmly-welcoming Mrs Whistler and others of that family, while Harry could no longer enter the Vicarage, an impossible situation had developed. The firm's stationery now bore his name alone, and, left to herself, Nell would have settled to be the wife of a village builder, striking some compromise between two modes of life; for all her life she would be, and wish to be, adaptable to the man who was dominant in it, while preserving a strongly personal style and set of customs. Now the only solution was haste – followed by disappearance. In point of fact this was not uncongenial to Harry, who had his doubts about remaining always in that village: it had seemed an obscure corner when he returned from abroad. So this old family firm passed out of Whistler hands and was sold, and he invested his few thousands in a timber merchant's in the City. Meanwhile, to escape the tension at home, Nell worked in London for Dr Barnardo.

They were married in September 1898 at St Luke's, Notting Hill, from the house of a Storr cousin – the bride in a white coat-and-skirt,

hardly anyone present but the witnesses – and honeymooned at Lulworth Cove. Her spirits were not lowered by so humdrum a wedding, for their secret downland courting and her resolution to defy convention gave a heightened sense of romance, like some episode in a novel. No invitations had been posted, yet her list of wedding presents from both sides is long. Among them I find no entry for her father and stepmother, a fact that must have sharpened the pain of a man naturally generous, who could not, in honesty, give one; the relentless moral consistency of the Victorian precluded it. When all is said in mitigation, the charge against him must be unkindness more than snobbery. The marriage may have looked unpropitious. He had done nothing to make it less so, much to make it more.

What Harry thought about his father-in-law will presently emerge. What Nell thought was simply that all would come right, and she was patiently determined that it should. This sanguine if risky philosophy was nourished by her faith, in which a sense of God's love and an awareness of his blessings was paramount. She held to it all her days where human relations were concerned, in spite of an extreme nervousness of accident and illness, and it stood her in good stead – except once.

Meanwhile, at some gathering where parsons' wives hob-nobbed, Mrs Chute encountered the second Mrs Ward. "I hope", she said as she passed by, "you will take better care of your second daughter than you did of your first!"

Wimbledon. From *The New Forget-Me-Not*, 1929.

· *II* ·

TO A BRAND-NEW villa on Chingford Green in Essex the young couple supplied the name Summerdown; and from there Harry went up to Bunhill Row by train. They were well enough off to afford a cook, and a house-parlourmaid whom Nell taught to wait from behind her chair at meal-times, happily "playing houses" in her mother's manner, and though much alone, she was content as she rode about on her bicycle, sight-seeing. In Summerdown a girl baby was born and christened Jess after her grandmother.

Harry had put his money into a firm that was failing, and was desperately trying to restore it by himself. In the end some dishonest employee went to prison, but nearly all the money was lost. At this mortifying time, Charles Ward advanced £100 of a legacy from Nell's mother, due to her after his death, and his nephew, Lewis Worge, having money to invest and full confidence in Harry's capability, offered to buy any business that he cared to run. Across the river at Eltham in Kent a builder-and-decorator's business was up for sale. Harry asked Nell if she would mind living near an office with his name above it, and she said she would not. So it was back to the trade that he knew best: he could not escape it.

They found a home at No. 5 Park Place (now Passey Place), a short residential road leading off the High Street. This was a plain mid-Victorian house of stock brick above stucco, rising to a single broad gable, and Nell's bedroom was at the back, looking out over a little walled garden with a lawn and some pear trees. At this period the centre of Eltham was a Georgian village, with an air of much greater antiquity, lent by the ancient royal palace nearby. There was still some country round about, though gradually the green spaces were being overbuilt, a process soon to be promoted by Harry Whistler in a modest way. For he made a success of his business and put up several houses "of good class" and no distinction, in the roads called the Courtyard and North Park, varying some contemporary pattern very

slightly from one to another. He also set up as an estate agent, and as an unqualified architect of small "alteration jobs", taking such care as his scholarship permitted with the restoration of old interiors. The offices were in a Georgian building on the corner of the High Street and Court Road, with "Whistler and Worge" (pronounced to rhyme with "berg") painted on the fascia above them, and with a showroom, inside which, among other bathroom fixtures, a WC pedestal was on display. Nell persuaded him to replace it.

She was again rather isolated, and it made little difference that her husband presently became churchwarden; for here she was at once below and above local society. It did not "call", because he was in trade; she did not mind, because it was *nouveau riche* and flashy. In Park Place, in 1903, a son was born, named Denis after the lost Ward brother who had been Harry's best friend, but always to be called Denny; and eighteen months later, on 24 June 1905, Midsummer's Day, there was a second son, christened Reginald John in the parish church, but intended to be known from the first as Rex – a name not found in either family, but liked by Nell for its kingly sound. He was a robust baby like his elder brother.

When Rex was two they moved to a roomier modern house in the Court Road, built by Harry on the site of the village pond, for a man who had named it Bryher. It is now replaced by a Congregational chapel. Here there were two large nurseries, a big garden and a tennis court. Business was thriving, and soon Harry could buy out the ineffective Lewis Worge altogether. At one moment there were forty men, not one of them allowed to be a union member, in the pay of this firm which was sometimes referred to locally as "Whistler and Worse". In the same year, 1907, he bought his second car, a Gobron-Brillié, a French open tourer whose back seat you could enter only from behind, and by lifting up the folded hood. There were not many cars in Eltham at the time.

In 1907, too, Charles Ward left Wootton after thirty-two years, to become Rector of Walsham-le-Willows in Suffolk, where he was presently regretting the much higher standard of intellect among parsons in the ambience of Winchester. Before he went, he did something good. It was pitiful that Nell should never see Wootton again, and he invited Harry to bring her with Jess on a last visit. It was her first in all the nine years that followed her rebellious marriage, and yet there had been no real rupture because of her resolve that there should be none. Here, then, was a reconciliation, whether explicit or not, to be reaffirmed in the following spring when Harry, Nell and the three children all stayed at the new parsonage – in fact a very old and

picturesque house, of which Harry made water-colour drawings, giving one to the Rector. It has to be remembered that neither father nor son-in-law was obliged to overcome an instinctive dislike of the other, though it is true that disapproval of an action often leads to dislike of the agent. It was not so with them. The elder had respected the younger, thought him sound – but unworthy. As for the younger, his attitude is best revealed when I say that I at least, much the youngest of the children (still unborn at this period) had no notion until many years after my father's death in 1940 that their relations had been anything but good. If Rex had that notion it did not impress him enough to mention it. Being the eldest, my sister knew – and wept bitterly when told by the son of the Rector's second marriage that her father was not a gentleman; but she was abroad for nearly all my adolescent life. Our father always spoke of our grandfather with admiration for his gifts of learning and preaching, with amusement at his liberality, and with sympathy for his money troubles. Had he felt the slightest resentment it is inconceivable that he would not have shown it by a look, an expression, a sardonic joke. He was far from obsequious and by no means uncritical; much given to cynical if fairly amiable derision of others – and rather specially of parsons. Brought up to go to church but to ridicule the parson, he remained an anti-clerical churchman all his life. For him the main exception to the Rev. Chutes of the Cloth had been the Rev. C.S. Ward.

That this could still be true after his marriage is explained by two characteristics. He was magnanimous – and he had no social ambition. Although among the qualities that had charmed him in Nell was no doubt her greater refinement of mind and manner, he had not thought to raise himself by marriage, as his earlier choice of a wife had shown. Thus he was not wounded by being deemed "not good enough" by her father. Content with the class structure of his rural England, he probably saw this as a reasonable attitude to take. A father would think that, though brothers might not. After the death of Nell's brother Denis in South Africa, Harry's one remaining close friend was her brother Basil: of whom he drew and coloured a superb caricature, owlish, dignified, and slightly bottled, which made my mother expostulate, and delighted Rex.

So, thanks to his magnanimity, the two moved at last into a less absurd relationship, where the Rector could visit the family in seaside lodgings, and a year or so before his death, in 1913, could at last stay with them at Eltham – a portly old gentleman by now, who helped to mark out the tennis court, sat quite immovable in the swing when all his three grandchildren together tried to oscillate him, and enjoyed his

motor drives into Kent. "I had better take a stroll", he said, when the car broke down, and Harry, with head behind the brass radiator, humouring the ignition, dropped something and swore, as I was often to hear him, later on. "The atmosphere is getting rather blue!" He was free, once again, to think pleasantly of his son-in-law. Nell's policy had proved successful. Here was an object-lesson in simply refusing to acknowledge estrangement.

Of course her father had by then satisfied himself that Nell was still the Nell he had loved, that she was happy, with promising and lively children – the only grandchildren he ever saw – and that it was she who was setting the style of the family; her husband was obviously content that she should. The Rector may even, one hopes, have wondered what the fuss had been about, when his daughter was only doing what she would have done in any marriage with a man who suited her. Suited they were, pretty well if not ideally; and united through life by tenderness, by admiration mixed with amusement, and by complete loyalty. There must have been many times when she felt the lack of a well-read companion, many when he found her way of life less homely than his mother's: to a lower level of refinement a higher is apt to appear unspontaneous or stilted. She was lonely when he spent long masculine evenings round the billiard table he had installed above his office. Still, there were parties when they sang together, he with his tuneful tenor voice, she at the piano: he had given up the violin, but his pleasure in music remained. And the Ward brothers were always coming and going. "I keep this place as a playground for your uncles", he observed to my sister.

Of their intimate life they revealed nothing. He might relish rude stories and innuendos, and she might give only a conventional reproof because her sense of humour was lively; but this was not very revealing. They were not, it must be observed, even late Victorians, they were mid-Victorians, and of an absolute reticence. My sister and brother could therefore form opposite opinions as to which of them cared more for making love. On the one hand our mother seemed eager and impulsive and excitable – but embarrassingly prudish. On the other hand our father seemed warmly disposed – "Kissing begins at the top and works downward", he once observed – but rather in awe of the highly-sexed. "Some of these women are really *keen* on it", he would seriously confide. "Fearfully keen on it!" The likelihood is that her romantic ideas of bringing a child into the world never quite came to terms with the actuality of this necessarily rough but always tenderly considerate male – and that his need for quite a simple but repeated and spontaneous response was hardly met. It may be indicative that

we called them "Daddy" and "Mother", half-way to informality; and it is difficult to see her as a credible "Mummy", her intense love was more emotional than physical. Later on, when it came to enlightening their children, they simply abdicated. My father's only contribution was to observe, years later, that he always did think that one of his sons would be a lad for the girls, from the way he used to jig up and down at night. Instruction was left, in my own case, to an uncle by marriage, who seemed to be disgusted by sex, who talked of "going pure" to a woman, whatever that might mean, and who thought that little emotional booklets on the Communion Service were a substitute for the information I was soon receiving from the boy in the next bed, partly garbled. Not that it mattered.

It seems that our parents may have used no means of contraception, since there were two miscarriages between Rex's birth and mine, and another later still. My mother would have liked seven children, though without liking babies at what she called "the pink blotting paper stage". I was born on 21 January 1912, and christened Laurence after Wootton St Lawrence, but spelt the other way, to be classical. Thus I was six and a half years younger than Rex, and had a father and mother whom I can only picture, at furthest remove, in advancing middle age, he being forty-six at my birth and she forty-two.

Having no strong ambition themselves except to raise a family and support it in reasonable comfort, our parents were of the kind that pins the major hope on the children; in other words they belonged to the generation of the matrix, not the gem. Such parents are good for children who do have strong ambition, and mean to be gemlike in achievement – if they only can – provided two conditions are met; and they seldom are. Firstly, parental hope must not be too hard to live up to, and nothing must ever be tacitly demanded, like the winning of a scholarship or prize or good degree. And secondly, paradoxical as it may seem, parents have to put each other first. Then children escape both daunting expectation and spoiling attention, to creep or race ahead – creep in my case, race in Rex's – with a general sense of backers in some discreet bandstand. Our parents met the first condition, as I shall show, and I should say they met the second equally well. Big sacrifices were made by both, but I cannot recall an occasion when either of them allowed the passing needs or comforts of the other not to come first.

In this they showed natural wisdom, unpremeditated, as also in never making too much, outside the family, of their children's promise and youthful achievements in the years to come. But in other aspects of parenthood my father played no part, and my mother revealed a

silliness that seems to have been innate in Ward women, or perhaps rather in Storr or in Utterton – a legacy down the female line. She called her boys Baby Denny and Little Baby (though Rex was big enough) until the former was approaching three, and she indulged in much shaming cheerfulness in public places and in company. They do not seem to have suffered from it as badly as I should in my turn, when perhaps it had grown worse for the last child, often called Lauriekins up to, and far beyond, the age at which it embarrassed me. She would greatly improve as a mother of grown-up children. The silliness, it will be seen, was not of the kind that derives from current fashion in child psychology; on the contrary, it hid behind an assumption of commonsense which would have spurned as "piffle" the very notion that a child could be considered psychologically. Her mother being long since dead and probably no wiser than herself, there was no experienced elder woman on close terms whose example she could have followed, if she would. However there was always a nanny, for better or worse, and later there was a governess.

Separated by only eighteen months, Denny and Rex were uncommonly well attuned. "They were devoted to each other", a childhood friend has written, "and inseparable companions, almost like twins, and I never remember them quarrelling, though not in the least alike. They seemed to have endless topics of conversation, and much fun together." My sister confirms all this. The elder was tall and slender like his mother, pale, but with Whistler colouring, dark hair and luminous, dark eyes. The younger was in looks much more a Ward, with grey-blue eyes and very pink cheeks: decidedly chubby. Denny was the more mature for his age. Intensely loving, he could not, like Rex, broadcast an easy affection; for he was reserved, even secretive, and rather precise in manner. But if more devout in his prayers, being serious, he was also more deliberately mischievous. At Walsham he went to the end of a passage, took a run at his grandfather from behind, and ejected him into the Priory garden, thus unconsciously avenging his mother's exit of ten years before. Rex was, or, more correctly, seems to have been at this age, the happy extrovert, ready to embrace and kiss all comers, more sociable and funnier to be with, voluble with comic ideas, the favourite of the nanny, the unruffled round-faced onlooker of rows between brother and sister. Content to be led, he was yet near enough in age to feel obliged to keep up, and no doubt thought it the more necessary because they were even presented to the world as the twins they were not – always dressed alike. In summer they wore tunic suits of drill, coloured ones on weekdays, white ones for Sunday church-going, which had to be sent

to the laundry every Monday, but were deemed well worth while. With these they had big-brimmed hats of straw on the backs of their heads, kept on by elastic under the chin. In winter they wore sailor suits of blue serge.

Obliged to "keep up" meant that when Denny dived from his mother's high bed, all twinkling with brass knobs, into the blue centre of the carpet that was a swimming pool, Rex must do it with as much abandon – he would not plead infancy. It meant that when Denny, later on, climbed daringly high into one of the big elms along the garden fence which had known hedgerow and pasture before the villas came, Rex must climb as high, if he could. Thus childhood gave, or at any rate enforced, the impulse to prove himself, which privately was with him all his life and ultimately dominated it.

There was no deep rivalry in this, and none at all in their most frequently shared occupation. Many children draw and paint, but in this family it was done by all with unusual application. Certainly the atmosphere was favourable, but only inasmuch as our parents had themselves always done it, and to present a baby with a pencil and a piece of paper came natural. Each child in turn saw an elder at it, and needed after that no encouragement. Heads lolling on arms, the boys remained absorbed in it for hours. On Sundays, from the time they were four or five, my mother would read them the Bible stories, and while she read they would begin to put down their notions of the Expulsion from Eden, Cain and Abel, Jacob's Dream or Rebecca and Eleazer; or of the Entry into Jerusalem or the Journey to Emmaus (p. 26). In this way they were well grounded in the Bible and the beauty of its language. There seems to have been little to choose between them for some years, though Rex may always have been the more dedicated. Even on the holiday sands of Southwold and Cromer, where children do not often draw, except with the corner of a spade, he was likely to be seen with his drawing-book placed on the wooden rail down which the bathing machine was designed to roll; and he was not a boy who shrank from physical fun. In those stuffy but delectable lodging houses their Aunt Dorothy was a guest, as a rule. At first her stepmother's remarks had made her horribly ashamed to tell anyone that her sister had married a builder, but she was soon fond of him, and, being pretty and flirtatious, aroused some slight jealousy in her sister. She had an agreement with Rex. She would give him a new drawing book every time he finished the current one, on condition that he returned it to her when full; and thus amassed a great number.

Back in Eltham they were going, first one, then both, to Babington House, a girl's school round the corner in North Park, with a class for

very small children of both sexes. Isabel Smith, the drawing mistress, soon recognized Rex's talent, and raised him, for art, to the astonishing height of the sixth form. There he would arrive in his sailor suit to be petted by girls of seventeen whose drawing was less vivid and confident than his own. We were all brought up under a ban on the slightest "bragging", and it seems inconceivable that Rex ever had a tendency to that, so the singling out did not make him a prig. Once, the class were set to draw a casserole and two hard-boiled eggs, cut in half. Later, when these models had been removed, he was observed still bending over his paper – pencil held in that singular fist which no one, luckily, made more than casual efforts to correct, and which everyone who knew him in later years will recall.

"Rex, what are you doing?"

"I haven't finished these eggs." Laughter from the form. "Oh – they've gone!"

So was revealed, for the first time, a life-long inclination to invent rather than to observe, from which would spring the inexhaustible fecundity of his fancifulness, and also that side-stepping of problems which precludes the highest art. It is also true that throughout school life any kind of lesson would have shown his progress in art better than the one so drearily devoted to that subject; for he was bored by school work, and when bored always fell to drawing. Similarly, mental effort was always easier with visual aids. Someone at last taught him to spell his own surname by pointing to a board at Well Hall Railway Station with the large word "Whistle" across it. I guess that Denny was already beginning, though only just, to show himself the cleverer at school work, age for age.

Their themes were shared: ships and steam engines, soldiers drilling and fighting, with the Boer War and the Indian Mutiny for inspiration. Topical themes played their part: Blériot's flight across the Channel in 1909 – the Coronation of 1911 – the launching of the *Titanic*, and soon the disaster, in 1912. Then came the Declaration of War outbidding all subjects. Below the nursery windows army transport hurried up the Court Road towards Woolwich Arsenal, chalked in large letters "To Berlin". War with its rapturous indignations and fearful odds, its lovely bloodshed and daily solemnizing in grave, grown-up conversation, was simply a new and more lasting excitement to them. My father, who was forty-eight at the outbreak, volunteered for war work and was trained to supervise munition manufacture at the Arsenal. Looking in on the boys asleep in the night nursery, my mother thanked God that they were both so young.

The war encouraged them in one unusual direction. "Though the

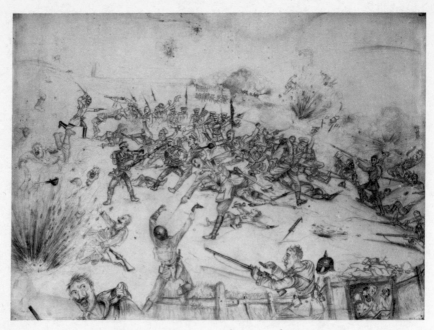

Battle scene drawn at the age of ten, 1915

kindest of little boys," a friend has written, "they loved drawing tor-
ture pictures, with the most ingenious and involved machinery of a
Heath Robinson type." There was individual torture, and there was
mass extermination. Denny seems to have initiated this, but Rex shared
the impulse to the full, then and later. Violent death would be conspi-
cuous in his work right through adolescence, would indeed never quite
be abandoned as an agreeable subject for doodles. But it was all –
always – a fantasy. Never would he draw atrocity or terror as they
really are or might be. One Christmas in the Thirties he asked me to
give him Goya's *Disasters of the War*. The fascination exerted by this
book, and by the same artist's *Third of May, 1808*, the greatest paint-
ing of terror that exists, implied no inkling of a similar talent; nor,
truly, would he have wished to possess it. His own horrors are disin-
fected by a kind of innocence, never far from absurdity and sometimes
frankly humorous. His revolutionary scenes are comic opera, all ban-
ners and the antics of escape. Even when wholly serious, he withdrew
from close scrutiny of the intolerable. In his altarpiece at Brompton
Oratory (stolen in 1983) the Tyburn martyrs hang from a gibbet as far
away as he could place it while still telling the story.

Another source of inspiration came from the comic-strip cartoons
of the children's paper, the *Rainbow*. Mrs Hippo and her assorted

later retrieval &
in place.

20

animal family appeared in that, and again in *Playbox Annual*, the book that became for us a feature of Christmas morning. As young children we were fortunate in having unsophisticated parents who did not try to give us taste, that grown-up property no child can truly own or use. To a child's imagination bad pictures may be more stimulating than good; there may be more inspiration in the round white clouds of everlasting summer that peep above the bungalow on the cereal packet than in a Raphael. Denny and Rex pored over these strips and needless to say made up their own, with narratives that presently outdid them in length, running into twenty, even forty, little frames full of energetic action. For many years it was Rex's curious method to draw his figures from the feet up, and there was a kind of logic in this. After all, the floor or roadway was there before the feet could walk on it, and the exact length of a body was difficult to judge. It would not do to begin at the head only to discover that the feet finished six inches above the surface, or as much below it. So a page from some early sketchbook may show a pair of carefully drawn boots striding down a street by themselves.

There would come a time when children would be enchanted to receive from Rex a rebus letter, where all the words are represented by objects, with letters beside them added, or put in and then crossed out, as was necessary to form the homonyms (see endpapers). This, too, came direct from the comics and annuals of childhood. The earliest example is a sequence by Denny at the age of ten, where it is the names of towns that are drawn rebus-fashion. I mention this only to remark that as the elder brother he probably suggested new departures to the younger, and it was he, I think, who began the craze for inventing elaborate machinery with a great deal of plausible detail. Rex, following and going further, developed through the years a gift for explanatory drawing which would arouse wonder in builders and craftsmen of all sorts, seeming, as it did, unexpected in so fanciful an artist.

In these early years he did not think of growing up to be "an artist". It was not a notion entertained at home. But Miss Smith at Babington House suggested that the boys should join the Royal Drawing Society directed by T.R. Ablett, and send in work for the spring exhibition. This Denny first did in 1911, and Rex a year later, when he received a prize, the first of an unbroken sequence won every spring for twelve years. Miss Smith used to say, "Rex, you must win me the Teacher's Gold Star!" And in 1914 she did receive it: "For having discovered the cleverest pupil of the year. Viz: Rex Whistler."

One by one they moved on to a preparatory school, and the choice

had fallen on Merton Court. So in the autumn of 1913 they were catching a Sidcup bus together in scarlet caps and ties, there to be known as Whistler 1 and 2. To me it is strange that Rex was ever Whistler 2, so completely would he wear for me the mantle of primacy. Day boys, or at least junior ones, are not conspicuous at a boarding school, but G.C. Lines, their headmaster, had not forgotten them after forty-five years. "They were both rather shy and retiring, Rex less so than Denny. Of one thing I am absolutely clear and that is Rex's skill as a 'sketcher', and the vivid imagination he showed. At that age he seemed to foresee the 'warfare of the future'. He gave me one of his loose-leaf drawings. His sketches struck me than as wonderful." Indeed an extraordinary number of his childish drawings would survive in many hands, on account of this precociousness.

One morning in February, 1915, Denny felt ill at school. He left without permission, caught a bus home, entered the house unobserved, and put himself to bed in the dressing-room where he slept. I see clearly into his mind. It was just what I should have done – the equivalent of what I did, later on, when, bicycling home at speed, I let a parcel come between knee and handlebar, and got up from the roadway with pouring forehead, and a crater in my knee, some flesh left behind. I straightened the wheel, rode home, and induced the maid to help me mop up without antiseptic, before telling my mother. I was shy of her quickly drawn breath, of a too-intense *concern* – though first-aid of this kind might have been considered likely to heighten it. The concern was more distressing to me than the five stitches that followed without anaesthetic.

As for Denny, that day, it was the onset of a virulent form of measles, caught at the school and complicated by whooping-cough. Soon all four of us were ill together, Denny and Rex the most seriously, needing separate sickrooms and provided with three nurses for the twenty-four hours. The house had turned into a nursing home.

After a few days of apparent recovery the doctor said that Denny might get up for an hour. He protested vehemently, but was induced to dress and brought down to the dining-room fire. There he played listlessly, until he complained of feeling cold and was sent back to bed. Pneumonia followed, with the sense of mounting apprehension felt through shut doors in each sickroom. When both lungs were involved there was no hope; for penicillin was still a quarter-century away. He died on 18 March, at the age of eleven and three months.

The effect on our mother was disastrous. Tormented by those last hours of the drowning body, with its heaving chest and dreadful gasping, her grief was sharpened by remembering his instinct to stay in

bed, by the poignancy of a child's helplessness before a grown-up decision; and of course she blamed the doctor in her mind, though it was not her way to do so, in distress, more than gently to his face. But beyond that, her religion, fervent and instructed as it was, proved simply inadequate to meet this blow, her notion that God's love would shield us from harm had been conceived too naïvely or cherished too wilfully, in view of "all the changes and chances of this mortal life" – words she had often enough repeated in church or at the prie-dieu in her bedroom. Forty years later she could be brought to speak of those days, with regretful self-deprecation. "I lost my faith for a time, you see. I didn't think God could be so unkind." When asked what our father's faith had been like, she replied quietly, "like a rock, I think." I saw how much she had relied then on a man who never spoke of faith at all, and seemed to go to church out of habit or to please his wife, but whose compassion for her and for his child could draw on a better-balanced hope of some ultimate meaning.

She did not collapse, or cease to tend carefully her other invalids; but there is said to have been an air of horror in the house, and somewhere in my brain cells is the imprint of its actuality, sealed away, but only just beyond recapture – all but a memory. What I remember is the smell of some inhaling lamp, and on the ceiling one circle of calm and haunted light thrown up by the nightlight floating in the basin, through immense caverns of dark, sorrowful time. Denny himself I have forgotten. I think some harm was done me then, when I was three, but it is never possible to know for sure if your primal defects should be blamed on someone else, or on your stars, or on yourself. And if to some extent the first was right, well then, it seems as though I had already forgiven her long before that possibility occurred to me. Once Rex mentioned that he could not understand, at the time, why death should be such an absolute catastrophe to a mother who believed in God. Quite so. I think I was told that Denny had gone to heaven – and saw through heaven like a paper screen; that he had fallen asleep – and inferred that sleep was perilous. For many years, just when I crossed the brink into sleep's first fiction, I used to start back, not frightened so much as wide awake and alert, from the risk of the unknown.

My mother could not face the funeral, and my father went alone to Wootton where she wanted it to be, with the wooden cross he had made, the grave to be next her father's. Denny's class sent snowdrops, in the solemn wonder of hearing that Whistler 1 had died; and soon forgot about Whistler 2 altogether, until some of them recalled him, years later. He too had been very ill, but perhaps had greater stamina.

He had ruptured himself with coughing, and went to the Great Ormond Street children's hospital for an operation, which does not seem to have worried him greatly. But that was later. Watching from a window of Bryher the coffin being carried to the hearse, with all those flowers, he and his sister felt nothing but profound relief, she would tell me years afterwards, the novel ceremonious moment quite detached from the reality, yet helping in its way to make it more acceptable; which is what obsequies are for.

The reality for Rex was very hard. He had lost his close companion and seemed for a while as unbalanced as one of a pair of interlocked trees when the other has come down – a friend described him as appearing quite aimless in the following weeks, while another records him as saying that he did not want to live without Denny. If that sounds like the kind of comment a child might think appropriate, it is possible that he acquired at this time – because he seems to have been markedly without it before – that sense of the sadness of life which any sensitive person in later years could detect beneath his gaiety.

It is interesting, if hardly fair, to compare the twenty drawings Denny made, sitting up in bed during those five days of supposed convalescence, with drawings by Rex at the same age, a year and a half later. There is no doubt that Rex was leaving him behind in imagination and skill, in the energy of his figure drawing, and, most tellingly, in his sense of a picture as a composition. There is also no doubt that Denny showed promise. He drew better than I should at the equivalent age – to make the only other detailed comparison I can. It seems to me, as to others who knew him, that he would have become an artist of some kind, and I fancy he might have proved the architect of the family. If so, there could have been scope in the Twenties and Thirties for a fertile collaboration between the two of them – indeed, between the three of us, in course of time. And if so, the splendid library of Basil Champneys, our old architect-cousin, would surely have been his, since it would have been mine if I had not abandoned architecture for writing and glass-engraving. Had I grown up with two elder brothers, it seems unlikely that Rex in second place would have emerged as my unquestioned leader, dominating my imagination as he did for some years.

Eltham, to my mother, had become inimical, and the raids on Woolwich nearby and along the Thames made it still less congenial. Friends who had gone to live at Abbots Langley in Hertfordshire, on the other side of London, found furnished rooms and encouraged her to take them. My father yielded to her wishes, as he always would, though it meant leaving his business unsupervised in the hands of a manager,

while he transferred to Luton, where Kent's Knife Factory had been adapted to make shells, and from where he returned by train and pony-trap at week-ends.

The neighbourhood was liked. There were girls of Jessy's age. And a house was looked for and found in the Abbots Road, a recently-built villa rendered in white roughcast and called The Knoll. It was much smaller than Bryher, but, then, life itself "for the duration" must be smaller – except that at once it was bigger for our mother in a social sense, back among the small country gentry of her native world, free to join them in their war-work, their fêtes and sales, and in taking on and personally caring for a street of poor houses known as her "district". There I would sometimes accompany her, or go on errands, where the little iron gates, to my mind, said very slowly, "ma-angle wu-urzle" as they opened on to hot geraniums – and beyond that on to small interiors agitated by clocks, where old people sat, no more mobile than their pungent furnishings. This street looked like the edge of a town; nevertheless Abbots Langley at that time was still essentially a country village, having only a ribbon or two of city men's villas, half-concealed by sticky berberis and laurel; and if the country beyond was only as deep as the Home Counties were capable of being, it seemed by contrast remote and somewhere else to a child who found those inroads of suburbia from the first unaccountably and deeply depressing. We had a longish strip of garden at the back of The Knoll, with old fruit trees that exuded gum, a high privet hedge that must have been older than the house, and a strip of kitchen garden alongside it. There was a meadow with buttercups in front (now covered with bungalows), a shady dingle beyond that, and beginning close behind those Edwardian houses of the Abbots Road there were woods and breezy pastures unfenced, chalk pits and a spinney full of bluebells.

Into this unremarkable England the war intruded with sights and sounds that did not greatly disturb. Troops camped in a field, and disappeared. Searchlights caressed the clouds to south and east. The guns towards London might thud, a siren be heard; occasionally a plane would groan across; once only the loud gun at Leavesden went off. Sometimes children were brought downstairs. And once a stricken Zeppelin hung in the darkness, an appalling glow-worm, lighting up from miles away every detail of the road for my father, whom the barrage had called out. But no bomb fell in that neighbourhood. Anguish exploded just as suddenly, but privately, in house after house.

That was a dread our household need not suffer. Yet it seemed to our mother that with the onset of this hideous war all had changed, and that the best was in the past. She thought her youthfulness had

vanished with it; but in that she was mistaken. As for Rex, he was fortunate in being at an age to find war exhilarating: too young to be involved, too old to be infected by his mother's nerves. He was soon out of the wheelchair he had been ordered. A retired schoolmistress in the same road was teaching her own daughters and some others. Clearly it was right for him to settle in as a day boy there before attempting his first boarding school alone. Denny was seldom mentioned, to us at any rate. The dead fall piteously into separate silences, the deeper the more pain they cause. Only in prayers every night by the bed his name would always keep its place in the familiar sequence, long after his likeness had faded, and the sound of those two syllables seem tender, unearthly, and very small, like a tiny noise, a double note unexplained, in an empty room. How long Rex continued consciously to miss him he never told me and I never thought of asking, but he once told a friend that he had always been waiting for me to grow up and be companionable.

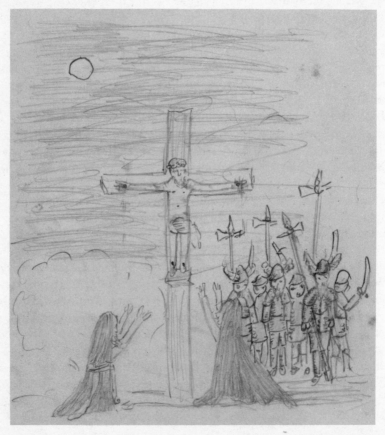

Drawn at the age of five

## · III ·

SIXTY YEARS AGO, and more recently too, it was axiomatic in
our walk of life that a girl could go to day school or be educated at
home by a governess shared with other girls, as my sister was, but that
a boy must go to boarding school, to learn independence and be tough;
and this notion held, notwithstanding the majority of Englishmen went
to day schools, and were not noticeably more dependent or soft than
the minority who did not – our father himself being evidence of this.
Really the notion obscured another, much more to the point: to be
accepted by the ruling class and share in its prodigious advantages a
boy must talk with its accent and have been to one of its more elevated
schools. A father who wished his son to have a better chance in life
than himself might consider the expense worth while. Yet I doubt if
our father would have acted on this notion unless persuaded by our
mother; for he was not one of those self-made men whose ambition is
transferred to their sons – to see them assume a status not to be
enjoyed by themselves. But certainly he wanted us to have the best he
could afford, and was content to leave to her the inquiry into schools
about which he knew nothing, and, after some discussion I suppose,
the final choice. The fact that this arrangement did not seem to
diminish him, or even strike one throughout youth as abnormal, is a
mark of the "balance of power" they maintained. For though it was
evident later that he deferred to her in these and other social matters,
he was not in the eyes of childhood a nonentity, but the masculine
ground on which we relied, so that his very occasional outbursts
about extravagance or the imminence of disaster, as money troubles
thickened and blood pressure rose, were frightening like an earth-
quake; and though she wrote the programme of our lives (his included,
to a large extent) she did so in a wayward, unpredictable, timorous
if optimistic manner that was far from dictatorial – never wrangled
with him, seemed to yield when he was angry, got her way only by
arts of a feminine kind – and generally was no more like the con-

27

ventional picture of a dominating wife than he was of a hen-pecked husband.

In 1916, at the age of eleven and a half, with a public school in mind, Rex left home to become a boarder at his second preparatory school, Gadebridge Park, Hemel Hempstead, distant a pony-trap drive. "I did a drawing for a boy yesterday", he wrote in his first letter home, "and after that I got no peace everyone asked me to do them one. This is not ment for brag just to fill up." This careful disavowal reflects the family ban on any showing off, which I have mentioned; and the story itself suggests that he arrived well-aware of his best passport to acceptance. It was indeed the best there could be, even better than the gift of clowning and miming which some children possess; for that can presently invite an angry reaction and an itch to suppress the entertainer, whereas there was nothing to find fault with in the way Rex went quietly to work by himself, attracting in a very short time an audience. His easy unassuming manner throughout life must be partly due to his luck in possessing a gift he could rely on in any company whatever.

"I am very happy here", he had begun, and since it was quite a good school, through which talented people have passed without recorded injury, he might have remained so, but for a singular misfortune. He was bullied, not by any of his fellows, but by one of the joint-headmasters, described as an irritable man with no understanding of boys. It is true that Rex was useless on the playing field, backward in the classroom, and vague, but there were others no more satisfactory to a conventional schoolmaster, and Rex felt that he was picked on for quite special sarcasm by a man who personally disliked him. Whether that was so or not, his health began to suffer from anxiety, he was often ill in bed, and at other times the matron had to sit beside him through every meal to cajole him into finishing food that he could hardly swallow. In this school food was a deliberate punishment, and a boy who was naughty might be put on rice pudding for a week. But at home Rex never mentioned his dread of that master until he had left Gadebridge Park, fearing that intervention by his mother would only make things worse for him, as it undoubtedly would have. On the last morning of each holidays he shut himself up in his room to weep and weep, and in the afternoon was driven away to prison, red-eyed and speechless.

One contemporary remembers him as looking "scared and bewildered"; another as "a misfit ... I don't think any of us ever really understood him or took him very seriously - except for his drawing." He sounds like a different boy from the one who had travelled with

Denny to the school in Kent. Another speaks of "a sense of 'different-ness' and of loneliness on his part – which is, I suppose, as near as the ordinary thirteen-year-old can get to recognizing a genius". But then a fourth recalls "his intense sense of humour – we never stopped laughing". And his gift for verbal fantasy impressed them. Lying in the sanatorium during some ailment he dilated on life in heaven, where the angels go about with nothing on at all except bedroom slippers. Even some of the staff began to recognize talent in due course: one master was struck by his ability to chalk a free-hand circle on the blackboard, and used to boast of him to parents as "a boy here who is going to be a great artist" – adding that he was not much use at anything else. No doubt he was happier towards the end of his time, with the midnight feast in the dorm and other escapades to report. "I have kissed every made in Gadebridge except one all more than once, and 3 of them 3 times each. And of course I have kissed Miss Barr 2 times. I haven't got anything else to say."

He was then thirteen, and about the age when my memory begins to provide distinguishable images of him (Pl. 3), though they blur with others from the years to come; for the characteristic scene would always be essentially the same. He is seated at the dining-room table in The Knoll. I smell his coloured inks, redolent of lamplit timeless-ness. I hear the dry, crumbling sound as he sharpens a pencil point against the lead-coloured top of his thumb, or the lively ticking of his nib on paper, then the tinkle of brush against cup, the very tintinna-bulation of contentment. He is never silent unless being read to by our mother; and never still. If not talking he is quietly singing to himself, or more probably whistling a popular song, but with lips twisted round to one side in an odd rubbery way that would earn him at school the nickname of "Bungey" for a time. I hear that crooked, mellifluent, milky-sounding whistle break out again, always perfectly in tune, as he pauses for a moment of consideration, with head tilted, fingers drumming the table, knee jigging, and heel drumming the floor. I see the moving hand from which the legends flow without the least apparent effort – the hand held in that unorthodox way, shut into a kind of fist, firmly gripping the pencil that spears it at a steepish angle, pressed down by the first finger, with the thumb clasped across it. This grip, as I have indicated, he would keep all his life for drawing and writing, but would use a more open one, later on, for painting in oils on an upright canvas.

School was now manageable, if tedious, and after all rather trivial when compared with the active interests of the holidays, though here a disappointment occurred. In the village the rich friend who finished

prep school in the same term, the Kindersley boy who had been so often in our little house, and to whom he was devoted, spending much time with him on bicycles and ponies, all at once dropped him completely on returning from a first half at Eton, much to Rex's mortification. He continued to send in work to the Royal Drawing Society, winning each year a bronze, silver or gold star, and sometimes two, and in 1917 Princess Louise's Gold Star, the highest award, which could be won only once.

My father was now Inspection Officer at the Luton High Explosives Factory, an anxious job, for on him and his staff ultimately depended the reliability of fuses: the all-too-frequent carelessness of a girl at the bench could kill men at the gun, yet the rate of delivery was constantly stepped up, and there could be conflict also between civilian authority and military or naval. At one moment a store he controlled was high-handedly commandeered and sealed by the Navy. He reopened it – an unheard-of liberty – and faced the fury of several beribboned figures from Whitehall in his office. "You *dare* to break the Admiralty seals?" The phrase was repeated with menace. "Yes, I dare! And if you do it again I shall break them again!" It was courageous, and though he won, he must have foreseen that it would not improve his chances of promotion and a higher salary. Rex paid a visit to Luton once, and returned to make from memory some drawings quite remarkably detailed and complex for a boy of twelve, where a factory of the period is seen with its overhead transmission and forest of pulleys driving lathes below. Memorizing was encouraged by the Royal Drawing Society, and so of course was drawing in preference to painting. It is an odd fact that the greater part of his boyhood work is in black-and-white – pencil up to the age of eleven and indian ink thereafter. It seems that his childhood paintbox had fallen into some disuse, and certainly his colour was childish when he began at about the age of fifteen to take obvious pleasure in painting. Even odder is his lack of interest in a beautiful effect until then. Realism, invention and humour he pursued. Beauty was simply not the aim.

The notion that he might earn his living as an artist was still hardly entertained by our parents: at this period they shared the *Punch* view of Art as a mode of life slightly comic, rather effeminate, and probably impoverished. My mother had thoughts of the Army – as an honourable and manly peacetime occupation, of course, and always assuming there would be no question of a war. Years after his death the inconsequence of her mind was seen again when fantasy met reality in a single sentence. "I used to dream that he might become a soldier! – Of course I didn't know then that he would have to be." It was supposed

that his accurate drawing might be useful in the Royal Engineers; and by the irony of events he did in the end make lucid sketches of all sorts of military gear. But the redoubts and redans in her mind were those she had seen illustrated in her father's textbooks for coaching in the 1890s. Partly the inspiration may have been Great-Uncle Edwin Utterton of the Royal Welch Fusiliers, who had fought in the Crimea and the Indian Mutiny and had been killed in New Zealand. Anyhow, Rex was entered for Wellington and Haileybury, both army schools, with the final vote cast for Haileybury because it was nearer home. Of its houses Highfield was chosen for what may seem a rather contrary reason: it was supposed to provide better food and some degree of home comfort. For example, it installed the new boy in a shared study instead of in a houseroom, a genuine advantage to all but the most innately gregarious. With an effort in his final preparatory term, or perhaps with less effort than luck in the exam, Rex rose to the level of the Common Entrance and passed in. He arrived in May, 1919, and was placed in the Lower Fourth, the bottom form but one. Remembering his misery at Gadebridge Park, his mother asked that he should not be beaten. Fortunately he did not know this. Fortunately his housemaster was a kindly, ineffectual clergyman who was not tempted to visit the iniquity of the mothers upon the children.

In those days Haileybury was a philistine school on Victorian lines; nor does Highfield House strike one as exceptionally civilized in retrospect. There was a great deal of beating, a great deal of fagging, and full adherence to the school code of privilege and taboo, concerned with jacket buttons (one, two or three undone, according to seniority), caps (three prescribed angles), whistling (forbidden to new boys) etc., etc. – all this in addition to enduring a measure of contempt throughout the school; for Highfield was a small house, separate from the rest, and hardly ever successful at games, which was all that mattered. Most fatuous of all was the rule that boys in different houses must never make friends or take a walk together. What probability was there that in a school of five hundred and fifty any boy would find his most congenial fellows in a random group of thirty-five, only about nine of whom would be roughly of his age? Several others, who might have been among Rex's best friends, could share with him only the muted life of the classroom.

Then there was the initiation ceremony, a gratuitous ordeal for the "nervy new-guv'nors". It was taken for granted that every "new guv'nor" exhibited "nerve" or cheek. This ordeal meant singing an unaccompanied song before the whole house, standing on a chair on a table. Rex escaped in his first term by arriving late after quarantine,

but endured it in his second, when he sang "Clementine", and got through well enough to relate it at home with some sense of achievement. The thing was not to break down – but also not to sing too well, for that would be showing off and would invite retribution. One of the house prefects used to beat in the dormitories for pleasure, or to relieve his own exasperation: "I *hate* this place!" he would scream. It was no lasting safeguard to do nothing wrong; for then you would be beaten on the grounds that you had "escaped too long".

Rex would always get by. And perhaps in his first letter home there was something more than the need to reassure himself and his mother, since there is, when young, an excitement in taking the next step and joining a more impressive community.

> It's ripping here, and I'm enjoying it like anything. Sorry I didn't write yesterday but I had hardly any time, every time I started I had to get up and drive someone away from stealing my grub, it's not considered greedy here, you simply have to, or your grub will have gone before you can turn round.

No doubt he was already using his passport to popularity. "He made his mark in this manner during his first week", says Terry Clarke, afterwards Brigadier and Conservative back-bencher. Another remembers that when studies were reallotted there was keen competition to "share one with Whistler, please, Sir!" – a reflection of his likeableness as well as of his skill with a pencil. He had the luck to discover at Highfield, among those thirty-odd, a boy about a year older than himself whose imagination answered his own, although, or rather because, it was literary, not visual. They became great friends. But I leave Ronald Fuller to give his own account.

> Almost the first thing Rex did when he came to Highfield was a portrait of his form Master as an Ancient Briton, with a long dreary moustache and bristles all over his legs. I remember the excitement it created, and the characteristic way Rex brushed aside praise.
>
> The studies at Highfield opened off a long concrete corridor, lit at the far end by a flaring gas-jet. His was gloomier than most for the window opened on to a small concrete yard, used only for miniature games of cricket and an occasional rite of making new boys climb a drainpipe, underneath which a bonfire had been lit. The corridor echoed at intervals to the rush of feet, as fags answered the shouts of the prefects. This was the scene Rex remembered and referred to often in later years – the noise of boots on stone, the Saturday afternoon smell of things being fried, the mud and the murk and the naked flame. Yet at the time he was happy; and he

always seemed to enjoy a crowd round him, even when he was drawing. I remember him best (when he wasn't drawing) as struggling vociferously in a tangle of arms and legs.

"Quite dreamy, but very pleasant" was the verdict of his first half-term report, and the truth is that the boys were always more alive than the staff to his capacity and promise. The standard of teaching in the pit of an average public school has never been likely to inspire, and least of all in 1919, a very unpromising year to enter one, when most of those who might have taught with enthusiasm were dead in Flanders or not yet demobilized, their places being taken by the ageing or the semi-invalid. "Art", it is true, was on the curriculum (taught only to the Lower School), and in that weekly period an object would be put on a table, sometimes the plaster cast of a limb, and the class would be set to depict it in pencil. Later, Rex would embellish his version. He would show a carpenter's saw biting into the calf, or a drawing pin just below the lifted heel, with a few drops of blood coming down and a pyjama leg above. For that, on one occasion, he suffered the fury of the art master, whose brief reports gave no encouragement, though accurate as far as they went. "Form felt in detail, but not comprehensively – lacks knowledge of construction." There was a rudimentary art school, a place to work in, but Rex seems never to have used it, and was given no instruction in oils, nor even encouraged to experiment – an omission for which he paid dearly at the following stage. As one contemporary puts it, "The art master thought nothing of his obvious gifts."

Other masters knew they existed, as time went on. It was Rex who inscribed the vellum scroll presented to Lord Allenby, the returning hero. Then he drew a small poster in aid of the school's club for East End boys – but it had to be suppressed at the last moment because it contained in one corner the caricature of a clergyman on the staff who had just left hurriedly. He was also called in, when he was fifteen, to paint a garden back-drop for *The Importance of Being Earnest*. The medium was powder paint and whitewash and he was helped by a congenial master, C.A. Ronald.

I remember that Rex did the arrangement of flower masses and a beautiful little statue on a pedestal which formed the centre of the scene, leaving me the rough stuff – sky etc. We spent a number of very pleasant hours at the work, exchanging scarcely a word – to me he seemed always very reticent, but very much enjoying the quiet interlude. We only realized, somewhat ruefully, when the scene was done, that we should have painted it from an eye-level much lower

than our own: when the curtain went up the garden looked as though it were rushing steeply uphill! Still, I remember it was much applauded.

Here was a first practical lesson for an artist who would become in the 1930s, in his stage designs as in his murals, the best living demonstrator of *trompe-l'œil* perspective.

Strangely enough the member of the staff who took most interest in Rex was the medical officer, Dr Lemprière. He was there for thirty-five years, he told me –

and I always maintained – while Rex was at school – that he was the only boy I had ever known who had the certain marks of great talent amounting to genius, and that his success was certain.

I got to know him as a patient, and once when he was in bed, and we had an appendix operation in the next bed, he made me two delicious bizarre drawings of an Elizabethan and modern operation, rather gruesome, of course. I used to hang them in the room reserved for sick masters, whose sensitive souls were so perturbed that they had them put front to back! He used to come to tea with me and on one occasion drew and painted my airedale, the first dog he had done, he said.

Besides being the doctor, I ran the Gymnasium and all physical training: being in the Lower School he had to come, and was always late, with one shoe, or an odd pair, no belt, or handkerchief (we always began with nasal drill), and I remember saying to him, "My dear Whistler, what are we to do: it's no good my beating you. Couldn't you *please* really try and be in time and fully dressed, just to please me", and I can see his smile now as he promised, and really did quite well afterwards.

Terry Clarke, senior and a prefect, used to employ the same tactics, but with an ulterior motive. "You're too old to beat. Draw me a picture!" It was an arrangement that suited them both. For Rex was frequently in minor trouble. He would take short cuts on runs, coolly judge his moment, and stagger home just in front of his friends as though utterly exhausted. The discipline of school he found irksome and unmanageable, rather than odious: in the winding of puttees he had, needless to say, his own style. To escape the full tedium of corps drill he contrived to get himself into the band, and might be seen in a small clutch of buglers rather guiltily sloping off to practise their discordant warblings under the larks on Hertford Heath. In the end he was exposed. For when he stood on parade with pursed lips and

inflated cheeks he was uttering no sound at all, and possibly had never learnt to. There followed a precipitate return to the ranks.

To revert to the tough but friendly school doctor for a moment, Rex became his patient in the cruellest manner, caught out with mumps at a medical inspection on the very last day of the autumn term, with Christmas, the long-awaited, the magic day in our family, now to be spent in the sanatorium. John Bett, younger by a year and trapped in the same way, was not much consoled by being put to bed beside one whom he had "admired at a respectful distance". Soon, however, he was attending and listening – to a sequence of drawings and the fantastic gloss that accompanied them, while Rex, quite clearly, set himself to entertain the younger boy. "I have never forgotten that Christmastide, which remains a most happy memory." So, as a naval officer, he would write to me twenty-eight years later, on learning of Rex's death. On another visit to the san, Rex faked a great jagged star across a large windowpane in the ward to the dismay or fury of all who entered. "Somebody will have to pay for that!" Dr Lemprière announced.

Other practical jokes come to mind. There was a time when a curate was known to be arriving in Abbots Langley. Rex, always a lover of the fancy-dress occasion, and a natural actor, set out through the village in a black suit, with reversed collar, wide-away black hat and a large prayer book under his arm, followed inevitably by the amusement of children. An elderly neighbour was shocked by this disrespect, and another lady claimed that the new curate had raised his hat to her most charmingly. The imitation even took in his own father. This seems improbable, but it was really so.

His narrow bedroom overlooking the road at the end of The Knoll, which I often shared with him in the holidays, had a few "good" pictures in reproductions – art prizes probably – but I doubt if he had as yet foreseen an assault on high art, though by fourteen he may have been privately hoping to practise – say as an illustrator. At that age, when answering questions in some album which had the heading "Confess Your Favourite Fancies", he named Rackham as his favourite artist, and in his drawings of the period we constantly find gnomes' houses built into the wildly contorted roots of trees, while the branches themselves take shape as weird faces, crooked hands. Fairies flit, lanterns wink from tiny casements, warlocks or witches hob-nob below them; nevertheless his own gnomeries are quite different from Rackham's. His notion of the weird is not wistful but relishing. His gnome houses are not vague eerie caverns, they have chimneys, steps and knockers – all as circumstantial as the son of a builder might make

them. And before long his goblins are almost always in eighteenth-century clothes.

This is notable; since I doubt if at sixteen or so he was aware of any adult revival of the Georgian, in so far as it existed then – a revival he himself would be promoting very strongly one day. If he was familiar with Lovat Fraser's work, which I doubt, he was more familiar with the prevailing opinion, inherited from the last century, that the romantic was essentially the mediaeval, and that the Georgian age was wordly and banal. How did he come to feel instinctively that this was wrong? It was partly that through a long century of disrespect the Georgian had *weathered*, as it were. A fresh eye might suddenly find in it the sweet and the urbane, now also appealingly far back in time – and, more than that, the unattainably secure. This might be one reaction to the menacing ugliness of all that had supervened, including war, a craving for really civilized security – albeit at the same moment Rex might respond with zest to the excitements of the post-war world, cars and aeroplanes and films. Thus in his mind was set up a contradiction that could never be resolved.

Rex looked at the simple rectangles of Abbots Langley Vicarage, and saw them as poetry, a response that no one had thought of making before. So the mediaeval gives place to the Georgian in his drawings, and soon Rackham was forgotten too. In a drawing done when he was seventeen, and by then a student, we see a red-brick Georgian house in romantic twilight, knowledgeably drawn. An elderly Georgian couple have answered the front door, where they stand in amazement, as well they may; for the Christmas waits below them are still and for the last time Arthur Rackham's gnomes.

With Rackham had come colour, and a sense of beauty, this new notion that a picture need not rely on action, horror or humour. It was a notion developed in the peace of the holidays rather than at school. And then there were water-colour paintings inspired perhaps by those Christmas annuals, firelight scenes with pipes and tankards, sunsets, and venerable cottages. Suddenly "Chu Chin Chow" was flooding his mind with a zest for oriental gaudiness which could only be expressed in the brightest coloured inks, and was soon transferred to the *Arabian Nights*, illustrated at vast length. At thirteen he had been taken to that highly successful musical, his first, and reverted to it in a letter home, where the sketch at the top shows bouquets, boots and bananas being hurled at a Chinaman whose eyes and teeth form the name of the show. It is called *A SLIGHT DEFERENCE OF OPINION IN THE ORDIANCE.*

Such was the mind of the junior boy whom Ronald Fuller presently

singled out as a heaven-sent collaborator, or accomplice. Ronald was an intellectual, as Rex never was, a little older and much higher in the school. Ahead of his companions in form, he had had to mark time for a while; so he began pouring out a cataract of verse and prose under the increasing influence of Coleridge, Poe and de la Mare, which nothing then could staunch. Soon he was having it illustrated for a share in his pocket money, and was finding his artist quite a match for him in speed and facility. In five years, from the age of fourteen, Rex provided a hundred and eighty illustrations, nearly half of them in colour, forty for the manuscript books of verse, and twenty for an ambitious "History of the World" in three volumes. Drawings follow text in mood: sad-romantic for the verse, grandiose for the history, and frightful for the fiction. Ghosts rise from bed and mummy-case with unspeakable expressions, fingers clutch or twitch, and in the many scenes of execution, even when simple strangulation is the order of the day, or rather night, there is always an evil-looking brazier at hand for good measure. Drops appeared on the brow of one suicide contemplating his end:

"Has he got to sweat all that much?"

"You'd sweat if a corpse three weeks old had just fallen on you out of a cupboard. It's only a bead or two. ... Anyway he suffers from the sweating sickness." And an extra large bead was added.

The school may have had nothing to show at that period as interesting as this formidable joint-industry behind study doors, of which authority knew nothing.

Their minds were in tune, and it is hard to say who was influencing whom. Rider Haggard and Longfellow surrendered their position.

I was the first to find Poe on the library shelves. ... I lent Rex a little pocket edition of Poe's Tales, and we would recite passages about the dreadful disintegration of M. Valdemar; but it was, I think, the poems which influenced him most. Almost certainly these were Rex's introduction to romantic poetry; Herrick and de la Mare followed a little later. Sometimes I thought that he felt to be serious about anything was dangerous. When there was no one else about he would read aloud "Ulalume" or the "Night Piece to Julia"....

Cricket was intolerably boring, but rugger he learnt to play with abandon. In "Hoips", a game for new boys, he received a kick which broke his nose. He played on, then called at the san to show it to the fearsome Dr Lemprière. Some painful pushing and it was more or less restored, but with a knobbiness added for keeps to his romantic pro-

file. As left-wing three-quarter he won his house colours, and is remembered by several as a courageous tackler, going hard and straight for those much bigger than himself: "running very fast indeed and taking great risks and getting rather damaged", as someone puts it. His joy in the game is shown by his joining the West Herts Club for a season or two after leaving Haileybury, and playing in tough matches with older men. He might have had his school colours, and regretted leaving early on that account alone.

For ahead of him lay the ever-darkening mountain range of the School Certificate – through which a pass was not considered too likely. He now wanted only a life of art; so the artist, Eric Kennington, staying in our neighbourhood, was consulted: much impressed by a drawing of guns passing through the village, he strongly urged that art should be his career. Our parents had come round to this opinion with some misgiving, and Rex left Haileybury in the spring of 1922, not yet seventeen. There was in fact no alternative; for had he stayed another term he would have been superannuated.

There had to be a parting gesture of some kind, and that was contrived: the Kissing of Ethel. Kissing had always been in Rex's mind. At three he liked to "suck the honey out", as he said, from the plump cheeks of his sister's governess. At six, told to "salute" the dancing mistress, when the girls curtseyed, he had flung his arms round her. By the time he was kissing "every made" at Gadebridge Park an element of bravado had entered in; and this final episode was all bravado. Ethel was a maid at Highfield, described as "tall, hideous, and in a permanent fury", a formidable woman. Rex bet that he would do it, and a good number of sixpences were quickly at stake. "I think we would have wagered against him in half-crowns." From a breathless crowd in the passage he marched into the scullery, grasped her round the waist, and gave her as smacking a kiss as anyone could wish. There was no answering thunderclap. Rigid with indignation, "she stalked dumbly upstairs to Mr Dewe's study". Nothing much happened to Rex, or indeed could happen on his last morning. He may have had to return the sixpences. He may have had to apologize, which no doubt he did gracefully, and with some remorse, if her feelings were really hurt.

All in all, Haileybury was less enjoyable than it may sound; it is simply that merriment leaves anecdotes where dreariness does not. In later years I often heard him rail at the stupidity of the place, the squalor and crudity of herded boys, himself included. "What little brutes we were. I remember filling a water pistol from the rears and squirting it at some wretched new boy, assuring him that it was quite

clean. I used to paint with that water too – after pulling the plug half-a-dozen times." He vowed that he would never send his son to a boarding school, yet I suspect that he would have, or would have compromised with a day public school, such as Westminster. Still, he was fond of Haileybury in a way. He went back several times to see his friends; for he had left them all behind, and felt the loss of them. After that he still went back to see his housemaster, whom he often referred to as "darling old Tom". – "Tell me what you think about going down to Haileybury", he wrote. "I feel rather in the mood for a little self-affliction." On his final visit with Ronald Fuller it seemed appropriate to discover coffin trestles in the room at the sanatorium which they were given for the night.

## · IV ·

PONDERING the family photographs of pre-war Eltham (Pl. 1), the children on the curly garden seat, myself not there, or only just, no disaster yet befallen, my father serene and established, my mother betrayed by the camera into a gravity she did not feel, and behind us the villa, with the maids, the nanny or governess, the car, the fairly flourishing business, it seems as though there should have been in the 1920s a great nostalgia for "the good old days". But that I do not recall, though life had become, and would for ever remain, more pinched and money-troubled. This was partly because Eltham to our mother did not now represent "the good old days" so much as the place of the disaster. Prostrated by that at the time, she did not believe in perpetuating grief and not enjoying oneself. One of her Victorian stories, told with a touch of fascination for the wrongness it revealed, was of her Utterton great-aunt's family, all young people, who had been put into deep mourning and forbidden to play the piano for two years, because a newly-married sister had died at sea of her first pregnancy. Yet our disaster had no doubt intensified her nervousness. She would never again take an illness like measles lightly, or listen to any local doctor who decided that a child should get up from bed when the child himself was against it. I as the youngest and the last was the victim of these deepened qualms; and perhaps she turned me for a while into something like the Nervous Child. Towards the end of what seemed in those days a very long drive in the fully-loaded T-model Ford with the brass radiator, from Hertfordshire to Selsey Bill and the exciting sands of August, we came upon the scene of an accident, the first I had encountered – a pool of dried blood in the road and a twisted motorcycle on the grass. Rex aged sixteen, had to get out to examine the remains. A mile or so farther on, the main road crossed a disused canal by a wooden bridge. "Are you sure it will bear the weight of the car?" It would not have occurred to me that it might not, but suddenly the horror of the accident had been transferred to

40

the cause of my mother's doubt, and I could never take part in any
car-expedition from Selsey without dread, because it always involved
the crossing and recrossing of that bridge. I thought I was mad, a
notion somehow confirmed by the lunatic gaiety of seaside architecture
and the continuing squeal of tyres on tarmac through the long, light
hour after every bed-time. I suppose there were times of remission on
the sands, where Rex was winning the *Daily Mail* prize of £50 with a
figure of Neptune six feet high, made of sand, seaweed, bits of wood,
etc. But I could no more tell him than my mother or father that I was
out of my mind.

On the other hand, some of her qualms were so far-fetched as to
have an opposite effect. She had always been scared of lightning, and
as a child, during the sermon at Wootton, had leapt from the Vicarage
pew, only to be recalled, in shame, by a stern command from the
pulpit: "Sit down, Nell!" Right up to the Second World War she
would telephone Rex or me in London if she had seen "several bright
flashes" in the direction of the metropolis. The result was that I re-
joiced in thunderstorms, and have always thought they provide the
luckiest, quickest, most exhilarating, least painful, and probably least
offensive means of going out. I once climbed the Cobham Monument,
the highest column at Stowe, in a dazzling display all round, partly as
a dare and certainly at risk, since the lantern was struck some years
later and His Lordship toppled from above it.

But chiefly "the good old days" was not a theme because of my ·
mother's capacity for living in the present, and heightening its impor-
tance. With no nursery now, I was more in her charge than the older,
nurse-reared children had been. Nevertheless from the age of four I
had a companion, Katy Buckle, a Norfolk girl of fifteen who came
chiefly to look after me, stayed with us for most of her working life,
and later looked after my daughter Robin from her infancy. I loved
her almost as dearly as my mother. Her home far from anywhere, in
some great park on the edge of a wood, her gamekeeper father and
his whistle, her mother's huge bakings for the sportsmen's teas, were
intensely romantic. Deep woods around that enviable home seemed to
deepen those we plunged into ourselves with the tea basket, to smell
bluebells or blackberries, stare at sorrel or dog's mercury as we drank,
and watch some fly draw the secret ideogram of summer across velvety
greenness. My belief is that those who will one day be artists, whether
visual or verbal, acquire as it were a palette of significances in child-
hood, a palette of primary meanings, which may be happy or unhappy,
beautiful or ugly, frightening or consoling; that most of those meanings
will be obscured later on through being taken for granted, and that

those few which stand out in memory seem quite a random selection, unaccountably acquired on some particular but trivial occasion. Was it *one* wet afternoon with Katy, shuffling home along a muddy road, that gave me the archetype of puddles? Was it one plate of filleted white fish on my knees, with sunlight going on abstractedly outside the window, that means being kept in bed? Such "primaries" are incommunicable and quickly boring to anyone else who has his own. I will go further and suggest that all children acquire them and nearly all adolescents discard them as they feel compelled to "put away childish things": it is not so much that few can make use of them as that many throw away the chance to do so. "The artist is not a special kind of man," said Eric Gill, "but every man is a special kind of artist." Or might be. But for this to make sense we should have to abandon the conception of "fine art" as an esoteric cult.

My mother's contribution to the meanings – and she must have made them equally for Rex – was more conscious than Katy's, though no more deliberate in the sense of instructing. She loved a spree herself, and any ordinary occasion to shop could be turned into that. We paid visits to the dentist in St Albans. On one of these I encountered and recognized the abbey – an enormous, grey, rustling room, bigger than any I had ever seen, and not impersonal and swarthy like a railway station, but made all of points and patterns by the actual hands of skilled men long, long ago, made by Normans and Romans, full of the dry, austere smell of history, holy in some way and only to be whispered about, yet not Sundayfied at all but delectably weekday, and in tune with the teashop and my new sticks of plasticine: a vast shrine for the delicious modern moment, enriching it with all the sadness and wonder of things past, such as we loved to brood on, mother and son. In later years she would read in the paper that Kenwood or Keats House had been opened to the public, and those we would explore together, with growing knowledge and as happy a sense of occasion.

My father could not heighten life in this way, but he loved outings in the car, and talked often about the beauties of landscape and old buildings. I came to realize later that more than most businessmen or practical men he had thought his early meanings worth keeping. Round the fanlight at Wellington Villas had been a rim of bright glass of various colours in the 1830s manner: when the same tree and cloud could be translated into vivid red or blue, and still be part of a true world, it had seemed to him they must be magic apertures into heaven. In middle age he spoke with awe of standing under the stars one night until the reality of the universe suddenly came home, and "the silence

of the infinite spaces" frightened him, who had never heard of Pascal. Oak's rather similar experience in *Far From the Madding Crowd* could be expressed in words that are immortal. With more reading my father might have had words to satisfy a philosophy of life that included some reflection and deep wonder. But he seldom now read a book for pleasure, though he might consult one for information on local history or antiques.

In some far-off production of *The Taming of the Shrew* he must have played Petruchio, and would declaim in fruity tones, self-mocking with appropriate gestures, "For 'tis the mind that makes the body rich ..." sometimes lapsing into burlesque:

> What, is the jay more precious than the lark
> Because his *fevvers* are more beautiful?

Another of his remembered speeches was Brutus's, "There is a tide in the affairs of men ...". But he did not think he had missed his own tide, or seem to imagine any other "fortune". Rex saw him as essentially a merry man, for all his toiling, and once exclaimed, "God rest his merry bones!" when they were still vertical, if wearing out. He had a constant appetite for jest and ridicule and no great objection to being the target of it, except once, when my mother and I substituted a dummy for herself, between the sheets, and genuinely frightened him on coming to bed (which brings to mind a later instance of her way-wardness, when, as a priggish schoolboy resting with her one after-noon, I read aloud *The Origin of Species* and, conscious of unusual stillness, looked over my shoulder to find her reading a novel to herself).

His hair, which he kept throughout life, had now grizzled. His moustache was trimmer than before the war. His voice was gentle but had lost the Hampshire accent it presumably once had, without ac-quiring genteel affectations. He still dropped the occasional "h" like his London mother, so there came a day when one inquired, "Why does Daddy say 'Aphazard' – then 'Hapazard'?" "Well, you see, he's been so much with the men." It seemed the explanation at the time. This was the only occasion I can recall when my mother, having no alternative, acknowledged any social difference.

Parsons and their families were apt in former years to be among the greatest snobs in talk, perhaps because they were compelled to be unsnobbish in action: from the effort of treating everyone in the parish as equal in the sight of God they may have found relief in talking about "that class of person". Our mother was no exception. She talked snobbery, but did not practise it – or ever adopt towards a social inferior the different tone of voice that infallibly betrays and is in-

tended to betray it; which is one reason why she was liked by those who worked for her, and successful with servants. Where her husband was concerned she neither talked snobbery nor allowed herself, I fancy, to indulge it in her thoughts. Here loyalty was reinforced by disinclination. It would have seemed to throw doubt on her great act of rebellion – to be a kind of admission that after all they had been right, and she wrong. Thus, different values were applied inside her marriage and outside – her turn of inconsistency being always above average.

I think my father could be described as happy in those years after the war, enjoying his week-ends, a keen gardener, tinkering with the car, driving to his son's speech days, like many another daily-breader. In recollection there issues still from the bathroom where he shaves the whistled Intermezzo from Mascagni's *Cavalleria Rusticana*, forlorn and far away to me, but to himself no doubt the sound-track to contentment. And I go with him to his kitchen garden in hard March Sunday sunlight, before the boredom of morning church, where he tenderly puts together, with his smoke-stained fingers with the neatly pared nails, a little bunch of violets, intensely scented, for my mother's dress.

All the same, his way of life was absurd. As my sister once observed, it is not usual to leave both home and place of work, and settle far afield because a child has died. Parish registers confirm that. Transferring from Woolwich to Luton for war service meant leaving his own Eltham business, for the duration, in the hands of an assistant whom he liked and trusted. Temptation proved too strong, and he found he had been constantly cheated when he tried to rebuild it. That was the year, 1919, to have left Hertfordshire and returned to Kent – not to Eltham, indeed – but farther out on the same line, to country quite as good or better, and perhaps within range of my mother's Storr cousins at Brenchley; always an inviting place to her as the scene of her parents' courtship. But from the age of fifty-three, for many years, my father walked a mile to the station, took train twenty miles to Euston, crossed to London Bridge Station, took train to Eltham, walked to his office; and the same every evening in reverse, a double trajectory right across and beyond the metropolis. To a business that never greatly prospered again he later added architectural work for Whitbread's. At night the blue smoke plumed up and frilled between his fingers on the drawing-board. My mother might lovingly come down to bring him soup or cocoa after midnight, might worry about his bronchial cough throughout the winter. She never thought of moving house against her own interests; at any rate she never urged it, for he would always do what she wanted. Soon they were fixed, on the wrong side

of London. Nearby Haileybury had been chosen for Rex, and later on a Hertfordshire prep school for myself. And now Haileybury was over, and such was the family scene in 1922 to which Rex returned.

Launching out into art seemed a chancy undertaking, but he had, as always, the backing of his parents, whatever their doubts – no minor advantage this, when one thinks of the opposition that artists have commonly encountered at home. Three things had weight with my mother – the decision was again largely hers – in choosing the Royal Academy schools for his attempt. The training was free. Joan Dewe, the daughter of his housemaster, and the only art student we knew, was entering, the same term. And surely the schools of the celebrated Royal Academy must be as good as any in existence? My mother sent up the ten or twelve drawings required, and Rex was accepted as a probationer, on trial for two or three months.

One morning in May, 1922, he walked down the narrow sloping path at the back of the Academy into that gloomy, impressive under-world. Charles Sims, the Keeper, had recently abolished the Junior School, so that new students, who were supposed to have studied first somewhere else, were put into the Senior School straightaway. Not content with this, the eccentric Sims had also abolished his teaching staff. It was to be a one-man institution. Consequently there was little or no instruction, as my brother would bitterly complain. Most if not all his fellow-probationers, men and women, were much older than himself, and had done at least a year at another art school, while Rex was still sixteen. They would not remember him at all; so we rely on Joan Dewe. "Rex seems to be looking round all the time, and not getting down it it", she reported to her father after a week or two. In fact, they met very seldom; for both had been put to study from the model, and the men and women had separate Life Rooms, for de-cency's sake. When they did meet it was generally in the statue-haunted corridors, where Rex, she has told me, seemed "such a lost soul", nervously fingering his tie or pulling up his socks.

He was not happy. He had been entirely self-taught. Or at least the little schooling he had received had been of a postal kind, in the form of annual critiques from the Royal Drawing Society – which only encouraged him to develop the gifts he had by nature in superlative measure: visual memory and inventiveness. He did not know how to work from the model; and he got at the Royal Academy, that summer, only one lesson in drawing – so he said.

More than that, he needed encouragement, or at very least an am-bience of friendship, but he would tell Edith Olivier years afterwards that his only friends were the porters. The other students ignored him

or observed his youthful efforts with amusement. This, too, is remembered: it was the custom to leave work overnight at the school, in folios along the walls, and Rex would find to his disgust next morning that unknown jokers had been playing games with it, crudely adding to the drawing and quite spoiling it. They are not likely to have been moved by malice towards a shy and very inoffensive boy, and another explanation must be found. Rex, as we have seen, used to trick up his own "set studies" in the art class at Haileybury, adding irrelevant and irreverent accessories. He was doing it again. One fellow-student, who recalls nothing else about him, can recall just this – "figures and scenes and so on in the margins. ... He used to add to his life drawings garters and hats. He also painted faces on the lay figures." What was not reckoned with by evening humorists, who outstayed him when he left to catch his train, was that these frivolities were *his* frivolities, and did not invalidate his work in his own eyes. He could not long resist them, for study was arduous, but fancy a delight. There may also have been in his uneasy mind the idea that at least he could be funny on paper, that his witticisms would pleasantly attract attention to themselves, as they had (and would) in every other environment.

At home, in the summer evenings and during week-ends, he was making his first attempt at oils, an obligatory painting for the end-of-term exam. This was on a biblical theme, and for some reason it had to be circular, which would not help a novice. Rex had never even dabbled; and there was no one to help him. He bought the essentials, and set up his canvas in the little pergola'd space at the back of The Knoll. It advanced slowly, with a good deal of repainting, and a good deal of discussion in the family; but father and mother could offer only naïve and unhelpful advice, which sometimes irked him. "You give your opinion, and that's all!", said his father, stumping off. "Well, of course that's all!", said Rex – both of them more worried than annoyed. And his mother's soothing words were equally exasperating. In that unhappy month he was angered by criticism – yet needing it. There was no other time in his life when the reverse was not true. For normally he knew what to do, had no need of advice, and was content to hear it, however pointless, and on occasion to take it. Of course, to fumble at a new medium is nothing abnormal: other students were doing the same. But Rex felt himself on trial altogether. He would have been happier with his canvas at home, if he had not believed that he was failing in London.

The painting he sent in is forgotten by me, but Joan Dewe describes it as "strange, and not typical at all". She thinks that on many days he did not even put in an appearance at the school, and that he

Welsh Guards.
Codford St Mary. Wilts:

My dear Sir Edwin

May I be allowed to
add my heartfelt congratulations
to the countless ones you will have received
already, on your being given this
most glorious of all Honours,
(so long & so truly deserved)
The Order of Merit
I was thrilled & overjoyed to hear
of it, & should have written
before had I not been laid
low by the cold & snow &
Germs of Codford.

yr. in admiration
& affection
Rex Whistler.

Jan 31.
1941

Letter to Sir Edwin Lutyens, 1941

submitted very few drawings to the final exam, where ten or so were required. There arrived, then, the day when the results were declared. Apprehensively he made his way to the school, and as usual no one took any notice of him. Only his friend, the door-keeper, greeted him; and one look at that kindly, disappointed face was enough. "Never mind, Sir, you'll do better one of these days!"

Because it was a bye-term only two other probationers in painting had been examined for studentships, and the verdicts are recorded.

> Vera Bodilly and Sydney Lewis passed.
> *Not Passed*
> Whistler, Reginald John

The verdicts were arrived at by Sims in consultation with such members of the Council of Royal Academicians as cared to attend, and it may be, as someone seems to recall, that visiting RAs had been shocked, during the term, to find on one drawing-board a likeness of the model, plus stockings and a panama hat, or something of the sort – though needless to say, Rex will have played no tricks with his submitted drawings. That year the Council had for President Aston Webb, the architect, and included among others the following: William Orpen, Frank Brangwyn, D.Y. Cameron, Adrian Stokes, William Llewellyn, Reginald Bloomfield and Edwin Lutyens. Only a few of the full twelve are likely to have been present for the judging; it would be amusing if Lutyens was one, for he became an admirer of Rex's work, a creator of opportunity for him, and a personal friend. On his death in 1944 Rex wrote, "I am really sad and feeling much loss at the news of darling Sir Edwin's death. I loved him very much." But it is highly improbable that the great architect turned up for the examination of six painting and sculpture students. Had he done so, and heard of the irreverent embellishments, he would certainly have voted for Rex. I picture the moment of the verdict, and tremble as if his fate still hung in the balance. To think that he might have been granted the benefit of the doubt! Had he stayed at the Royal Academy he would have emerged a professional artist, an illustrator certainly, but he would never have been given the Tate Gallery Refreshment Room at twenty. He might never have become a mural painter at all.

However, at the time he had simply failed. He slipped his drawings into a portfolio, and went out into Burlington Street. He must have come home very sick at heart, that evening. It was 18 July: by chance the pre-anniversary of his death in battle, twenty-two years later.

## · V ·

THERE WAS NO question now of abandoning the career of artist. At home it had been debated whether he should go to the local art school in Watford, but Rex strenuously resisted so dismal a retreat into provincialism. We were still in touch with that family, now in London, who had been our neighbours and only close friends in the old Eltham days, the Hammersley Heenans. Eileen, a little older than himself, was now a sculpture student at University College in Gower Street, spending part of her time drawing in the Slade School of Art, housed in the same wing. There she seemed to be as happy as he was unhappy in the rival place. To them he repaired at once in very low spirits with the news of rejection.

Mr Hammersley Heenan had been fond of Denny and Rex from early childhood, and impressed by the promise they showed. He told Eileen that she must get Rex into the Slade as quickly as possible. The Slade, however, was not free: it cost nearly £30 a year. Nevertheless, Eileen was empowered by my parents to approach Professor Tonks straightaway, at the beginning of the autumn term, late though it was to apply for entry. She spoke of the young friend who had been rejected by the Academy judges. "That's good enough for me!" said Tonks – meaning of course that he would see him, not that he guaranteed to take him on. But it looked propitious.

At the meeting which followed there was a witness, another member of the staff, and it is George Charlton's account that I now give:

I first saw Rex Whistler when he came, one afternoon in 1922, to the Slade. I happened to be with Tonks in the Professor's Room when he entered. Tonks had not seen him before, I feel sure, and neither had he seen any of his work. Whistler showed us a number of drawings done on sheets of paper about quarter Imperial size, drawn in black ink, and they were of a somewhat crude character, but one soon forgave that, owing to their irresistibly comic ideas,

49

broad humour being their sole aim. Nevertheless, behind these drawings could be discerned a draughtsman capable of development.

Tonks glanced through the work, his grin steadily broadening, until he looked up at Whistler and asked him what he wanted. Whistler replied that he was a student at the Royal Academy, but he had been asked to leave "for incompetence". Tonks turned towards me, his eyebrows raised, and he gave a chuckle, which I interpreted as meaning, "Good gracious, we'll take him, and we'll make something of him!" Which was what he said after Whistler had left the room.

It was characteristic of Rex, who always had a great contempt for evasions, to say simply that he had been sacked for incompetence – and he could not have taken a better line with Tonks, who hated pretentiousness. It was characteristic of him too, in his youthfulness, to offer humorous drawings. Humour was still his strength; beauty he was not so sure of. Again this was lucky; for Tonks had an ample sense of humour, and would not have been much impressed by Rex's magazine-idea of the beautiful. He showed the drawings to A.H. Gerrard, the Professor of Sculpture, that same day. "If we were commercial gents", he chuckled, "we'd get this fellow to sign on the dotted line. ... We'd make a money-spinner out of him!" A potential comic artist, certainly. And what more?

Had Rex applied in the normal way, along with other young people, Tonks would have accepted him, no doubt. But he would have missed the keen enjoyment of scoring off the Royal Academy: he is said to have written specially to Charles Sims to thank him for so kindly providing his best pupil, and when news of the letter somehow spread to the Academy students there was a good deal of disloyal amusement. All this put Rex at the outset in a favourable light. It is worth observing, as a proof of modern educational idiocy, that today any art school would have to turn him away for not possessing the obligatory "A levels".

The academic year for the Slade, as for the rest of University College, began in October. New students were set to draw from the antique until Tonks pronounced them good enough to draw from the living model. Painting came later, if at all. Some students drew from choice for the whole three years. Some were so much in love with the place that they then became part-time students, returning year after year – as indeed would Rex. They were therefore a mixture of the old and young, mostly of the young, and at seventeen and a quarter Rex

was the youngest of all, and seemed so. There were still a few ex-army men delayed in their training by the years of war, but these must have dwindled by 1922. Rex was of the new generation, of those who were not haunted, hardened or embittered by the missing years – of those to whom the 1920s were all a promise and an escapade in a world largely new. If the war years had been a bad time to enter a public school, the post-war years were an excellent time to enter an art school, or one such as the Slade, alive with enterprise, and with no sense as yet of disillusionment, with a notion only that the grime and the cobwebs of Victorian-Edwardian habit had been sucked away into that appalling vacuum.

Rex came up to London by an early train with his father, crossed Euston Square and fell in with the crowd of young people entering the spacious quadrangle. To begin with, the hours were from ten to four in the Antiques Room, followed by one hour of "short poses" in the Life Room for those first attempting to draw from the living model; or there might be lectures at that hour, on the history of art, on perspective, etc. There was a book to sign on arrival, but nothing to show if you went away after signing: it was easy to forge a friend's signature, yet perhaps hardly worth while, for only continual absence was likely to be observed. Having paid to be there, you did not have to answer to the State for patronage, and you could do pretty well as much or as little as you pleased. In short, it was more like a club than a school, the atmosphere not only exciting but delightfully easy-going – rare combination – spiced only by fear of the formidable Tonks; and he was not formidable in the orthodox schoolmaster's way. Artists seldom are. One morning an unaccountable hollow rumbling sound rose up from below, as though all the furniture in Gower Street were being moved at once. Tonks strode to the door in the corner, opened it ajar, and quickly returned:

"Do you know what they're doing? They're *roller-skating*! ... Do you think they saw me peeping?"

Tonks set Rex to work on the antiques and told him to draw at his own speed a large number of plaster casts that surrounded the walls. A day later Rex deferentially reported that he had done this. "Good heavens!", cried Tonks. "My dear chap, if you can do that you can draw everything in the world in a week!" I possess the sheet of cartridge paper, kept for sentiment's sake, and endorsed, "The first drawings I did at the Slade." Here and there, where an arm or foot is wanting, the outline is pencilled in, though not modelled like the rest. Missing heads are supplied, complete with natural hair and living expressions, sorting oddly with the obvious statuary of the parts

below. But there are no jokes, on this first page intended for the master's eye. How long Tonks kept him among the plaster casts I do not know, if any longer at all. But there was time for him to be spoken of with amusement as the young student who was completing the statues, a thing which few other students of his age were capable of doing plausibly. Soon he was in the Life Room, or Dungeon, sitting astride a "donkey", as the narrow seat is called that has an upright support at one end for a drawing board, and facing the naked model on the "throne".

There was a male and a female model alternating between the men's and the women's Life Rooms, a week or so in each, and it depressed him at first, like other students no doubt, that their bodies were usually so ugly. An assistant instructor would wander about giving advice, and from time to time Tonks himself would make a sudden appearance. This was an impressive moment to all, and a distinctly alarming one to many. For his comments, though rare, could be humiliating, and were uttered in a clear voice and with a turning of the head that involved the whole room as audience. Sometimes it was the model who evoked them. "After a certain age", Tonks would croak, "the muscles of the stomach relax, and *the whole thing sags*." And the long bony hands would be dropped in a deprecating gesture. (Rex was an excellent mimic.) If ever Tonks gave praise it was best not to be too enchanted. "What shall I do with it now?", asked the eager girl-student. "Frame it!" was the answer, as he passed on to his next victim. This kind of incident inspired Rex's caricature. "Professor Tonks and a promising pupil."

There would be a tap on the shoulder, the pupil would rise, and the Professor would occupy the donkey. Often he would say nothing. He would place in the margin a lively and revealing note of the muscles of an arm or thigh, fine draughtsman and accomplished artist as he was in his own right. To say nothing oneself was no guarantee of security. On one occasion he looked at a girl's drawing – looked at the model – looked at the drawing again. "Do your glasses suit you?" The poor girl burst into tears, blurted out, "I think you're very unkind!", and ran from the room. Whereat Tonks is said to have glanced round in genuine distress; for he did not like to see himself as a bully, and was in fact warm in support of the young (provided always they did not turn modernist), and even humble towards them, although the weeping girls who were to be found not infrequently in the women's washroom may not have appreciated this. "I can honestly say", he wrote to A. M. Daniel, afterwards Sir Augustus Daniel, Director of the National Gallery, "that I love my students, men and women. A more

beautiful relationship between people can hardly be imagined" – this is touching in its comedy – "I cannot bear the idea of treating them badly, whether they are in themselves promising or not, besides we do not know this." *There* is the humility.

As we have seen, Rex had difficulty in working from the model at this early stage, though he would discipline himself to overcome it. To look and draw comes hard if you are prone from long habit to take a mental photograph and recreate. So, once again here, as in that girls' school at Eltham, he was raising smiles by busily drawing a model that was no longer there. But far more often he was drawing something else in the margin and for his own amusement, before the weary nude stepped down. One day, I have been told, Tonks discovered him pencilling away with his back to the model, and was angry, describing it as quite pointless. On the other hand I had this from W. G. Constable, recently Curator of Paintings in Boston, who at that time was much in Tonks's company:

> At dinner one night [Tonks] remarked how puzzled he was that anyone so talented should be unable to work direct from the life, and that he did not know how to handle the problem. I said I had always understood that Hogarth and Daumier had similar difficulties and that both relied upon memory for their drawing. Later, Tonks told me that he had encouraged your brother to work in this way, by first studying the model and then drawing from memory –

and Tonks felt he was justified by results. It was quite contrary to his normal teaching, and evidence of more open-mindedness than he is generally credited with. Rex needed no persuasion to this method: some years later when he had finished his training and was already well known, a student saw him enter the Life Room, find a vacant seat, contemplate the model for a minute or so, and turn face-about to execute a detailed drawing of the pose. It was an enjoyable exercise of memory rendered slightly more enjoyable by the interest aroused.

I have asked several of his contemporaries how quickly he made an impression at the Slade, and the answer is always the same: immediately. Of course that odd grip on the pencil was enough to stay a wandering glance, and then it was hard not to be intrigued by a hand so busy when others were idle, and not to observe such a flow of peculiar ideas. On his first day he found himself sitting next to Stephen Bone, also new that term. Waiting for the model, Rex drew "an obscene sphinx". Bone was taken aback. It was not sexually obscene, but it seemed so vulgar and unaesthetic, so unlike what a serious student ought to have on his mind; and yet the drawing was so vivid and

confident. "He burst in upon us", Bone told me, "and shocked and impressed us all." To Bone – the son of a distinguished artist and with a kind of Grand Tour already to his credit – the unsophisticated Rex seemed "rather raw" on arrival, and raw he was, aesthetically. Students with less art in the background were more entertained than shocked. Another remembers "innumerable drawings of a great monster racing car with Rex himself at the wheel". In a sketchbook of the period, among Georgian whimsies, architectural notes and romantic poems, there is the carefully painted design of "An 'R. J. W.' 60 h.p. Sports Model (Guaranteed To Attain a Speed of 120 m.p.h. During First Year)." It was built "by the R. J. W. Car Manufacturing Company Ltd". For Rex had not yet dropped the initial of his second name, John. I myself designed "Laurence" cars in rivalry, but Rex warned the public against them, as liable to fall to bits or explode, with a great deal of libellous visual evidence. Then in another sketchbook we find "My 40 h.p. Renault, for Parties, Balls and Big Functions Only." This is a motorized version of the Lord Mayor's coach, all gilded Rococo, with swirling acanthus mudguards, and two stiff flunkeys at the back. It had to be a Renault simply because the curves of the old Renault bonnet were half-way to Rococo already, he said. One could not find a better symbol of those two contradictory fantasies that would always furnish my brother's imagination: the fantasies of the new and the old. He set out to be an accomplished man of the modern world – who would care only for a dream of the past. One day he was sure to get that Swallow Special, which he bought later on, stuck in the mud beside some country gentleman's obelisk, though he could drive it more skilfully on the road than most artists of the avant-garde could drive a Morris.

And if these fanciful cars, like his notions of life on a film-set, or of new-style evening "Fashions for Men", reveal some independence of mind, so also did his own appearance and behaviour. In dress, in taste, in habits of thought, the average art student was as conventional in his own way as the average subaltern or débutante – little though this statement would have been relished in the Life Room. What could be made of a boy who did not seem to notice that he did not conform; who arrived in a proper suit (bought at Baker's in the Tottenham Court Road), holding an attaché case that contained a book of poetry or memoirs; who was known to play rugger; who frequently whistled American popular songs of the "do-de-o-do" variety; who, worst of all, carried about with him, and openly studied each day, for its cartoons, the *Daily Mirror*? Some students may have secretly indulged some of these tastes. Rex saw no cause to be ashamed of them. I

remember a weekend a few years later when Brian Howard, at that time in full canonicals of Oxford aestheticism, amiably mocked my brother for the ra-ra-ra kind of song he relished. "Well, they're college songs", said Rex. "And if you don't like collegiate things, what *do* you like?" So, for a while, it was –

Collegiate! Collegiate!
Nothing intermediate!

But notwithstanding the ready-made suit I doubt if Rex had really outgrown the chronic untidiness of his schoolboy appearance – doubt if to the bowler hats on the early train he appeared to be one of their kind. To them his hair, with its charming wave across the temple, would seem longish, though fairly trim; and he liked rich and unusual colour-effects in shirts and ties and pullovers; and soft dark hats worn with a rakish brim.

After two months of it, he wrote to Ronald Fuller:

I suppose you heard I failed to qualify as a student at the Royal Academy School? I now study very diligently at the Slade! It's perfectly wonderful there, and I can't imagine how I could ever have existed at the RA School. Professor Tonks, the principal, is rather awe-inspiring and about the ugliest specimen I've ever seen. The only annoying thing at the Slade is that most of the students wear sandals and bobbed hair, and I simply *can't* bring myself to do that.

Many are the caricatures he drew of them: the men slate-blue in the jowl, with concertina-corduroys and dejected toe-nails; the bobbed and fringed girls in obligatory John dresses, apt to strike, hand on hip, the obligatory Dorelia pose. All the same, his caricatures are not biting, though funny; they express quite a genial amusement. It would be misleading, however, to create the impression that Rex was a "colourful" personality in the accepted sense, or at all exhibitionist. Throughout life he was inclined to take a back place and keep silent in company, until sure of his ground: "quiet and a little shy", as Frank Ormerod says, although "he always seemed to have something, some innate power in reserve. I remember well his quick manner of speech, the rapidity with which he took up a point or a mood, and the rich personal flavour he gave to conversation." To them all he seemed both aloof and likeable, intriguing combination.

At first there was not much talk to be heard in the Life Room. It was hard work for the class, trying to concentrate inside those windowless walls; and coming up out of the Dungeon into daylight, with the leaves idling down from the lime trees in the quad, gave a sense of

expansion and leisure. Among the crowd there assembling the only person Rex knew was Eileen Hammersley Heenan, whom he described to Ronald Fuller as "a very nice girl – though perhaps a trifle Bohemian". On fine days he used to eat his sandwich lunch with her, lying on the grass, and she became a kind of elder sister to him. His youthful good looks, his singular personality, his very indifference, made him attractive to the girls, and in the end most of them were in love with him, it has been said. But though susceptible, he did not invite this, and Eileen, the childhood friend, gave protection. Once in the quad a girl-student threw a banana skin at him. He disregarded it completely. But he blanched and muttered in fury: "Now I can understand why people commit *murder*!" The slight vulgarity of it provided a vent for the embarrassment.

But new friends were made – among them another student in his first term, who seemed to share Rex's fondness for dressing up. They learnt how to construct masks of papier mâché, and, to begin with, each would contrive one during the weekend as a joke, to surprise the other with a new disguise on Monday morning. The masks were simple enough at first, derived from plaster casts of classical heads, and very crude in the execution. But as time went on they became more grotesque – or else more beautiful, with eighteenth-century beauties and Hawaiian dancers for model.

> Feathers, wire, pipe cleaners, sticky paper and string, twisted into lace or curls and set with jewels ... were added to complete the startling effect.

It is Oliver Messel who writes, and he continues:

> Later I had an exhibition of my own more elaborate ones which was seen by Cochran, who produced them in one of his Revues, and therefore all my subsequent work in the theatre can really be traced to those days. I look back with happiness to prolonged luncheons in the squalid surroundings of an ABC or the humbler restaurants of Soho. Rex would always carry a small sketch pad and a set of coloured ink bottles, and sometimes the napkins and table-cloths were used as well. Palladian Palaces and legendary figures, side by side with ladies from English tea-rooms – the surrounding fellow diners were turned into fabulous monsters.

Term had been running for a fortnight and more, when a new student appeared in the Life Room who made an equally quick impression, with his slender figure and extraordinary beauty, like a more

delicate Shelley. This was Stephen Tennant. In the silence of the sombre room he looked round, wondering who would be congenial. There sat Rex, seeming different from the others and more interesting; but Stephen was hesitant too, and it was some time before they chatted during one lunch-break, sitting in winter sunshine under the columns – shared their sandwiches, and talked of Poe, the book in Rex's hand.

In March 1923, during Rex's second term, our family moved from Abbots Langley to Pinner Wood House in Middlesex, a move towards London which seemed like one away from it. For the house and its two neighbours stood in a pocket of pure country, curiously solitary, with fields rolling up towards widespread woods, and not a villa in sight; though it is true that we made it seem more remote than it was by deliberately never taking long walks. It was an ancient and pictur- esque house exactly of the kind to appeal to my father: he and Jess could not believe it was the one offered modestly for sale, when they drove up to it, and the fact that he could afford to buy even as a bargain a house decidedly bigger than The Knoll, with a rambling garden ringed or set about with trees, is proof that since the war he had revived his Eltham business to a fair extent, or anyway believed he had. The old farmhouse had been sensitively improved with a deep bay window built out over a porch, on barley-sugar columns painted white. In that room, it was understood, Bulwer Lytton had finished *Eugene Aram*, when he and his wife had the house in 1831.

Rex was enchanted by his father's purchase, and in his sketchbooks made numerous drawings and paintings of it from every side, with his own quite practical idea for extending the front in the same style, so as to provide himself with a studio above an archway. The house might almost have been invented by him: it was architecture of the kind that he had been drawing for some years, low-ceilinged, romantic, with curious instances of carving, and with narrow casements opening above flower beds.

The time had come for Rex to begin painting from the life in oils. No one was ever allowed to do this until he had covered a good many sheets as a draughtsman; as Tonks said, "that is what a school of art should be, a school of Drawing". To emphasize this he would some- times take a good pupil out of the Life Room and up to the room next to his own, to work by himself, saying that if he had done a decent drawing he could now paint from it. Rex pretended it was going to prison, though it was known to be a privilege. Nor would Tonks permit any ecstatic yielding to colour, but imposed a narrowly re- stricted palette. The clutch was let in very slowly, very soberly – the

first day in "laying the dead colouring", with muted darks and lights, the second in getting right some portion, say the neck, both in itself and in relation to the rest. All of which was under the general supervision of a very distinguished painter, if not exactly a great teacher, Wilson Steer, the close friend of Tonks, who said of him, "Steer is the simplest man I have ever met" – using the word with the connotation of integrity. Taciturn, not to say lethargic, Steer moved among the easels, seldom venturing on more than the briefest opinion. However, as Tonks saw it, "his influence, by his simplicity, has been very great"; and behind the scenes, George Charlton tells us, his counsel was paramount – for example in the allotting of prizes, which at the Slade have often been prophetic of success in after life.

Meanwhile Rex was reaching for knowledge in other directions, working as he had never worked before, and reading constantly. He went voluntarily to the Bartlett School next door for a year's lectures on architecture by Sir Albert Richardson, the architectural historian and a very popular lecturer. Descended as Rex was on the Whistler side from generations of modest builders and decorators, his instinct for building was innate; and then there was Paul Storr on the other side, more remote, but more credibly accountable for so passionate an interest in design. Rex filled a notebook with delicate detail drawings from Egyptian and Greek temples, etc., gaining useful knowledge of the fundamentals. With Oliver Messel he explored quiet corners of London, alleyways of Hogarth's date, the river steps at Wapping, the York Watergate that was believed at that time to be by Inigo Jones: of this he made a lively pencil drawing. But there was – to begin with – no connection between the architecture he was studying and the architecture it amused him to imagine. His own fantasies had become quite extravagant, as he designed for himself in semi-humorous mood a supercolossal palace, at least a hundred and fifty feet high. "My Private Bathroom" is a swimming pool with a gilded canoe bobbing on it; while a note directs us to "H and C taps on right of steps into water". A staircase grander than the Vatican's Scala Regia is entitled "Back stairs to servants' quarters". The style is gargantuan with touches of Art Deco, and recalls nothing so much as the Teutonic nightmare of the Goetheanum at Basle, designed at about this time by Rudolf Steiner. Later on, he applied to do a term of sculpture under A. H. Gerrard, who soon told him he was wasting his time, since he "only wanted to do romantic/baroque stuff – flowing hair and all that", and not to grasp the essentials. Gerrard reports that he was not to be put off, applied himself creditably to modelling, and did complete a workmanlike head, that of a Roman woman, although, not surpris-

ingly in the circumstances, "he seemed very shy". It was a small instance of his determination to do what he wanted to do, had to do, undaunted by the force of current critical contempt.

When the year ended in July Rex had won a second prize in figure drawing, and, far more important, a scholarship for his second year. This was renewed for his third. Yielding £30, it accounted for the fees with a little over, and so from the age of eighteen he cost his father nothing at the Slade.

# · VI ·

THIS HOPEFUL BEGINNING put Rex in specially good fettle for the summer holidays of 1923, and very different they felt from those of last year, spent wrestling with oils in The Knoll's garden. After breakfast he went to his studio in an outhouse at the back and up a flight of steps. During daylight hours he was busy there on his picture for the Slade's annual Summer Competition, "my first serious attempt in oils", as he said. Through the garden at Pinner a stream flowed in and out of a longish kidney-shaped pond, dotted with water lilies, which to us was the "lake"; and it curved round a mysterious "island", really a peninsula, thick in shrubs and wild flowers. We poled about in a punt, making the water lilies swirl and drown briefly in a smell of cold mud. Upstairs in the water closet there was a fitting for the toilet paper which described itself as "The Ship Roll Fixture"; but the name was stamped along a metal ribbon in such a way that it was more logical to read it as "Roll The Ship Fixture" – and this nautical command was often to be heard aboard ship. Rex and Jess played a little tennis on the court in the garden. The warm nights were fragrant with stocks and phloxes. From the lit windows of the drawing-room, or on the lawn itself where we used to carry the cabinet gramophone, dance music swooned. None of us took much interest in classical music as yet, unless you count our mother, whom we liked to hear at the piano, swaying through Schumann, Strauss and Chopin, her polonaises, waltzes and mazurkas of the old Wootton days; and it was too early for the wireless – at any rate we had none. But Rex was always buying records of foxtrots and popular songs, and on the back of one was a tune called "Minnetonka". It had a moment, a tiny figure in the accompaniment, that thrilled us. He would point it out to visitors, and we would stand on the lawn waiting for it to come round. I can see him departing in the "Royal Barge" one day, on some voyage of discovery, setting sail to the strains of "Minnetonka", with cries of "Roll the ship fixture!" and gestures of heroic farewell.

In October he was back at the Slade, waiting for the result of the competition, "a palpitating mass of nerves". He was awarded one of the second prizes of £5, and later sold the painting to Mr Ablett of the Royal Drawing Society, his childhood mentor. Nan West, afterwards Mrs David Robertson, recalls that it seemed "enormously competent and quite different from the dim linoleum-like paintings we all seemed to produce at that time. I remember that the students found it rather shockingly gay and flippant." She believes that the prize was accompanied by "many warnings and much advice" from Tonks. For Tonks was puzzled; so, too, was his colleague, the inarticular painting master. Clifford Bax, the composer, reports that meeting Steer at an exhibition he asked if there was any student at the Slade likely to become important. "Yes," said Steer. "There is a boy named Rex Whistler. ... Only he won't take anything seriously." George Charlton comments that this could be misleading, for Rex was "a great worker". – "We never had a harder," he added to me. Tonks put it like this to Augustus Daniel:

> Whistler has extraordinary gifts, all except the power of observing anything in particular, and even this at times he has, when he *paints* from the model, but with a pencil in his hand he is incurably unobservant. He does things with ease I could not begin to do, he has all the qualifications of a great master, *except* what the bad godmother arranged he should not have, the power of looking.

On the other hand, to Osbert Sitwell Tonks said that in a lifetime he had met only two or three natural draughtsmen, and Rex was one, able to draw anything set before him, and to give it form and content. Thus he varied in opinion. "Hideous rapidity and loathsome fertility!", he is said to have exclaimed when his eye fell on Rex's first contribution to the monthly Sketch Club show, some "period piece" of naïve fantasy, and to have set before him as a half-jocular punishment an object at that time thought specially disgusting, a huge, ornate, Victorian ormolu clock, brought specially to the Slade and placed on the landing. But such a task could not trouble Rex, though it may have bored him; for as Tonks then discovered, he was an accurate recorder of any artefact. It was the living form that he was felt to fudge. "The most remarkable student the Slade has ever seen", Tonks would tell a later intake, and that was not excluding Augustus John. And to Jack Beddington of Shell, when asked to recommend an artist for advertisements: "This young man has the greatest facility for draughtsmanship since the Cinquecento" – praise extravagant enough, even when

one notes that he used the word "facility", and was not, obviously, implying achievement.

We can sum it up in this way: Tonks at first thought, may always have thought, that Rex showed promise of great genius, but reconciled himself to the flowering of a lesser talent which he took every means in his power to promote. He was never anything but helpful. It was not so for some other brilliant pupils whose reputations in our time may stand higher. For these were they who were affected by the modern movements abroad, in short by Post-Impressionism, and under Tonks the Slade more or less remained blind to it; though I must not exaggerate his orthodoxy. For example he could respond to the beauty and originality of Stanley Spencer's work at an early age, and remarked to him just before the awards were announced for the Summer Competition in 1912, "We've decided to give you the prize. Mr Steer thinks so: he doesn't understand your picture, of course!" Later he was much impressed by the pencil designs for the Burghclere Chapel which Spencer brought to the Slade to show him. But Spencer was not so outlandish after all, and had affinities with Giotto and with the Pre-Raphaelites. It could fairly be said of Post-Impressionism that Tonks detested it. Here a clear distinction must be made: where Tonks was against, Rex was merely outside. Tonks, responsible as a teacher, with the hardening prejudice of age, could only attack what he mistrusted. Rex, freelance, with the flexibility of youth, might shrug his shoulders or might even enjoy, but in any case must go his own way. Had charming and persuasive Roger Fry, promoter of the Post-Impressionists in England, himself been Rex's professor, this could not have been remedied.

No doubt Tonks cherished a hope that Rex would be one to rescue living art, but it would be misleading to suggest that he did not think the same of several others, and have from time to time his special favourites – very few of whom in the event fulfilled his best hopes for them, but that is nothing to be charged against a teacher. His letters of the Twenties contain many encouraging comments to or about Tom Monnington, Winefred Knight, William Coldstream, Allan Gwynne Jones, Robin Guthrie, Daphne Baring, Mary Adshead and others, but in Rex's day the star, for Tonks, was indisputably Rex, who accordingly enjoyed some freedom.

A plump mulatto lady came to draw in the girls' Life Room at one time, where men were not allowed. Rex and Stephen pretended to be in love with her. They swept in one day with a bouquet of white roses, to the delight of the class, and presented it to the lady with such winning grace that she too was enchanted. But the best-remembered story is this one. The entrance to the Slade consists of wooden doors

which have a second pair of glass-panelled doors set back a little distance inside them, the lower part solid, with the glass beginning at high-dado level. It occurred to Rex that when both pairs of doors were shut the shadowy space between them looked exactly like a lift. He went in, announced "Going down", pressed an imaginary button – and sank smoothly out of sight with an unconcerned expression and the soft nasal hum of machinery. Presently his head reappeared with the same discreet hum and the same evenness of motion. (Years of "full-knees-bend" under Dr Lemprière at Haileybury had trained those thigh muscles.) He rose to floor level – rose a little above it – sank with a slight jolt, opened the doors, and stepped out, as if preoccupied. It was funnier still when he called in friends and trained them so that several disappeared together, two chatting, one reading the paper, or when someone went down and someone else came up. They would wait until a stranger approached, the aim being to keep him there until the lift reappeared. I might add in passing that as well as having strong thigh-muscles, Rex, who was slight, if fairly tall, being of my height, five feet ten and a half inches, amazed the Department of Anthropometrics, when they called for "guinea pigs" and one of their gauges recorded the prodigious force of his grip. Though my own hands are very strong he could always catch mine in a tussle and hold them. It may be that his delicate yet vigorous drawing depended on sheer strength under control.

The penultimate day of the summer term was devoted to the Slade Picnic, when three or four charabancs were hired to take eighty or ninety students to some such place as Epping Forest, under the nominal supervision of some junior members of the staff, who made little effort to contain the high spirits of the picnickers and had little chance of doing so, dispersed as they soon were. On one occasion a party broke into a small fairground, where the boys made the girls mount the horses, and managed to get the roundabout revolving, even with the music playing, it is said. As part of the canvas cover had not been removed it was torn, and when the proprietor arrived in fury it was Rex who gave him the address to which the bill should be sent: Professor Tonks's. For Tonks approved of spirited adventures and relished all aspects of Rex's work, the fantasy, the nostalgic sentiment, the comic ingenuity, the caricatures (he was himself a witty caricaturist); also the sinister and sanguine fictions. He was charmed by a fearfully bloody drawing called *Revolution*, one of several made by Rex in his earlier period. The inspiration was the Russian Revolution – and the prospect of the same thing happening in Britain, which filled the middle classes with considerable alarm, as the Labour movement

gained strength after the war. My father and mother were staunchly and indignantly Conservative, and Rex never saw any reason to discard the political views he grew up with, never suffered from the doubts that in this century have troubled so many intellectuals and artists who were by no means Marxist, but promoters of individual freedom. When news came that the first Labour Government had not been re-elected he was about to post a letter, and wrote on the back of the envelope, "Just heard the election result. *Thank God!!*"

I could not say that his parents' political *opinions*, fortified by the *Daily Mail* and *John Bull*, had weight with him as such, but my father had been to some extent involved, if I remember right, in the riots of 1919 at Luton, when the town was for some days under military occupation and the girls in the munition factory went wild and attacked the management. The story could have added to the general effect of news coming from Russia and elsewhere. Rex made several drawings and a poster of Bolsheviks contorted with bestiality, and slobbering with lust for blood. On the other hand any Marxist might have been satisfied with his drawing called *Planters*, where a depraved white man sits boozing whisky in the sun, close to an overburdened nigger in an agony of thirst. But the Russian Revolution slid back into the French, or into any other upheaval occurring in the safe and picturesque past, with swaying flags and well-coordinated mobs.

Certainly it was felt that he could now do nothing wrong at the Slade. It is a proof of his good sense that he never exploited the advantage, and of his likeableness that nobody seems to have resented it. He was not exclusive, though he had his closer friends, and of these Stephen Tennant, or Napier Tennant as he chose to be called for a short while, was pre-eminent. As at Haileybury in bookish Ronald, so now in aesthetic Stephen he found a perfect companion – one better suited, really, to his mind and outlook in the years immediately ahead, though both endeared themselves by love of poetry. No one else at the Slade cared for it, and it was this that brought them together, when Rex on that first meeting introduced Stephen to Poe, as Ronald had Rex. They began to discuss Shelley, Tennyson and Keats, Housman and Chaucer. Ranging wider as time went on they read Willa Cather and *The Secret Garden*, Pepys and Edna St Vincent Millay. They read the new de la Mare play, *Crossings*, and waited eagerly for his next book. As warm days returned they read aloud to one another in a quiet corner of the quad.

"I'm going down this weekend to stay at Lord Grey of Falloden's house in Wiltshire!!!", he wrote to Ronald in July, 1923. This invitation came as a delightful surprise to my mother, with its promise of

his entering a social world quite outside her reckoning. "His step-son, the Hon. Napier Tennant", Rex went on, "is at the Slade and we've got rather a 'case' (to use the college expression)." A "case" was the Haileybury term for a love affair between boys, that most shocking aberration at a public school. Whether it was thought by some that they really were in such a case I have not discovered. Possibly it was. In fact they were not – and Rex would not have written thus if they had been. By this age any homosexual leanings he had were not towards a male more feminine than himself, and Stephen himself saw "no trace" of them: "it was always beautiful girls", he has told me, though Rex made no progress with them either. Twelve years later when their friendship had faded and they were loyally pretending it had not, Rex wrote, "Thank God it grew and lasted all this time owing nothing to unhappy destructive *sex* . . . physical love."

That first week-end at Wilsford introduced him to the life of the civilized country house which was to offer him so much that he enjoyed, and it could not have been done more aptly than in the serene Avon Valley, with the cool profiles of Salisbury Plain on either hand, where the love of beauty was assiduously cultivated. It was alarming, without doubt. Yet it may not have been his introduction to rich living as such; to a house with many servants, embarrassingly present all the time. A *nouveau riche* lady in Berkshire had commissioned his first portrait – only to decline it, perhaps because he had recorded her as necked like a bull. On a visit to her opulent home, finding his suitcase unpacked and his dinner jacket laid out, he resolved to conceal from the superior footman the vest he was wearing, and at bedtime hid it in a little drawer. Next morning that cruel man made a silent search for it, opening cupboards and drawers until he could spread it out, with its mortifying holes, while Rex all the while, peeping over the eiderdown, pretended to be asleep – a theme for a strip cartoon by Bateman, or indeed by himself.

Quite different was the atmosphere at Wilsford, deep in a solitude of ilexed lawn and willowed river, a gabled Jacobean house designed by Detmar Blow in 1906 for Lord Glenconner, Stephen's father. It is true that his mother, Lady Grey by her second marriage, could be a formidable hostess when she wished, and many years later Rex and Edith Olivier agreed that it had never been a happy house, in spite of her graciousness and love of God: there was always the sense of steel in the caress. Rex never encountered that, and was acceptable at once, as a much sounder companion for Stephen than most of his new friends in the post-war world, so that his week-end visits multiplied. The new poetry enjoyed there was chiefly Georgian, with the work of

the older living masters, Hardy, Housman and Bridges. The cold
douche of T. S. Eliot had not washed over the warm and precious
velvet of those lawns, still less the outlandish flotsam of Ezra Pound.
Lady Grey liked anthologizing, and both she and "Sir Ed'ard", as Lord
Grey was called, a strong Wordsworthian, were readers aloud, and
friends of local literary men such as Henry Newbolt and Oliver Lodge.

In the following year Rex told Stephen,

> I'm compiling a little anthology (too grand a word really) of all
> my favourite poems, so that I can always be able to read them,
> whenever I want to. Only a very few, of course, as it takes so long
> to write them out. ... Can you remind me of any particularly lovely
> one? I've got, of course: "Annabel Lee", "To One in Paradise", "La
> Belle dame sans M", "The Listeners", with one or two rather sweet
> little flowery ones by Herrick, Shelley and others. [See note.]

On the title page of "An Anthology of Mine", as it is called, we see
an Elizabethan so deep in thought as to be shown anchored by spiders'
webs to the stack of his books. But that is the only note of humour.
All that follows in these glimmering bright-coloured pages is romance:
much Poe, much Keats, some Hood and Tennyson (but no Words-
worth, or Byron); some Marvell (but no Donne); some Hardy and
FitzGerald (but no Browning). Also some poems by his friend Ronald
Fuller. Indeed, so potent is the flavour of romance that the
seventeenth-century poets seem at one with the Romantics. Modern
poets, apart from de la Mare, do not appear until later in the book,
and then there is some Brooke, Edith Sitwell and Siegfried Sassoon. It
was Wilsford, I think, that introduced him to the Georgians, and
though many of them might be as dull as Drinkwater, yet from Drink-
water himself he took one memorable poem, "Moonlit Apples": he
had heard the poet read it aloud there. Still, there are more by de la
Mare than any poet, dead or alive. He was not held to be the greatest,
but to Rex he was the supreme romantic of the modern age, creating
a world of his own by transfiguring with strangeness what was fami-
liar and at hand. Rex, too, was romantic, and would create a "world",
different yet enriched by that other, and to some extent in debt to it.
How often he would apply the epithet "de la Marish" to some scene
in his mind or actually before us – an old house at twilight, withdrawn
into the premature night of great elms; the last lamppost of a town
shining down on a creepered wall; numberless moods or moments in
which there might be an element of stillness that seemed to hover
indecisively between the innocent and the uncanny. The effect of this
on his own art is never seen in the big "set pieces", the conversation

pieces and murals, where the romanticism is of a more sophisticated kind, but in his homely works, the illustrations to Hans Andersen and other books for children – one by de la Mare himself.

The poems are neatly written out in Rex's early hand, upright and rounded. The drawings be-gem almost every page with their bright, early colours. He would soon think them childish, but for me there is a visual poetry in their ingenuousness of a kind not found in those more sophisticated works. They seem to perpetuate the mood of Pinner Wood House in 1923, and in fact his picture for Keats's ode "To Autumn" recalls the old home. Alas, "the old home" is what it soon was, and after only fourteen months. My mother had taken against it. She was going through the change of life in her early fifties and was never well. In the spring holiday of 1924 I had bronchitis, reminding her of Denny, no doubt, and was kept in bed for longer than seemed necessary, for in fact I was healthy enough, and never had a day's illness throughout my school career. She thought the place damp and depressing; we thought she knew it to be haunted. She was frightened of the dark pond and its deep muddy bottom, though there were hardly two feet of water to drown in. Admittedly there were practical reasons for moving on, in that our dear Katy Buckle left, and it was hard to find anyone to work in a place so curiously isolated, near to London though it was; also the garden was unnecessarily big and expensive. Nevertheless, it was another instance of my mother's wilfulness, like causing her husband to commute daily between Hertfordshire and Kent. There was no anger at the decision, only wretchedness. "It almost breaks my heart to have to tell you", Rex wrote to Ronald. "My father has made a certain profit over the sale, which was quite necessary I believe, as we are supposed to be very hard up." It had been sold to "a painted young heiress". Rex could not bear to meet her when she came to look over, and drew me out to a garden hedge behind which he made scathing comments. Within a year or so, as he foretold, it had been tricked up like a road-house with black beams, and brick chimneypieces.

At eleven, I was just beginning to be companionable in spite of the six-and-a-half-years difference in age, and one outing he took me on, perhaps the first, was to the British Empire Exhibition at Wembley, where the Prince of Wales, life-size in moulded butter, provoked laughter, and the switchbacks thrilled. There were two, the Giant Racer, on which you did seem to race another train, alongside, above, or below you; and the Grand National, where you climbed slowly to a height far above the roofs, and saw approaching you the drop – very terrible if you had managed to secure the front seat, as we had. "O the giant

switchback!", he wrote. "It's a mixture of David's Leyland and Heaven on Earth" – David being Stephen's dashing brother, who had made the huge curves of Salisbury Plain flow by like a shaken rope.

Our new home in the summer of 1924 was Warren Lodge near Farnham Common in Bucks, consisting of an old cottage with a late Victorian villa-block in front, which my father improved, employing his own men and following Rex's ideas over glazing bars and other details. But it looked and largely was a villa, and its small garden marched with a neighbouring villa's. Behind a pollard ash it faced the open common, and beyond that lay Burnham Beeches, open to the public, but at this time very often a solitude – a great pleasure to my mother who was happier again, and some compensation to Rex. As he told Ronald,

> The woods here are wonderful – Enormous twisted, aged trunks, and a dim green twilight caused by the dense leaves above. ... And there are lakes too, "lone and chilly, with the snows of the lolling lily"! surrounded by misty silver birches – You simply must come some time and explore them with me. Imagine what the woods will be like in Autumn! One of the lakes I have named "Auber", though it is almost too beautiful to be called a "dark tarn". But it is most certainly surrounded with "ghoul-haunted woodlands", accordingly named by me "Weir"!

In any case the sharp disappointment of that move was assuaged by what was suddenly offered.

# · VII ·

TO REVIVE mural painting was a post-war project very dear to Tonks: "The only way is, to do it. It is no good talking about it", he wrote to Augustus Daniel, and he affirmed that an artist would never succeed unless he began young. A scheme to embellish the new London County Council Hall, by two of his best pupils, Rodney Burn and Robin Guthrie, started well but was defeated by the indifference of the LCC, much to Tonks's indignation. He must try another way, as he hinted to Daniel on 24 February 1924:

> There is so much activity here, some I cannot tell you of until my mouth is unsealed ... the LCC and every other public body who barges into art may go and be damned. If we do anything decoratively it must be with the poor and humble, I have the men, I only want a little money to pay their journeymen's wages, that I believe I can get. Whistler I must set about painting the East End, he would set them dancing.

Tonks had inherited from Brown, his predecessor at the Slade, a small fund for the promotion of mural painting, perhaps £200, and he had asked Charles Aitken, the Director of the Tate, if he could recommend some hall for the experiment he had in view – mindful that Aitken, as former Director of the Whitechapel Art Gallery, would know his East End and its social workers. Aitken knew Archie Balfour, who ran the Highway Clubs for boys on behalf of Eton College and was willing to meet Tonks and take him down to their Memorial Club at 293 The Highway, Shadwell, installed in a converted public house. There Tonks had eyed a large bleak room some forty feet by thirty, with a stage or platform at one end, and in his mind was already distributing the panels between Rex and Mary Adshead (afterwards Mrs Stephen Bone). Rex decided to paint scenes of Londoners enjoying themselves on a visit to a place like Hampstead Heath. In one panel he showed them dancing to a flute and a fiddle outside an inn; in the

other, with accordion added, dancing in a circle, old and young. Wishing to make the scene contemporary, he put them in modern dress – with a touch of gypsy, as part of the stock-in-trade taken over from Augustus John. But working people in the 1920s on a visit to the Heath may not often have danced in a ring like children, to a violin and flute: the foxtrotting boys of the club will hardly have recognized themselves. Here was a naïve attempt to blend realism and fantasy, the actual present and the legendary past, and having come to think it unsuccessful, from then on he gave himself to fantasy pure, in his important works – to an Arcadian world, not necessarily remote in time, but always in the past, a world where the illusion would be snapped by anything more up-to-date than a bicycle, and even that would seem too modern before long.

During the summer term Rex and Mary Adshead were allotted a bay of the Architectural School to work in, where they grew to feel a certain contempt for the student-architects, playing cricket with T-squares while they themselves worked so hard and so late, and a certain sense of importance whenever Tonks on his daily visit brought in some grand personage, to be mimicked by Rex on departure, though he had shown exemplary deference at the time – as indeed he always did to his teachers, Tonks describing him to Daniel as "modest and of a humorous turn and you would be pleased with his company, a good specimen of the public schoolboy". On they worked into the summer vacation, now having the empty Slade to themselves, until in mid-August the canvases could be put up. Then Tonks gave a dinner in his Chelsea home to celebrate, the guests being Archie Balfour and Aitken, as well as the two artists. "There was some excellent and most amusing talk afterwards", Rex told Stephen, "in the Studio (such a marvellous one) during which, as usual, I played the part of audience only." They had been down to Shadwell, touching up for a day or two, using Mary's little Fiat because my father would not lend Rex the Humber, to his irritation, "and the street and alleys are fascinating, yet repulsive – full of cut-throats and human vermin!" This is in the mood of all his drawings of low life at that period, a mood he would presently find echoed in the verse of Edith and Osbert Sitwell: fascinated and repelled describes it accurately. There now followed a second celebration which brought Balfour an agitated letter from Rex:

> When I read that the members of the Club were inviting me down there, I grew chilled with terror. ... What shall we have to do (Miss A and I) when we are there? You see, I can't make myself sociable,

unfortunately, in the usual ways. To begin with I can't play any cards at all (except "Snap" and "Happy Families"!), I can't play bagatelle, and also, I can't (and I absolutely refuse) to sing to anyone in the World! *And*, of course, if by any chance I have to make a speech – I shall swoon AT ONCE. However, I have Professor Tonks's order to accept ...

The artists went, and, though a little embarrassed, were not pressed to do any of these things.

But funds had run out, and at this date only the long wall had been painted. For the stage wall, allotted to Rex, Balfour with his connections among the rich and influential was engaged to find a patron, and thought of Joseph Duveen, later Lord Duveen. "He is going to be tempted", wrote Tonks, "with a Serbian Prince at dinner, who has expressed aloud a liking for these particular pictures, so Balfour and I and the Prince ought to be able to pick his pocket." Afterwards, when Duveen visited the Club, it was in his mind that the young painter concerned had the same surname as a celebrated artist of American birth, so he addressed him as Rex Sargent throughout. But he was delighted, and in five minutes he told them to go ahead and he would cover the cost, whatever it might be. It was he himself, he wrote, in the letter that accompanied £200, who was "the favoured one".

Tonks had told *The Times* about the murals, but considered their reply offhand. In his position he could afford to write again asking them *not* to send their critic down, thus implying that he had secured a rival. The result was a visit from Charles Marriott who "seemed fairly overcome". A long column then appeared for 24 September, with two photographs on the picture page, one to each artist, the first critique of any importance that either had had. "By any standard the decorations would be good", it said. "As the work ... of two young artists of about nineteen they are extraordinary. Mr Whistler is the racier in feeling, Miss Adshead the more poetical." Having in mind that the epithet "poetical" would often be applied to Rex in years to come, this comment may surprise. But it was just. The explanation, however, was wrong: that he "obviously derives from the Dutch and Flemings" – schools of painting that never meant anything to Rex. What those panels derive from is his own established practice of illustrating "racy" scenes on paper. Human figures in action supply the foreground, as they do in his Summer Compositions of the period; they would gradually be set back, and reduced to the scale that Claude gives them, and for the same reason, that he was happier with land-

scape. But at present he has not the confidence to rely chiefly on landscape. Summing up, *The Times* critic declared, "Here and now we have in our art schools all that is needed for a real revival of mural decorations."

Working so hard for Shadwell had put Rex far behind with other undertakings, now urgent. One was his first illustrated book: thirty-two drawings for *Arabella in Africa* by Sir Frank Swettenham, mostly realistic in treatment. The urgency arose from a chance to go abroad. Stephen Tennant had tuberculosis and was resting at a sanatorium. The convalescence proposed was of the kind that only a rich family could provide: a winter in Switzerland under the care of his old nanny, and of a resident doctor and tutor, specially engaged for the purpose. Lady Grey saw in Rex the ideal travelling companion. Would his parents consent? Would Tonks? It would mean missing all but the first fortnight of the autumn term.

As for his parents, they agreed happily enough, although they would be quite alone for the first time, with me at boarding school, and with Jess already departed to East Africa. There she would begin farming with friends who knew no more about it than she did, Rex fancied: "I am already busy on a design for her tombstone." As for Tonks, he was enlightened enough to think that Rex had earned an irregular holiday, having worked hard throughout the summer vacation, and that his imagination might profit from it, even if it was only at a Swiss resort, and not, alas, in Italy. But he had his own plan for Rex as well. It had been perceived that the Memorial Hall would look much better if the platform opening did not reach to the ceiling, but was turned into an oblong proscenium arch, with a flat piece across the top; and Duveen's generosity made this feasible. Really, Tonks said, he should give this work to another student, but he would keep the whole wall, top and sides, for Rex, on the strict understanding that he was absent for only one term.

Stephen had written gracefully to my mother to ask her approval, and Rex wrote to Stephen, "So far my role seems only to have been that of magnanimously accepting, and that only on (what must seem to you) certain conditions! But I know you know I'm most frightfully grateful to you and Lady Grey, and that if I could have my own way, I'd pack my toothbrush (and Euthymol) right away and follow you to the moon!"

As guest of a friend so much richer than himself; and in social matters so much more experienced, he was inevitably the follower, but they discussed their colour schemes for the winter on equal terms, in letter after letter, and with an enthusiasm that can seldom have been

matched in young men. Rex asked for ideas on how "we may array ourselves. Pale pink riding breeches, for instance, or blue leather gaiters with yellow straps ..." A few days later he was writing on the cool "battlements" (under the central portico) having escaped from the Life Room:

> I've found it quite impossible to work today, with the heat downstairs and the tempestuous excitement. Really, I must say, you leave me but few colours to wear! Yellows and blues you have barred as ugly, you have appropriated scarlets and jade greens – also chaste white! So apparently the only colour left me is *black*. As a matter of fact I've got jade green jerseys and scarves (I hope you don't mind) and bright magenta.

He had soft felt hats for them both, and for himself leather gauntlets on the back of which he stamped and brilliantly painted his monogram, with bright daisies on the palms. His recent friends of the West Herts Rugby xv, now discarded and forgotten, might have felt uneasy. With his prize money from the Slade, and with the murals and the illustrated book, he could afford to be fairly lavish over clothes. "How about those snow caps? They are really meant for ski-ing, I believe, but they look rather lovely and rakish with huge peaks."

Stephen was paying for them both to go equipped with opulent suède-covered dressing-cases, with gilded initials on the lids, outer covers of canvas, and containing an array of gold-topped glass bottles, each with a monogram – cases quite heavy in themselves before anything was packed in them, and presupposing a world of manservants and porters. Rex wrote,

> How wonderful it's going to be at night! As we pore over the mahjongg table in the flickering candle light, we shall hear (with what safe cosiness!) the inky pines rocking and groaning out in the bitter raging night – and far away, borne on the gusts of whistling hail – the distant howling of a wolf! Just like the Peter and Wendy hut!

"With what safe cosiness!" Cosy was a word he often used with relish to describe situations of safety amid danger. For he was inwardly apprehensive as well as outwardly adventurous; which put, as it must, a strain on him. Privileged indeed at nineteen to be making this first visit abroad, companioned by a nanny and a very efficient manservant for courier, without need to book a room, or buy a ticket, or prepare anything in advance but his own wardrobe; and to be met at his destination by the doctor-cum-tutor.

They crossed the Channel on 23 October, no novel journey to Stephen, who now liked to feel himself the experienced traveller as he wrote his diary, and for once had not been seasick, though Rex, he noted, "became rather silent and lemon-coloured". The efficient servant managed the customs while they ate, and presently Stephen was pointing out to Rex from the train window a ruined château "I always look out for", a perfect setting for a Corot or a Fragonard, he said. Later they were "resting for dinner" in the Rue de Rivoli. Rex reported to Ronald,

> We stayed (in a magnificent suite!) at the Meurice Hotel, which overlooks those divine gardens, of the old dream palace of the Tuileries. ... We visited the world's most lovely sweet shop, called "Au palais gourmandises" (what an excellent name!) and made several purchases, and we also drove in state through the Bois, past the wonderful Arc de Triomphe and out to beautiful Longchamp. Napier Tennant and I spent a good deal of our time strolling, curiously attired, in the Rue de Rivoli, the cynosure (or so we hoped!) of all eyes! – with strange little felt hats over one eye *and plus-fours*!

– a new fashion, not favoured by Rex for very long. Then the night express to Montreux, and the little mountain train crawling up into picture-postcard land, green, blue, purple, white – fir-trees, sky, shaggy slopes, white caps – and in such heat that the floor of their compartment was soon, Stephen wrote, "ankle deep in discarded scarves and coats". And so to Villars where the unknown Dr Macfie was on the platform to escort them to the Villa Marie Louise.

It proved to be a large chalet of conventional shape, lodging also three other visitors, and run *en pension* by an English couple with children and plenty of servants: not at all like the Peter and Wendy hut. The boys found their bedrooms adjoining, and next to them their private studio, all with windows agape at a view that was conventional too, but none the less staggering, as the earth's floor fell away into the valley of the Rhône and its mountain walls soared up around it. Impossible not to be thrilled: and Rex was presently trying to paint it in his sketchbook, adopting for the occasion, to simplify matters, the style though not the lightness of a Japanese print. The heat continued through leisurely days, with much resting for Stephen. As for Dr Ronald Macfie, MD, LLD, he was a plump, middle-aged, lowland Scot who combined doctoring with teaching, wrote verse, wore stiff collars, and was genial. At first he dispensed a little tutoring in literature, history and geography, but this, it seems, was presently allowed to lapse by

mutual agreement; not, however, French, to which the boys applied themselves for an hour every evening with Mlle Cremieux, a demure and rather charming young Swiss. Rex could not speak French and made little progress, but he did learn to read it with pleasure – Rostand's *L'Aiglon* was the principal book – and copied out and illustrated poems, even getting a few verses by heart, which in years to come he would suddenly rattle out fast, in a chanting sort of voice which he would never have employed for English poetry. As if ingenuously, they would ask Mademoiselle to explain what some voluptuous passage in Verlaine or Baudelaire really meant; and she would shake her bowed head and say she couldn't tell them. "It is bad." In the same spirit, while having mumps quite severely at Haileybury, Rex had tried to get information from the nurse on what *exactly* it was that might go wrong if one was too energetic. Much of the day they spent photographing each other in desperate situations that could seem like stills from a Hollywood film. And Mademoiselle became less demure. She can be seen in various snapshots, head downwards prostrate on stone steps, having murdered her lover; dishevelled under wreckage; and slung over Rex's shoulder as he fires from the hip.

Impatiently they waited for the ice, but the rink thawed again each day. They went on expeditions by car and train, Stephen steadily growing stronger. Once from some great sun-dazzled height they looked down, not on the Rhône valley now measurelessly far below, but on a huge simple lake of white cloud, sharp-edged along its "shore" of mountains, with frozen breakers rearing up against them. Rex sketched it for his mother, but the scenery, he said, "is quite unpaintable – at least by me – and I've never seen a painting of Swiss scenes yet that I wouldn't exchange a coloured PC for!" There was a touch of exasperation here, I fancy. Francis Towne could have done it, or John Robert Cozens; but he knew nothing of them, and little of Turner. In any case he was not aiming to be a landscape painter – as yet.

Suddenly "an awful difficulty and temptation has arisen for me here ... something which in some ways I had rather feared", just because it would be torturing to renounce it. Lord Glenconner, Stephen's eldest surviving brother, planned to take Stephen – and Rex if he would come – all the way down through Italy by car, visiting all the famous cities, until in the south they embarked to return by sea, with a call at the Spanish islands perhaps, and certainly at Lisbon. Unimaginable chance! But what would Tonks say, to whom the promise has been given? Well, Tonks *had* said at farewell that he hoped Rex would get to Italy, if only to Florence for a day. And then there was his Slade

scholarship: could he resign it, and try for it again? "I shall throw myself into his hands. ... I wish to do whatever is best for my work, and I'm quite prepared to return. ... I take it I have Daddie's and your permission." Anyway, a decision was not needed yet, for the plan was still a secret from Lady Grey, and she was coming for Christmas.

Meanwhile the ice came, and with good instruction from Dr Macfie Rex found that he had not forgotten how to skate, but decided with Stephen that they were overdressing for the sport while they were novices, and accordingly they modified their outfits, and were soon rapturously gliding to the waltzes and polkas that swooned and simpered from the bandstand; he could think of nothing else.

By the time Pamela Grey was installed in the hotel, giving white-tie parties – luckily Rex had brought both tails and dinner jacket – Christopher Glenconner's little Grand Tour had quite dissolved, he was going to Florida instead, and in any case Lady Grey would not have allowed Stephen to make long car journeys or to come home by sea, bad sailor that he was. Instead, she would take a complete villa for them, perhaps in the Italian lakes, perhaps on the Riviera. Could it possibly be in *Rome*, Rex begged, (still with Tonks to square), but no, Rome was too noisy with its trams. Tonks was now approached, the most being made of the chance to visit Florence, Rome, Milan, Pisa etc., also to do serious work in a quiet atmosphere (which, to tell the truth, had lapsed on the holiday mountain). Any books they wanted would be supplied; and Dr Macfie would resume literature classes. Tonks did not hesitate:

> I hasten to answer so as to prevent any anxiety on your part. By all means take the opportunity. You are doing the grand tour not, alas, as it used to be done, behind the measured tread of horses, but at least in comfort. Make notes and really try and see the best things. Call on the British School of Rome. ... I hope Tennant has made really considerable improvement, please give him every kind message. It certainly is a great opportunity for you. I hope you both read and speak French. A little Italian you will have to master too. The decoration must wait.

This meant Shadwell. As for his scholarship, it could perfectly well run from April to March next year. No professor could be more compliant – or more wise. So Dr Macfie set off for Rapallo, house-hunting westwards along the Riviera, found a villa near San Remo, and engaged a cook and maids; and Stephen lost no time in choosing guests with his mother, Rex reported – including "a Miss Edith Olivier, whom I haven't met".

For the sake of the cathedral and the opera they would break the journey at Milan: "Apparently the opera is some of the finest in the world, I didn't know it before", Rex wrote. This they did – in their own fashion. Perhaps the Doctor was less efficient than he seemed. Departing from Villars, his fuss appeared to be unnecessary; but, then, half-way across Lombardy, he sprang into the compartment with the news that they were in the wrong section. In utmost agitation an immense amount of luggage was ejected through the window, and the train was already moving away to Turin as they jumped. So now, in order not to miss *La Traviata*, a big car had to be found for the sixty-mile drive: this gave Rex a splendid first taste of the Italy that was becoming, that very day, his true homeland – at least his other true homeland, constantly to be mixed and married with England in his imagination. Milan Cathedral was "the most lovely place that I have ever yet seen"; and here was another "first" for him, a Roman service, in full spate. He sketched and described it with relish to his mother. Profound darkness. Gradual sense of a throng, all standing. Clouds of incense teeming up through far-off candleshine. And that distant crying voice –

> It seemed almost the voice of a maniac ... on a high screaming key, with the words being spat out in harsh grating yells ... a blurred white figure with waving arms and tossing head could be seen creeching about in a high canopied pulpit. Then the choir began to sing and the sound of their voices rose and rose till it seemed to go up to the distant roof in a vast pyramid of deafening sound.

And more yet about rows of priests, and the flinging of censers. It shows how deeply he had been stirred by this his first encounter with theatrical and sensuous religion that even while seeing it as outlandish, if not slightly comic, he could add, to needle her gently, that if a spare priest had come along that moment he would have been his willing convert. Well, it would have been conversion to the Roman Candlestick rite and nothing to do with faith or belief. This is a common experience in the Protestant North, as when we are intoxicated by Verdi's *Requiem*, and afterwards sober up on the reflection, "not in remembrance of anyone I really loved".

Two days later they were train-catching again. Arrived at the station, Dr Macfie went to buy the tickets and they awaited his return, reading magazines on a seat in the booking hall. He did return, but only after a surprisingly long time, nearly apoplectic because he had been awaiting *them*, had put all the luggage in the train, and the train had now gone. However, it was all repossessed at Genoa, intact. And

so to the Villa Natalia in the Corso Cavallotti, San Remo, with no sense of anticlimax at all: on the contrary, "almost unconscious with delight". Recurring superlatives of youth – expressive of a wonder and a simple happiness that would not last for very long. Rex quickly sent a sketch to Lady Grey. It was true that the "quiet" house of her directions proved noisier than Rome itself, when at intervals throughout the day and night the garden shuddered to the international expresses; but that steep garden ended in a terrace above the beach, and beyond it was the fabled blue. All was new to Rex, palms and orange trees and aloes; an old town with arched and narrow ways – the very streets he had been inventing years ago but placing farther East for his Arabian Nights; "plenty of lovely nuns, but many more sinister black priests". And inland there were olive slopes and the romantic ruins of Bussana Vecchia, the little hill town destroyed entirely by an earthquake about forty years before: scenes he would be drawing more assiduously than anything in picture-postcard land.

At the end of March the arrival of that Miss Olivier was awaited, though not with unqualified eagerness by Rex, for he understood her to be a great bluestocking, an undergraduate of St Hugh's College, Oxford, in the days when they were still quite rare, the daughter of a clergyman, a spinster in her fifties who had lived all her life with her spinster sister – and was now mourning her – and had been offered in her grief this holiday by Lady Grey: it did not amount to a notably welcome addition to their life for three weeks. The woman who arrived from the station holding Stephen's great bouquet of violets, smiling and a little shy, was short, with a long nose and brown-black hair rolled on top; short-sighted, vivacious, not like an intellectual or a schoolmistress, quite eccentric, apt to scratch her head vigorously in animated talk, and to kick out a foot in amusement or expostulation; clearly in genuine mourning for someone beloved, yet ready and thinking it the best thing to take pleasure in all that was now offered, and particularly in the company of these intelligent boys. That night she listed the household in the journal she would keep to the end of her life, including "Rex Whistler – a delightful keen boy, who loves talking." After a rest she had come down to the sea terrace for tea, and they had plunged into discussion at once, and again later. "Terrific arguments at dinner", she wrote. Someone asked what one really wanted in life. "We all said we wanted power – the doctor furious as he only interpreted it in terms of money or guns. We all meant *influence*, a spiritual power, but he would not see this and scolded us all dreadfully."

The boys were now tired of him, and relieved that he did not often

go on their expeditions. But Edith was at once in tune with them, and this was not as surprising as it might seem, for her childhood home had been Wilton Rectory, she had known Stephen from birth, and belonged to the Wiltshire world of his parents that Rex had entered two years before. She was no typical daughter of a parsonage, but full of outside activities that her good mind made her effective in, and had sometimes been chaffed by Mildred, her dead sister, for her "grand friends". Rex might have met her sooner had it not been that during Mildred's last illness she had been unusually restricted. Unperceived by her as yet, another stretch of her long useful career was opening out of sorrow, and this arrival marked its beginning.

She introduced them to Pater, reading him aloud on Leonardo because they had just seen *The Last Supper* at Milan. She had also brought with her Edith Sitwell's long poem, *The Sleeping Beauty*, and read that aloud, enchanting Rex, who gave her his drawing of the gardener for Easter, and would soon be reading it aloud to me.

> That gardener was old as tongues of nightingales
> That in the wide leaves tell a thousand Grecian tales
> And sleep in golden nets of Summer light ...

This was poetry, intensely romantic in a new fantastic way, that he responded to. When, to keep up with T. S. Eliot, Edith Sitwell moved on to "Lady Bamburgher's shrunken head" with an impressive apparatus of notes, he was disappointed. In her journal Edith Olivier observes that he hurries to his drawing pad the moment they return, that he is unselfish and responsible, always buys the tickets "and looks very solemn over it", doubtless on account of the difficulty. They played paper games, they danced in the casino. Then she records – "A great day for me ... *I had my hair cut off. Bingled.*" She had arrived with hair in a bun on top and a velvet ribbon round the brow, just as she had worn it fifteen years ago, before the war. The bingle was a version of the shingle, now forgotten: they had been imploring her to do it all the week. "I am afraid I am rather absurdly old to do it, but it does suit me, I quite agree." And she never reverted to a bun. Decidedly vain of her appearance, she did not pretend to be younger than she was: she acted young to the extent that she felt intrinsically youthful, and risked appearing comic in her eccentricity. Also she felt herself to be a natural actress, and would have tried to make the stage her career, but her father would never have countenanced this, and was quite unaware throughout life of her fervent, abiding ambition. All this enabled her to carry off a change of style, and soon to be uninhibited among her multiplying youthful friends. A glimpse of a different Edith

is revealed by those few pages of the journal at San Remo, and it is after they have all been to Communion on Easter Sunday at the Anglican church. "Happiness is there for me, perhaps only there now. It brings *all* near together and the past is not over. In the afternoon Rex and I went to see a motor race. ..." But this struck her as both noisy and dull. Then she was away to England, revealing her new look with some misgiving to a family who were, in fact, shocked by it: short hair, shortened skirt, and mouth made up, discreetly.

That same day Rex set out, in apprehension, on a five-day trip to Rome, Pisa and Florence, the first he had made by himself abroad, for which buying the local tickets had doubtless been a little practice. It was Holy Year, and "I feel rather inclined to disguise myself as a Pilgrim and go through the big toe-kissing ordeal", he wrote to Archie Balfour, with sketches to show kissing Papa's toe on one side of the page, and biting it overleaf. He was fairly well catered for: hotels had been booked, he had an address or two should he care to use one, and the trains had been worked out by the helpful Scotch doctor, if that could be relied on. He would be travelling on a pilgrim's ticket, uncomfortably but cheaply.

Sitting up all night, weary from shallow sleep, he watched, like many another newcomer to Italy, an early sun overlook a countryside which made him feel the journey alone would have been worth while. "But Rome itself! – at the end of my first day in the eternal city, I feel speechless with wonder at the amazing beauty and romance." A horse-cab to the Colosseum, then a day-long stroll to the obvious places, sketching rapidly – an architectural detail, a boy's head, a uniform. But it was ancient Rome or the Rome of Shelley that he chiefly saw that day: wistaria linking wall to broken column, mossy plinths, poppies waving on the shattered cornice. Only two days – followed by two hours in Pisa, now making sketches for the cabman, to save time; and after that two more days in Florence. "Can it be lovelier than Rome?" Not for him! There was nothing unique in his submission to Rome (for it had the force of a religious conversion), and nothing exceptional in the rapture, other than the sheer intensity of it. But this intensity he often felt, and his written words on beauty were never mere gush, but an attempt to match extreme emotion. It is what made his life, when reckoned as a whole, thoroughly worth living, for all its sadness and its brevity. "How marvellous to be in a city where *all* the houses are beautiful!", he exclaimed to Stephen on his return, and it sounds undiscriminating. He meant that the later centuries, the humbler streets, composed a fit setting for the gems and masterpieces, as indeed they do, or did still at that time; and this was

a modern thought, not possible to think before the present century. The whole of Baroque Rome had come alight for him, glowing with a radiance never felt before. And all this, and the new friend at San Remo, had resulted from those first tentative greetings in the Life Room, those sandwich lunches under the limes. "Stephen owes a great deal to Rex," Lady Aberconway would observe later on to Osbert Sitwell, when her drawing room had often entertained them all. "The other way round you mean", would reply the more percipient Osbert. Nevertheless, Rex had been pulled a little off-course by that alluring friendship in establishing himself as the man he really wished to be.

Rome. From *The Next Volume* by Edward James, 1932.

# · VIII ·

JUST IN TIME for the summer term Rex was back in London where Tonks had been grumbling, "there seems to be a lot of decoration about, and *therefore* (perhaps this is not fair) Whistler keeps away". He was thinking of the proscenium arch at Shadwell, where in the end Rex painted Comedy and Tragedy: on one side young people dancing to a lute and a saxophone, odd combination, to signify datelessness; and on the other a hooded skeleton leaning close to a willowy youth with a flower in his hand – this a likeness of Stephen Tennant, whom he evidently did not believe to be as seriously ill as he would soon prove to be. "Social engagements play so large a part in the artist's life now", Tonks complained. This was when Balfour took Rex by car, pleased to show him off, to numerous country houses in Scotland. The Highways Club, long since abandoned, was one of several high-minded ventures aimed at giving poor boys a social centre, while instilling the notion of good citizenship; but when a socialist became manager Balfour resigned.

One engagement had been planned before Rex and Edith Olivier parted on the Riviera, a visit to the Daye House, her home inside the wall of Wilton park. Through a short tunnel of yews he saw a little stone-built house of about 1840 in the Italianate manner, largely surrounded by magnificent trees, yet with a flowery garden and a glimpse of the park – secretive, peaceful, and destined to become his second home from that hour. At one corner was a wooden room, a surplus army hut from the war, already well covered in honeysuckle and roses. This was the Long Room, where Edith entertained her guests, with two girls to cook and look after them. Everything was exactly as it had been when Mildred was there, with the permeating difference that she was not. By dying she had opened opportunities quite unforeseen.

Edith recorded her youngest guest talking nonsense gaily, "he excels at this", and also how others "pale beside Rex's burning enthusiasm ... His subjects possess him." Two callers made disparaging remarks

about Epstein's *Rima*, the recently unveiled memorial to Hudson. "Rex could not believe in such Philistines, and it was most amusing to see his colour come and go as he tried not to contradict them. They said all the stock things – as if they *must* be caricaturing the bourgeois critics. Rex and I are prepared not to like it – but felt we would defend it with our life's blood then." Later, when he had walked across Hyde Park to see it, he thought it "a very lovely work of art", and later again, when it was daubed by vandals, exclaimed, "I should like to paint them all with pitch and drop them down factory chimneys." This was in the style of his mother, who said of other hooligans, "I'd have them all whipped with a thrashing machine."

Returning from matins, that first Sunday, Edith found him drawing the Palladian Bridge from memory – when she left he had been providing himself with a bookplate. "Such exquisite fine work, such free design, spirit and *engouement*", she enthused, and of course such "miraculous speed". In point of fact it is, for him, tight and laboured, and though he had a block made he did not use it for long, and came to regret it hardly less than one for Ronald Fuller, his first, a sight of which in use would soon make him say, "I almost vomitted." During a year in which they did not meet, Ronald had gone up to Merton, a strikingly good-looking, reticent and celibate young man, who would get a second, fail to get a post in the British Museum, begin to take an Egyptology exam, and on an impulse quit, walking out into a life of temporary posts in prep schools, so often the resort of those who hope to write books. The few he did write, too quickly, were not first-rate; for wide reading itself could not supply the mental edge that might have made them so. Thus they were in contrast, this pair who formerly had seemed of equal promise, the one accelerating fast, the other slipping, with too little drive, too little enterprise or confidence perhaps, even to suggest a meeting. It was left to Rex. "Confound you!" said his note, "I've trudged all over Oxford trying to find you."

A young man eager to succeed would be a snob if he valued the successful only, yet he cannot but be drawn to a circle where exciting things are done, planned or said. For a time Rex believed in Ronald's talent, and was only exaggerating when he wrote to commiserate with failure, "I'm confident that your great genius will sooner or later assert itself." As school friendships go, this one enjoyed a long life. "Let's have out old Ronald!", he would say, and go to fetch him in the car. Delightful when there, he grew to seem dispiritingly inert when away, and gradually the inclination faded. For his part, Ronald recorded every meeting with relish; pasted every smallest newspaper cutting into his "Rex Whistler" scrapbooks; bore not the slightest resentment in

his flawless humility; and many years later, having become my close friend, shared with me the task of cataloguing Rex's works. Among those new friends of the 1920s he would not have shone, and sensed it. Obscure they would have said. Quite dim to Rex's bright.

To his newest friend, Edith, Rex dilated on his hopes. "Says he can't paint in the Impressionist way – like Velasquez or Whistler, though he thinks it the greatest – but must always build up from form. ... He wants to do everything, to etch and engrave and build houses as well as paint, and already feels life is too short for him!" His painting life could have been very short, as an entry for November, 1925, reveals: "Rex makes my heart stand still by telling me he saw an oculist yesterday who says his eyes are *very bad* – not apparently the eye itself but some constitutional thing which affects them ... I see Rex is terrified – says he'd rather die or lose both his legs. Oh – the darling." This obscure trouble had him visiting three costly specialists, for eyes, for nose and throat, and for the X-raying of teeth. "It's rather a bore that they cannot find out the cause of my cyclitis", he wrote laconically. Months passed, and with the eye neither better nor worse, Sir William Lister could only advise him to wear goggles when the wind was cold. "I sat next to Lord Grey", Rex recorded of a lunch at the Berkeley Hotel in one of his brief attempts to keep a journal, "and we discussed nearly all the time eye troubles and specialists"; but not encouragingly, as Lord Grey had been a patient of Lister's himself and was now nearly blind. "I do trust my affliction is quite different. I felt very proud to be seen lunching in public with so distinguished a statesman!" – a rather dull man, in point of fact, whose indecision as Foreign Secretary had done little to avert the most appalling war in history, with even worse after-effects that would never cease to cancel lives, Rex's life among them. "Lady G advises me to go to a man called Price." This must have been the spiritualist medico whom Rex did visit with Pamela Grey, at her request, and expense, and accompanied by his disbelieving mother. They chatted in his consulting room until the healer suddenly appeared to fall asleep, when to the disgust of my mother, because her own silliness was not of Lady Grey's type, his voice came out deep and different, indicating that his defunct partner had lost no more time in getting through than courtesy demanded. *"There is nothing wrong with the young man's eyesight"* was the diagnosis. Cyclitis is defined as an inflammation of the ciliary body or middle layer of the eyeball. Though still giving trouble years later it very gradually passed off, never to return, while Rex's recurrent look of illness would worry Edith always.

After Mildred's death there had been a move to commemorate her

in one of those little books of gathered tributes: it would need, said Sir Henry Newbolt, their neighbour at Netherhampton, a biographical introduction – which only Edith could supply. To do that would help her, he perceived, and it did, in a surprising and abundant manner. Being praised for her piece, she was released into authorship. The idea of a novel came to her suddenly in the night, soon after her return from San Remo; two chapters had been written by the morning, and all of it within a few weeks. The sister of a friend was a novelist, who quickly found her a publisher. And there she was, launched at fifty-four on a career of success in both Britain and America, without the least misgiving, fret or disappointment. Though not so conceited as to deem herself important, she was soon expatiating eagerly, with lifted chin, in the company of authors like de la Mare, Siegfried Sassoon, David Cecil. "I have such a delightful idea for ...", "I've thought of such an amusing way to ...". Rex made little decorations for *Mildred*, the first in any book to display his style; then for *The Love Child*, that first novel. Steadily through the years of their long friendship the framed originals multiplied on the wall above her dining-room mantelpiece, even as the Daye House itself sank deeper into branches every summer, until from the Porthole Bedroom nothing but leaves could be seen on either side. They cascaded through the early light on a fine morning, or else they might appear, on waking, to be stitched into one hissing tapestry of rain. Rex also began decorating the first, January, page in her visitors' book, which now began displaying so many eminent names, and he continued to do this, year by year: sometimes with a water-colour drawing of great delicacy, later with a comment on the times, the war against Germany, the entry of Japan, and for January 1943 a shaft of light into the dungeon of Europe.

*The Love Child* is a fantasy. The story of a maiden lady called Agatha, recently bereaved and very lonely, who reimagines an imaginary childhood playmate so vividly that Clarissa materializes and comes to live with her. Conceived at this period of her own bereavement, the theme must be thought to have significance. But what does it signify?

"Left the delicious Daye House and darling Edith whom I adore", Rex wrote in his journal. Their minds answered one another on many levels, for she was, as we have seen, a most unusual Agatha, able to live at ease in a post-war world of lax talk and behaviour, without compromising her principles. True, the people in her segment of that world were mostly deferential to those principles, though not when it contained an element of Bloomsbury. There was "a disgusting party" where Arthur Waley and Francis Birrell ridiculed God. "I could hardly

bear it. . . . Perhaps I was only a coward, but I thought that whatever I said would only give them more chance to blaspheme." Rex's Anglican background was quite similar to hers, though his faith was far less certain. That did not matter. With gravity for him never far below humour he could slip into serious talk with her by the hour, on Denny whom he had vividly dreamt of, on death and doubt; and he could know that she would not be distressed like almost any other Victorian lady – his own mother, for example, whom he considered, as it happened, more spiritual than Edith, despite the little chapel in a turret of the Daye House. "I imagine Edith *groaning* at her prayers, with a great deal of effort," he vouchsafed to me in one of his unverifiable guesses, "whereas I'm sure Mother gets through at once."

There was one subject they could not usefully discuss, erotic love, simply because it was outside her knowledge. It might once have been otherwise, but any suitor available to the Rector of Wilton's three daughters was *ipso facto* not good enough for the Rector, who was also Chaplain at Wilton House. One daughter did escape, after a four-year engagement which could not even be mentioned in the household; but of herself Edith says, "I rather shared my father's fancy for the unattainable in bridegrooms." This might be partly to protect him, for betrothed she had once ventured to be, until disapproval killed it. Then, she continues, in widowhood "he liked us within call", that is Mildred and herself, and he had kept them so. Her second novel, *As Far As Jane's Grandmother's*, quickly following the first, had for theme an autocratic elder, and was "really a symbolic picture of life in my own father's house". Well, she had struck a better bargain with virginity than spineless Jane in her novel. She might be no rebel like our mother, but she had made the very best of her life. She was game: for the big opportunities and also for the little ones. It was she who heard tell that two aeroplanes were plying for hire in a field not far off, a new experience for Rex too, enthusiastically recorded by him – the "cushiony" feeling as they rose – the insignificant cathedral – the waving to one another – and how they gabbled of nothing else until bedtime. "Agatha", she had written, "was amazed to find how easy it was to do an unprecedented thing."

Had she fallen in love, or was Rex her child, her Clarissa? "Since seeing you against that pink pillow in bed the other day", he wrote, "I feel I must, in honesty, raise your marks for seduction from 5 to at least 8!" This would not be very flattering if seriously meant. Presently he would be bringing a girl to stay and opening his lovesick heart to Edith as to no one else. So sensitive a man could not have done this had he ever met the faintest tremor of jealousy. Edith had become his

best friend, to flirt with by way of encouragement, and be cosseted by. Anything more amorous would have been grotesque. With his bad eyes and frequent look of exhaustion he was indeed "fair game for this Queen of Coddlers", as she called herself, ever eager like his mother to give him a day in bed. It was two years before he introduced her to his mother, described that night in Edith's journal as "a pretty woman – gentle and firm – lovely grey blue eyes".

If there was any concealed jealousy it was his mother who felt it, for those frequent week-ends at the Daye House; yet increasingly he enjoyed her company. She was nothing like as widely read as Edith, but she did read for pleasure, and read the kind of book he liked himself, diaries and memoirs of court life, of social and artistic life; eighteenth-century letters; Jane Austen, Trollope, Borrow; these she would read aloud as he drew, and in return he introduced her to much contemporary fiction, de la Mare, Willa Cather, David Garnett. To each author – if not quickly dismissed by her capricious taste – she would bring the same freshness of response that she brought to the events of daily life. On his own he was now reading Benvenuto Cellini, Vasari, Ruskin, always with a book on the table at his solitary meals in cafés round about the Slade; for this backward schoolboy was making himself one of the best-read artists of the day. What he read he talked of. Consequently his mother was enjoying a bookish companionship denied her for a quarter of a century since she parted from her father; and in addition she was enjoying vicariously her son's first successes in Society. She would not have allowed that this was necessarily snobbish. Despising the Bohemian, she admired the kind of artist who moved with grace in the world of affairs, such as Rubens, whose life she had been reading, whose example she liked to fancy that Rex might follow in some modest manner suited to the age. She would have been shy of entering the grand world herself, and anyway had little chance of doing so, confined as she was by marriage and by lack of means.

It was in these years, I now see, that my father, still joining in, and mostly merry at meals, began to withdraw gradually from a central position in the family, not into himself, but into our circumference; and chiefly because he was no reader. It was a mistake that his brothers with no better chances than himself had not made, but it was a mistake made a long way back and by now irremediable: one that a father-in-law could easily have helped him to remedy – by accepting a son-in-law before it was too late. In 1926 he was sixty, quite stout now, often bronchial, still working long hours in London or at home over his drawing-board, redesigning the complex panelling for Whitbread's

public houses. Needing few relaxations except the daily paper and gardening, seldom taking alcohol, he never bought anything for himself that I can recall except necessities, and had next to no social life. We were an isolated family, by choice as much as by chance, keeping up with a few relatives, including my father's mother, a lively and cheerful old lady whom he treated with marked tenderness, and who amused us by treating him, in return, as a schoolboy. There was also Hector Whistler, a first cousin of Rex's age and an artist too of talent, whose naïve self-advertisement exasperated his uncle and tended to reduce his visits, though he and Rex were on friendly terms.

Oppressed by falling income, my father was still content to let his wife make rash decisions if she thought them for the good of his children. She had read in 1923 that the palace of the Dukes of Buckingham at Stowe, set in marvellous gardens, was to become a public school, formed on fresh lines under a very young headmaster. The freshness and the youth, and the gardens, appealed to her, and a guinea had been sent to put my name on the books. But when we arrived for an interview with J.F. Roxburgh it seemed inconceivable to her that I could go to school down such furlongs of avenue, and under so imposing a portico. I was accepted, however – J.F. saying, with that inimitable charm, "I wish I had more like him!", a phrase not exactly coined for just one interview. So then she fell to praying, also quietly contriving, that the fees would be vouchsafed, and to a good extent they were, partly by Sir Francis Champneys, a rich cousin by whom I was vetted; partly by the Fishmongers' Company.

For his final year at the Slade, begun in May, 1925, through missing the autumn and winter terms, Rex returned as leading student and already an influence – "swept up into demigod circles", as one contemporary puts it, and no doubt basking a little. The more reverential anecdotes probably belong to this year: how he was seen painting a canvas with both hands at once, how Tonks had said, "I can't teach that young man anything!", a remark which allows of two interpretations. There would come a time when Tonks would say, with humility that touched Rex greatly, "Teach me how to draw trees." There would also come a time when a student would exclaim, in reaction, "Let's get Rex Whistler round and tell him how we hate his beastly drawings"; though imitators have not been lacking from then until now. It was taken for granted that he would carry off the prizes, and he did win the Summer Competition with his Trial Scene in *The Merchant of Venice*, full of figures, and still preserved at the school: also a Sketch Club award for a *Last Supper*. For the Christmas dance in the Antiques Room a fellow-student produced a large cartoon that

featured Tonks crowning Rex with laurels. Rex himself hung up a large canvas horizontally below the one very powerful ceiling light, so as to make luminous an Apotheosis of Tonks in the Tiepolesque manner, seen in a toga surrounded by girls – a technical *tour de force* that would have some effect on Rex's future, because Aitken of the Tate was Tonks's guest, that night. "Really remarkable", thought the Professor, "Most amusing."

Tonks now put Rex forward as an illustrator to his friend George Moore, who after much doubt and negotiating wrote as follows:

Dear Mr Whistler,

I shall be very glad of your company at luncheon on Tuesday next. I hope you will be able to come on Tuesday, for on Wednesday I shall be seeing Mr Evans [of Heinemann's] about the illustrated edition of Peronnik, and it would be well that we should go through the book together with the view of making a selection of the scenes that call for pictorial comment.

Sincerely yours
George Moore

Please to bring the book.

Before reading *Peronnik the Fool* Rex had submitted, on demand, some specimen drawings. He now recorded:

To Ebury St for lunch with Mr Moore. He was in very good spirits, seemed entirely satisfied and told me that he had overcome the difficulty that was so worrying him, when I had last seen him. He gave me a long but very incoherent account of the story, with some very improper incidents, which almost choked him with glee, and caused him to stop in his narrative! On parting, he invited me, kindly, to lunch with him at any time and show him how the drawings progressed.

Only two days later he was sent by Heinemann long extracts from a letter by Moore, requiring "several more *trial* drawings before giving the commission for certain! ... Went to Tonks, and he has advised me to do nothing more for the present, as I *cannot* be fairly expected to keep doing trial drawings for ever." There it ended.

# · IX ·

REX COULD NOT understand why Tonks was trying to stop him competing for the Prix de Rome, describing it as burial for two or three years, asserting that no winner had ever done anything afterwards: "You can go to Rome at any time, and get more out of it when you are older"; all of which was clearly disingenuous. Dejectedly he thought that he was viewed as a light-weight after all, who had to be saved from humiliating failure. This depressing conversation took place on the last day of term, and a few days later he was summoned back to London, unaccountably. Tonks wanted him to paint the restaurant at the Tate Gallery!

Already a handsome benefactor of the Tate, Duveen well remembered the Shadwell murals, and had promised £500; so a committee would be formed consisting of Charles Aitken (the Director), Tonks himself, Archie Balfour, and for architect Lionel Pearson. Tonks and Rex went down to inspect.

At first glance Rex was astounded by the sheer magnitude of the undertaking, one of a size seldom offered to a boy of twenty. The room was nearly sixty feet long and over thirty wide, with a central door at each end and three round-headed windows facing the Embankment at semi-basement level; all else blank wall: perhaps one thousand three hundred square feet of paintable surface above a necessary dado. Left to himself in that daunting emptiness, he began to form ideas in high excitement. A restaurant must be agreeable to eat in, entertaining. There must be a unified treatment of some sort. At the end of his 1925 sketchbook he scribbled a notion for the long unbroken wall - statues in niches, punctuating pastoral scenes, etc. Second thoughts quickly followed. Why punctuate at all? Suddenly he saw a continuous picture running all round the room and somehow accounting for the doors and windows. A continuous picture would need a human theme to hold the interest, and only a single theme could give unity. Why not an adventure story - the same characters

90

starting out – shown nine or ten times over – and returning to their point of departure?

It seems to have been that rare thing, an original idea. In the history of art there have been many processional paintings around rooms, such as the Mysteries of Isis at Pompeii and the Benozzo Gozzoli cavalcade of the Magi in Florence; but the progressing figures do not recur. And there have been innumerable panels in every sort of medium where events in a single story are separately framed, one or two at a time. A recondite precedent could be found in Japanese narrative scrolls. But these are small-scale; and certainly Rex did not know of them. The inspiration was humbler. In childhood he had often thought himself into a willow pattern plate, where the threatened lovers on the bridge are already in the air as birds; moreover he was constantly inventing picture-stories – sometimes with the frame-lines of a strip cartoon left out. But what story should he tell? Well, it ought to deal with food and drink – perhaps an expedition in search of choice varieties, through ideal country. Thus was born in his mind *The Pursuit of Rare Meats*, an Arcadian strip cartoon (Pl. 27, and see note).

"A story-telling picture is as pathetic and ludicrous as a trick played by a dog", says Virginia Woolf in her essay called "Pictures", "and we applaud it only because we know that it is as hard for a painter to tell a story with his brush as it is for a sheep-dog to balance a biscuit on its nose." If it is as hard as all that we can only wonder that innumerable painters have been doing it throughout history. But her statement itself would be ludicrous if it were taken to reflect on crucifixions and shipwrecks, Rembrandt and Goya and the Turner of whom Sickert was thinking when he wrote, "All the greater draughtsmen tell a story." Mrs Woolf must have meant the Victorian narrative picture, where every detail is a painted paraphrase for words, containing information that we have to decipher. This was not Rex's method, but he was independent enough at twenty to be quite unimpressed by fashionable scorn of the "literary".

Moving clockwise, he would have them set out from the left-hand corner of the main wall; for if not there, the circling might seem to go on restlessly for ever: not what he wanted. A painted town in that corner could be made to contradict the corner, coming forward to the angle, with two sides slanting back in perspective. From the right side they would leave, and to the left return. While he was at work on long strips of paper there was a hitch. Sir Philip Sassoon, a trustee, wanted a competition, Rex was told by Tonks, "so I may not do it after all". That was on a day when he had brought coloured chalks to the Slade to become a pavement artist in the quad. Emerging for lunch the

students were confronted by a plate of fish, a loaf of bread pierced by a knife with the legend, "Easy to Draw but Hard to Get", and other gaudy images, all behind a cap already containing a few coins. "Collected quite a sum for the Slade Centenary Fund!", he noted. The Centenary involved a royal visit and brought no joy to Tonks, who said that "like all royal visits" it gave "a feeling of being stuffed into sawdust with the mouth open". To the astonishment of some who knew how possessive he felt about the Slade, Tonks had told Rex that he could do what he liked with the wide stone staircase. Thus on the great day, being faced by palms and looped red curtains with gold tassels and fringes, Their Majesties were forced to pause – for all the "risers" of the stairway had been gilded, and it seemed to be of solid gold, as in a fairy tale.

In point of fact Sassoon was not so keen on a competition as on securing a masterpiece by J. M. Sert, the fifty-year-old artist of Spanish birth, then at the flamboyant summit of success. This is understandable; for Sert was the fashionable decorator *par excellence*, with whom Picasso, Gide, Cocteau, Diaghilev and many of the brilliant were content to hob-nob, having on balance more respect for his wealth than disrespect for his talent. Sassoon had employed him at Port Lympne, and at this date had naturally not heard of Rex Whistler; who hoped on his way back through Paris to visit Sert's studio – telling his mother, "he is the great wall painter of the day, apparently. I don't know if he is really 'great', but he's earning enormous sums." But there it was, Duveen would be paying, and preferred to pay for new talent. "So now Whistler is in possession and full of an admirable idea", Tonks told Daniel, having just been shown the design.

I am sure you would be delighted. Such gaiety and ideas, so continuous, it is really a dream. I mean really like one (the phrase had almost lost its meaning). I have never had anyone like him. He amuses me because he has a certain gift of humour, I can not describe it, very subtle, that touches some recesses in my mind, all hidden under a most respectful (and really respectful) manner. If only we can save him from the Pit, because directly he is launched he will be an amazing success.

While this was being written Rex was not dwelling on success, because that day he had returned to a Slade already desolately empty for the holidays, to see Tonks, and take away his last belongings; and that night he wrote this:

I can scarcely believe that my last term there is over, and unutterable dejection overcomes me now that I begin to realise my Slade stu-

dentship is over for ever. It won't be the same going back there as a visitor. I shall feel an outsider and ignorant of all the schemes and interests that will be going on within. Some of the happiest days I have ever spent have been at the darling Slade, and I feel unending gratitude to it, and Prof. Tonks for all (however little) that they have taught me.

For the task ahead he would of course need an assistant at first, and was worried that any student good enough would really be too good for the drudgery involved. And Tonks did offer it to one of his best pupils, already engaged on her own murals elsewhere, Nan West, a stormy and often unhappy girl who many years later was to kill herself, having written but not published an autobiography. She was to have £3 a week for the short time she was needed, and Rex £5 a week until the work was done. In view of this, it looks as though there might have been some difficulty in satisfying Sert. After meeting Rex at the Tate, Nan relates, "Tonks and I walked some of the way home together, being careful to avoid Ebury St because he said that George Moore was sure to be leaning out of his window and would "bawl unseemly remarks", (such as "what innocent young girl are you now leading astray?"). Her job was laborious enough. "You might just fix that wall today", said Rex blandly; and all day she blew fixative through one of those little right-angled sprays intended for small-scale drawings. Arriving dutifully at ten she soon found that he arrived at any time. "When he did come, no one could have been sorrier ... the apologies were tremendous. Wouldn't it be better if we both arrived when we felt like it and hoped it would be at the same time?" The excuses, not that there needed to be any, were various and fantastic. He had been called away to tennis lessons, had taken a few days off to design his tomb, etc. This conveys his kind of talk – though you have to perceive the self-mockery. Nan, who could respond to "his wild gaiety and enthusiasm", could also privately deprecate "his florid and bizarre taste, his affected language, and his way of working which had no relation to anything contemporary". When Tonks looked in, and they were found there together, "he would give us an occasional sly glance to see if we were falling in love, perhaps he intended we should. I did love Rex, very much indeed. I don't think he thought of me at all." In that sense, he did not.

One day he was absent about a possible advertisement for Monomark, taking the rough sketch that had been requested. An assistant was seen to have misgivings,

   ... but didn't quite like saying so to me. So he asked me to sit

in a kind of waiting room, while he took it to show to a great
pig-headed bull-necked buffoon called *Colonel Hutchinson* –

met on the previous visit.

My door was open and this *ill-bred loathsome beast* came out
across the passage and said in a loud voice, "It's no good at all.
Rotten! It's kid's work!" I felt absolutely *sick* with rage and shame
and I don't think I shall *ever* forget the intensity of my feelings at
that moment. But I was too feeble to *say anything* when the little
man came back, and said how sorry he was, "but perhaps another
time", etc. ... I merely said "I don't mind at all", and *tore my
drawing up*. But I *did* mind, and *still* mind enormously, not because
I thought it was a good drawing (for I know it wasn't), but on
account of the odious and rebuffing way that Hutchinson cad spoke.

Pride, as it hardly ever did, burst through modesty.

To think that that Swine should insult me like that. Good God I
can draw a thousand times better, at twenty, than *any* of his vulgar
and conceited old "Poster" artists. How I hope one day to have an
opportunity to slight him viciously – in return.

He resumed painting with relief, and then the General Strike occur-
red. That day he stayed at home in Buckinghamshire to see what
would happen, but on the second and subsequent days he made the
slow journey to and from the Tate in trains densely crowded with
cheerful commuters – along streets tidal with walkers – in windowless
buses smeared with rotten eggs – "everyone frightfully helpful and
good Samaritanlike" – Paddington Station so full of volunteer porters
that "old ladies had even knitting and umbrellas carried for them". He
was not impelled to join in, because he had a job and an abnormally
anxious mother; though had he been at the Slade still he might well
have volunteered as did Claude Rodgers, William Coldstream and
several others, with varying effectiveness. The strikers soon capitu-
lated, Nan reappeared, and there were jokes about Aitken's head on
a pike. To many of the ruling classes it was all in retrospect an
alarming practical joke, but one giving much reassurance, because the
suddenly extended shadow of the Kremlin had been compelled to
retract just as rapidly.

In the murals, though the scenery must change along the route, the
light must be constant to give unity. It should be always afternoon, so
as to achieve a general "Chinese wallpaper effect", which, however,
would be dull on so large a scale unless modified by realism. What he

aimed at, now and for ever after in a mural, was playful ambiguity, a game between illusion and decorative flatness. The windows and doors must be accountable on the illusory level – yet the whole be accepted as a decoration – yet the walls still pretend to be dissolved. Anyway, he could not manage variable weather, not having learnt, as yet, to paint out-of-doors. On these walls nature is derived from art. Cinquecento trees drawn up into impossible puffs look quite at home in landscapes having origin in Claude.

Not so his architecture, since that he had been drawing "from the life". If Lady Grey had chosen Rome rather than San Remo there would have been instances of Borromini here. As it is, all the classical and Baroque buildings round the walls are of the English eighteenth century, and often identifiable though strangely placed, in the mode, it may seem, of a capriccio by Panini. But this is not a capriccio. For there the aim is merely to surprise; whereas for Rex it was to construct an ideal landscape, desirable to him, and so, he hoped, to others, which in murals he continued to do with increasing subtlety. We see the Palladian Bridge from Wilton (but ruined here), one of the Boycott Pavilions from Stowe, and a vast attenuated version of the Stowe Corinthian Arch. "I almost envy L", he wrote, after driving me back for the summer term. Wilton gave nothing better, apart from that superlative conjunction of the bridge and house, and he assumed that my response to Stowe must be the same. But it was not. He in sophistication saw an eighteenth century still there, (playing fields and classrooms overlooked). I in simplicity saw what that age had pretended to recreate, the temples, woods and lawns of a timeless Arcady. I knew they were only the toys of Whig magnates and worldly politicians, yet they seemed to have become, or rather seemed to be in themselves, detached from origin and even from the architects designing them, truly timeless and Arcadian. He emphasized a past, and I a present. So I wandered about in hours of freedom, reading *Paradise Lost*, and with equal excitement discovering Keats and Shelley: seeing the Palladian Bridge half-buried in a hill of cowslips, and the Temple of Ancient Virtue dead asleep in sunlight between explosions, white and black, of mock orange and yew. It was all extinguished like an old religion, and yet living, in this brilliant May of 1927, with the dual significance of certain dreams; and this dream held for me the novel notion that I might become a poet. I had written a poem on the Rape of Proserpine, which was liked.

What about the people in the picture? We should not be surprised to find a fashionable party in Georgian clothes moving round the walls on horseback and by coach. It is not like that. First comes a young

man on a bicycle in drain-pipe trousers and red jacket, followed by a kind of horse-drawn circus cart driven by a military gentleman in high collar and stock – later he will be wearing a bowler – accompanied by two pretty girls, one with an Eton crop. Those left behind are mostly elegant Victorians, but include a modern girl and a boy in plus-fours. Then to welcome them home on the adjoining wall there are Victorian red-coats, silk hats being raised, a parson in a dog collar – while the young blood rides in with the lady's maid perched across his knees.

It is all in the mood of Russian ballet: "deft and light-hearted", Osbert Sitwell would soon say, adding that a hundred years before, such a room would have "thundered with heroic forms". Rex, tongue-in-cheek, was taking out of context the traditional types of pre-war England to make fun of their decorum. Mockery was in the post-war air from Lytton Strachey's *Eminent Victorians* of 1918, and he was adding to the savour. It exhales from much that he enjoyed, Firbank's novels, Belloc's *Cautionary Tales*, soon Ibert's *Divertissement* where it is Mendelssohn that is mocked, with police whistles frantically shrilling in the final gallop. Three pillars of society, the policeman, the parson and the soldier, all incurably old-fashioned in uniform and bearing, make frequent appearances in Rex's early work. Edith Sitwell had her version of the third in "Colonel Fantock", the poem of hers he most often read aloud ... "Old military ghost with mayfly whiskers". Her ribald verses in *Façade* had been brilliantly set to music by the young William Walton, and today this record, frequently on Rex's turntable, more than anything else, except perhaps the music of *Les Biches*, also known to Rex and described by Poulenc as a "ballet for pleasure's sake", breathes that air of the Twenties, at once tart, nostalgic and irresponsible, which his paintings and drawings of the decade more wistfully give out. Irresponsibility so harmless and amiable in England, so ferocious and menacing in Germany! While the endless dirge of Mac the Knife and the savage caricatures of Grosz, like voices heard at the onset of a nightmare, warned and at the same time paralysed, inhibiting all healthy action, farther west there was no sense as yet among the young of anything as malapert as fate. While snooks are being cocked there is no thought of triggers.

> Alas! regardless of their doom
> The little victims play!

Or as they themselves preferred to put it,

> In the meantime
> In between time
> Ain't we got fun!

Wiser heads might sigh with Gray, "Ah, tell them they are men!", but were dismissed for having caused and sustained the quite surpassing folly of a war. The Between Time – to give it retrospectively the only apt name – had no obvious end.

Rex's mockery was wistful because, unlike the others, he was half in love with what he mocked. Had the war never happened a different and probably more gifted set of young men, progressive or reactionary, would have exercised leadership in Britain without sense of dislocation from the past; and Rex would have been more at home among those. But now it was over, and too ugly to dwell on. When the reminiscences began to flood from the presses he once called it the Bore War. He admired a man like Osbert Sitwell who had known the trenches for a while and stayed detached, and one like the brave Siegfried Sassoon, who had protested. The war had obliterated so much that he valued, giving only in exchange this exhilarating freedom, to question, break the rules, and laugh. Across that gulf there had been security, confidence, tranquillity – good things that he craved even more than a fast car, to potter slowly through a hamlet. At the Tate, in the meantime, he entertained himself, and others.

Vogue words give the temper of an age. In recent years a work of art has had to be "disturbing" to be good, or rather to be "valid", whereas in the Twenties it had to be "amusing", which is now regarded as a trivial criterion; though whether it is unquestionably better – a more "valid experience" – to be disturbed than amused is not self-evident. The Tate murals were accepted as amusing, and in many details as "absurd", another vogue word of the day, bestowed then as praise. In fact Rex's themes are not all light-hearted, but include the grotesque and the pathetic, as in his painting of the hands of the drowning child who has fallen into the river.

Edith was concerned. "He looks strangely, curiously ill at times. He will be such a very great man if he lives, and I pray he may, for the good of this poor earth." And again in her journal: "He will certainly make money *if he lives*. I only fear he will kill himself from strain." None of this came true! He did look rather ghastly at times from long hours and late nights, and evidently needed a studio in London. This he could not afford on £5 a week, and so for once, out of character, he dropped a hint. Within four days well-connected Edith had got him, not a loan but a gift, a hundred anonymous pounds, worth twenty times as much today, from Lady Mary Morison at Fonthill, and had posted it off.

How can I think you enough. . . . I should have guessed that you would put yourself to the trouble of finding some kind benefactor

for me. I should like to try and repay this most generous rich friend of yours in "kind", i.e. by a number of drawings and paintings "assessed" at a low price.

Edith advised him to start searching at once while the money lasted, and in the end he found two big rooms near the Slade in a neighbourhood, once elegant, which had conveniently declined, but not too far as yet – on the first floor of No. 20 Fitzroy Street, that Georgian street of celebrated artists, Whistler, Sickert, John, Duncan Grant. Before he could find time to furnish and move in he took a month, free as usual, on the Riviera.

Urban Summer. From *The New Forget-Me-Not*, 1929.

# · X ·

LA PRIMAVERA was a large house with a large garden, overhanging the waves at Cap Ferrat, and taken for Stephen's benefit by Lady Grey, who was there herself this time, to entertain. On that account it compared with the modest house along the coast, two years before, as a university compares with a school, but Rex could not bring to it the same spontaneous happiness. Life here was comically of the kind which Tonks knew to be a danger, and called the Pit. Edith Olivier was there, of course, and at first rather silent among Stephen's liberated friends. "They think they have a monopoly of modern ideas." One girl "talks of prostitution lightly as a possible way of getting money – manière de parler. The open mind rather than the promiscuous body!" At least it was gratifying that such things could be said in front of her, but not in front of Pamela Grey, only three years her senior.

A stranger was added: "Cecil Beaton has arrived, a marble face and voice – hard polished surface, but not unattractive." After dinner he showed them his photographs, "incredible that they *are* photographs at all". And soon the camera was clicking again. He was another who had just achieved high life. "What on earth can I become?", he had implored a friend. "I shouldn't bother too much", was the reply. "Just become a friend of the Sitwells and see what happens." This he had done.

Rex arrived and was given a room in Edith's flat. "My bath is really in his bedroom – but we are so easy with each other that this seems all right. He looks on me most simply as a Mother." In her room late at night he described the discomforts of the journey with a detestable stranger. "May Hell devour her!", he suddenly exclaimed. "This was so surprising from his good earnest honest respectable lips, that I laughed till I went to sleep." To exhibitionist Cecil he gave an "impression of exaggerated retirement".

There now arrived to paint Pamela Grey's portrait a lady with a cockney accent and a large white face, whom nobody loved –

accounted later by Edith "the most crashing bourgeoise bore". Coming in to a conversation about Edith's love child without knowing it was the title of a book, she was shocked. Rex was saying he would have to have one too, "one way or another", and then "everyone was saying it was *the* thing to do". Everyone was sharing in amusing outspokenness, admiring and dissecting: "we discuss people's characters *all* the time – generally each other's", wrote Edith. "Played personal games before luncheon, marking each other for points of beauty." She was often at the piano "for wild singing". There were acting games. There was filming in the garden, "all painted up to the eyes". There was a visit to the Gaumont studios at Nice and a meeting with Betty Balfour, the film star. As Rex observed, the one who was really left out was Lady Grey – bringing back from a bird shop all the sick birds, a car full of cages – and glad of any companionship from rejuvenated Edith.

The Stanleys of Alderley arrived to stay, the Douros to lunch, the Scarbroughs, the Islingtons, the Guinnesses; and there were smart luncheon parties in return, one up in the mountains with the Balsans (ex-Duchess of Marlborough): English nobility, French nobility, the talk mostly in French, with Rex feeling awkward. When Princess Louise came to lunch and was not met by host and hostess as planned ("very bad of them") it was short-sighted Edith who first realized that one of the embarrassed ladies at the drawing-room door was Queen Victoria's daughter, and hurried forward to make her curtsey. She was enjoying nearly all of it, happy to be photographed by Cecil "in the most amazing poses, generally upside down – on the floor – in a flower bed and what not".

Such photographs were soon being taken at Wilsford too, so that one can see how Rex looked in a line-up with Osbert and Sacheverell Sitwell, Rosamond Lehmann, Elinor Wylie, the poet, and Edward Sackville-West, lying on their backs under a leopard skin. One taken by William, the footman, of a Wilsford house party shows seven of them perched on the rail of the rustic bridge, all dressed as Watteau shepherds and shepherdesses, Stephen and Cecil in graceful postures of display, quite outvying the girls, Rex at one end, distinctly selfconscious. What would have been the comments – now – of that West Herts Rugby Football xv? Reassuringly, the middle shepherd is William Walton, imperturbably masculine and careless how he looked or what he wore. A similar party had descended on Lytton Strachey at Ham Spray. "The night before, they had all dressed up as nuns, that morning ... as shepherds and shepherdesses", he wrote. "Can you imagine anything more 'perfectly divine'? ... Strange creatures – with just a few feathers where brains ought to be." But he was not un-

attracted, taking E. M. Forster to Wilsford, where they found Walton, Arthur Waley and Rex. For lunch out-of-doors in dazzling sunlight they were all given "gigantic plaited straw hats", and were almost continuously filmed by the footman. "Stephen was extremely amiable, though his lips were rather too magenta for my taste; Arthur was positively gay; Morgan shone as required; W.W. said absolutely nothing; and I, sitting next to Rex Whistler, couldn't make up my mind whether I was attracted or repelled by his ugly but lust-provoking face." Previously Strachey had described him as "rather à la Philip IX of Spain in appearance – 'maussade' perhaps is the word, but he seems serious and unconceited". As against that, when the films were shown Edith thought that "Rex always looks a round-faced baby. They want to do *Young Woodley* with him as Woodley. He would be perfect."

This Wiltshire group was largely artistic and literary, but it overlapped with others more obviously composed of "the Bright Young People", the label already in use. Rex was only on the edge of them; too poor, too industrious, and perhaps too contemptuous to spend time in a paperchase across the counters of Selfridge's, or even, though he loved fancy dress, to remain out of ordinary clothes, as Cecil Beaton did, for a week or ten days at a time.

Only a few miles from Wilsford, unfenced and with a grassy floor and no conveniences then, Stonehenge might attract the whole party in cars on a visit of impulse. Late one night, about Midsummer, it included three poets and a novelist, to let off fireworks, sing and dance to a gramophone through what Rex described to Ronald Fuller as a "wonderful orgy", though that was hyperbolical. Hardy, who brought Tess and Angel to the stones for the exaltation of their tragic parting, would have found ironical amusement in the scene. After Stephen had been introduced at Max Gate, by Siegfried Sassoon, his new friend, and had made his little rush of eager steps to shake hands, Hardy described him as the only man he had ever met who walked like Swinburne.

No Slade contemporary entered the group or survived in it for long, and Rex moved away from his old companions. Yet life was not always so carefree for his new ones. In some country houses wrath was mounting against Stephen and Cecil. With them he went to a party, all three dressed as beggars, incurring the complaint that too much was revealed through the rags – not perhaps by him, if actually by any of them, but he might seem to have been at risk. For his part, he saw no objection to Stephen's making-up, as long as it did not show, but was worried for him now because he "puts on as much as a girl". Others were less tolerant. At a ball Stephen danced with his

partner holding a book in his hand, and this was outrageous on a formal occasion when the men must be as uniform as penguins while the girls could be as polychrome as butterflies – which made a pretty spectacle, one must admit. The men must not draw attention to themselves. That was the real charge against Stephen, an irrefutable one. His delicate health was his protection. But Cecil was pushed into the river at the Wilton House ball, to the indignation of many besides Rex when this little-observed piece of bullying became known. "What an amazing thing is this hatred of the unusual, from Shelley onwards", reflected Edith.

It was still being talked of when Rex took me with him for a week's holiday at the Daye House. That little house no bigger than our own; the servants pleasant country girls like our own; our hostess a country clergyman's daughter like our mother – it was surely the best possible introduction to social life for a childish boy who had never stayed away except with relations. All the same to a child brought up among the reticences of a more middle-class mode of life there was something to alarm in the casual freedom of the aristocratic one, long since adopted by Edith, who anyway was rather alarming in her own right. It was then that I first heard the impressive name Lebohmord, sometimes shortened to 'Bohmord, though never, I think, by Edith; but I was doubtful of the spelling, for it was said in such a quick, dismissive and superior tone.

Why did Mr Hicks call Edith Edith, when Edith never called him anything but Mr Hicks?

"Well, I suppose he likes to think he's in Lebohmord."

So it was some kind of club or society, but surely one would know if one belonged to it? Apparently not. A little later it seemed to me that the name was not often mentioned by those who undoubtedly did belong, which made me wonder whether Edith was not in some sense a country or associate member.

That Sunday the light was truly spanking in patrician trees around the house. The Palladian Bridge far off along the river was more exalted than mine at Stowe, and seemed so in disposition, loftily absorbed in some cool, exclusive daydream. Under a flashing blue-and-white sky the bells for Sunday matins flung out, as we approached in Edith's little car – pealed out with all the mindless hilarity of a smart wedding. The high Victorian-Italian church itself contributed to the theatrical effect, and appeared to me more arrogant than elevating. The townspeople who greeted Edith were supers. In the red plush family pew just in front with the enormous prayer books the Herbert boys, David and Tony, behaved badly, turning round much of the

time and giggling. Afterwards Edith remarked on their bad behaviour, but quite indulgently: it seemed to be acceptable, perhaps normal, in this translated version of an English sabbath.

After church we went to the house, for me to see the state rooms, and listened to jazz on the gramophone in the long library, sitting on the floor. An undistinguished figure appeared at the far end. "Get up, Laurie, it's Lord Pembroke!" I should have known how to behave without prompting; but I did not know how to be, I could not think of anything spontaneous to say about the Double Cube, the loveliest room in England – and I now delighting in architecture and beginning to draw it. I was not tongue-tied, but all I could do was try to imitate my brother, whose charm was so effective, in style of talk, in gesture, even in expressed opinion; and the futility of this embarrassed me acutely as I stood there perceiving for the first time the degree of dominance his personality had established over mine, in all but its central privacies, and without his ever wishing to dominate. The central privacies would go for nothing here, and were at best still largely inarticulate.

Already first impressions had gone down in that unremitting journal. "Rather a dear little boy of fifteen, with white face, dark eyes and a nose." Kindly she was, yes, but so devoted to Rex, so admiring, that there seemed to be no place for me, his uglier shadow. I felt that if I disagreed with him on any subject she would think me bumptious and uncouth; she made no attempt to bring me out by asking if I did disagree, let alone by inviting me to do so. Lists of his virtues, I now find, were being committed to the journal on those very nights: "funny, earnest, brilliant, conscientious, loving, unexpected – oh so unexpected ..." and again, "I suppose Rex has faults, but I can't find them. ... He has everything I want – genius, brilliancy ..." and nine other singular merits largely additional to those already listed. Simply, she doted. "How I adore him and he me!" That Sunday I was confirmed in my opinion that I could never compete with my brother, however much I might share his social life, and that I had better not share it too completely. I must have my secret being; I was not lacking in objectives; I must make my own obscurer way towards them. A green hill is not the same world to a mole and a hare.

The week-end was rendered stranger by the presence of another guest, Brian Howard, the young Oxford friend of Harold Acton, Robert Byron, etc. – to give him the only label he would ever earn. Rex had found him there before: "Brian at his worst, trying to make grand 'art' conversation, insincere and flashy and paradoxical, Rex honest – and honestly bored. ... There could not be more opposite people." I

had not met his like. He drawled and capered, called the servant girls "sluts" and "skivvies" as he chased them with screams into the kitchen, called the food "disgusting" as he helped himself to more on the side table. In the bedroom I said how funny he was. "He's rather a bore, really", said Rex with dampening effect. Yet he was kind enough to me, and it would be unfair to see only an ulterior motive in that. He invited me to stay with him – that is, with his mother. "Of course he can't, Brian!", said Rex quietly, who was quite equal to handling him. Five years before, an ingenuous Haileyburian might well have been impressed by a sophisticated Etonian, but by now the one had turned a good footage of paper and canvas to some advantage, and the other had ... capered. That virtually was all he ever would do. No flouter of established values did more to advertise the chief of them: self-discipline.

Harold Acton had persuaded Gertrude Stein to speak at Oxford, after which Brian busied himself composing verbal portraits in her manner. At the Daye House that week-end he produced this, on Rex, half perceptive and half vacuous.

> Goats are slow but sure. Surely they are sure footed. A goat has a bland hand, a suave hand. Direction is rough, but this direction has smoothed its roughness. Laughter in the ballroom, in the bath-room, in the bar-room – but the laughter is an urn. Goodness and gracious goodness, not an oath. Twisted power, strong as string so that it can be made powder. But power. But goat.

The capricorn quality derived partly from Rex's romantic, or, as Strachey saw it, unromantic, profile, broken-nosed and subtly resolute, partly from the air of power conveyed by unselfconscious dedication, an air which Brian knew to be painfully lacking in himself. He left within a day or two. "Didn't want to go, but I had to make him – three boys, one being the exhausting wilful tremendous Brian, are too much for my strength, my household, and my baby Austin. When he had gone, we were marvellously still and peaceful." I remember that tranquil moment, and how presently we went to Netherhampton House near-by, the home of Sir Henry Newbolt – a chance to meet my future grandfather-in-law; but he was away, and this I never did. "The boys drew and painted – Rex a water-colour painting of the garden porch while funny little Laurie crouched about like a goblin 'measuring it up'. His drawing-book a crowd of figures, nothing else." Rex teased me that I was bound to revert to the family trade, one day. "You will! I shall find you pottering about a builder's yard!" No Life of Art for me.

Out of Rex's unexpectedness came the complaint that he dreaded going to parties – so keenly that he was uneasy the whole day before one. Edith and he were preparing for the Fonthill ball, and he could do no work, wishing their "cosiness" need not be broken into. "Says he *only* likes coming to me here, or going out with me in London", noted Edith: "Of course I *adore* this." Well she might. Unexpected, too, must have been his hot involvement in the new prayer book before Parliament. Like her and because of her he was ardently in favour. "I discuss the 'deposited book' with *everyone* I meet now, have had some very enjoyable conversations. ... We *wallowed* in religion: from the Bible and Christ's teaching to cathedrals, candles, embroidered albs (or copes? – whichever they are) and tin Tabernacles. *You* know what I had to say about the last!" When the cause was lost, "It is just sheer deep-seated bigotry and ignorant fanaticism", he raged. Faith was a frequent topic, when with Edith. "Talked as ever of eternal life, this enveloping mystery and loveliness." Yet Rex had no confidence in eternity. "The future life he thinks only a guess" – "a fifty-fifty chance" was his way of putting it – "and he loves this earth which he is certain of. *All* that he loves comes through the eye or the ear. I say, he only loves 'em when they get that touch of Eternal Spirit which the cow in the field cannot get." My own notion is that though he sometimes prayed, and liked the solace and beauty of familiar words in church, he did not really need a religion except in a time of ordeal, as most people then do; that to him art was a religion, but not one of a visionary sort. Even later, when his work had lost frivolity, it was not a vehicle, it spoke only for itself, not for reality beyond. In this, on his humbler level, he was unlike Blake and Palmer, and like Constable, who celebrated the beauty of his world as a faith, but in his altarpiece at Brantham could only be sentimental. Rex's few religious pictures are sentimental for the same reason: they convey nothing experienced, merely ready-made pietism.

Art was the alternative religion, and what Tonks wrote to Daniel, Rex may well have heard him say. "It is a divine calling, we are nearer God than the Pope – even if we only wash the floor of the Temple." Edith's interpretation is interesting.

In the back of his mind I see he fears religion, thinking that if he listened too closely to it, he would be told by his conscience that he ought to give up painting for good works, and this he knows he couldn't do. ... He must have imbibed a Puritan religion which is still his fundamental sense of God. ... He has a beautiful fine sensitive conscience and is *really* good.

It may be that he acquired in childhood at the time of Denny's death an unconscious disbelief in immortality, but though our mother's faith was weak in its acceptance of grief, it was not so in its response to joy: in her simple way she strongly believed that artists made beautiful things to give God pleasure, and would find in heaven, which was much more beautiful than earth, much more scope – many times applying that to Rex. When he had an uneasy conscience it came to him direct from the New Testament, where so much is made of sacrifice, so little of aesthetic experience, where reliance has to be placed on the poetry of Christ's sayings – and on that one box of precious ointment. But it needs to be added that a conscience of this type is not confined to Puritans; also that where one Hopkins has actually made the renunciation, many an artist must have wondered distressingly if he should. And this Rex continued to do. Months later he spent three wretched days in London which began with a realization of the miseries of people in the slums, those he had called "cut-throats and human vermin", and their associates. He found himself crying, and could not expunge the impression. This was the kind of thing he told Edith late at night. She gathered that he felt he should give up painting and work there, "and I know not how to advise him, as though it is heroic, yet his art is heroic too, and it is a sublime gift. But yet, why does he have these visions sent him? I fear advising him against his real conscience, but *could* one advise the sacrifice of that Genius?" She took it seriously enough to consult the Bishop of Salisbury, who, not surprisingly, thought that he might have to make the sacrifice.

If Rex never seriously intended renunciation he knew it; for he had long since set himself to cultivate self-knowledge, and he felt a corresponding scorn for self-deception:

> I agree with you that there must exist some absolute criterion of goodness and I feel, too, that every one of us (whether Christian or otherwise) has the knowledge of what that criterion *is*, deep, at the back of our consciences. But not so deep that it cannot be raked out at a second's notice to *decide definitely* for us whether the action we propose is *good* or *bad*. Unfortunately there seems to be one great hindrance which may prevent this Supreme Standard from deciding for us – and it is self-deception – do you not agree?

This had been precipitated by some news of Brian Howard's moral behaviour.

> It doesn't seem fair that you and I should be wracked day and night with the consciousness of our evil deeds, while that great hulk of a

Brian sleeps the sleep of the comparatively just, does it? Just because he won't prod his conscience. How I *wish* I could poke it for him.

On re-reading it, this letter struck him as priggish, and he asked Edith to destroy it, unlikely as it may have seemed that she would.

# · X I ·

IT WAS WHILE he was teaching Edith architectural terms as they strolled in the gardens at night that they thought of a book they could do together, the story of a deserted mansion, taken over and lived in by its statues. "No one was ever more in one mind than we two are!!!", she told herself. Discussing it again in London he kept hugging her in excitement, and then reverted in dreams all night to its architect, Königsmark Piper (a play on his own name), whose notebook would supply the material, and whose remains would be discovered in a capacious urn (sketched in a letter), more than twice as big as the one I had found for him at Stowe, solemnizing in the undergrowth. She could have written such a fantasy extremely well, and it is sad for her reputation that they put it aside when another thought occurred. Why a new story needing new illustrations? Why not the one nearly painted on the walls of the Tate Gallery basement, *The Pursuit of Rare Meats*, with photographs? *The Love Child* had been well reviewed. Newbolt thought it "the best first book I have ever read": better than *Lady into Fox* by David Garnett. She wanted her successful pen to promote Rex's brush by attracting people to the Restaurant. So it was that he enlarged on his unnamed characters and their doings and she made up her "Guide to Epicurania", finding cryptic names, mostly anagrammatic, and suggested by the anagrams in the introductory story to *Come Hither*, which de la Mare had said she was the first to spot.

To help her, Rex drew out the entire scheme on long strips of paper thickly annotated. In one place she tells how two of the adventurers, Król Dudziaz (Polish for Rex Whistler) and Prince Etienne (Stephen Tennant) find on a hill top near the borders of Cathay a dilapidated wooden cross with the initials "D.A.W."

> They saw that some previous traveller had left here the only memorial he could offer to a loved companion who had died by the way. Król first wanted to repair the little cross, but the prince pro-

posed that they should leave in its place the urn they had brought with them [from a ruined palace]. This made indeed a far more beautiful memorial, and the two young men carried it to the top of the hill, and set it up on a pedestal, upon which Król carved the words: "In Memoriam, D.A.W.". ... There it remains to this day.

Sometimes Rex thought of that small wooden cross, made by his father and now decaying in Wootton churchyard, imbued with the arbitrary strangeness of life: of two brothers, one locked in oblivion, the other forging on. He pointed out the urn to me in a half-humorous way that meant he was not sure what I felt about Denny, if anything at all; and really at that time, with no personal memories surviving, I felt nothing but impersonal regret, together with a trace of old uneasiness on behalf of our mother. Thus an urn to Rex was more than an amusement. It was "the Urn", the hollow-sounding symbol of mortality, which for him could strike a chord of gravity and gaiety at once, heard often in his talk and sometimes in his work, a very English ambiguity of mood – equivocal as the look of English weather.

At the Tate the interrupting visitors multiplied, and Nan West admired the way he handled each. Once an effusive dowager appeared, whom at length he succeeded in escorting upstairs; but then – it seemed – she could not resist returning for a second ecstatic circuit of the room – "Too, too divine! *When* will you paint me on my bathroom wall?" – working herself up to a dance along the murals, until the cushions fell out and his red-chalked face was wiped clean. A coil of new paint-rag had provided the toque.

The artist Claude Rodgers came, could get no answer, but was presently let in. "Don't tell anyone. I was just reading a novel!" As he was being paid by the week, Rex explained, it would not do to work too fast. This was the kind of cynical joke he sometimes made when displaying his own wares, self-depreciative for fear that he should seem self-applauding, and I should think regretted. Naturally it was passed on. As against that, Aitken reported to Duveen that Rex was earning his fee, "and really has given good value", and Duveen on a visit was gratified to have paid for two works, Stanley Spencer's *Resurrection* and these murals, and sent Rex £100 personally as a bonus. By the autumn of 1927 the canvases were up and he was painting in the actual room among the tea-drinkers, not greatly liking it.

I am disgusted and sickened with the result of nearly one and a half years hard work, and also with the inane and opinionated people who are in control ... the selfish and narrow-minded ravings of Tonks, the architect Pearson, and Aitken, who *all* have different

opinions as to how the dado and columns should be treated. Each is testy, fearful that his valuable advice is being disregarded, and I have to stand there and thank them for their kind help – which they accept as their due.

Tonks could be testy with the painter too, as when he advised experimenting with highlights in white chalk, and finding his advice not taken at once would not speak to him for days.

There is a fable repeated in the press from time to time that Rex went slow on account of being paid by the week, until "the authorities stopped the payment, whereupon Whistler stopped the painting and went away". That is what came of one injudicious quip to a fellow-artist. Self-interest, if nothing else, would have ruled out dawdling: the room which was to make his name must keep him poor until he was rid of it. Already there was praise from R. H. Wilenski the art historian, William Rothenstein the artist, Patrick Abercrombie the architect: "I fancy there will be a boom in Whistler", Tonks prophesied. But Rex was tired. As the "miserable execution day" approached, "I'm frantic with anxiety", he wrote. "The window-wall ... seems even more governess-water-colour-like than before." This wall was far from finished.

It was 30 November. My father and mother came up for the occasion, somehow to be given beds in the half-furnished studio. The invitation cards said 3 p.m., and Rex drove them there in good time, but had no intention of entering until just before the hour, to the intense consternation of everyone awaiting him. Then faces here and there in the throng were torturingly recognizable – Osbert and Edith Sitwell, Cecil Beaton, Lady Lavery, Christabel MacLaren, afterwards Lady Aberconway – faces with that utterly relentless and serene immobility which a waiting audience always wears for an unconfident performer. If he actually had *to perform*, to speak ... the thought was grotesque – and yet he had had to refuse explicitly! He was hurried away. But Professor Tonks was briefly beside his parents: "A remarkable achievement! A remarkable achievement!"

On the platform half-way down the room were Tonks, Lord D'Abernon, Chairman of the Trustees, and Bernard Shaw. Duveen was abroad, but had sent a telegram. Apprehensive of the empty seat up there, Rex had picked one below, and to his great relief the ceremony began. But soon the Chairman was hailing him, and up he had to go "like a lamb to the slaughter, pale and very calm and still", as Edith Olivier noticed; after which "he looked down and *endured* while three speeches were made". Thus he can be seen in the newspapers.

Lord D'Abernon described the paintings as "buxom, blithe and debonair", not a bad description if the familiar words are pondered. The aim, he said, was to encourage British art. If only a fraction of the funds for educating the poor could be spent on educating the rich! The speech may have had effect on some potential clients.

Shaw was expected to be witty, and was. Since Hogarth, artists had mistakenly been gentlemen, but Rex Whistler had worked for so much a week. He was entirely unlike the other Whistler – above everything a gentleman painter. Rex should be regarded as a house painter, and be called in like the plumber. He would name a moderate sum, behave like a workman in the house, touch his cap to you, and never be confused with the dukes and duchesses who came to luncheon, though he and his bag of tools might be sometimes in the way.

Tonks began with affectionate memories that embarrassed his subject more than anything hitherto. "A dreamy creature" had wandered into Gower Street one day with some drawings in his pocket and found Tonks, who therefore had not found Mr Whistler, though at once perceiving what a find he had made. He agreed with Mr Shaw – had always maintained that the proper place for the painter was the servants' hall. (Laughter.) This was jocular, but Tonks did always fear the seduction of the artist by high society, not least in Rex's case. Having done much, he continued, to brighten the East End for the poor, Rex had come west in the hope of doing as much for the rich. Here was an unhappy touch, implying that the nation's art gallery belonged to them. But Tonks was keen to entice new customers, and for more than just one artist.

> Mr Whistler, however, was not the only young painter who would make the best use of opportunity, and he [Professor Tonks] would be delighted, if people wanted a little change from Mr Whistler's work, to introduce them to others who were, he would not say as good, but at least interesting.

And Tonks's hope was fulfilled, if not by ex-students of his own. As a direct result of this room Duveen paid for the decorations at Morley College across the river, by Eric Ravilious and Edward Bawden, fanciful, but in a different way. Rex presently found them "quite enchanting". This November day at the Tate saw the climax of Tonks's own campaign for mural painting. Within three years he would retire from the Slade, never to enter it again, so painful was farewell.

Studying the floor all the time, Rex had winced at Shaw's reference to the "other Whistler" who had "left several excellent works", but could no more have painted these murals than he, Mr Shaw, could

have done. It was well meant; but as Rex observed in the crush after-
wards, "very ambiguous". He esteemed his great namesake, though
supposing there was not even a remote relationship. Thus it stirred
him, when one day he was announced for luncheon at a drawing-room
door (without bag of tools), to be greeted by his hostess, Katy Lewis,
with the words, "It's a long time since I heard that name in this
room!"

They were telling him it was a triumph, but he could only say it
had felt like a tragedy. "Saw Rex's father for the first time," Edith
wrote, that night, "a small dark second-rate man." A few polite re-
marks in a crowd are not much to go on, but she meant second-rate
in social class, a test she could immediately apply. As for his mother,
who looked "so pretty and exquisite", she was more riled by Shaw
for being "the most conceited man in England" than, as Edith sup-
posed, for "implying that her precious pet was not a gentleman".

One friend was absent, drearily occupied at a prep school in the
provinces, Ronald Fuller. To him, if he had been prone to envy, the
contrast could have been sharp, and characteristically Rex softened it
for him, quoting Dr Johnson's early career, and making the least of
the murals. "I fear you will find them terribly trivial, and perhaps like
G.B.S's speech 'would-be-funny' too!" There was no fear of a bad
press, for there had already been a good one, and with Shaw on the
platform, full attention was assured. When I looked for *The Times* in
the library at Stowe I found beautifully clear photographs of the work
spread right across the picture page. At lunch time the history tutor
whom I had never yet spoken to, Martin MacLaughlin, sought me out
to ask if I was any relation. Then – should I like to be a history
specialist after taking School Certificate? The younger brother, he
reckoned, might perhaps show some promise, and would surely be a
means of meeting the elder. In due course Rex would be embellishing
his blackboard with coloured chalks. Thus the picture page that morn-
ing probably shaped my future. But for that, I might have specialized
in English and gone to Cambridge like my grandfather, to contend
with the ideas of F. R. Leavis; for Stowe was a largely Cambridge
school. Young MacLaughlin was its cleverest Oxonian. Perhaps he
would have booked me for history anyway, for he was alive to archi-
tectural enterprise, if not much to poetical, and soon I should be
making measured drawings of the temples and south front for the
school magazine, much encouraged by Rex. But, Cluffy's cynical view
of history would clash with my Shelleyan idealism, and weaken
application. Brilliant teacher and starved homosexual, fundamentally
unhappy, years later he would die of drink.

A few days after the opening, a visitor who had gone round the murals in a leisurely way noticed the artist "sitting alone at a table eating tinned peaches". It was Siegfried Sassoon. He had met him at a Wilsford week-end, Sassoon's first of very many, spent largely in fancy dress (though not by the selfconscious poet), when Stephen, Rex, Cecil and the girls had come on as nuns; then, after a moment's black-out, had appeared in pyjamas, and danced to the gramophone. "It was very amusing, and they were all painted up to the eyes, but I didn't *quite* like it", Sassoon recorded. Rex interested him "in more ways than one", as he sat down now, and found him "a quiet and (seemingly) modest youth", after which, "congratulating him cordially on his decoration, I departed".

In the small hours of 7 January 1928, the Thames, flooding level with its parapets, broke them clean away and drowned a number of people sleeping in basements. Into the Tate basement it poured in a mud-dark tide, nine feet deep, hurling stored pictures about and saturating twenty thousand drawings and water-colours by Turner and other masters. When the water subsided, Rex could not face the aftermath alone and rang up Archie Balfour to accompany him. Despondently they looked into the Restaurant, to find "the whole *room* itself", he would write to Osbert Sitwell, "completely wrecked. All the gilded canvas has peeled right off the dado and columns, the black block floor has swollen into huge waves", and some of the painted canvases had sprung apart and wrinkled. "Well," he said to Balfour as they mooned about, "at least the mermaids came into their own."

Edith, ringing up, heard him lament the ruined Turner drawings and speak also of his room. "He *wouldn't* treat this as the real disaster", she noted – adding what was hardly necessary to record, "which *I* think it is." Happily his canvases did not seem to have suffered disastrously. "*Tempera non mutantur*", quipped Punch. But the method was not tempera, it was oil paint used with a wax medium, specially designed to allow washing from time to time, and it stood up well to this appalling wash. Then, astonishingly little damage was found to have been done to the old master drawings. The room was got right, but only after a very long closure, so that Rex could not press on to completion, as he meant to in the first glow of success, having Edith's story to keep up with. By then the impetus had decayed. The weak areas and the ghostly figures can ultimately be ascribed to twenty minutes' experience of Thames water.

The "boom in Whistler" began at once, with Tonks provocatively telling a former pupil, and her well-to-do husband, that they were not up to appreciating Rex. Sir Courtauld Thomson wanted a mural panel

for his hall at Dorneywood in Buckinghamshire, Osbert Sitwell wanted a bookplate, and there were numerous soundings. There were also numerous invitations, far more than he knew how to refuse – or accept – as Society found him no less agreeable than talented. A lunch, tea or dinner, often in distinguished company, is recorded for a while on nearly every weekday, and meant the rupture of concentrated work in order to put on party manners, party clothes. He did daily battle with shyness on entering a drawing-room because he liked being liked. He knew his head was not turned, and would stay unturnable. But he saw temptation; and felt ashamed also that he so much enjoyed the tricking up of a studio, the search round about for French chairs, urns and busts, the upholstering and gilding. A serious artist, he said, only wanted a room to paint in, and only wanted to paint. He could not repudiate the urge to decorate, born of humble family tradition, and would have been mistaken to try. But he hoped to find a means, and a mode, of being "serious", all the same.

That was Tonks's hope for him, as he walked over from the Slade for tea. Shown Edith's typescript, he made Rex read it aloud, and was tickled to be in it himself as Dr Knots. But to Edith's chagrin it was rejected by Heinemann in "a horrid letter" which Rex refused to read out on the telephone, the gist of it being that the story was a private joke, and would do his reputation more harm than good. It was her first taste of unsuccess, and "I feel quite humiliated", she put in her journal. When Secker also declined it, the project was quickly forgotten, and by then there was no heart for the house-taken-over-by-its-statues. There would have been no time for it, in any case; for within a week of the Tate opening Rex was summoned to the office of the British School at Rome, where Lord Esher offered him what amounted to an honorary scholarship. He could go to Rome when he liked, do what he liked, stay as long as he liked: all free. He would paint and paint, and hope to hold on return the exhibition that would prove him to be serious. Tonks of course was behind it, wishing just this.

First there were two portraits to do in pencil, preceded by one of me, by way of practice; then there was Samson pulling down the Temple of Dagon, drawn in one night. This theme from the Old Testament came from far away Sundays when his mother read aloud and his pencil kept pace, and was better suited to him than themes from the New. Among the latter was the *Last Supper* which had won a prize at the Slade. Christ with raised hand is seen from behind, radiating light on the disciples, round-faced and surprised, and wearing, for some reason, eighteenth-century costume. Daniel of the National Gallery, who bought it, called it his Hunt Breakfast.

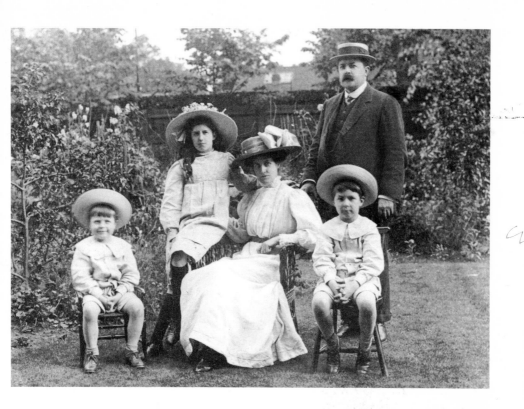

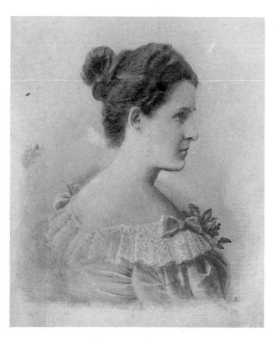

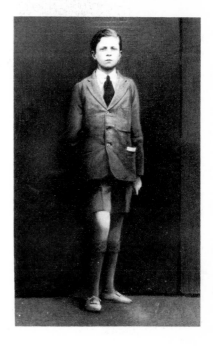

1. In the garden at Eltham, Kent, c. 1911.
Rex, Jessy, Nell, Denis, with Henry Whistler standing.
2. The artist's mother in 1898          3. Rex aged thirteen, in 1918

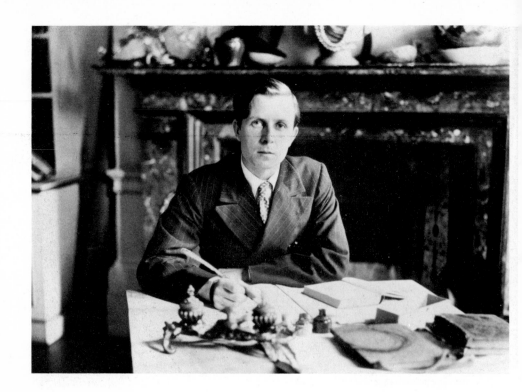

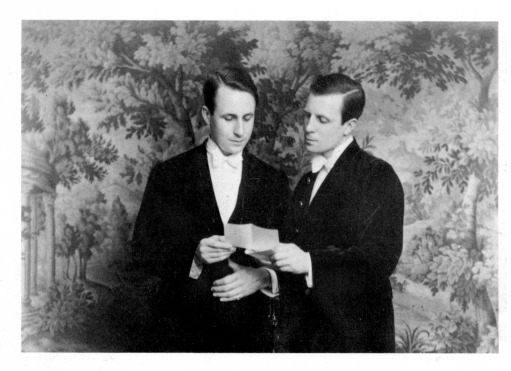

4. At his table in 20 Fitzroy Street, *c.* 1927, aged twenty-two
5. Aged thirty-two in 1937, with the author, aged twenty-five

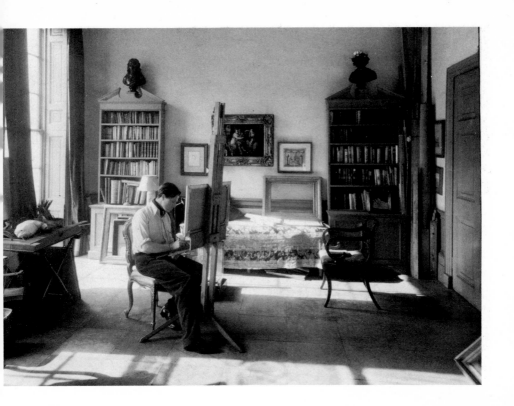

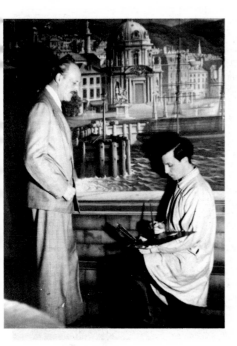

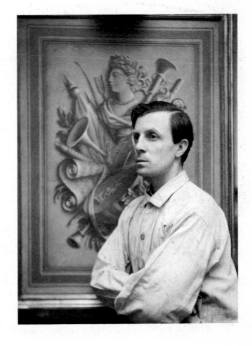

6. In the studio at 20 Fitzroy Street

7. With Lord Anglesey in front of the
mural at Plas Newydd, Isle of Anglesey

8. With a painted trophy, c. 1939

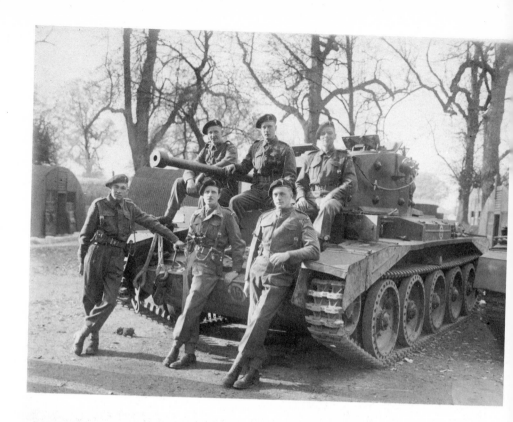

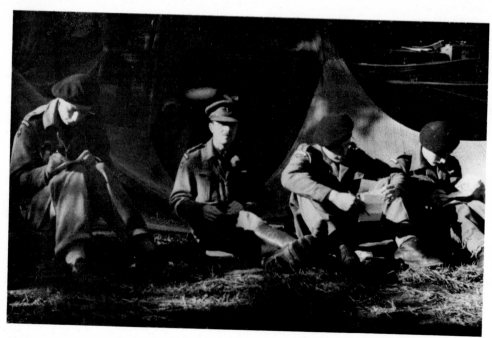

9. With the crew of his own Cromwell tank, at Pickering, shortly before D-Day
10. Censoring letters in a Normandy orchard, 1944. The last snapshot.

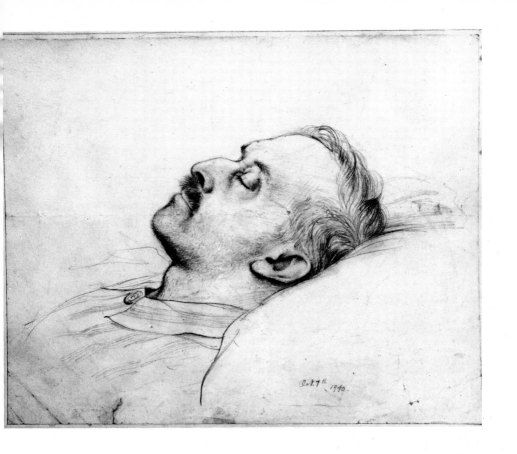

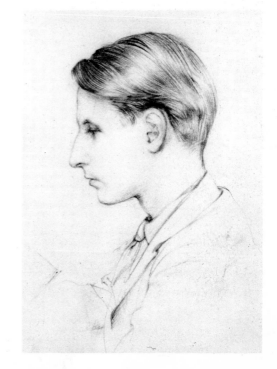

11. (above) The artist's father,
lying dead, October 1940
12. (below) The author at about
the age of nineteen, c. 1931

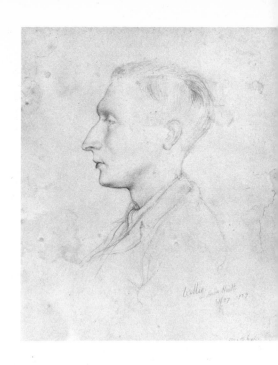

13. (above) William Walton in Bavaria,
aged twenty-seven, 1929

14. (below) Arthur Waley at 20 Fitzroy Street,
i.e. between 1928 and 1938

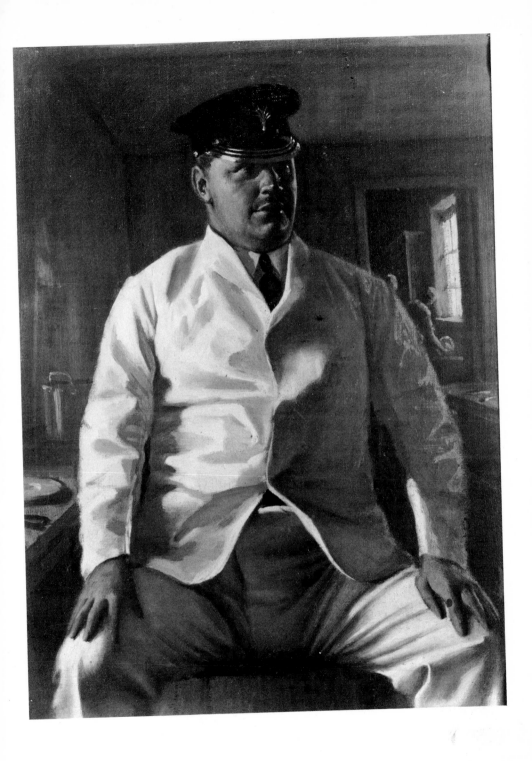

15. *The Master Cook.*
Sergeant Isaacs of the Welsh Guards, 1940 or 1941.

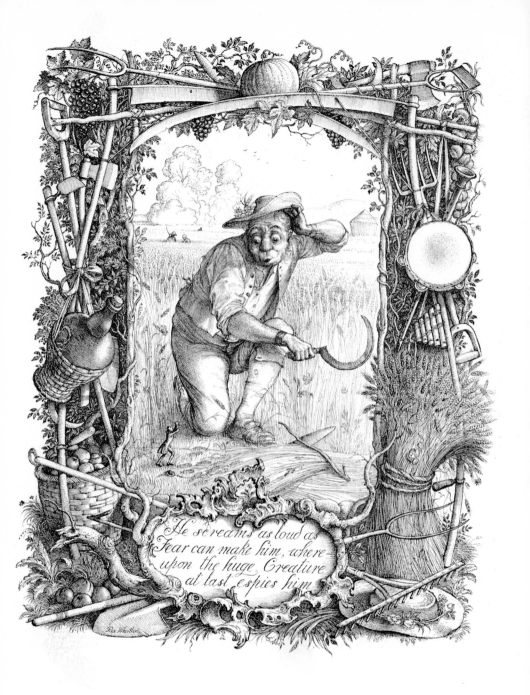

He screams as loud as Fear can make him, where- upon the huge Creature at last espies him.

16. *Gulliver's Travels*, 1930.
Discovered in the Cornfield.

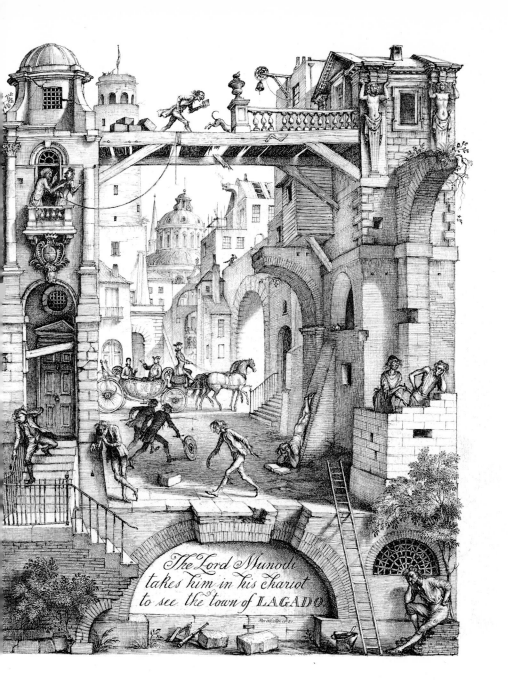

The Lord Munodi
takes him in his chariot
to see the town of LAGADO

**17.** *Gulliver's Travels.*
Sight-seeing in Lagado.

18. (above) *Le Spectre de la Rose*, 1944. Design for the curtain.
19. (below) *Le Spectre de la Rose*. Scene design.

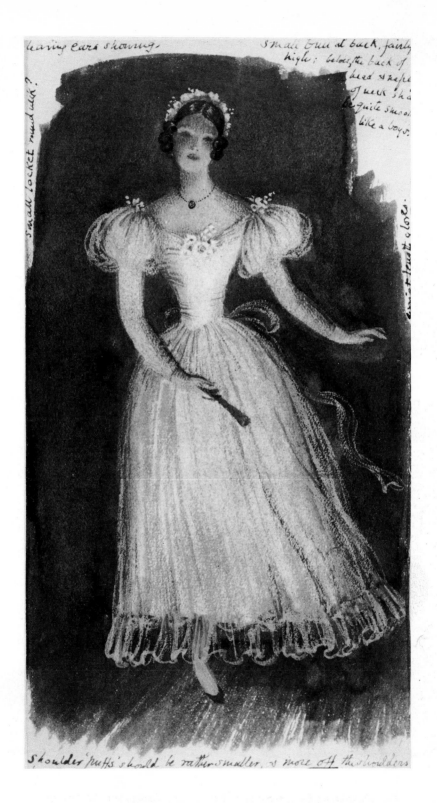

**20.** *Le Spectre de la Rose.* The girl's ball-dress.

**21.** (above) Mural at 19 Hill Street, London, 1930–31
**22.** (below) *In the Wilderness*, 1939

23. (above) Murals at Mottisfont Abbey, as proposed in 1938
24. (below) Murals at Mottisfont Abbey, as carried out in 1939

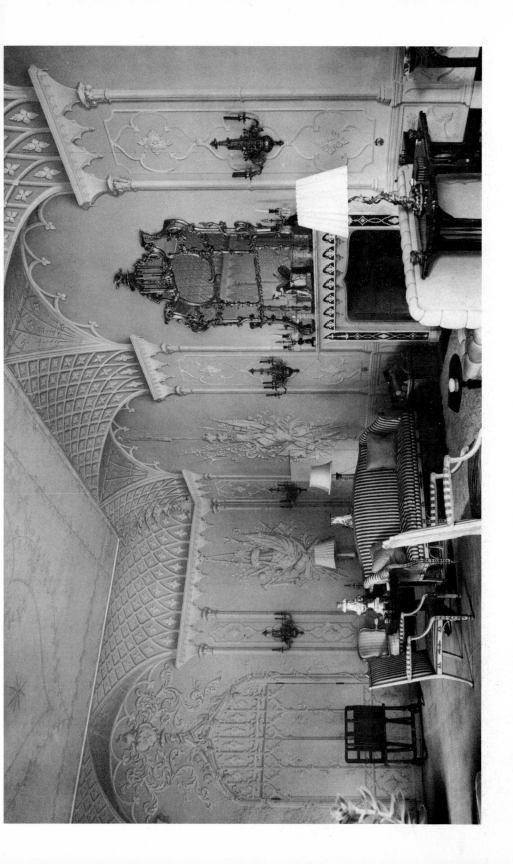

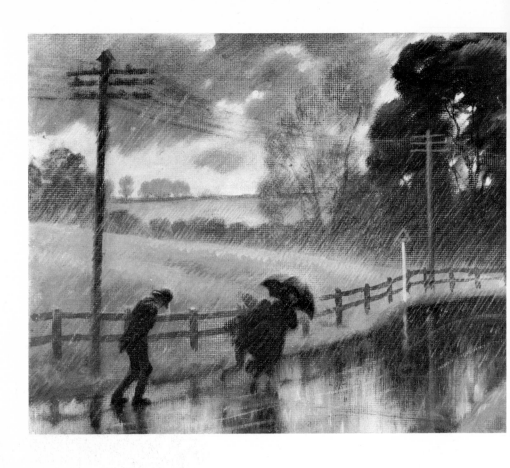

25. *The Buckingham Road in the Rain, c. 1936*

# ·XII·

NO INCIDENT brought home more poignantly the difference be-
tween Rex's life and mine. Our mother and I came up to help him get
away, and because it was my first night in his big Georgian rooms I
keep the feel of it still, quite distinct from countless later impressions;
and how, with clothes, documents and sketchbooks lost and found, he
leant back in the taxi, pale and speechless, as if awaiting trial, but
already established and sought after, already familiar with "abroad";
and how at last, waving from the compartment window, loving yet
glad to be behind it, he slid away out of Victoria supremely into
further easy success.

He arrived at the British School before the students were up and
was shown to a sculptor's studio on the ground floor, a large room
with a gallery, where his bed was placed. While he was having break-
fast out-of-doors in the *cortile* several friends from the Slade began to
appear, Nan West and Mary Adshead among them. Behind the
Wren-Lutyens façade the work-a-day interior struck him as "some-
thing between a school and a sanatorium", airy and doorless, "but as
it's so divinely hot this is delicious". Naturally his eyes were very soon
on the Borghese Gardens which lie between the School and central
Rome, filled as they were with lakes and ruins and everything he
wanted from gateways to busts on pedestals, all "half in and half out
of the indigo shadows of vast ilexes". Misgivings dawned.

> The incredible beauty of these ilex trees leaves me with a sort of
> aching longing to do something *with* them, to paint them, to draw
> them, to do anything rather than *waste* them. ... But of course it's
> no good at all for me to try to draw them, the insignificance of the
> feeble little pencil marks makes me want to laugh.

Nevertheless life was a pleasant mixture of companionship and
solitude. There were meals at a long table, a commonroom where they
danced to the gramophone, the occasional studio party; otherwise

complete independence and no curiosity about one's work or engage-
ments. Sight-seeing began for him with a few students who were will-
ing – to Nemi, to Tivoli, to a Roman church or two – then continued
with Mrs Wingfield, of the British Embassy. Tonks had written to
Glyn Jones, who had overlapped with Rex at the Slade and was now
a Rome scholar, asking for a start to be given, "but it was like giving
a start to a bird – he was off at once into Roman Society – 'higher
circles' I never got into". And Mrs Wingfield had the entrée to aston-
ishing palaces. In June it became extravagantly hot, as hot as Rome
ever is in August, which worsened a growing discontent.

Edith had once surmised that great art demanded sheer hard work
and concentration, though by no means aiming this remark at him,
her paragon.

> Well, if you're right I am certainly doomed to never rise above
> small achievements, for I have now come to realize and perhaps for
> the first time I face it as a *fact*, that I am *incurably* and hopelessly
> lazy and lacking in the power to concentrate. I *know* it and have al-
> ways known it really, only I used to tell myself: "you can exert your-
> self if you *want* to". I've been wasting my time here *abominably*.

By way of illustration he went on:

> The little scribbles which I do on the envelopes and at the tops
> of my letters are the greatest proof of all. ... For though naturally
> I hope they may amuse you I must admit that that is not really why
> the sketches are there! ... I first of all get an envelope and address
> it and then waste a little while scribbling on the back my monogram
> etc. I then get my sheet of notepaper and prepare to start, but I
> *simply can't*. I have to start scratching some futile little thing at the
> top. ... One of my great difficulties is to prevent myself from "de-
> corating" my *business* letters! It is this same *inability to concentrate*.

Thus he nagged at himself like a tongue compelled to worry a gumboil.
No one ever decorated letters more profusely and often than he did,
and it is ironical that the recipients should chiefly treasure them for the
evidence that misery preceded their despatch. But this is an exaggera-
tion. He did detest writing difficult or politic letters; knew how easily
they are misconstrued; qualified and elaborated any statement that
might conceivably cause offence, and altogether agonized too much.
"If I wasn't so miserable at having hurt Stephen, I should be *angry*
with him for *being* hurt!" But once embarked on writing to someone
sympathetic, he enjoyed himself – it may well have been an excuse for
not painting – and sometimes wrote six or eight pages. Writing a

dozen long letters to Edith and his parents in those fifteen Roman weeks, as well as several to friends, gave relief from the wretchedness revealed by his diary. "Nothing done." "Nothing much." Sight-seeing apart, many days have no other entry. "Sun. 13th. Did nothing, absolutely nothing." Disappointment by now not far from despair.

As a guest he had no part in the annual exhibition, but the architects engaged him to add little figures, trees and mountains to their huge measured drawings, a task he could almost perform in his sleep. It was something to do, so he worked with them for several nights until three in the morning. Naturally they warmed to him; and he for his part got on well enough with them, while never quite seeming to them like a proper artist. When Professor Curtius came to tea with Rex he took a great liking to him, and afterwards told Mrs Strong, a great personality in Rome, what a pleasure it was to meet an artist "*who did not think it necessary to have long hair and be untidy*". Rex underlined these words for his mother, daring her ever again to say the opposite. At the farewell party for Professor Ashmole and his wife, one photograph shows Rex in a blond wig as Nero's wife Poppaea. Later that night, comically made up under a sombrero, he sang with considerable style "In a little Spanish town", a recent popular song that he had to be coached in, burlesquing it – with Ian Richmond (afterwards Professor of Archaeology) as the girl behind the grille. Later still, his good acting was seen when he appeared with Edward Halliday, the future RA, as respectively manager and compère of a fair-ground boxing booth, Rex going round the audience to solicit volunteers. Up came the future architect Amyas Connell, a likeable tough New Zealander who had worked his way to Europe as a stoker, and now with his first blow almost lifted the "champion" off his feet: both of them fairly drunk by that time. Rex, turned referee, was worried to see the fight becoming seriously heated, and his efforts to cool it while remaining in character were funny. He too was fairly drunk and in the night took mustard and water to be sick, and failed. He was assumed to be not actively concerned with girls, nor indeed with boys in a sexual sense, yet was thought to have a touch of girlishness himself, in speech and gesture, which earned him the nickname "Rexina".

Having helped the architects and archaeologists, he tended to consort with them, and it was with two of the former and one of the latter that he set out on an expedition to Capri. "I mean to drown all regrets and any few remaining worries in the Blue Grotto and bathe and bathe and bathe, and in between, draw." They stayed for four nights in small hotels and were much in each other's company; so it was a pity that his companions proved "rather tiresome – being very

schoolboyish and bantering most of the time". It was quite good-
natured banter, but when directed at his sense of the past and its
beauties, he had to keep uncomfortably silent. Still, there was amazing
blue in the sea, beyond all preconception, with great patches of bright
viridian green in the crystal-clear shadows; there were little beaches
here and there between nearly vertical cliffs to bathe from, all the
morning; then over one thousand feet above there was the ruined Villa
of Tiberius, for them to pace to, slowly, through the heat of the
afternoon. Up there, the island was mere map, and far off through the
haze Vesuvius pushed its plume of white and yellow. While his com-
panions continued their survey of the villa he clambered among the
tumbled archways and vaults waist-deep in flowers, "great explosions
of mauve weeds ... the ground a sea of poppies, cornflowers and
broom ... everywhere flowers of the *sickliest* pink and the *eggiest*
yellow crowd together". And he did "a little (very little) drawing":
mere outlines for landscapes never painted.

On the third day Monte Tiberio was abandoned to the heat, and
they spent all the time in the water or on it: there were small canoes
for hire, very easily upset, and at first Rex, who was a very moderate
swimmer, kept within range of the beach. But it was so calm that he
and another decided to paddle along the coast to the Blue Grotto,
unvisited as yet. Round the points it became a little choppy, and
anyway his friend's canoe was leaking. Presently it sank. This could
have been decidedly dangerous to them both, as the cliffs, diving sheer
into the water, offered nothing like an adequate handhold. Fortunately
boats emerging from the Grotto picked his friend up. But the Grotto
itself as a result Rex never saw. Moreover he got badly burnt on the
shore next morning, their last, while he was wishing that his body
could be as brown as the tough New Zealand one, photographed
beside him, and only succeeded in turning parts of it brick-red; so that
the nine-hour journey back to Rome was made in "great pain and
misery", a feverish ordeal he long remembered.

The students argued constantly and teased him for admiring the
Baroque. "They have an absurd *scorn* for Rome and never go out."
Under their influence, making use of the fine library because he could
not work, he discovered Le Corbusier.

> I found a book which is *wonderful* and which is shocking and
> interesting me *enormously* ... *Towards a New Architecture*. ... I've
> only read a page or two yet, but it's engrossing, and like an *icy-cold*
> shower bath, which is quickly penetrating to the skin in spite of all
> my Classical and Baroque "mufflers" and "wraps"!!

Of course he repudiated the dogma that "a house is a machine for living in", and must have spotted the fallacy: a machine can only execute the pre-ordained, however complicated, which life is far too unforeseen and variable to feed it; even a bathroom should be more than a machine for bathing in, and is less inviting – therefore in a true sense less efficient – the nearer it approaches that. His next letter carried a head-piece of more than usual Baroque richness, with an afterthought beside it: "you will see from this how much attention I am paying to old Corbusier!" When it was reported that someone in England had heard of his reading, and foresaw a conversion, he replied, "I am very *Urnest*, and shall remain so in spite of Corbusier." Within a year or two he thought he might be "rather bored with the 'New Architecture' altogether – in fact I'm sure I am, I hope every steel girder in London rusts through".

His language was always vehement. In the palace he would design for Edith, when her second novel had brought her a fortune, there should be a Hell Room where he would caricature "with fiendish accuracy ... Martin Secker (for spurning the murals-narrative), the group who ducked Cecil", and many others, all in the hands of torturers whom Brian Howard would be good at choosing. But on further thought Secker did not really deserve "so much attention". It does sound excessive. But one has to remember that the fashionable language of the time was inflated, to match the general feeling of restraints removed. Not only was anything admired "quite divine", anything lovely "incredibly lovely", but if anything specially pleased you it made you "mad with delight", whereas if something put you out it left you "utterly shattered". To moderate the superlative would seem like "careful speaking", which was governessy and genteel. Very well. But suppose one had had the Beatific Vision, or heard one's child scream to death in a fire – what verbal currency could be found, not effaced with daily use? Moreover, Edith liked him to prefer stylish friends. So we need to discount what she said about the British School on his return. "He *hates* its atmosphere. .... He dislikes their spirit intensely." The truth is that students anxious to make answer to the twentieth century were at a loss how to use a city where the century's contribution was negligible, or decreed by Mussolini. The painters, even if hardly aware of Post-Impressionism, would have been better off in Paris, the architects in Germany or America. The school seemed an anachronism. Why were they there?

But then, why was he? It may seem pointless to ask such a question of the one student who idolized Rome in the traditional way. Devastating heat was now replaced by brilliant light, with a cool breeze.

I have been painting fairly regularly every day on the Palatine, and at the baths of Caracalla. That sounds as though I was producing a lot of work, but I am doing *terribly* badly - without exaggeration - and I've not yet done a painting which I should dare to show you. Of course, the "views" and "artistic bits" are *so multitudinous* that there is very little need of selection. One can just plant one's stool in any likely piece of shade, and rely upon there being some group of broken columns or fragment of weed-festooned Roman brickwork already tastefully arranged for one, in charming (if not highly original!) compositions!

I am trying very hard to paint *exactly what is before me*, painting trees where they really are not where I would have them, or "bending" them to please myself. I also try to get the effects of sunlight as it actually is - and hardest of all, perhaps, to paint colours as they really *are* - to my eye. This last is the hardest because it needs the most discipline. *Grass*, for instance, is such a *hideous* colour I often think, and it is very hard not to "improve"! upon it. But I'm sure Tonks is right in saying that I *must* paint from nature, in order to learn, and that if I continue to paint out of my head always, I can never hope to improve.

So he wrote to Edith. He was trying to do two things at once: to learn to paint what was there, which did not need his presence in Rome, for it could have been done just as well from the back window at 20 Fitzroy Street, and at the same time to make pictures out of what he worshipped, pictures that would be true and personal interpretations. Failing to do both was so painful it nearly stopped him trying. "I may as well wait till I'm home again, and save my time here for fuller admiration. Do you think that mistaken?" A fortnight later he put his plight to Tonks in a letter that became a heart-cry.

There seems to have been some *spell* on me, which made me *quite incapable of doing any work!* Fortunately about three weeks ago I met a friend who lives here, and who is a very keen landscape painter. He luckily has a motor, so that we have been able to go out to lovely quiet places in the country, and paint there undisturbed by the *loathsome children* of Rome, who make it almost impossible to draw or paint in the Borghese Gardens or in the streets and squares. I do think it *beastly* of them, and of their grown-ups too, who haven't the manners to stop them, for they scramble and jostle round, call to others to come, and even get *between* one and the object. Have they *always* been as tiresome as this?

I am distressed to find that I simply *can't* paint straight from nature at all. I of course knew it would be hard, but it is *infinitely harder* than I had imagined, and seems to be *far beyond* my powers and I don't feel I shall *ever* be equal to it. The results are *ghastly*. My idea of an exhibition when I returned is fantastic!

Tonks's instinct was to reassure rather than to be consistent. If a young artist was baulked but trying hard, point him to another way round. "Do not be disturbed by not being able to paint landscape direct, I cannot in oil and very badly in water-colour." (In actual fact he was a fine outdoor water-colourist.) "Steer now does all his studies in water-colour, and I advise you to do the same." But Steer was an old man, as the "now" indicates, and probably had recourse to water-colour for that reason. This did not help Rex, and he was right to plod on. Even Claude had merely sat contemplating out of doors, until he met Sandrart brush in hand among the rocks of Tivoli, after which "he began to do the same", and, in the latter's slightly patronizing words, "in the end achieved works of great value"!

The new friend referred to was Lord Berners, living at No. 3 The Forum, a distinguished address. "He's such a sketching *enthusiast* that his example has galvanized *me* into a little activity ... I tire of it after about an hour while Lord B can go on for two or three hours without getting up." Again the heat became unbearable for carrying equipment, "like stepping into a huge kitchen or the stoke-hole of a liner ... the streets and houses all shimmering and sickly". Gerald Berners's car and chauffeur were a boon and a means of escape, indispensable really. "I have been getting a *tiny* bit better lately, though I still find it incredibly hard, and I do *horrible* paintings!" It was Berners who got him a pass for the Palatine; Berners who introduced him to other influential friends, like Mrs Strong, and Berners who drove him to the Bosco Sacro, to Passarano, to Castel Gandolfo and Lake Albano ("hackneyed compositions", Rex records; and many were scraped out). So once again he had been impelled to seek the company of a rich man, and though quite content with simple living, he never denied that he enjoyed good food and drink, the candlelit table with amusing talk, the car out to somewhere ravishingly beautiful.

Remembering a name, he found an address, and invited himself to stay with Aubrey Waterfield at Aulla. There he found a fortress on top of a high hill, with a garden on top of the fortress (the rooms strangely underneath it), and from the battlements "range upon range of icy jagged mountains, the Carraras thrusting fantastic marble spikes into the air"; also two rivers uniting round the base of the hill. A week

followed of bathing, exploring and drawing, returning weary and bliss-
ful every night. Especially the villa at Caniparola *"completely
dumbfounded"* him: every room elaborately painted in Rococo arch-
itecture, "and with original furniture and hangings!!! *Such decorations
as I have never seen before! –* I know all my letters have been crammed
with superlatives!"

A younger new friend was Bill Montagu-Pollock of the Embassy,
later Sir William, British Ambassador in Berne. When Berners left,
these two continued motoring out of Rome, and had one ill-advised
adventure, camping high in the hills with not enough to eat and not
enough bedding – to find both bed and clothing saturated with dew at
three in the morning – no breakfast – and a long drive back to Rome
bumping on the rim after two punctures. The consequence for Rex
was four days in bed with a feverish chill, within a week of his return
to England. A day or two on the shore at Ostia was contrived with
other students: "to get brown" again. Then it was 7 August, with the
remaining inhabitants of the school on the steps, waving an affection-
ate goodbye.

Though he did not know this, before he set out for Rome, aged
twenty-two, D. S. MacColl, the artist and critic, had praised his matur-
ity, Aitken had said he did not need to go there, Tonks had foreseen
it as a turning-point. They were all wrong. He was far from mature,
he needed Rome for its architecture at least, there would be no
turning-point in a career that only required to develop steadily – but,
say, through forty years or so.

# ·XIII·

THE HOPE OF an exhibition had vanished in the heat of Rome, but the last weeks, out with Berners, and at Aulla, recharged him to look back on "the incredible amount of pleasure" he had had – so much, his thoughts seemed "composed of *different stuff*". Soon he and Edith were driving in her little car to Renishaw, to stay for the first time with the three Sitwells. "Yes," he had written, "I too like Osbert very much, though, of course, my liking is lessened by knowing him to have been so double-sided to Stephen and Cecil. But I am also rather enraged by his pompous condescension in telling you he 'liked my face' – perhaps it was 'meant nicely' ... but the remark sounds very 'Osberty' to me."

Every night at Renishaw, William Walton and Berners played wild cacophonous duets impromptu, at Osbert's request, to drive Sir George Sitwell to bed. "A shadowy man," he seemed to Edith, "exquisite and cruel and sinister and bladelike." When they had succeeded, Osbert entertained his guests, as was his wont, with unkind, amusing stories about people he disliked (or liked). Virginia Woolf was often a butt, for her unforgivable success. On one occasion in London, while waiting for her to be announced, he told the others, "you will find she smells of camphor balls – she will be wearing an old lace curtain from some Notting Hill lodging house. Would you like to know the form her madness takes?" Stephen Tennant expostulated mildly, "Osbert, you really *can't* say such cruel things about someone who will be here in a moment as your guest!" During dinner Virginia Woolf remarked, "I keep hearing from my friends the horrible things Osbert says about me!" She was not bad at reciprocating. There were several celebrated moths that never could resist each other's candle flames.

Rex circled in the background, and anyway did not invite singeing. Perhaps the unkindest quip at his expense was that he and Edith, like débutantes, had come out in the same year. "He is very quiet at this sort of party", she noted at Renishaw. "No one would know how he

rattles his nonsense when alone with a kindred spirit." She spent a memorable morning with Edith Sitwell, hearing her read aloud her new poem, "Gold Coast Customs", and weeping when the poet wept, in pity for the suffering poor. The unhappy Lady Ida made a few appearances. "There was this feeling of mystery and madness", the journal goes on. "They say the house is haunted, but the ghosts are the living people." Still, it had been "a marvellous visit - a *mine* of poetry - and such fun too. Beauty and Humour and Wit."

Edith was a tireless driver, and one day soon afterwards was at Farnham Common for lunch, to take us to a week-end at the Daye House, my second. My father was away at work. Still seeing Rex as a schoolboy at twenty-three, she observed him being "very grown-up and tender" to his mother; who supplied an enormous picnic tea which "the two boys" easily consumed in a lane above Newbury. That was just before we called, unannounced, at Burghclere Chapel, to find Stanley Spencer at work on his supreme half-finished murals, and amiable enough to let us climb the scaffold to view the top of the big *Resurrection*, just begun. Supreme I think them now, but was too obtuse then, brought up on elegance by Rex, not to think the figure-drawing as awkward as Edith did, though I could enjoy, as we all did, the nature-painting, and something of the mute compassion that makes this the most moving of all war memorials. "He and Rex talked grandly as two artists together." Rather, on Rex's side with respect, and on Spencer's with a certain curiosity, to meet a youth who rode on the next wave of mural decoration.

"Laurie very gay and not a bit shy." Yet I am ashamed to find that an odd incident occurred, not on my first visit to the Daye House, but now, when I was all of sixteen. We were being driven to Sunday church, next morning, and quite sedately by Edith, who was always apprehensive of accidents "with such a precious freight as Rex" in the car - but the main road was damp and greasy. She got into a skid with her erratic steering, had no notion what to do, the car swirled this way and that, banged into the park wall and overturned, the pram-like body disintegrating literally on top of us. "Rex darling!" - Edith slightly slurred her "r"s - "Ryex darling, your *hands*? Are your *hands* all right?" It did not matter what had happened to my members. Nothing physical had happened to any of us, it transpired. We clambered out, stood in gaping relief around the remarkably complete wreckage, and walked home.

But I was feeling unreal. "Laurie was frightened and faint and was knocked out for most of the day." To be truthful I had felt no fear at all, nor faintness afterwards. Reality dissolved, that was all, and I was

allowed to lie on my bed, not without a hint of scorn on Rex's part. I had had a worse accident bicycling; within a few years would experience a much worse one in a car, when Rex was driving; and worse of course would be met with in the war: all without this particular sense. It was due to social tension – the constant strain of being but a brother's brother, in the courts of the 'Bohmord. As such, by stepping carefully like Agag I could manage to get by, but not when physically turned arsyversy, even without scratch or bruise – indeed either would have helped. Clearly I was a babyish sixteen. Rex drew "The Great Accident" in the visitors' book: first the three of us advancing smugly with large prayer books in the miniature saloon. Then the pile-up: all arms and legs.

Edith's call at our home had been her first in four years' friendship, and she had never stayed there; which suggests that Rex had not been over-eager for the week-end visit he now arranged, in order to spend Sunday with me at Stowe, and show her the great gardens. Now she could take a longer look at his father, who had at last sold the Eltham business; though he continued to work at home for Whitbread's. "A man really of the lower classes – a shopman kind of man. He talks a lot and I think they are rather frightened of him as I expect he is always cross. Rex *cannot* be his son." The alternative was inconceivable. But this offended against a precious article of faith: breeding will out. Genius, she knew, flowers in bad soils, but breeding talks, breeding is not to be counterfeited. And Rex seemed outstandingly well-bred, an aristocrat of instinct. When she had shut herself into the guest room her bewilderment went down into the journal, and persisted through the week-end.

> He adores his mother, but she is *really* a kind pretty governess, and his father is *terrible*, an awful little clerk with black hair and moustache laying down the law about trivialities. Rex perfect with them both. ... But it's unbelievable that these two barn door fowls can have hatched this wild swan.

Naturally her first wish for Rex had been a home that she could socially approve of. Deprived of that, she could only heighten praise by dispraise, an impulse revealed many times in the journal. If the nest was so ignoble, the wild swan was all the nobler. It was awareness of this impulse that put the strain into my visits to the Daye House, made to feel that though I was like Rex superficially in voice and manner, I was not Rex, and it was no excuse if I was someone else.

On their side my parents found Edith surprising, decidedly eccentric, and quite comic. Brimful of warming admiration for their son, she

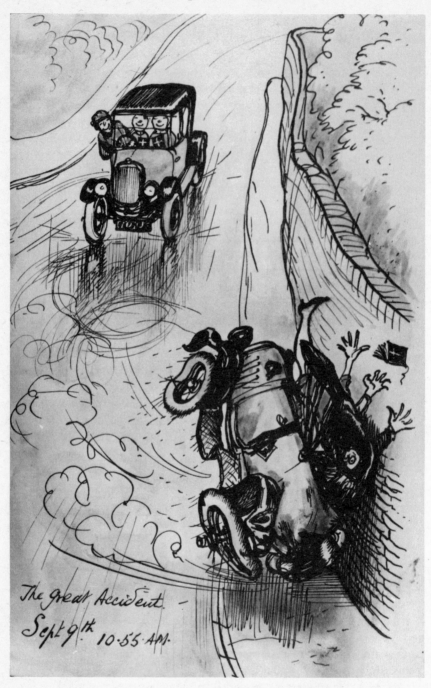

"The Great Accident", 1928

was careful not to be possessive – deferential, rather. Under easy talk they were of course uneasy with this intellectual friend from the grand world; were trying hard to raise their customary level of intercourse, and treat each other's notions seriously. Rex was politely taking up his father's banalities, as if he could will them into seeming less banal. From this Edith deduced, quite wrongly, that son and mother were intimidated. She had forgotten that middle-class people "on be-haviour" are never spontaneous, and lack the freedom from restraint which the aristocracy share with the intelligentsia.

Rex wondered how the journal would receive, behind that bedroom door, impressions he could guess, but certainly he did not guess their vehemence. It merely annoyed him, as he told me afterwards, to hear her putting on for our father's benefit the special joviality she kept for bluff farmers, while she rallied him with wagging head. He wished, now, that she could get to know them both better, and a year later, when he would have to be in Kent for a production of *Comus*, begged her to pay them a visit on one of her long drives. But it was worse than pointless. In the fond interpreter's absence no sign was trans-mitted over tea-cups of any quality that could conceivably make them endearing and amusing companions to their son. "*Incredible* that they belong to Rex. Mr W is a really common man – like a commercial traveller – looks dreadful and has a most inferior mind – full of shopman's clichés. Pretty Mrs Whistler "sweet" in so banal a way, always saying the rather stupid obvious thing."

An exciting opportunity was offered. Lutyens wanted him to paint in the Viceroy's House at Delhi, and was writing to Lord Irwin. Rex would have made an ideal collaborator, adding lightness to interiors that are too much "architect-designed"; for Lutyens never had, like Wren and Vanbrugh, first-rate decorators at his command. But nothing came of this.

The little mural at Dorneywood near Burham, now National Trust, pretends to replace a screen by an open portico into a formal garden, thus confirming that *trompe-l'œil*, worked out to be right from one central viewpoint, had become a favourite treatment. Everything here is sharp yet serene, as in a rare kind of dream. On top of a column we see Flora and Cupid. We see them again closer-to, where they have floated down in real life to bring summer indoors with a côrnucopia of bright flowers. The exact repetition in the girl's pose calls to mind certain subsequent paintings by Delvaux, and suggests that Rex was not far from the gentler productions of surrealism; only, all here is unrepentant grace, and devoid of uneasiness, for the aim is to felicitate rather than disturb. But Cupid's pose is not exactly re-

Reversible Face for Shell: The Scholar × The Bruiser

peated. He at least is disturbed. He starts back, doubtful of Spot, the little house dog, asleep on the terrace. Playfulness precludes the true solemn intensity of surrealism.

While he was at work, Princess Louise came to stay at Dorneywood, and often watched him. She said, "Now's your opportunity to stock up with brushes, and fill your paintbox, and charge it all to Sir Cour-tauld! He has a great deal of money and will never notice it." Perhaps she guessed that Rex was not asking enough. For his needs he never would, and he shrank from exploiting his "boom" and establishing a precedent. Trained from infancy never to be swollen-headed, he was probably bashful of being thought so, if he jumped from £5 a week, as recently announced in all the papers, to fees that might well have made his work seem more desirable. Thus diffidence led him to a life full of pot-boilers and ephemerae, drawings for advertisements, book wrappers, serialized stories, fashion magazines, stationery and invita-tion cards; also humorous advertisements chiefly for Shell–BP who were pioneers in the employment of good artists. It was for Shell that Rex invented his Reversible Faces, long afterwards published in *¡OHO!* and *AHA*, where the same features form two very different characters. This he enjoyed, for he liked to turn his hand to anything, and it pleased him to reflect on Hogarth doing much the same in Georgian terms. There would be big commissioned works in plenty, but that one-man exhibition would never come about. Decorator, illustrator, stage-designer he would seem – the last career beginning when C. B. Cochran commissioned curtains for his yearly revues, some of which filled the theatre with a gale of laughter when revealed. In one production Rex made friends with an artist he admired, Christopher Wood, whose death beneath a train in Salisbury Station, venue for such easy greet-ings and affectionate farewells, would haunt him because it may have been suicide. Success in the comic theatre led forward to success in the serious. And all this resulted from the *Pursuit* round the Restaurant, and would have done so if the paint had been utterly effaced, on that night when Father Thames satisfied a pair of mermaids.

# ·XIV·

A YEAR OR SO after Siegfried Sassoon's first meetings with Rex as the old friend of his new friend, Stephen Tennant, their friendship suddenly began to unfold. Stephen was leaving for Bavaria, where the other two were to follow him; for he had tuberculosis again, brought on, it was thought, by Lady Grey's death. Rex gave her a graceful headstone in Wilsford churchyard.

Acutely lonely in Stephen's absence, Siegfried saw Rex many times in the winter of 1928, taking him out or to his flat in Campden Hill Square, where a head in pencil was begun, "while talking about Stephen. ... He left me his Roman sketchbook to look at." In Fitzroy Street for a final sitting, he was faced by a Beaton photograph of Stephen. "Kept glancing at it wishing he were with me."

Then Siegfried drove Rex down for a week-end at the Daye House, crawling through fog, and finally through the ice into the pond at Winterslow Hut. Hours passed, to Edith's increasing anxiety for her "two beloved guests", and then there was Rex's voice on the telephone, "shattered and agitated" – that is, weary and apologetic – because, having pedalled somewhere on a borrowed bicycle, he had to ask her to send a lorry. In the end they were got out with pickaxes before it came, and arrived at about ten with the caviare, the chocolates, the huge photographs of themselves, but with Rex looking "quite dead" to the distracted Edith, while Siegfried appeared fairly buoyant, "talking brilliantly about their adventures and everything else. It might have been such a terrible thing and the car might well have turned turtle." By contrast, after a morning for both in bed, Siegfried was too tired for an expedition, and Rex drew all day. The three stayed up till one, while the gramophone played ancient jazz and Edith tried to get Rex to bed. "I told him I should ring up his mother at midnight, saying 'Bad news about Rex. He won't go to bed.' He said she would fall unconscious." He asked to be called at 9.30, and Edith sat with him while he had his breakfast. "Then I saw sleep flood over him

again! He lay back, and was asleep in a minute ... till 12.15. How I have enjoyed this week-end."

Siegfried got him to drive the Packard back to London, gave him dinner, and afterwards wrote this in his diary:

> Am feeling rather worried about R, who is showing signs of falling under my spell, which is very nice for me, but an awkward situation. I have been very careful so far – but I fear he is on the verge of the precipice. I am jolly and friendly with him, and he is a charming companion. It would be easy enough to succumb, but would be no joke, once it began. No doubt he realizes all this, but cannot face the facts as clearly as I can. R is desirable, but I can't divide my heart into partitions, and if I were to try the experiment I should find myself betraying [Stephen], who has given me his whole heart. I don't want to be unkind to R. So far he has said nothing, but his behaviour has given the show away. Going to and from Salisbury every milestone seemed to belong to S. I can see an emotional crisis looming ahead of me.

He may have taken Rex too much for granted – who, a month later, while Siegfried lay abed at the Daye House, had a different story to tell Edith in the car. My Stowe tutor had achieved his object, and proudly taken Rex to stay with Lord and Lady Longford in Ireland. There, Edith learnt,

> Rex fell in love with a very pretty girl and now feels a fool, and ashamed of his response to her sex appeal. He kissed her, and has never had an affair of the kind before. *How* I love his exquisite sensitiveness and candour. Talking of the love affair, he said, "I felt so far from *you* in Ireland and as if I should never see you again, and so ..."

The sentence is uncompleted.

The girl in question, Gwen Farrell, later Ann Martelli, told me that if Rex kissed her it was not on the lips and she had not realized for fifty years that he was much attracted, though she was herself, but was as diffident as he. Back in London he had taken her to lunch or dine three times in quick succession, and once, finding her hand was cold in the January street, had said, "Let me warm it", and put it in his overcoat pocket with his own. Then abruptly he stopped seeing her, because he thought, wrongly, that Frank Pakenham was pursuing her, and lacked an equal confidence to compete, I imagine. Had he done so, he might well have won her love. I had not heard of her, when, sitting pensive with elbows on the table, he wistfully shook his head

and murmured "Gwen! – Oh, Gwen!", not too lugubriously. It struck me that he meant to make display of a grieved heart more than to invite inquiries; at any rate I made none. First forays into sex, whether early or abnormally late, as for him, are touching when the heart is involved. In spring light two swallowtails make their feint for a moment; then diverge for ever.

To reconcile these stories, Siegfried's and his own, we have to go a long way back. Whether Rex had homosexual tendencies at school is unknown to me and immaterial: obviously he did. In a young male society as unnatural as a single-sex school, almost everyone had the tendencies, and whether they resulted in practice of one kind or another is immaterial, too; though if discovered, it was grounds for expulsion and the wrecking of a future. Schoolmasters seldom discovered it. What they could not help observing was the very occasional "case", to use the Haileyburian term already mentioned, the true love affair between boys, which could be so emotionally exalted as not to be physical at all; but ended in removal, none the less. Rex had no "case" to answer.

In "The Slade: The Story of an Art School", an unpublished work, Michael Reynolds remarks that though the Twenties no doubt was a time of emancipation, "most of us when we entered the Slade, were not only sexually inexperienced, but also – thanks to the public school system – sexually inhibited. The women students, though they outnumbered us by three to one, seemed terrifyingly inaccessible." At that stage Rex had become aware of divided propensities: susceptible to girls, though out of reach, and less strongly to men who were more dominant than he was. He saw himself as dashing on the rugger field, physically adroit, but also slight and oversensitive. Privately, he took boxing lessons, I recall, perhaps after he returned from Rome, but not for long, it was too boring. He wanted to be forceful – and had an inclination to be yielding.

Once when he was twenty-one, on a long evening drive in an uncle's open car, he and I were alone on the back seat beneath a rug as darkness fell, almost lying, with our heads close together for tedious mile after mile, myself receptive, as so often, to his talk. He began to unfold a fantasy he indulged, concerning the war and the Americans. In those years he and Stephen hero-worshipped America, as they knew it through jazz records and the silent cinema – the speed and brashness and go-getting modernity, the uninhibited fun and the ingenuousness, while Stephen, at one moment (if a moment can be said to last a week) wore horn-rimmed glasses à la Harold Lloyd, but with no glass in them. And all Yankiness would soon be epitomized for Rex by Gershwin's

*American in Paris.* Well, in this fantasy, there he was, a few years back – out in Flanders – at the Front – an English officer cut off with his unit under fire, heroically holding out in a desperate situation. And then, at the very last moment, *the Americans* charged in, big, tough, casual, undaunted, shouting friendly reassurance, commending and embracing him, true brothers-in-arms in an access of transatlantic camaraderie!

Other memories float in from early manhood, each insignificant itself, and seem with this memory to form a tissue of some possible significance, like fallen petals in the corner of a stream that coalesce to build a hazy raft. Fooling one night, too weary to put himself to bed, he wanted to be carried there by silent slaves and undressed without exerting one fingertip, all but filleted, with lolling head and expressionless face; and demonstrated this on the sofa. He was shocked on being told that a dinner party in the Southern States might easily end in a fist-fight between competing males: "the *barbarity* of it!" He had heard of a woman who had slapped a man's face at a party in this country. Governed by an inviolable code of respect for the fair sex, what on earth could one do? "I should faint, I think!" The interplay of force and submission held an interest; and even cruelty observed had a fascination. I say "even" because to initiate cruelty at any age was quite out of character, but he would get up from his work table when a high dismal note first sounded from a corner of a windowpane, and watch for a long time the febrile fingering and trussing up and turning round and bumping away, and then the almost motionless absorption. One day, he said, he had stood in his studio for a long while, with eyes shut and quite still, discarding irrelevant thoughts until he believed he could imagine the sensations of a man about to be hanged. If he had known Berlioz's *Symphonie Fantastique* it would have been among his records, surely, for the "March to the Scaffold" would have thrilled him with its luxury of self-pitying self-drama. In any context, to sharpen the imagination was his aim. Thus a bullet wound was too commonplace in newspapers and books to be realized at all, "but imagine a steel rod being driven right through you – that's what it would be like!" Bullets had been seen both entering and leaving in his boyhood inventions, but never with complete conviction. Always too gentle to invent real horror, he responded to it.

Cecil Beaton gladdened Edith one day, later on, by a eulogy of Rex that included, "No sex talk – doesn't think of it." Cecil would have been surprised. Rex thought of sex with a sensual imagination that was sometimes a trial, and told me that he made erotic drawings. He probably destroyed them soon, or in the great tear-up of 1940, when

the notion of his mother coming on them would have been distressing. The few that have survived, mostly in pencil, must have been overlooked in early sketchbooks and are harmless enough. They all show a naked or partly naked young couple tenderly entwined. In one a youth is carrying off a girl from a female figure who kneels, imploringly. If rape, then of a qualified sort, for her arms are round his neck as he kisses her. In another they are Cupid and Psyche, he with winged shoulders and surely with Rex's own features, romantically conceived. They seem to say that love is an affair of longing rather than fulfilment. In a fourth outline in ink and probably of 1925, the girl is seated naked on the edge of the bed consoling her lover who kneels between her knees, in tears. It is the tune of the desolated child, transposed into the key of adult sex, the need for confession, absolution, reassurance in the arms of a mother who is also desirable and young and childlike herself. "*I* was a child and *she* was a child, in this kingdom by the sea", as Poe had written, in a favourite poem.

But some young people develop very slowly. In 1925 Rex was twenty, and he was not yet twenty-five when he entered the magnetic field of the man who had written of himself, "In me the tiger sniffs the rose." Remembering the fantasy of rescue by the large and the loving, it is easy to understand that such an admirable and humane man as Siegfried Sassoon, MC, embodying the heroism that had exalted war and the sensitivity that had inveighed against it, with his strong boyish looks only made more endearing by the large boyish ears grown at right-angles to them, with his wayward and humorous mind that wrote ruminative poems very much to Rex's taste, would be temptingly dangerous to flirt with; not at all in competition with his poor, rich, seedy, absent, beautiful friend, but oblivious of that friendship for a happy week-end – more temptingly dangerous, soon after drawing back from a girl.

It is highly unlikely that as an adult Rex practiced homosexuality of any kind, if indeed he ever had, and he thought it hateful that every firm friendship between men should be accounted homosexual. Still, most of his male companions in peacetime were this, and not entirely by chance, for like Siegfried they were not all in the world of decorative art! I think he took to them unconsciously because he had some degree of affinity with them, consciously because they did not challenge his masculinity with women. When one of his rare heterosexual friends did that, even without being in active competition, and merely by being virile and successful, he felt diminished. Hence the joy of the companionship with Stephen in which his feminine aspect could expand unsexually, and leave him free, one day, to be a man for a

woman. He had felt no sexual jealousy the previous year when Sieg-
fried began to monopolize his friend. "I haven't heard from Stephen
for a long time. He must be lost in Central Europe with that Fox-
hunting Man!"

Three days after the wise decision about Rex, Siegfried took him
out to dinner to meet Edmund Blunden, and to draw his portrait in
pencil when back at the flat; which he did in one sitting that lasted
until 1 a.m. He had done a number by then, at this stage getting better
likenesses on paper than on canvas. Bending over one, fairly pleased
with its delicacy, he muttered the name Ingres, and it was Ingres he
took for model, as in his heads of William Walton, Arthur Waley and
Siegfried himself (Pls. 13 and 14, and see note).

Chains of lasting friendship were still lengthening out from that first
conversation on the grass of the Slade. One now ran from Stephen to
Siegfried to Blunden, and on the day after the portrait, Edmund him-
self added a new link for Rex. That afternoon he went to discuss a
Collected Poems with his friend and publisher, Richard Cobden-
Sanderson, who had founded a small firm near the British Museum,
soon to prove brilliantly successful, but where most of the brilliant
success could be ascribed to one of his young partners, Kenneth Rae,
then aged twenty-seven. Kenneth was charmed and amused by Victorian
annuals, and was privately collecting them when it occurred to him
that a modern imitation, witty and nostalgic at once, might effectively
catch the mood of the moment and prove highly popular for Christ-
mas. Well-known authors could be asked to write briefly and lightly
on topical subjects – but who should do the illustrations? Everything
would depend on that! Blunden said, "Only last night I met a young
artist called Rex Whistler", and related what he knew. The Tate Res-
taurant was recollected. With Cobden-Sanderson's approval Kenneth
looked up the telephone number.

"You haven't the least idea who I am, but I'm a publisher. Edmund
Blunden has been telling me", etc., etc. The project was outlined.
"Would it interest you?"

"I'd like to come round and hear about it." And he did so, straight-
away. Then they walked back to Charlotte Street to dine at Schmidt's,
and on the spur of the moment went over to the Scala nearby, to hear
Beecham conduct *Dido and Aeneas*. This was the easy origin of a
pleasant book, *The New Forget-Me-Not*, which did for Rex as illus-
trator what the Tate had done for him as mural painter.

Siegfried, an eccentric driver who had collided with an island in an
empty Bayswater Road, out of sheer irritation with some bore he had
dined with, got Rex to drive the car to and from the Daye House for

another week-end – with a detour to show him Wootton Church, Denny's grave, and the Vicarage. They did not go two miles farther to look at a pair of Georgian cottages where the Whistlers were born. Perhaps Rex was not aware how pleasant they were. He took no interest in the paternal background, only in the maternal, poring over groups with crinolines at Brenchley. It was not only Edith who fussed about his looking "dreadfully done". Siegfried was concerned. Late hours and drink were an occasional cause, the cyclitis another. A Sassoon postcard from Monte Verita says, "So glad to hear you aren't as bad as I thought. But take care of your *eyes*. If you don't I'll set about you and close them up with my fists, and then you'll be obliged to take a rest. Your drawing is very funny and delights me. But hasn't produced any *words* yet." This was for *The New Forget-Me-Not*.

Soon afterwards, in April 1929, Rex paid his fourth visit abroad, as the guest of Stephen at Haus Hirth near Garmisch in Bavaria. Edith was there already at no expense either, and had an impulse to surprise Rex on the platform at Munich, where he planned to break the journey for the night, and see for the first time South German Rococo. So they moved together through the silvery riot of the Amalienburg, and went to *Così fan tutte* at the Residenz – "audience very smelly" – with a twinkle of white, gold and crimson, ghostly all around them, lit only from the stage. This illuminating happiness had to absorb a grievous loss: he had left his Rome sketchbook in the train, with all his architectural notes and several sketches, and would never recover it (see note). Then Edith lost her spectacles for a while, and finally Rex left his overcoat and passport at the hotel. For an hour or so in the train they were too worn out to speak, but later played a game where she made a scribble, and he turned it into a picture with the smallest alteration.

William Walton was at Garmisch station to meet them, and on the following day Rex was allowed fifteen minutes with Stephen in his room. "Onkel Walter" and "Tante Johanna", well-born on her side, were a couple impoverished by the German collapse, who took English and American paying guests, of a select kind and at a price. Simply, they were beloved. Even Edith was hard put to it to express her adoration of Johanna Hirth. "Nothing can equal her. Words cannot describe her unique distinction, and the loveliness of her noble nature. I feel that anyone who is guided to this place ... *must* be *a chosen person* ... Stephen has been led here for great purpose – that the loveliness in him may grow and the other side vanish." About once a week he had a pneumothorax, to collapse and give rest to one lung, and after it the infection was always found to be less. The Heidelberg

specialist was full of hope; he only wondered, according to Edith, "how anyone so heavenly – so *'unerdlich'* – so spiritual – can face this rude world". He viewed Stephen as a Botticelli – as a Fra Angelico. "Isn't this marvellous for a great German scientist?"

When Siegfried arrived Edith saw that "everyone adored him: he adored everyone". If this sounds like an unfamiliar Sassoon, so it was. "No one would recognize the rather grim alarming aloof poet of London in this gay creature who runs in and out of the room saying again and again how happy he is." He was in idyllic mood because he was with the beloved, and the beloved was getting better. "What a happy day!", sighed the patient, sinking back on his pillows after an evening talk. Only Walton's enthusiasm was qualified by the unfriendliness of Onkel Walter, who had recognized that he was not of gentle birth with the acuity of one who was not himself.

By arrangement, Rex had arrived just in time for Stephen's twenty-third birthday, and described it all to his mother, the bowl upon bowl of gentians, the circle of chairs round the circle of presents round the ring on the cake.

> The candles were lit and then word came that his highness wouldn't be down for ten minutes, so they were blown out again hastily.... Uncle Walter and Willie Walton were posted, outside the door, and halfway up the stairs. Twice false alarms ... Tante Johanna's taper leapt. ...
>
> At last he came, looking very lovely, in a long velvet dressing gown of orchid mauve with silver braid, and mauve silk pyjamas. Then following moans of delight and kissings for everyone. The goggling faces of rosy country maids could be seen stuffed round the crack of the door while Stephen knelt on the floor.

Rex's social descriptions are often very like his humorous advertisements for Fortnum and Mason, and Guinness. There, then, was Stephen on his knees "saying lovely things to each giver" without the least embarrassment, though Rex felt embarrassed when his own "meagre present" evoked several of them. The top present was a little pearl-surrounded locket given by the mad King of Bavaria to an ancestor-by-marriage of Tante Johanna. The whole performance, with supporting cast, was perfect.

The cast included an American girl who was staying there independently with her mother, very pretty, with long golden hair, and a show-off. She danced a flamenco dance with castanets, she flirted with the young Prince of Hesse who was often in the house, and was swept up in his arms at night, amid laughter, and carried upstairs as if for

ravishing, and flung on her bed. Rex, attractive but aloof, did not try to compete, and was in two minds: envious – but chiefly put off by behaviour analogous to lobbing the skin of a banana in the quad. So, when they played, it was like children. Frau Hirth had prescribed for them both a patent energizer called Electrolyt. Rex pretended to detest this, and had to be chased by the girl all round the house and garden until he was caught and forced enjoyably to swallow it.

They lay in rows on day-beds in the garden, in dazzling sunshine, against a Wagnerian back-drop of snow-clad mountains, transparent in the heat. But the great snows had broken the roof and Walter Hirth was keen to add two extra rooms for more guests in the attic. Hearing this, Siegfried, who had made £1,800 out of *Memoirs of a Fox-Hunting Man*, wrote to his banker for £500, and – hearing that – Stephen matched it. Thus on his own birthday Onkel Walter was winningly presented by Stephen with a single roof tile. "This means your new roof, given to you by Siegfried and me!"

There was in any case strong Anglo–German accord in that house. Walter Hirth was fervently for peace: "We must *all* work for it!" But he could not accept that the Germans were to blame for the war, not that anyone had hinted that they were, but he knew what was thought. He blamed Russia and France, and lent Edith a book to clinch the matter, "Though even by selecting documents I don't find that it does." He was stirred. He needed to convince. The Germans had been tricked at the Armistice. To illustrate the point he gripped Rex by the back of the neck where he sat, and bent the young Englishman's head forward, which Rex found undignified, but had to accept. All was friendliness, really, with enduring affection; and later Rex gave them a decorative advertisement in English, listing all their impressive patrons, which was reproduced, small, for sending by post. Knowing Stephen's nanny better than anyone except Stephen, who could not cosset her in her senility, Rex read the newspaper aloud to her each day, and when she died soon after her return to England he asked to see her, and drew her head on the pillow with tenderness; it was his first encounter with the dead. He played with the comic dachshunds, Leusl and Traudl, and did only three out of the thirty small drawings for *The New Forget-Me-Not*, hopefully put into his programme for the holiday (pp. 11 and 98). By strength of mind he wrenched himself away from the Siegfried idyll.

# · X V ·

THERE WAS A BOOM in fine illustrated books, and a publisher as shrewd as Dennis Cohen of the Cresset Press was alert to turn a classic text into a pretext. Hence the idea of a superlative Swift, and his letter of February 1929. The emphasis and the comments were added later by Rex, and record what he came to think of the bargain.

> To confirm the arrangement we made today, we have *much plea-sure* [I should think so, too] in agreeing to a fee of £150 for 12 illustrations and 4 head and 4 tail-pieces for our edition of *Gulliver's Travels*. These should all be *completed by the second week in July, 1929*. [Ha! Ha!]

Later five maps and a title page device were added at the same rate of pay. There would be a hundred and ninety-five copies on hand-made paper and another ten on vellum. The page would be big, excitingly so, and Rex with his inclination to draw small was debating how to fill it, when Kenneth Clark's book, *The Gothic Revival*, appeared. There he found the design that set him off: one by Richard Bentley from the 1753 edition of Gray's poems, illustrating the *Elegy*. What it showed, ostensibly, was bard's attention being drawn to headstone by hoary-headed swain, but the plate was mostly framework, with a bit of ruin, farm implements, corn, etc. This is Rococo: where a theme is not decorated but the decoration is itself the theme, proclaimed in a language of enjoyment. Thus in Bavarian churches crosses reel and tumble, angels laugh as they plunge from the high dive, haloes look slingable as quoits; and if Christianity could be exclusively what it professes to be, a religion of joy, this style might be of all styles the most spiritual; for it is always singing and what it sings is carelessness, or lightness of heart. That mood is not sustainable on earth. But in heaven quite a number of the "many mansions" may be done in the style, a larger number than may have seemed tasteful to some saintly Victorians, on first encounter. Also it goes well with Mozart's *Coronation Mass*.

In Swift's masterpiece there is nothing Rococo in spirit, a style which would hardly reach England for another five years. It must be allowed that he is almost beyond illustration, through being so ambiguous in purpose, or at least so ambivalent in effect; from the day it appeared in 1727 adults and children were delighting in the book, for different reasons. We may assume that such an author would scorn illustration entirely, thinking it irrelevant and no artist capable of matching him, in any case. Not at all. He quite fancied the idea. Just after publication he saw in Pope's house the new edition of Gay's *Fables*, with little head-pieces by Wootton and Kent, charming but of no great merit. He would have been content with such charm; and proposed "something of the sort" to Motte, his publisher. What he got was a sequence of unworthy editions illustrated in the humblest chapbook manner, followed in the next centuries by many artists, few of whom have been as good as Grandville and Bawden, and none right for every side of his genius. There was one contemporary who could have done him justice, and Swift knew this.

> How I want thee, humorous Hogarth!
> Thou, I hear, a pleasant rogue art!
> Were but you and I acquainted ...

Hogarth, alas, was of another party, and no friend of Pope's circle.

If Swift could study Rex's attempt (Pls 16 and 17, pp. 147 and 164) I guess that, marvelling at the penmanship, the eccentricity of Rococo emphasis, and the quality of reproduction, where the plates come very close to the original drawings, his verdict would be that his humour and invention had been met very well, and his satire but insipidly. Rex had only known the first two adventures, and in some bowdlerized edition for the nursery. Reading the full text he missed much of the political mockery, but delighted in the scorn of human pettiness and grossness, quoting to me with amusement some of the filthier episodes and franker descriptions. He did not see Swift as morbid and savage so much as candid and perverse. As a matter of fact his own squeamishness had given him a notion that recalls one of Swift's. Speaking once of the offensiveness of defecation he said, "You feel it ought to be a repulsive thing only men have to do, but alas it's just as feminine as masculine!", a truth he found hard to reconcile with the beauty of form, the delicacy of heart and flesh that he adored in the female. This recalls the protest of the lover in Swift's poem "Cassinus and Peter" – "Oh! Caelia, Caelia, Caelia sh –." But he agreed that the more beautiful the creature the more detached from the drawbacks of the flesh, as tending to surmount and redeem them by beauty. He could

not illustrate the more disgusting episodes, nor would the public have accepted them visually. But his Yahoo women do not even have dugs that swing between their fore-paws, and Swift would think them merely uncouth, not horrifying mates for Caliban. Otherwise he follows Swift very well, who setting out to write of a huge man in a tiny world (and vice versa), foresaw the difficulty of staying consistent, and set himself a scale: one inch to one foot. Working to scale was no problem to Rex, but a pleasant challenge. Both fudged it a little, now and then, for plausibility's sake.

Taking on the task, he thought it would be "rather fun ... 2 vols as big as family Bibles": to be finished in six months, which was surely time enough. To show Cohen, he roughed out a sketch of Gulliver clinching matters with the captain of the ship, and made a finished drawing of it for a frontispiece. The Press was prepared to match fineness with fineness by adopting an unusual method (see note), and Rex tested it to the full. Never had he drawn so large so elaborately, nor would he ever again; for he quickly perceived what a task it was going to be for that finest of nibs. By that time he was committed, but was soon trying out a much quicker technique of pen-and-wash for the head- and tail-pieces and the maps, and thinking the result "just as good", and wishing he could use it throughout. It is delightful, certainly; but something would have been lost. Once in a lifetime the effort was worth-while: artistically, that is. And surely in a way he enjoyed it. Inventing the theoretical mad town of Lagado, he merged picture with frame, for this once, and introduced a mass of absurdities not found in Swift; he could expound the local reasoning or lack of it behind each one. That I know he enjoyed.

Six weeks had gone by since he returned from Bavaria, when in June he took off again for Rome, and watched from his sleeper, south of Genoa, a full gold moon spread enchantments in the manner known only to train windows: ancient olives and rocks in slow dance, light over multiplying seas, "rookeries of houses to the very edge", like a flowing scroll, or like a mural. "I feasted my eyes and heart, until I fell asleep." And in the taxi next morning he could hardly sit still for the joys of recognition, not having dreamt of a return so soon. Content he might well feel. For he was about to stay for five weeks, free again, in the comfort of Lord Berners's house in the Forum, with a free journey back by road. It was far too good an offer to decline. It would also be a fruitful arrangement with a pleasant if rather childish companion, willing often to pace him at another easel, and to entertain him now and then, in a way he did not usually mind, with some Roman social life. But here a minor fret obtruded. Princess Caetani

and her brother came to lunch, he speaking no English. The conversation therefore, as between all well-bred people, was in French. "I could have kicked myself for not being able to speak it properly", he told his mother. "I *must*. Have you heard of a good teacher?" But he never would.

On the second morning, his twenty-fourth birthday, he had begun with a side view of the Arch of Constantine, working from ten till one. Almost every day he painted in some celebrated place and more confidently now, sometimes alone, sometimes "bothered by urchins" who knew as well as he did that these were conventional subjects for the foreign artists. Not that he minded that, or them so much, this June. Almost better to be bothered by urchins than embarrassed by educated onlookers; as he was – for a few years. Next year, while he was sketching Wilton House from the river, the whole Pembroke family trooped out to stand behind him. They might as well stand at your writing desk, he complained, and say, "Let me see what you're saying in that letter!" Not a phrase in his Roman diary recalls the anguish of the year before – "Did nothing, absolutely nothing." And for superb relaxation there was St Peter's, astonishingly lit at night for the pact between Church and State. As they approached through the crowds, dome and lantern were seen to be netted in jewels like a spider's web after a shower; and below them "every corner and column and sculptured saint had its festoons of fire! Yes, it was *fire* ... flaring torches!!", so that, over the swarming heads and the bands, "the whole vast cathedral, glowing in blood-red light, seemed to be flickering and shimmering as things seem when looked at through tears."

They moved to Tivoli for two nights, driving out through great heat in the late afternoon, but cooler on that height, and booked rooms in the only hotel, The Sirena, on the very lip of the gorge above the pounding thunder of the cataracts, and close to the Temple of Vesta across a tree-filled ravine; then drove out again and painted till dusk. The chosen place was through the viaduct at the end of the valley, where the outline of the town with its tower takes shape against the sky like a toy steam locomotive, advancing almost to the edge of the precipice; where also, immeasurably far below, the unspoilt campagna of that time stretched in a grey-blue haze to its horizon, much as when Turner or Hubert Robert or even Claude had known it. Hereabouts it was – or literally just here, perhaps – that Claude had learnt to paint from nature. To Rex it was as good as if no artists had painted there before – and more challenging because they had; which may epitomize a viewpoint very different from that of his talented contemporaries, who would never have painted there at all. Nor did he ever give a

moment's credence to the theory that one "ought" not in this age to paint in certain modes or places. He was a true traditionalist, ambitious to do in course of time – but differently, and as only he could – the thing that had been done by great forerunners; after that, who knows, something else perhaps. So back to dine late on the terrace, and walk round the narrow dark streets, warm cisterns of acceptable strong savours. Then "to bed. Sound of waters."

Next morning they bathed in the sulphur baths, and then climbed down to look at the Grottoes of Neptune and the Sirens. As he described the descent to Stephen,

> it was *wonderful* down there and rather repellant too, (in the way some orchids are). Everything was quite covered by the *enormous rank vegetation. Huge* green leaves of Dock – (I think) – overlapping everywhere like millions of great green plates! piled up and all dripping, dripping, and pattering with the spray from the waterfalls. All the rocks were covered in that brilliant green *finest* grass – like hair, softly rippling all the time under the white smoke-like spray. I *wish* I could describe it, but everything seemed *too* green and luxuriant and the humid air was full of that awful hot suffocating smell of *growth*! The Grottoes were suddenly very cold as one went into them – with low gnarled arches of rock oozing with slime above and the water rushing into it at *incredible* speed but quite smooth like a rod of glass. . . .

In the evening they resumed their paintings at the viaduct till darkness fell again. That night, leaning from the window of room 19 in the roar of the waters for the last time before sleep, he stared down into the ink-dark gorge and pictured them shooting out of sight and mind, while he pondered a theme that had occupied his thoughts off and on all day. For he had just finished writing Edith a six-page letter, begun on his bed during the siesta, which, though casually worded, not to say spelt, is more than any writing that survives a key to his imagination. He began by saying that though Italy was so intensely beautiful, it was also deeply sad, in an enjoyable way. It had

> that kind of thin exquisite grief which so much poetry gives one, and which we have often discussed, and tried to analyse, haven't we? I don't think I feel any melancholy when looking at some distant or beautiful Italian *landscape*; but it is *where people have lived,* (some old sleepy farmhouse out in the Campagna, or a little dark and boarded up palace in a side street), which moves me most deeply. . . .

It is as though I am suddenly *reminded* of how we used to live in those long ago drowsy, pastoral centuaries, and I feel as though I was *an old man* full of sad longing for my vanished youth, and worried with a kind of *regret* for the way in which I must have wasted or not valued properly those wonderful and beautiful, and now irretreavable days!

He was an impenitent romantic in a generation which had broadly rejected this attitude. That "thin exquisite grief" had been voiced for him by Tennyson,

> In looking at the happy Autumn fields
> And thinking of the days that are no more –

or since Tennyson was sighing for a personal loss and Rex for a social and historical one, better still by de la Mare:

> Our hearts stood still in the hush
> Of an age gone by.

Here was nothing exceptional, but common ground with many artists of that great revival in which Rex meant to have a modest place, within a very late wave, much later than Yeats with his summing up of the Nineties – "We were the last Romantics".

Rex says that he did not think that he felt this enjoyable melancholy for landscape pure. But has anyone felt it for that, I ask myself – if indeed landscape existed pure in a country so deep in the tilth of human history as Italy? Did, for example, that painter of delectable Italian melancholy, John Robert Cozens? I see that Rex was right. "It is where people have lived", in Cozens too; or where they have laboured and all their labour in the end has come to nothing: the broken rhythm of the faraway Roman aqueduct with sections missing like the teeth in a skull, all so ineffectual and diminutive in the extent of the Campagna. Then I notice that the world in which Rex says "we used to live" is not the ancient world at all. It is the very Italy that Cozens thought insignificant, a century and a half before, while he bumped across it in a carriage with William Beckford, offended by the smells and the poverty, nervous of "the pestilential air", in Beckford's words, and thinking the occupants of little palaces in side streets unenlightened and obtuse, if not as contemptible as Shelley was to think them. "A good illustration", Rex would say, "of what I mean by 'not valued properly'."

Romanticism over history, like falling in love, may be always to some extent illusion. It longs for what it sees as the best. And the best

is a genuine aspect of the whole; many periods have been nourished by glorifying a past that never really existed, yet contained the good things and the virtues admired. The hush of an age gone by was never felt outside a daydream: it must be remembered that de la Mare's poem is about children who, listening to stories, became lost in the romance of "once – once upon a time". So was Rex, and he would not have minded the comparison with childlike wonder. But it was not entirely a daydream. The drowsy, pastoral centuries did exist when wars were in abeyance, to the extent that life changed its pattern very slowly, and was gracious to those who had enough, and was enhanced for them by decent craftsmanship in almost all they saw and touched – and was not threatened and encroached on, not uglified and crowded out by noise, speed, shoddiness, and mass-production. Fundamentally what he regretted, even hated and feared, I should say, was the Industrial Revolution itself; hated and feared it the more sharply by reason of his place in modern history, cut off by a war like a crater in civilized life, an unbridgeable fault, from that graciousness. In one aspect the post-war world seemed loud, grubby and haphazard, like its traffic, its hoardings, its excreta of jerrybuilt bungalows, compared with what he could remember and hear tell of. But this was merely the latest acceleration of a cancer deep-rooted in the past. Something had gone wrong, far back – wrong with the life of the West – to produce the swollen populations, wretched in the dropsical cities. Something had been thrown away. He could not come to terms with industrial society. Nor could Palmer and Calvert, a century before.

Yet in a way he came to terms with it extremely well, as we have seen. He rejoiced to be young in the liberated Twenties, exploiting the benefits they offered to those who were lucky like himself. It would be silly not to, and no benefit to anyone. He did not fool himself. Brief comfortable trips to Tivoli, Frascati, Albano and elsewhere, provided by his little Grand Tour – so much more expeditious than Beckford's – owed themselves to the car; and cars were built only in dropsical cities like Coventry, Detroit and Turin. In his philosophy there was a major contradiction, and he recognized this. When pressed to resolve it he could only wish that the benefits of progress – in medicine, welfare, education etc. – had been garnered, and the mischiefs avoided. For the sake of that he would genuinely have sacrificed cars, railways, electric light and much else. Ingenuous perhaps; but it is not an artist's job to propose retrospectively a different journey for a civilization. He lamented the one that had been taken, that was all. Only, he could never convey such notions with a brush. "Staying in this country gives me agony continually of longing to be a poet, or next best a [prose]

writer, but my painting can never express all the things that I feel. ... To say what one *wishes to say* is the almost impossible thing."

Making poetry was in his mind at this moment, for he had just had news from his mother that rejoiced him. I had won the school prize with a very long poem, and some shorter ones had given him the notion that I really might become a "maker" in the greatest of the arts. I was beginning to emerge. We might become allies in art, like the Sitwells! No fanciful future for me could have pleased him so much, aware, as of course he was, that in drawing he must always overshadow me; though perhaps I had enough of that to make an architect. A project was forming in his generous mind.

The Tivoli painting took eight or nine hours in all, and now the two artists were smoothly being swept back to Rome through the heavenly twilight. "The Campagna at dusk! It makes me groan – the very thought of having to go from Italy!" Very different had been the emotion that Beckford, near the end of his pilgrimage from England, imparted to his companion Cozens in the crawling carriage, with surely a visible effect on his water-colours: "forced to dwell upon the dreary scene, the long line of aqueducts and lonesome towers. Perhaps the unwholesome vapours, rising like blue mists from those plains, had affected me. I knew not how it was, but I never experienced such strange, such chilling terrors." It was believed that smell itself caused disease. One member of the retinue died of fever, Cozens fell ill with it, and Beckford too, "wishing for the lovely green country of England". There is much to be said for the swift excursions of the twentieth century, even if they have to be made – but why need they be? – between mile after mile of the same advertisement, and it is not cynical to say that aesthetic pleasure begins in physical well-being; for we are primarily bodies. If there were a meter to record aesthetic pleasure I can believe that Rex would score a quite exceptional reading, as he did at the Slade with his phenomenal hand-grip. But excess of pleasure, he would sigh, is no proof of an equivalent talent.

In Rome he found letters and photographs from Siegfried and Stephen, still abroad together, Stephen much recovered. For another fortnight he painted on, including a portrait of Berners, now in the National Portrait Gallery: "Alas, only *too* like him! And so it cannot give much pleasure. He is *so* charming and kind." Early in the visit he had asked his mother to post out material for the *Gulliver* drawings, but his well-kept diary of work shows no use of it at all, even after Cohen pressed him. At last they set off in a leisurely manner through the heat, with a stop of four days at Aulla. There he bathed several times in the river, he told Edith, "with William the chauffeur – so charming and

handsome! B. doesn't care much for bathing (like some other mis-
guided people I know)."

Picnicking near the lonely customs hut on the Mont Cenis, he wrote
"Mussolini's last tree" on a trunk, "and suddenly it became France,
lovely green France", virtually unknown to him; where presently they
turned aside to honour Rousseau's memory at Les Charmettes. So into
still lovelier country, while his neck ached with turning from side to
side in the car. Then to Bourges, then to Chartres! Beyond comment
by page six, but quite converting him to mediaeval Gothic, which,
only last year, breaking faith with his romanticism, he had condemned
for its "*striving*, religious element, this *frightful sentimentality*, which,
while being the very *cause of its existence*, is at the same time the
cause of its failure *artistically*". A dim cathedral with its storied glass
had moved him until now only as a narrative painting might move:
say, *The Last Day in the Old Home*.

In all, home-coming took a fortnight, with no rooms or meals to
order, no bills to pay, no particular boat to catch, or day to be in
London. Has anyone before or since ever travelled that route with
more unadulterated content – what with time along the road for sev-
eral oil paintings, "most of them bad, I think, and all of them rather
dull, but I have enjoyed doing them more than I can say!"

Tailpiece to *Gulliver's Travels*, 1930

# · X V I ·

THERE WERE TWO ROOMS to decorate, both fine opportunities, but "he can't get on to either because he is being choked by Gulliver", wrote Edith. "It's a nightmare." And still he found time to make five drawings and an elaborate title page for my first book of poems privately printed at Oxford and sold in the Stowe shop. Now the American girl met in Bavaria was brought down by Princess Imma Doernberg to stay with Edith while William Walton was there. According to the journal she flirted with the composer, who was relieved to be without a rival because "she likes Rex so much better, and he would have had all her attention!" Naturally, thought Edith, continuing, "Willy looks a pitiable little cad – and a diseased one too – rather like a maggot." Scathing comments, always kept to herself, relieved a certain aggressiveness, and did not invalidate her fundamental good will towards her victims. Cad to her, it should be added, meant nothing more dishonourable than street-boy, as it still did at Eton, and relates to an evening when in front of them all "with some purpose, he told us the whole story of his life so that we should realize that he rose from the ranks, and so far has made no money, so isn't marriageable. This made clear he can let himself go and is having great fun. I believe he has more character than appears." Imma Doernberg seemed to think he had, as well as genius; for within a month he and she had embarked on a long and deep love affair, leaving the attentions of her golden-haired American friend to be otherwise attracted. But not by Rex to any advantage, though he went to see her several times in London, and there, sitting on her bed one evening, with a cup of cooling coffee in his hand while she dressed for dinner, he found the skin of the hot milk in his mouth "and was terribly distressed. . . . I expected him to burst into tears." Playing childish was still the only mode of intercourse, and was taken at face value. It was not that he lacked the courage to break out of it and kiss her, shy though he was: rather that he was not certain of the consequence, or if he wanted it.

Thus, though she "really loved him", she said, the feelings he aroused were maternal. "Frankly, I always thought he was homosexual." In the private torment of sex he could not but feel the contrast between himself, preferred by several but inhibited, and Walton, entirely forthright with women. "Rex seemed ill and depressed. I feel he is *going through* something and hasn't told me", Edith wrote. She was constrained to give lessons, and then to take a paying guest, because she wished to entertain, in modest form, and her standard of living must be that of her friends: there were no poor ones in the circle except Walton. Although she never found him interesting, she liked him and was content to have him there, living simply in the Daye House, while composing his first symphony on the piano he had chosen for her.

When Stephen returned in August from his long convalescence abroad with Siegfried, Edith found him very thin but "exquisitely beautiful and bronzed", and for once even Rex had to provide the contrast that for her always sweetened admiration. "His face beside Rex's looked marvellous. R looked fat and white and *un-modelled* by him – though really he has such beauty." Now that Wilsford was his own he was busy with improvements, which privately to Siegfried were a "gaudy prettiness". To Edith he seemed "very tragic, standing at the door as we drove away". Yet a month later the great German specialist came over and pronounced him cured – no trace of the disease. Only he must live as an invalid for nine months more. "All we can do is surround him with our love", enjoined Siegfried; and in his fervour he set about excluding everybody else. If it meant the South, while the alterations were in hand, he would go with him and give up writing, if necessary. So presently there was a postcard for Rex from Palermo, saying simply,

> Many a mouldering gateway
> Tufted and antique,
> Causes me to straightway
> Softly shriek –
> 'If he saw it
> Rex would draw it'
> And I wish his pen were busily
> Engaged in limning Sicily.
>
> S.S.

No rumour of amusement at the fervour of the friendship was tolerable to the poet. Thus without a recognized breach there developed a new coolness towards the Sitwells, and in any case Siegfried's commonsense mind was less in sympathy with their literary programme

than hitherto. He regretted, as did Rex, the abandonment by Edith Sitwell of her earlier brocaded style of poetry, though rather envying her freedom to bring any two images together, however far-fetched, in the hope that they would spark. "I can't do it", he said. "I can't chance my arm like that." Soon he also found her pretentious as a critic, when she dilated on "dark sounds", "dew-weighted" syllables, or "the little cold wind of the two words beginning with 'h'". He summed it all up as "a little dark sound after the 'b' in 'balls'".

Rex had bought for £120 a second-hand Vauxhall saloon, a show-room model, which amused him by its custom-built bodywork in shades of burnt umber and raw sienna, with cord upholstery, trimmings of braid and little tassels here and there: he called it his "drawing-room". A fortnight later, while on his way to Wilsford and almost arrived, a horrifying noise set up under the bonnet, with blue smoke breathed all round it when he came to a free-wheeling halt: the engine had seized up with four piston rods broken. It was caused by an oil leak, not by negligence, and Stephen gave him £50 for repairs. There were other unwished-for adventures. On the way to the Sach-everell Sitwells he had some minor brush with the police and later wrote to Georgia Sitwell,

> Do you know how much those cut-throat pirates at Hendon Police Court fined me today? – a cool SIX QUID [equivalent to about £125 today: a spilling money-bag was sketched]. I got muddled rather, and pleaded *"not guilty"*, when I suppose I *was* really (technically) so they gave me hell. But the magistrate was a disgusting short-tempered old grocer, so it was only to be expected.

Then there was the bad accident I have already referred to, which not unnaturally appalled Rex, who was at the wheel, more than me, and happened at an inconspicuous crossroads among country lanes where no priority was given, and equal fault could be ascribed. Cannoned into sideways, our party was quite unhurt, but a couple were thrown out of their flimsy Trojan. Rex washed the man's blood-covered face with water from the radiator and his own handkerchief. The woman was concussed, with a little blood emerging. Presently a rural police-man declared, "In my opinion the lady's going to die!", but because of regulations involving county boundaries it was two hours before an ambulance arrived. Our nervous mother behaved calmly and well. It was later that she said, to reassure him, "Of course you're not to blame! They *deliberately* ran into us!"

In spite of that, he was a good driver who had no further accidents, a fast but skilful driver, who best of all enjoyed exploring slowly down

byways, green tracks, and out over turf, with eyes for any unknown hamlet, manor house, or little church that smelt of stone and plaster, and seemed waiting for just us, in a dark or golden daydream of its multiple, sad epitaphs. Hardly anyone did this, so farmers did not mind, and the churches were all open. Several times it led to a bedded axle and a spinning wheel, but local help was never grudged. It was cars that kept the circle in good shape, affording quick visits at the drop of a telephone, or extempore ones without its use. "Suddenly drove to see the Lambs", Edith records when Rex and Cecil were with her. "We all felt they loathed us. Cecil adored the sensation. The painter Henry Lamb stared at Rex all the time – never taking his eyes off him. We drove back laughing immoderately at having been so unwelcome." All the same, though Edith assured him serenely that "people do pay visits in the country", Rex was uneasy about this; especially when inflicted on a brother artist, knowing that the old-world social call had implied a fibbing servant, trained to say "not at home". He could also be made uneasy – unless it was carried out swiftly and with skill – by the "swoop", as the exercise was named by Lady Diana Cooper; whereby a party swept up the drive of a stranger to the very door, to take in his house for a moment, and make off. Rex told me he was a passenger with such a party, arriving in two cars, when they did this in the same place for the second day running. "What is the meaning of these extraordinary visitations?", asked the owner, coming out. "What are you trying to do?" – "I'm trying to turn round!", said the agitated driver, eager to escape; while Rex squirmed at the lack of courtesy.

Life in those twenty years of the Between Time was enjoyable, on the levels I write of, with the precarious enjoyment of a rigid but more beautiful world dissolving, and a freer but uglier one not yet established; of social rules relaxed but not repealed, (with many modern bureaucratic rules not yet imposed). Anything could be said in mixed company, but was not, out of deference to women. Free love was more a topic than a custom, and if respectable girls had lovers they had them discreetly; many did not, before marriage. The dancers on the ballroom floor might move on, late at night, from a sensuous whirling in Victorian waltzes to a sensual rocking, cheek to cheek in some nightclub. Rex relished both, formality and freedom held in equipoise. Exploring landscapes, he spoke wistfully of remembered unspoiltness, but then, out of his commonsense, allowed that you could not have clattered across the cowslips on Salisbury Plain in his father's Gobron Brillié, or found petrol within miles on the other side, had you succeeded.

Edith Olivier, a little under sixty, was enjoying herself beyond

measure. Rex and Cecil gave her a dinner at the Eiffel Tower Restaurant. "We walked the streets – the boys in wild spirits and pretending I was drunk. I can't think why the police didn't arrest us, as they led me along with my fur coat wound round me (often over my face), and kept pushing me so that I reeled, and then caught me." According to Cecil she would throw herself into a gesture – "my lover wishes it!" (meaning Rex). According to Rex, when at last they lifted her into a cab, weak with laughter, the taximan showed utter, silent disgust. Thus the Rector of Wilton's daughter was brought home, where the noise continued. "Both real schoolboys."

"We mustn't let Edith go too far", said Rex, when another such night was proposed. "Which reminds me, Edith, this time I do trust that you will *try* not to let the ginger beer get the better of you, but still, we'll let bygones by bygones. However, I mean to keep a good eye on you. I *know* you, remember." After a night out with the same pair, to see the comediennes Nellie Wallace and Beatrice Lillie and go back-stage to meet them, then to be entertained by Sophie Tucker over lobsters and champagne, "these boys are darlings to an old hag like me," she wrote, "making me feel *they* feel me their contemporary". It was bliss, but of a slightly insecure kind, as when Rex drew her portrait, "making me look a very old sad woman. I am horrified that he *thought this like me.*" He possibly did not, being still quite surprised himself when he got a good likeness, but this would be discounted; for what was drawn must be truth to him. One day she overheard her elder sister, all fond indulgence, pronounce it "*not fitting* that I should be friends with the young, but what am I to do, when I live among them?" Cecil, of course, thought her eager to have Rex in her bed.

When at some dinner party Cecil was berated, in his absence, by Virginia Woolf for putting sketches of her in a book without permission, Rex felt disloyal, but could not offer an adequate defence. The fact is he liked the company of the gay and superficial, and though he valued vintage conversation more highly, this was less relaxing, more demanding of his best. Easily available friends who could provide it and were conscious of unusual affinity with him, as he with them, were David and Rachel Cecil at Rockbourne, about ten miles from Edith. He stayed with them once or twice, yet in fifteen years their meetings were not very many. "He was one of the very best talkers I have ever met", says Lord David, a good judge, being himself pre-eminent.

He was the perfect man for a small dinner party. In musical terms, Rex was not a soloist, but a player of chamber music; the

ideal member of a quartet. He never appeared to dominate, yet in his company the conversation would not flag or get acrimonious or stodgy. So many good talkers talk only in one key, but he modulated from major to minor, from high to low in the scale, and yet always harmoniously. His art seemed natural and spontaneous, bubbling up under the stimulus of the moment.

When alone with these friends it would come no less natural to bestow an unpremeditated confidence. But the Rex who liked schoolboy raids between bedrooms, verbal rubbish, dance music, monologues in character by Oliver Messel, as funny as they were filthy, absurd games with a dog or cat, that animal, instinctive, ordinary Rex was not found in this friendship, where two minds of rare quality delighted in each other.

Then there is the curious case of Walter de la Mare. Rex placed him top among living poets, illustrated him better in two books than any-one else, even had for many years a home within four miles of the poet – and met him only briefly three times, once while staying with the Desboroughs at Taplow, when the literary lion was invited to breakfast, as he often was, rather against his will. Directed to a sofa, they took to each other very quickly. A new important friendship lay open, yet Rex made no request to drive over from Farnham Common, ten minutes away, though he would have been welcomed by one whose tea parties brought together many people connected with the arts. Needless to say, no approach was made by me on my own behalf, for initiative was something I had too little of, and diffidence too much; however, this was made good, later on. Perhaps de la Mare saw Rex as the darling of a richer world than he cared to frequent. Perhaps Rex waited for an invitation, being modest, and one who could normally afford to. He would have loved the man no less than he loved the work. On the other hand, the talk of most writers in a group he found selfconscious and competitive, as at Lady Ottoline Morrell's "Thurs-days", preferring the wider catch at Lady Colefax's, Lady Cunard's, Lady Aberconway's.

He liked to be with Cecil Beaton, if not too often. He liked an uproarious Sunday at the Daye House, when Edith on return from church was got up as a Toulouse-Lautrec trollop in extraordinary clothes, "with huge scarlet lips, and inches of black round the eyes", and taken like that to Stephen Tomlin, the artist. It happened that Tomlin had spied a romantic house among ilexes in a solitary valley of the chalk, and to this they drove, bumping over the turf, and at last looked down on Ashcombe, later in the year to become Cecil's home.

That afternoon two girls dropped in at the Daye House, and Rex set eyes for the first time on Caroline Paget, the eldest Anglesey daughter, and her equally beautiful sister, Elizabeth. That night there were high-jinks again; and much the same later on, when Beaton was replaced by Walton. "It was all that buffoon Willie's fault" – he had stripped Rex's bed to get him up – 'I still grind my teeth with rage at his locking his door the only morning I was up before him."

Rex paid several visits to Ashcombe, helping Cecil and constantly designing improvements, free of course: a stone entrance door in the Gibbs manner, a four-poster bed with twisted brass pillars. This was for Cecil's own Circus Bedroom, decorated one rainy week-end by five artists, and by Rex with a Fat Woman, in that vein of grotesquerie that yielded his Reversible Faces. He also caused offence to an amateur artist, Ruppert Von Bismark, by improving his Strong Man, and passed it off by saying he thought the whole thing was a joke.

Such labours of love held up work on *Gulliver*, which did not appear until the market had begun to slump, and nevertheless was sold out before publication. Rex appears to have been paid £195, or roughly £7 10s per drawing, (equivalent to about £160 today). "I am poorer than I ever thought I should be", he told Edith. No advance payment had been offered. What Cohen did offer, during the work, was £150 for the originals, or less than £6 a piece – in order to resell them promptly for £350. No commercial gallery would have required 133 per cent commission, but Rex was innocent, and he was needy. Later he bought them back at considerable loss, and held on to them. Thus in the end he received almost nothing for his masterpiece in book illustration (Pls 16 and 17, pp. 147 and 164, and see note). In a world where "the Smiths and the Jones and the Cohens and Cohns" are all rapacity's sons he was a novice, and never likely to complete his novitiate.

His private work might take him out of the more shark-infested waters, but here there was the problem that rich, potential clients simply did not know what a fair price should be, and left it to him to suggest; even those who were friends, as most of them became, could not tell what sum he ought be asking, to do reasonably well, and were probably quite willing to pay it, though naturally relieved when the fee turned out to be modest.

Stephen was ill again, and Siegfried was distraught: "I would gladly die for him." This love meant far more than the writing of books, and he settled in at Wilsford. Rex, due for the week-end, was recommended to stay at Edith's instead, with a chance of coming over if all was well, but refused, slightly piqued to be so commanded. However he knew

that he was now less important. A month later a visit was permitted and Siegfried records –

> S. showing him his shells, and both very happy, except on Sunday night when S. was rather tired and despondent, and Rex was self-reproachful because he'd made an exquisite little drawing of a shell, which he tore up because he thought it would discourage S. from drawing shells. So I was late up with the two of them, in succession, straightening out their sorrows!

In other words he felt in charge of both his young friends, like children, though they had been friends twice as long as he had been with either. He had forcibly put himself in charge. Soon, hour after hour, he was opening his anguish to Edith whenever he could get her there to dine, while the sufferer upstairs lay coughing, with a dreaded tinge of pink. The Siegfried idyll was over. Concern grew to possessiveness. Now Rex was not allowed to stay in the house. He came to lunch, and after it, not before, was permitted a visit to the sickroom; Siegfried notes the times, like a nurse filling in a progress chart: "He talked to S., 2.30–3." Some days later when Rex called again he was granted a few moments only beside the bed, and then found that Glen Byam Shaw, a crony of Siegfried's, was staying. "I *like* him, but feel very resentful."

Siegfried could not work. He could think of nothing else. He had to be everything to one who was everything to him, and in peril again, which the doctors now confirmed. Thus it was that "dear Rex", as Siegfried always spoke of him, simply because he submitted, came to feel himself a stranger, uncertain and shy, in a house full of memories, awaiting now the dreadful event of Stephen's death, a house suspended in the peace of its surroundings – as it would continue to be, could they only have foreseen it, for another half century and more – and under the same not-so-fragile owner.

Siegfried's fall was not immediate. It was tragic, being brought about by himself and not demanded by the situation: a noble mind made abject. He quarrelled with the resident nurse, went to stay in a hotel, left without saying goodnight, was hauled back, and bundled out in five minutes. His power had gone, because Stephen, though detesting the nurse, relied on her completely. Siegfried dared not agitate the patient – and he did! He withdrew to a distance, wrote reproachfully, causing tears; called, and was refused an audience; then found that E. M. Forster was staying, and felt as Rex had about Byam Shaw. Stephen was beginning to wish that he would stay away for ever, even

speaking as if he hated him to Edith, wise and troubled confidante of both. "He's like a half-fairy creature – captivating and cruel", she wrote. But by now sheer self-preservation was operating. Siegfried, by caring so fervently, was ceasing altogether to promote his good.

## ·XVII·

THE STAIRCASE at 19 Hill Street, Mayfair, rises round the hall to a landing, from which you look across to Rex's mural, over twenty feet wide above the slant of stairs (Pl. 21). It was the London house of Captain Euan Wallace, MP and Barbara his wife, she the eldest daughter of Lutyens. "It's such *fun* painting again" – after the *Gulliver*, this was – "I have fun looking down from my scaffold on the guests as they arrive. Sometimes I'm dragged in to lunch too, but I try to get food sent up on a tray." The first step had been to provide actual quarter-pilasters in the corners, so that a pretence column could be painted beside each, and the whole composition take off from illusion. It is a picturesque landscape again, with distantly a dome and a spire (after Oxford), a bridge and a river (after Claude) prancing horsemen, a gazebo, etc. But here there is no alternative sense of a chinoiserie wallpaper. The aim was to open a room convincingly on to a portion of paradise, as he conceived it, by the melting of a solid wall.

The composition is not balanced and tranquil, and by that criterion is a poor one, random and unsettled. This resulted from a wish to suffuse it with an air of gay romanticism, while pointing here and there to instances of fun – explainable as in a narrative picture. The fun may be subtler than it looks. Cupid, secretly enjoying the stolen apple, is not unobserved by the slim Negro footman, elegant in crimson and gold, who waits for his mistress with decanter and glasses, a rose twirled in one insolent hand. Nancy Cunard might sport a black lover, but a footman like this, in a casual setting like this of indeterminate date, where beyond the formal terrace all is disorder, has never existed. Rex's murals can be described as inconsequent, but not dismissed as uncontemporary, (if that test is one that ever matters); for there is no other period in which they could have been painted: the game they play with the past was a modern game, in its time. This one is also a kind of action-mural, reflecting the process of its own creation, where incidents were devised, debated, expunged or modi-

fied, and you feel that this might be going on still, if the artist were still about, and John and Billy Wallace, for whom Rex also concocted some of his Reversible Faces, still alive as children. One morning they discovered that the leaves scattered over the terrace had been swept into a heap by the garden boy. Another day a large spider appeared on one column, of the kind that moves round a room with long pauses for no apparent reason. When they returned it was found to be a few feet lower down; and there it remains. That January of 1931 Rex spent a ski-ing fortnight with the Wallace family in Switzerland, and though he wrote of "six falls a minute", surprised everyone by his agility in getting the knack. The guide, who had to have a testimonial at the end to show the civic authority, was not pleased at first with Rex's before-and-after drawing of himself as a duffer turned expert.

Stanley Spencer makes us share his delight in shapes, in the sheer repetition of quite commonplace shapes – lines of brickwork, bare feet, curtains blowing, piles of bread-and-butter. For Rex a good shape expresses vigour, and is presented as a paradigm. Smoke cushioning out from a chimney – piped water pointing its tongue – a dog that bounces like a rocking horse – the crimped crater of a rose – a detonation of lilac – the gratuitous flick of a lane into the distance – a spread of sea-foam like a hand of cards: there are examples everywhere in his work. At its best, rather, a shape expresses vigour; for at its worst it repeats a trick, a stylization he felt himself too easily content with. Hence the discipline of painting from the life in Italy, and the gradually subsiding groans as it became less painful. The discipline was not undergone to reconstruct his language of invention, but to purify and enrich it; or that was the hope. Already his handling of colour had improved. Nevertheless, "it's painted in rather my old boring way," he told Christabel Aberconway, "with horses all like this [sketched prancing] and all the trees forming the same sort of composition [sketched crossing], so you may not like it". Perhaps there was genuine disappointment behind this modest disclaimer, but Edith notes that he himself liked it "better than anything he has done". So did Tonks; which pleased him.

A complete dining-room was now to be painted at Port Lympne in Kent (Pl. 28) for Sir Philip Sassoon, once Lloyd George's private secretary, now Secretary of State for Air, the very wealthy head of that Jewish family to which the poet belonged, though they had never met. Osbert Sitwell was resolved that they should, over dinner at Carlyle Square; where Rex made a fourth, and according to Siegfried gave the party distinction, "pale and aloof, and looking down". He was looking down in embarrassment at what was gratifying Osbert, a wary con-

frontation, in the family name, of poetical vanity with worldly sang-froid. Later Siegfried wrote to Sir Philip, "You see we are not as alarming as we look!", but whether he meant poets or cousins was not clear.

Rex had adopted for no personal reason, and merely without questioning it, the anti-Semitism of his fellow-countrymen, unaware that he owed his very existence to an eighteenth-century German-Jewish piano-maker. (See note to p. 4.) He had grown up to his father's grudging admiration of the "Jew-boys", and had found in Society the same fairly harmless derision, except of course where a particular Jew was a lavish and entertaining host, when general dislike of the breed found room for the exception. Osbert was amused to repeat the comment of some Chinaman on Good Friday, "This day, Clistians, say, Sassoon-men killed their god!"

Sir Philip already had a painted drawing-room by Sert, an *Allegory of War* in moss-brown and gold, with elephants trampling the chimneypiece and the German eagle violently defeathered; notwithstanding which, in 1940, still in Paris, Sert would be flattered to report, "The Boss wants me in Munich." But Sassoon had by now, as somebody would soon be remarking, "graduated from Sert to Rex Whistler".

Rex found an undistinguished house on a superlative site. Like the Tate Restaurant but much smaller, the dining-room had a central door at each end and windows on one side only, also a barrel-vaulted ceiling of complex curves. He imagined it as a three-sided loggia supported by terminal figures all round, wide open on the fourth side to a painted landscape seen through them. That was how he designed it in water-colour, but even when the twenty or so lifted elbows were removed, and the figures were turned into caryatids, they still seemed too obtrusive. "His Majesty has commanded my presence down at Lympne. It's a *great bore*, but I shall be taking further drawings down with me, and I hope that *this* time the business will be settled – though there will be the *agony* of *saying the price*." Sert had never felt a twinge of that. When the Waldorf-Astoria rang from New York for the price of a painted ballroom, he finished his anecdote, sauntered to the telephone, and returned without delay, better off by half-a-million dollars in today's money, probably the highest fee ever paid for murals.

Rex now hit on the right treatment. He would turn the room into a blue-and-white striped tent. It would seem to have been put up between two doorcases of stone, and be looked into by windows at the back. These would have real curtains of the same stripes, exactly matching the painted material stretched in wrinkled *trompe-l'œil* across the curvy ceiling. It was not as rational as the first idea, but

much lighter and more elegant. On the main wall real tent poles (half-round) should be topped by real cords, bows and tassels of gold braid. Every chance of a trick should be taken, in this game between the real and the imagined.

Also he would lift the whole room, or tent, as if to the first-floor level of the pictured scene outside, so that we look down between the tent poles on a town with several favourite buildings – a Palladian Bridge, a Stowe pavilion, St Martin-in-the-Fields – to see a lady arriving in an open carriage on a visit to a friend. There are no spiders, there being no children, but there are several quiet jokes. The lady's country house, far off, is Faringdon, and the little boy waiting for the paddle steamer has a coroneted B on his trunk, for Berners, the eternal schoolboy. M. Stulik, the proprietor, stands at the door of "La Tour Eiffel", where Rex and his friends often dined. It is all another metaphor for the ideal: an urban version of a golden age, and mostly very English, with here a very Roman church and procession, and there a canal that shoots away to outpace even Le Nôtre. Ideal worlds can afford to mix metaphors. Samuel Palmer also blended the homely and the foreign when he drew a vine pergola outside an English inn, and a walled village of cosily-thatched houses. (See note.)

At last Rex braced himself to ask £800 for painting the entire room, and mentioned this to Cecil Beaton over supper at the Savoy Grill, in the presence of Tom Driberg; for he was too ingenuous to know that a gossip-journalist would not only publish it without permission, but would assume that Rex wanted the publicity. So might Cecil. A friend who took in the *Daily Express* telephoned Rex at breakfast, when he was about to drive Cecil down for his house-warming party at Ashcombe. Putting off departure, to the latter's chagrin, he made a "rush to Park Lane", as his engagement-sheet records. There he found Sir Philip exasperated, but willing to exonerate. A follow-up letter seemed politic.

I am still so miserable about that wretched press notice of the painted room. Everyone thinks me the most loathsome swine, I'm sure; and I can hardly expect them to credit the fact (though it *is* fact) that I never for one instant thought that the information might reach the papers . . . *that is the case, upon my word of honour* [heavily underlined]. The possibility even (though it was incredibly stupid of me) of that happening, did not once occur to me.

In faint self defence, in the matter of having mentioned the sum I should receive, I may say that it is not as unusual as you think to divulge the payment to be received for a job (though this perhaps

makes it no less a breach of confidence). I know the precise sums received from their patrons by several of my fellow painters, and have always told others previously what I was earning.

I have written to Driberg to tell him how caddish and grossly ill-mannered it was not to have asked my permission - *do please forgive* me for having unintentionally been the cause of this horrid piece of vulgarity.

At the top and bottom, to beguile, but not so florid as to look like merriment, there was a burning newspaper - and a draped urn labelled "remorse". In doubt whether he had asked too much and looked conceited, or too little and looked silly, he went on squirming in mind because the world, he felt, had been debating just that question over its breakfast; and for some days he lost all pleasure in the job. Driberg thought him a simpleton.

When he had something of substance like this to expiate, which was seldom, he could write a good letter, circumspect and taking pains with a first draft, but mostly his apologetics were employed on minor social lapses when, whatever contrition was appropriate, he packed in twice as much by underlining. He underlined like Queen Victoria, though more often to plead than to pronounce. As a boy, I assumed that this was the obligatory style of the 'Bohmord, until one day I saw a letter from Osbert Sitwell, straightforward, plain, unemphasized; and guessed that Rex's style might be his own. We both laughed over letters abandoned on his table with only three words written; "It was *so*" - heavenly, disgraceful; or "How *can* I" - even *faintly* hope to. "How would *you* put it, then?", he asked, and it annoyed me that I could only have put it in the wooden terms and shapeless scrawl of a schoolboy. More than most people Rex wrote as he talked - and by intention, too - to convey an intonation and a very gesture; and since he talked exuberantly he wrote like that. "You *never* said if you liked my idea." Here most people would feel no need to underline. His style was accepted generally as a kind of Baroque, full of verbal pilasters that carried only their own weight. "I have thought of you continuously during all these months", he wrote to Stephen Tennant in his illness, when "constantly" might just have convinced, and a simple "very often" have sounded more fond. Then there was his curious and affected way with nouns of duration. "Coming to London in a minute or two", (that is, two days later). "I *will* speed it up in a moment" (perhaps in a fortnight). In a similar vein an amusing letter made him "*yell* with laughter" (smile broadly). The aim in general was to keep relations smooth, and if some ugly nodule of reproach poked up, to

dissolve it with a charm of words, or brushwork. "To ingratiate himself, if still possible", he wrote, after missing a lunch party, above a thirty-minute water-colour, offered gratis, with the suggestion that it might be useful as a bookplate. It was. Sometimes he charmed away imaginary warts.

It was many months before the canvases left London, followed by five largely spent at Port Lympne, where, because he had had an assistant to pay, and could not resist adding a *trompe-l'œil* map and much else, he grumbled at last, "I have been so terribly out in all my estimates of this job." Now Sassoon wanted to shut the house for the winter, and pack him off, to complete the work next year, quite oblivious, as rich people are, of anyone's need for money at any particular moment. But, "I can do as much in a day as I do in a week when the house is full", he argued – and after "a slight skirmish" his host gave way testily, not without a thought perhaps of the hours his hard-working but intermittent artist had spent in talk, outings, and once in three days' flying with the RAF. "I have never before been pressed to leave my work unfinished!", Rex observed to Edith.

Now Cecil positively demanded their presence at a farewell party before his first trip to America, and "I do so dread that visit to Ashcombe", Rex said, foreseeing the usual crowd of superficial people, some of them dislikeable. It is noticeable that he never advanced beyond "My dear Cecil" in letters, though Osbert Sitwell and others, far less frequently met, moved from "Dearest" to "Darling". What he wanted instead was "one of our own delicious picnics", all the more because for five months he had not even written to Edith. She had made no complaint – merely noted after gossiping with Stephen, "Rex seems lost to us both, between his Sassoon painting and Malcolm Bullock."

This was an older man met in Philip Sassoon's company, rich, worldly, cynical, notoriously homosexual; and they were off to Paris together, to the fascination of Rex's young friends. They stayed at the Hotel Foyot opposite the Luxembourg Gardens, and visited all the famous places unknown to Rex, who had hardly seen Paris, except many times from the train going slowly round it. According to Bullock he was determined to be independent, and set out to buy busts for his studio, but returned shortly "with his hair over his face – couldn't make himself understood – the traffic went the wrong way – from that moment he never left my side". They saw a serious play, but Rex's lack of French made it pointless. They had front seats at the *Folies Bergère*, but he was "disgusted by the smell of female flesh" – heroically endured and made the most of by Bullock, as conducive to a sexual

weaning. He lay on Bullock's bed while they made plans. No claim is made that any carnality ensued. Still, it was regarded as a happy six days and was followed by a short tour of the West of England together. If Bullock can be trusted, it seems that Rex was, to some slight extent, provocative, and thought it harmless, there never having been any question of more. To Bullock, a significant incident occurred when they were playing the Truth game at a house party. Rex had to answer truthfully whether he would prefer to spend the rest of his life alone with Venus, Adonis or Hermaphroditus. He thought deeply before answering. "Not Venus, really – certainly not Adonis – I think Hermaphroditus might be most fun!", and then blushed. Why not with Venus? Too obsessively demanding, perhaps, not to mention wayward; or, as he said, more fun to be had from ambiguity.

But the quasi-feminine stance could only pall in the end. He grew weary of being monopolized, of the free seat for any production, of the long dinner, tête-à-tête, when any friend could be demolished. So he embarked on "the most awful correspondence", leading to the return after Christmas of a very expensive book, with the prim comment that he did not care to accept more costly presents than he could afford to give, which precedent shows to be manifestly untrue. His good wishes for Edith included the following: "May the New Year bring *ruin* to Secker [her publisher] and (partial ruin anyway) to Malcolm B." She wished he would break more than partially, fearing for his reputation. But that harm, he replied gloomily, had been done already. He must have known that it would be done; perhaps it rather pleased him. Anyway, it was not very serious harm. They got on to more acceptable terms, and later Rex painted Bullock a large panel, a *Farewell of Ulysses to Penelope*, a theme chosen for a personal reason not apparent to Bullock. It is his most Claude-like composition, but with a multitude of active figures, many of them naked youths and boys. One of these in the foreground would be impossible in Claude. A madman, foretelling the future in a pack of cards, has the artist's own grimacing features, hideously awry.

Meanwhile the Wilsford story took its helpless course. The new nurse had "lovely blue eyes", but they were close to tears in a fortnight, the servants were so rude to her. An apprehensive Siegfried was allowed back, lavishing presents on his "heavenly, inhuman" friend; who was not to be mollified by them. Stephen had thought up a present himself: he told Edith he would like to do the frontispiece for her new novel, knowing she could not refuse it to an invalid, and would feel what she did – underlining the words in her journal – "*I want Rex in all my books.*" However, that proposal was not pressed home. Rex

was back for two nights, wearily trying to bring peace. He lay stretched out on Stephen's bed among the necklaces and bibelots – but not to Nurse's satisfaction, "lying about, talking in this absurd way – very modern, I suppose." The invalid's lungs were bad again, and Siegfried in distraction made mistake after mistake, like arriving un-invited, to find him without make-up. Rex tried to intervene between tantrum and ensuing reproach, but in vain, and fled at last, to pace about the garage in distraction. He hated scenes and all social awk-wardnesses, and I have seen him fold himself into a sofa, knees work-ing with half-humorous embarrassment, humming loudly, pressing fin-gers into ear drums, to avoid hearing the words of our mother, as she amiably dismissed, on our behalf, an unwelcome visitor in the hall, whom she would have entertained, but for us. To Edith, Siegfried talked of nothing but these troubles, with "agonizing sighs" of "where did I go wrong?" Even now the end was delayed. Stephen would not see him for a year, but when told he might go to America at once wanted him back. And so on. From here, the story does not much involve Rex. So we will leave the banished Siegfried at the post he has driven miles to occupy: in a flower bed outside a Wilsford window, observing unobserved a supine Stephen. He lies there, not asleep, but with eyes shut and a seraphic, calm expression.

Headpiece to *Gulliver's Travels*, 1930

# ·XVIII·

REX'S CHARWOMAN and daily help for many years was Mrs Landeryou, well-known to his friends. She seemed to me as a country boy to epitomize the sad dignity of London, as she sailed along the street, quite kindly, but detached, impassive, disillusioned. When she brooded at a sunny back window she seemed the soul of London itself, that had never expected or imagined anything other than blank slabs of brickwork, and big downpipes with their kinks and nervous tributaries. She became quite good at taking messages, less so at improvising them. Diana Cooper telephoned.

"'E's 'ere. But not available."

"Why not? What's he doing?"

"'E's in the lav."

"How long will he be?"

"Can't say. Might be long or short."

This was recounted at the next smart luncheon. A true story preferred by him concerned one of those periods when he was working very late, night after night, and constantly tapping with his heel on the floor-squares, to some actual or remembered tune. He had bought himself a repeater-gramophone of American design on which you stacked "seventy-eights", to be dropped one by one with a thump on to an ever-spinning turntable. One morning his neighbours from below came up to say courteously, "We do understand that as a professional you need to practise – but could you possibly finish your tap-dancing at an earlier hour?"

To return to the country boy. I had been put down for Balliol by MacLaughlin, had failed to win a scholarship (one of his few failures), had been offered by the college an *ad hoc* sum for three years; later, I believe, supplemented privately by Sligger Urquhart, the Dean. After driving me there in October 1930, and helping me arrange an unsmiling room high over the front quad, Rex hugged our mother in the car.

"To think that Laurie is actually at Balliol!" He had high hopes of me always; and so often I should disappoint. His hopes at that moment were of watching me expand into modest brilliance like Sachie Sitwell, or at least swarm into it like John Betjeman – join societies, know everyone that mattered, write for undergraduate magazines, work hard and take off into some congenial career, as writer or architect or both; and he genuinely thought, perhaps humorously feared, that I had as much talent as himself, if not as easily effective – *that* he could not have thought. Being selfconscious and unconfident, I joined nothing, made few interesting friends, and went to few functions. With only a pound or two in a post office account it was not easy to go shares with others – or I thought it was not. Edith was quite right when she came to tea with me and we "talked poetry and chaffed ... he is quite a little boy, and only looks like Rex when," etc., etc. As for Rex, the long silence had done no harm there. "We are completely at one", she wrote, "and can talk more easily than any two people." A bold enough claim. "*How* we understand each other."

Oddly enough I did not greatly mind my seclusion. I was not idle. I had skipped back over the Georgians, and lived and wrote in my Shelleyan or Keatsian dream, and, more irrelevantly still, in their mythology. This did not worry a brother who painted Glaucus and Scylla and Ulysses; for Poussin to him might naturally be Keats to me. Had he not simply disregarded what had happened to art since *Les Demoiselles D'Avignon*? Well, yes, but he had found a manner and a public at once, and could afford to snap fingers. "Rex came to my room at midnight," Edith wrote, "and read me L's 'Death of Pan' in such a lovely deep voice." He was forming a plan.

*The New Forget-Me-Not* had been so successful that it called for a sequel, *The New Keepsake*, with similar trifles, one of them a poem by Sassoon which succeeds in creating nostalgia for a future, not a past – a future that has simply outgrown war, still a tenable notion in 1931. There was another choice paragraph by Max Beerbohm, again written after and about a drawing, one of four sent out to Rapallo. Max had written to Rex,

> How jolly to be young and gifted and prolific like you, and to fold masterpieces down the middle and cram them into small envelopes! I hope the Philippine decorations [Port Lympne] are proceeding apace and splendidly – and not being folded down the middle out of sheer light-heartedness.

This venture, and several book wrappers, had artist and publisher often exchanging visits across the Tottenham Court Road. Rex asked

Kenneth Rae if he would care to publish my poems – with perhaps a few decorations, by way of a bribe?

Memories of hopefulness and laughter survive from that small firm behind the British Museum, where of three partners the amiable "Wichard" Cobden-Sanderson ran the business, Boofie Gore (later Lord Arran) lay on the hearthrug biting his handkerchief, and Kenneth briskly and with taste planned the book; where also Edmund Blunden, a self-deprecating ouzel, might drop in with a jar of small oranges and a wooden fork to pass round. But Rex was holding up the printer. "We shall be much obliged if you will let us have the remainder of the illustrations within the next hour or so." There were no less than fourteen when my *Armed October* came out in 1932. "This is the first summer for several years that I have had no painting job to do, business is very bad indeed and I see I shall have to go on with my revolting little decorations for this and that, and wrappers and advertisements." He earned nothing from my book having done all the illustrations as a present.

Before this chance to be a published author, I had begun quite suddenly a happy love affair with a woman old enough to be my mother, but young for her age, vivacious and exuberant. Rex was upset. He wrote, and I could think of no answer. He spoke out when we met. "I shouldn't mind in the least if you had a mistress." What did he think I had? "Presently you will be writing her love poems, and then you will be finished!" Why should that, of all aspects, be the fatal one? He saw calf-love, helplessly trapped, which I found humiliating. After all, such beginnings can be helpful to diffident young men – in the abstract he would have said so himself – and they duly have ends; then the cost is in the pain inflicted. Years after his death a small clue was provided by Bill Montagu-Pollock, his companion in Rome. One evening he came to 20 Fitzroy Street to dine out with Rex, and he maintains that he was kept waiting, with his drink renewed, for about two hours, while Rex wrote me the sensitive, painstaking letter I have referred to, every phrase of it weighed and reweighed. "Periodically he would stop and confess to me that his motive in writing was nothing but jealousy" – meaning envy. In a moment of typically disarming honesty Rex said this to me himself, and remembering his social ease and popularity, I discounted it completely.

He sent copies of my book all round: one to Siegfried Sassoon. "As you will see, I have made the whole *appearance* of the book disgustingly precious, so please try to dissociate *my* part ...." Thus from the first a doubt obtruded whether new poems are best published with illustrations. On the other hand, what if without any they would not

be published at all? In my second year I changed Schools, and also rooms, moving to pleasanter ones overlooking the little church. He was now mildly scornful of my conversion to socialism, thinking it facile and conventional. I thought it weak to conceal it from Edith when she came to lunch, but I argued ineptly, allowing communist dictatorship to provide her with a weapon against social democracy. It "made me hate him", she wrote that night, and she gave up bothering about the younger brother. "I don't want to see him again." Such a brother might identify himself with underdogs. Rex need never do that. Yet he had compassion for them, though a stranger might not have guessed it from his heartless jokes: as when he proposed to reply to a tramp who said, "Got to live, haven't I, guv'nor?" – "I don't see why!" He was more disappointed with my general performance, when, inviting himself for the week-end, it was he who made the introductions of interest – for example, bringing Blunden to my room, to write his name neatly under mine, letter by letter, in a pen-and-ink Rococo cartouche already prepared on the title page of his *Collected Poems.* "Are you going to go obscurely through Oxford like old Ronald?", Rex asked discontentedly, remembering Fuller.

Now the book decorations he resented doing included some of the finest: those for *The Next Volume,* a private book of verse by Edward James, immensely rich patron and collector of the Surrealists. It was he who invited decorations for yet another first book of verse, but someone whose name was then unknown to Rex, John Betjeman. This never advanced beyond a sketch for the title page of *Mount Zion.* A lost chance! But though responsive to the wit and the originality, he never really took to the sophisticated irony of Betjeman, where, for example, the middle-class object of adoration is unaware of the glance over her shoulder – a glance deliciously exchanged with anyone equally alive to subtleties of class distinction. It was not his kind of humour. He made no natural pair with the troubadour of double-feel, and later he reacted as Edith did, one day, when "John made me very uncomfortable by all his carping comic talk about the Church of England... This is really *protective* as he feels religious but thinks his friends will think it funny, so he says *he* does" – especially in the company, as then, of a contemptuous Roman Catholic like Evelyn Waugh.

There was an Axminster carpet designed for James, and a grandiose equestrian portrait of him. After that, he was constantly dropping in uninvited, to stroll about the studio asking tiresome questions, impressed that even the telephone was not answered (while he was there), so intensely, Rex explained, did he hate any kind of interruption to his work. It is fair to add that James took no offence when tactfully

enlightened by Oliver Messel, and told the story himself. Also, in the absence of major commissions, there were several house-portraits done in oils, where there may or may not be human figures that are like-nesses of owners, but the true subject is the house itself – in its mood, as he felt it. The best is a very large chimneypiece panel for Haddon Hall in Derbyshire, so shaped as to extend the surviving fragment of an ancient painted panel. For this he paid a week's visit to paint a smaller version first on the chosen hillside, and make accurate notes of the architecture.

A more perfunctory landscape has a certain historical interest, and it resulted from another change of family house. Rex had never been reconciled to Farnham Common, depressingly suburban, or to a house that all agreed was too small: he and I shared a cottage bedroom for weeks at a time. We all wanted a country home with some charm, and one was found at Whitchurch in the north of the county, called Bolebec House after a vanished castle. Here my father in retirement began to carve wood at Rex's suggestion, taking lessons in London from an old Italian craftsman, and producing an acanthus panel and a vigorous trophy; and here Rex delighted to design brick piers with pineapples, together with new windows and door-cases, carried out by one of my father's joiners. Before this could be done, my mother, on a visit, fell and broke her femur. "I know that you are feeling more pain than you would admit to. You have always been to L and me a wonderful example of selflessness and almost unique integrity, and now we must add courage to your list of honours!" In the new garden Rex made with my help what he called in Georgian language "the improve-ments", a short avenue of limes crossed by one of flowering cherries. "Isn't it nice to think", he wrote to her, "what a good turn we are doing posterity?" There was also a raked wall of turfs designed to make a terrace of a sloping field. As we stood admiring our completed ramparts, he observed – "There's really no reason why our work shouldn't remain here for ever!" Within a few weeks part of it col-lapsed and we had to rebuild it at a less ambitious angle. Cherries and ramparts have gone, but some of the limes remain, now leading no-where.

The garden ended in a crest of rook-racked elms, overlooking two fields of ours, and beyond them the wide Vale of Aylesbury, enclosed by the Chilterns. This was what he painted, to celebrate arrival in real country, when Shell asked him for a poster, and in it, seated under a beech, he painted me (Pl. 30). In 1971 a proposal to build London's third airport at Cublington, very close to Whitchurch, and calculated to link London and Birmingham in due course with one

eighty-mile ribbon of urban development, was approved by the Roskill Commission – with one dissentient. This was Professor C. D. Buchanan, and it was in support of him that public opinion against the airport was marshalled on such a scale that the Government abandoned the project, to the general relief. An enterprising conservationist had hung up, outside the room in the Piccadilly Hotel where the Commission met, a copy of Rex's poster; and "this," said Professor Buchanan, "as I passed and repassed it day after day, helped to form my view. . . . It was as potent as any evidence I heard." No side effect could have pleased Rex better. Another landscape of the period, *The Buckingham Road in the Rain*, is directed towards the actual skyline that Cublington Airport would have defaced (Pl. 25).

Bolebec had its nondescript charm, but Rex would hardly have stopped the car here on some saunter, to fancy himself into it, had it not been for sale. I had many such saunters of happiness with him, but Edith probably had more, and one with her may epitomize them all. On a summer afternoon, this year, they set off exploring up the Avon Valley and finally arrived at Alton Barnes, under its White Horse on the Marlborough Downs. Near the end of a farm track they found a little church, Saxon and Georgian, where the churchyard gave on to the lawn of the Old Manor, through a low iron gate. They stood there taking in the rosy Georgian brickwork, the sash windows irregularly placed, the backcloth of trees, and the cool flourish of the downs. It had everything you could possibly want. Then, when he had vividly pictured his days here, perhaps with some unknown companion, some "not impossible she", there came as always the reflection, "not this". His paintings would never hang in those faintly-discerned, low rooms, his clock in the hall would never chime the peaceful afternoon away as he drew, no bust of his would ever turn its back to the garden on that very windowsill. Perhaps one day, but not yet, and doubtless never here.

They drove a few hundred yards to the bottom of the chalk, then climbed on foot to a flat grassy shoulder under the high point of Adam's Grave, where they had their delayed evening tea with the whole Vale of Woodborough below them, walled on the far side by Salisbury Plain. Here fancy of the not-so-feasible kind took over. "Rex said he would like a Kingdom of just that size, and planned his Summer Palace just where we were sitting, and a Versailles down in the Vale." Possible and impossible were always interchangeable.

# · XIX ·

BOLEBEC HOUSE was the first home to which either of us brought a girl: he at twenty-eight and I at twenty-one, which argues secretiveness or backwardness, or both. A letter arrived from Cecil Beaton in Hollywood. "How extraordinarily crude he is," Rex wrote to Edith, not unwilling to incite her disdain, "his one aim now is to advertise the fact that he is having affaires with women. His letter is full of such phrases as 'I have been entertaining a great number of fairly charming people in my bed and out' – and – 'I hope to find a companion for the love-nest Lylian T[ashman] is lending me (at Palm Beach), and I shall try to 'make' one or two of the stars that I rather fancy'." As quoted by Rex, there is nothing to indicate which sex, but this apparently had not been left in doubt. "The effect of it all", he went on, "is only to make it evident that this discovery of 'his manhood' is as great a surprise to him as to everyone else! I should have thought Cecil far too cute and too sensible for this, wouldn't you, but his anxiety lest the news of his naughtiness should not reach us is overcoming him." That a friend always thought of as homosexual, and therefore uncompetitive, and therefore in a radical sense inferior, should suddenly be crowing in this way was an affront.

Great change was imminent for three of us, Rex, Siegfried Sassoon and my obscure self. First, in May 1933, Mrs Dudley Ward, the Prince of Wales's friend, invited Rex to paint her two young daughters, Penelope and Angela (Pl. 34). He lunched there, then drew on his engagements sheet a tiny pencil head of the elder daughter. Showing quite unusual despatch, he made a sketch, and was soon painting Pempie on the canvas every day, "and almost dying of her loveliness. It makes the painting very difficult." Siegfried had finally received his dismissal: Stephen would not see him again, nor open any letter from him. Then, distracting a little, there was a pageant at Wilton for the Tercentenary of George Herbert, where Rex, with a little beard and moustache, and very hot in his velvets, took the part of Inigo Jones,

carrying a model church that he had made and painted in one day out of an oval hatbox and a glass dome; it is now in the Rex museum at Plas Newydd. Then news came of Beaton's return from the States. "Much as I like him", Rex observed, "I *wish* Cecil hadn't come back yet, it gives me a feeling of restlessness."

Max Reinhardt was producing the OUDS in *A Midsummer Night's Dream* out-of-doors at Oxford, and I was to get tickets. It would be my first meeting with Sassoon, and we were all to dine at the George as his guests, including the Society girl Rex was bringing down. Pempie was certainly beautiful, with a lovely figure and a charming diffidence. The weather held, and with the May bushes lathered in blossom the scene grew unearthly as it darkened, more for eye than ear; till the fairies were mere lights at great remove, and Puck sped away with one of them in his arms. It was such a night as one should fall in love to, having beauty at one's side, and Rex now knew that he had done so. Warmth was the one thing lacking, and he had driven down too thinly clad, but I saw her lend him her coat to put round his shoulders. Warming to the full magic of the final scene, inhuman and benign at once, he was rapt away into the fairies' goodnight, following darkness like a dream with sensations never felt before, hopes hardly to be entertained. Shakespearean magic seems to have affected us all. I could not bear my mode of being any longer, and resolved on breaking out.

That the prospect could so soon have seemed to him hopeless! Six days later, Edith, then in London, received "a cry for help" on the telephone.

> Found him half-demented with love. *Desperate. Shattered.* Can think of nothing else. His hand shakes so that he can't paint. He thought he had been in love before but this is quite another thing. He can't possibly marry – as he has no money. She would let him be her lover, but he knows he can't accept that from a girl of nineteen. If she had been married it would be another thing ... This love is almost *all* misery. He says she adores him. (He can't think why!) I felt in the presence of a great passion – for he has always been apart from such things, and his is so supreme a nature. Came down feeling that I too was shaken by love.

Soon he was at the Daye House in the same state,

> absolutely dead beat and looks it. He sees no prospect of marriage and in a way recoils from the formal bond, though *if he had any money at all* of course he would rush at it. Does not think living together is wrong in God's sight, but says he has too much

conscience, though she is willing and knows her mother could not throw stones.

He is much more likely to have said she might be willing. Next day he lay on the floor of Edith's room for an hour in the dark. "His agony is piteous. He longs to die. This passion must burn itself out though he thinks it can't till he has slept with her. He told her he would not see her again for a bit and she said she would do what he thought best." And the next day, "this fever can't last, and yet perhaps he's right in thinking that only satisfaction can quench it. I have a feeling that though she loves him it isn't at all the same thing for her. Fundamentally Rex *does not want to marry* and hates the thought of planning a little nest! All this clashes with his wildly romantic love." While confessing, he had clung to Edith physically like a child, and caressed her all the time, "an outlet for his frenzy".

Soon he wanted the confessional of an even older friendship, crumbling though it was, if only to allay curiosity, and told Stephen, "she loves all the things *we* love, and is divinely beautiful. But please don't ask about it from other people. You know how shy and secretive I am ... and the whole position is hopeless anyway." Of course there was curiosity, when he had never had a girl before; with some relentless quizzing by "insensitive" Cecil. "A little romance would do him good", suggested a friend to Edith. "He could only have a *big* one", retorted that stout friend. Though he writhed under all this he did not exactly conceal his passion. He took her to several houses, including Port Lympne, when Siegfried was there, watching wistfully young love that was ardently alive; took her to theatre, concert and exhibition. He was pleased when, on his way to sleep out with the sisters in their London garden, he sensed that Peter Quennell thought his life enviably romantic. He wanted to paint her separately as faithful Penelope, and did; wanted her always beside him, listening to records in the chair that breathed the cloud of dust that rose with the removal of books and the apology - while some messenger waited for a drawing - or so she would recollect it after forty years. He wanted to be envied, yet not to be discussed; because he could be ridiculed, because it was hopeless, the recurring word.

I used to be happy when alone, and sometimes I feel like going mad with depression ... I am told that it is considered "most unsuitable" by people whom it doesn't concern at all - and anyway *what* is unsuitable? Cecil tells me that I am thought to be rather "making capital out of the affair", rather *making the most of it*. I

told him he should not have repeated it to me and he agreed and was sorry ... I *love* her. That is all I need to say.

Altogether it was a year of new loves, interacting, I suspect. Siegfried suddenly told Edith, to her vast surprise, that he was vehemently in love with Hester Gatty, whose home was in Wiltshire, and that she was responding but bewildered, having hardly escaped from a long illness. He talked of the war, his men-friends, his complete ignorance of women, and how at the Wilton pageant, where Edith had introduced them, a swan flew slowly over and away, and seemed to him to be a symbol of Stephen passing out of his life. He was like a boy in love. And like Rex a little earlier he clung to Edith, but only to bless and thank. They talked of love's martyrs: of Rex himself, and of Imma Doernberg, now deserted by Willie Walton. Later, Stephen wept when he heard of Siegfried's new attachment. Then marriage followed quickly, with Edith, Rex and T. E. Lawrence about the only guests.

At Oxford my backwardness had reached its nadir when from apathy I took a room at the remote end of Walton Street, with a keening gas fire and no visitors; but now I was at least in the High in delightful Georgian rooms. I acted boldly. I crossed the Broad from Balliol unobserved, and took lessons in dancing, never having dared to attempt it hitherto. And it does require boldness to accept feeling foolish with a yielding but haughty young woman in your arms who insists that you take control of her, for just one purpose. But I learnt quickly, and revelled in the steps she taught me. This audacity was not dictated by love, but by a scheme of graduation into party-going, very ordinary but very thrilling to me, in which love might conceivably take shape. And it did. Now the affair I started with a girl undergraduate no richer than myself, with only such amusements as a film or a bus trip until I acquired a share in an old open Morris – now all of that seems like harmony, though in truth we struck some discords in the months of our novitiate. For a year or two we were in love.

My mother at sixty-three recovered completely from her broken thigh, thanks, she maintained, to dancing with her sons night after night to the gramophone. This was in Bolebec, and here Rex brought Pempie on the way to the Sacheverell Sitwells. Entering, she had the look of being startled by her own extreme prettiness, but perhaps it was really by his unexpected background – where the question was, no doubt, did he hope to marry a Society girl? Could he afford to? We both aroused misgivings in our parents. Encouraged by this visit I later brought my girl to stay. At any hour of the night the ear of my light-sleeping mother could pick up the murmured comment of a floor-

board. But a grieved rebuke next day would be nothing but a murmur, too.

Pempie's return from a holiday abroad threw Rex back into his passionate dream. She, happy to be with him again, he therefore "in a state of heavenly bliss", were met at Salisbury by sympathetic Edith, who was soon perceiving that she loved his jokes and obviously admired him. "I can't see their future, but I *must* support their present." If he ever did marry, Edith's old place in his life would be gone for ever. This she knew. And there was not and never would be in other contexts, later loves, a trace of jealousy in all the nightly doubts recorded by this faithful friend. She did not mean to hold him back, in life or art.

Why had it been "hopeless from the first?" Nineteen is not impossibly remote from twenty-eight. A small clue is to hand. Wishing to please, and not too familiar with some of the best restaurants, when taking her out for the first time he asked where she enjoyed eating, and she named a very expensive one, in her innocence. Later they ate more cheaply, but never very cheaply. She was not spoilt; there was simply in his mind a daunting difference of life-styles, and he did not want it to obtrude on hers. Sometimes he may have envied his fellow-artists along the street. They had no free holidays in Switzerland, Italy, France and Bavaria, but they had their girls to Bertorelli's and the Chelsea Arts Ball, less elegant in dress and manner though they might be; they had their girls. I doubt if he ever entered the Fitzroy Tavern.

His lack of means was widely recognized. "He was very poor, you know", said Edward James, reminiscing later. Here is what he earned for some individual works at this period. (See note for present-day equivalents.) For the Port Lympne room £800. For the sisters' portrait £200. For book wrappers £18–£25. In relation to time taken, a portrait was better paid than a room, while a wrapper was better paid than a portrait – seeing that a wrapper could be turned out in a single, relentless day. And this, just this, is what tempted him year after year to put the trivial before the significant, to exercise fancy rather than imagination. Well, in that year of love, 1933-4, his taxable income, with allowances for studio, car, etc. already deducted from the gross, was returned as £1,130: representing about £27,000 today. It may not have been riches by the standard of a fashionable portrait painter, much less by that of a Sert, but it was not, strictly speaking, poverty. He was poor only in the sense that he was spending all he earned, and often overdrawn. Remembering his modest style of living when at home or in his studio, and of dressing – he had the formal clothes of

a gentleman but only five or six well-made, day-time suits – I am amazed to discover that he earned even a third of that total, and even more later on, up to a peak in 1936-7 of at least £44,400 in modern terms.

How did he run through it? First by generosity. To speak only for myself, he would buy me architectural books, a new suit, furniture, framed engravings, lend me his car petrol-free, stand me a ticket for a journey or a theatre, pay for meals we had together, at least until I earned enough to insist on sometimes going shares. I never asked him for money in my life, but I see that it was he, not my father, who paid the Balliol fees. Add to this my sister abroad and her impoverished family, and other beneficiaries. But chiefly there were the parents. My father would have been content to end his life in suburban Warren Lodge, but Rex installed them in more congenial Bolebec, and was soon entirely supporting the household, with a gardener and two maids, in exchange for some capital and all the furniture. He never revealed to Edith this great handicap; for she would certainly have recorded it. He felt it humiliating to be pitied as the dutiful son of poor parents he eminently was. (Cecil Beaton, of middle-class origin, had a chauffeur by now.) He liked to depict them as cosily ensconced in North Bucks, which on the whole they were, even while they feared it might prevent him ever marrying. Edith had no idea of all this.

"It fills me with anguish, as he never *wanted* to spend before. He says it often costs £5 to take her out for an evening, and of course he wants to, *every* evening." £5 is about £120 now, and would have allowed for good seats at a play or opera. Edith went with him to our family solicitor, handed over share certificates, and signed a guarantee for his overdraft. Surely some artists have earned less and not thought themselves unmarriageable. And surely, as the welcome son-in-law he would have been, he could assume that his bride would not come to him quite penniless. Daughters of rich families have plunged for less – when there was love.

There was not love, of much depth. But she could hardly be expected to return that on the instant. She was flattered – and was likely, in the first excitement of his ardour, to be swept away, it seems. To have despaired from the beginning, not even for a week to have wooed with resolution, as some men woo for years, suggests that poverty and conscience were to some extent excuses. Conscience was not so nice that it precluded going to bed when this was the sure approach to marriage. It seems there may have been misgiving, that in effect he was waiting for an answer that was waiting for a question. If so, in that paralysis despair could lie, never revealed, except in mute caresses of

perplexed old Edith. Asked if he had done a portrait someone wanted, "I never *do* anything", he said.

Perhaps sexuality and heart were divided, and in one part of him he wished they could be children together, as in that favourite Poe poem of years back. He sketched the sisters as he thought they must have been, in bathing dresses on the sands. Edith, watching Penelope beside him over a shared paintbox, was gradually convinced "that this had better *not* be permanent ... She is a gay child. He says she does love him, but I think it means a smaller thing." The step that would unquestionably have made it bigger, whether for good or ill, was never taken. I think myself it would have been for good – and in the other sense as well. No later love would equal this, no second disappointment give so sharp a sense of the missed chance, of a future to be spent "in shallows and in miseries".

As it was, there is a slight but inescapable sense of unreality about this passion, as though in the first months he was in love, not so much with an exquisite girl as with the notion of an exquisite girl. The way in which our image of another person relates to what exists is a problem too deep to undertake in abstract, but in practical terms it seems there has to be a matching, and that this can make progress or not, or even be shattered by a shock. Angel Clare's terrible rejection of Tess after the confession is wholly credible, given his preconceptions: "You were one person; now you are another." Young people can suffer from unmatchable love, and Rex was young in this way. As a boy I fell utterly in love with Janet Gaynor when I saw her in a sentimental film, and the anguish I felt for a day or so seemed like madness, not because I should never meet her, nor because I knew that if I did she would not be that character, but because there was no one there at all, not even a ghost to cherish and console. Shadows on a screen are less than real meetings, but this may have been one element in Rex's distress, that his efforts to make the image answer the reality – doubtless extended through letters, pleading, reproachful, self-reproachful, richly decorated, wrily humorous – at last wearied her. So he watched her slip away, absorbed now in film tests; until he wisely decided to offer her an end to all meetings, and to take out six new canvases to Rome. With Edith he was silent, merely saying, "she doesn't love me as much as she did." When the answer came it was worded as such letters are: she agreed that if it made him unhappy, etc ... hoped that later on, etc. As he handed Edith the letter in his studio there was a record on. "Suddenly he seized me and we danced for some time – so like Rex."

He owed his chance of relief to Kenneth Rae, understanding friend

that he was. Dame Adelaide Livingstone had asked him, "What would you say now if the Fairy Queen appeared, and offered you anything you wanted?" – "To go to Rome with Rex!" – "Done! I shall pay for everything. But I shan't intrude! You shall stay at a different hotel, and sometimes we'll have a hired car together." Kenneth booked for ten days at the top of the Spanish Steps, overlooking Keats's deathplace, where they shared a room contentedly, and Kenneth read Hans Andersen aloud on the wide balcony with its view of St Peter's, while Rex made sketches on the fly-leaves of their Baedeker, for a possible new edition. Thus for the third time he lived for nothing in his favourite city. On the journey he had been doubtful. "As I always think of it so much and glory in it, I began to feel afraid that perhaps I had exaggerated", he told his mother. But not so – though "actually many things have been done in different parts by the Great God Musso which have certainly not beautified Rome." It was just before Easter, and the multitude of pilgrims chattering in divers tongues gave him "a curious feeling of being back in some past centuary. I don't quite know which." From dusk into moonlight they strolled among the plashing fountains and the indistinct statues, where the church doors, spread hugely wide for once, framed a daze of warmth beneath strings of chandeliers, all blazing. Kenneth had achieved entry to St Peter's, and on Easter morning they were up at three, smothered in Vapex for a prophylactic, and soon stationed far up the nave. Time crawled. The heat intensified. Rex said, "I'm going to faint." – "You can't!", ordered Kenneth, giving brandy. A priest did faint, on Rex's back. Again brandy was given. Ultimately, great lights and music and Il Papa. Kenneth soon had to order Rex out for more brandy and chocolate on the steps.

"I thought you were going to bring some nourishment yourself?"
"Yes, well, I brought *Madame Bovary* instead."

They went on to the English Church for a ten-minute Communion with the parson in top gear, and then Rex no doubt thought lovingly and long of his lost girl. But grief could also be assuaged in the cool lights and colours of spring among the asphodels on the Campagna. And the canvases remained in the hotel untouched. One day they took violets to the graves of Keats and Shelley. Finally Rex accomplished what was firmly his intention. With the help of their guide book he sought out San Lorenzo in Lucina, where Poussin is buried. They were pressed for time when, entering by the wrong aisle, they found mass under way. Undeterred, they crossed in front of the High Altar, genuflecting to the wonder of the congregation, put down their little

bunches of wild cyclamen on the painter's tomb, knelt in attempted prayer for some seconds, all eyes still upon them, and slunk out: "the whole thing", Kenneth remembers, "lacking reverence – even to Poussin." With the wish of the born romantic to be truly classical Rex set Poussin above Claude, though obviously more influenced by Claude. Poussin was Rome to him, and the gesture was well-timed. For this was farewell, without knowing it, to Rome for ever; even while his wish was to remain in it for ever. London had become detestable: "I never want to go back there again."

But he had to write next from that "dreary place", and from the plain brown, thin-lipped street, and from the studio he once and so recently delighted in.

> I find the pain is still just as great – perhaps worse. I fancy it is very much like the loss of a loved person by *death*, isn't it? ... I've no doubt I shall love other people before long – I trust so anyway – but I can't help feeling certain too, that sorrow for *this* love will never quite leave me. It's something, inexpressibly beautiful, lost to me – a lovely thing that died and I was powerless to save it, and I'm sure that whenever I secretly remember it in the far future I shall feel in some degree this yearning regret.

That night he had found a sonnet by Alice Meynell, and now quoted, changing the second person singular to the third.

> With the first dream that comes with the first sleep
> I run, I run, I am gathered to her heart.

If there was a dash of display in his suffering throughout, as in his joy at most times, it was no less pitiable for that, but this may have been what Cecil Beaton meant by "making the most of it". There was a strange experience, when looking up at his window in No. 20, he saw his doppelganger self looking down, very pale and woebegone. One day I found him sitting at his table with a distant expression, sadly shaking his head over a popular song.

> When a lovely flame dies
> Smoke gets in your eyes.

Taken seriously like that, the sentimentality seemed worsened by the lameness of the metre, and struck me, priggishly, as unworthy of authentic grief; but it came natural to him to find reflections of that anywhere, on Parnassus or in Tin Pan Alley. I think it was a moment when he tried to share the grief with me and got the wrong effect: in itself trivial. I gave him sympathy but not the comfort that a true attention would have given. Therefore, I underestimated the suffering

until long after his death. In short I was not yet the confidant he had been hoping I should grow to be. Although I was by now so close to him in other ways, indeed because I was so close to him, I had to keep the frontier closed between our new-found worlds, our two New Territories of love. If I went into his he might take over some of mine – purely, of course, in my imagination; he never dominated by intent.

Edith answered that what he had to bear was harder than the loss of love by death. "Thank you for your very sweet letter", he replied, refusing as always to take refuge in what seemed self-deception, "but I can't agree with you. Death is so much more *final*, and in any case I fear I shouldn't feel that loving proximity. Besides, there is always the barest chance that love may come back, isn't there?" That was very unlikely. Even his letters, and they must have been among the most tenderly and lavishly embellished, were destroyed, so it seems, in order to protect her privacy for ever, and out of guilt perhaps; so that posterity should think they had been nothing but brief friends. The incentive was no doubt her mother's long ordeal at the hands of the journalists.

He had turned a little to the younger sister, Angie, treated at first with affection like a child. She was more robust, and he had done her flatteringly in oils as "St Toughie", all in armour with a halo like St Joan; had drawn her asleep in the garden; and had made a ribald sketch of her with some allusion to overeating. But Edith advised that it could only be "a bit" of what he felt for the elder.

Three months after the end he was still saying,

> I can't write anything about my darling. I love everything about her to a torturing intensity. The slightest contact with her electrifies me to a degree I had never thought possible – outside a novel. But I think I shall soon be calmer and more used to this fantastic disease, then I shall be terribly happy and do wonderful things and every-thing will be the same as before between you and me and everyone, only much lovelier.

At least the painting that began it all was a success, when it was hung at the Royal Academy Summer Exhibition; delightful to the subjects and their mother, and selected as the best in the show by most critics, though unfortunately "skied" (Pl. 34). It was the first of his easel paintings to attract wide attention, and it showed that in portraiture he had gone for inspiration to the French School, from Watteau to Fragonard, whose work in galleries and books he pored over, with longing for that civilized world. The *Sunday Times* perceived "so much freshness and innocence in his vision that this exceedingly

attractive picture is far too genuinely personal to be hastily dismissed as mere pastiche". At once gloomy and tranquil, through it runs a road and then a gleam of river, painted last of all, to pull away into the unattainable. The sisters, in identical white dresses, pose pensively together by a fountain, as if waiting for a leisurely photographer – or as if to be painted by the early Gainsborough. They are doll-like in that manner, and not quite by accident; childlike in wearing party dresses for a picnic, and *à deux* at that. For ambiguities of admiration and sly teasing are here. The water spurts from a stone mask which is a likeness of the artist. with small satyr-horns and pained eyes turned helplessly to the beloved. Hardly aware of it, she unconsciously offers a few wild flowers in return. In a sly way new to art, I suggest, the romantic is laced with the humorous, yet not diluted by it. A Negro coachman kneels in mock obeisance – unloads a modern lunch of chicken and champagne, ample for two. Rex said to Mrs Dudley Ward, "you see I am spitting at your daughters because they look so ethereal, but are really waiting to tuck in!" The only agitation is in the black-ribboned collars to set off their loveliness, and in seven black wriggly lines above the hem of their skirts, like passionate underlinings in a letter.

The Old Street Lamp. From *Hans Andersen*, 1935.

# ·XX·

A WELCOME DISTRACTION was the designing of scenery for the new *Fidelio* at Covent Garden, and of course he imagined an unconventional fortress that was not mediaeval but Baroque. Showing for the first time on the stage an architectural scholarship unmatched in this century, he gave a gloomy menace to ringed columns and enormous keystones that seem to growl of Sanmichele or Vanbrugh. But he was put out by Erhardt's production, as he explained in "Problems of a Stage Designer", an article he contributed to a symposium a few years later (see note). He had determined the colour and therefore the lighting of each set, light being for the designer "virtually a part of paint", he said. Thus for the courtyard scene "a vast and mournful style of architecture was employed, bathed in the sad warm light of afternoon, and with brown shadows falling from the tawny battlements." But to a producer with ready-made visual ideas warm light could only mean happiness – unhappiness demanded cold – and the subtlety of evoking dread in afternoon sunlight was beyond him. Blue light it had to be, making mud of the colours already painted. Conversely, in the dungeon scene, lit only by torrid torches, Rex planned that when the invisible door above the turn of the stair burst open, an oblong of cool light should appear on the opposite wall (so painted). It was not allowed. Freedom had to come to those incredulous eyes down below, "not as a pure contrasting light, but fully as hot and red as the torches". It exasperated him to show nothing more than disgruntlement when overborne, "his sensitive haughty nature", as Edith put it, "*froissé* by the coarse shouts and wild German fury". He wished he was someone who could wave his arms and walk out. And this would not have done him any harm, in the event; for though it may be true that a loud answer turneth away jobs, a soft one does not necessarily secure them. The friction was enough for the tempting offer of revived *La Cenerentola* not to be confirmed, an opera that would have suited him admirably. It was on the first night of *Fidelio*

that little incidents occurred which hold the memory. When Lady Cunard's party pushed arrogantly in, Beecham had to shout at them, "Stop talking!" He had to shout again later, "Shut up you ——!" at applause from the gallery during Leonora No. 3.

To Rex, actors and setting formed one canvas in a frame, and to do only the scenery was no more satisfactory than to do only the costumes – as next happened with *The Tempest* at Stratford. Still, these are the most beautiful costume designs he ever made, and earned him a useful £100. He dressed the court party in outlandish versions of Jacobean fashion, plumed beaver, quilted doublet, puffed hose, etc. – all quite undamaged by sea-water, as the play insists, and all carefully researched. Miranda, in his note, wears a "homemade" dress of some material saved from the ship twelve years before, which again Shakespeare authorizes. Her green embroidered kirtle with a rope at the waist was in effect a charming frock of the modern age that only showed the girl's innate skill in dressmaking. For the masque in the play he took ideas from Inigo Jones, elaborating, while Caliban and Ariel were entirely free inventions: the first in Rex's grotesque manner with webbed hands and feet, the second – now in seaweed tied with pearls – now like an eager Roman boy in a short kilt of gold and silver. It is the greatest pity that he could not be given the complete production; and doubtless this was what he thought himself when he whispered to his companion in the stalls, "In paintings I've often seen a ship wrecked on a rock, but never till now a rock wrecked by a ship!"

Miranda's face in the dress design is not Pempie Ward's, it is the first with a marked likeness to Caroline Paget. However, it was not to her that he turned in his frustration, charged for love as he was and lacking outlet, but to Frances "Bunny" Doble, Sacheverell's sister-in-law, whose crinoline dresses for the lead in *Ballerina* he had designed while wholly occupied with Pempie. No personal involvement is revealed by his comment at that time, "Frances D (for a really indifferent actress) put up quite a good show"; but now, asking her to dine, he gave her two of the designs and soon made a brief attempt at an affair which dejected him enough to form a lasting aversion to Claridge's Hotel. There is also a very pretty water-colour, showing what he would have done with the setting for *Ballerina* had he had the chance, and apparently intended for Frances Doble, since the girl in the boudoir looks like her. But this she never received. It was kept for a more gifted actress, with a reputation far bigger, for better or worse.

Four years before, he had noted an engagement: "Lady of the Camellias. Tallulah. Cecil 7.15." That night the two men surely went

behind after the show. Tallulah Bankhead's talent was wrong for the part and the part was wrong for her public, who, as one critic said, preferred her as the Lady of the Camiknickers. Presently Hollywood made her an extravagant offer and she was gone: Thalia of the Bright Young Things, the very Muse of the Between Time in England. Three years of bad Hollywood films gave her a longing for the England that adored her, assuming it had not forgotten. As to that, doubts vanished at Waterloo Station, this May of 1934, when a vast placard, "She's back!" swayed above the old warm tide of fans. "I've been ill for five months", she told them. Still rather shaky, she had taken a suite at the Hotel Splendide in Piccadilly, and seemed to a friend "a more serious and poignant Tallulah than the one we used to know". But soon the gaieties began, and the entertaining in the suite, all in the care of the cool and humorous Edie Smith, who beginning as a stage-door fan had become a factotum.

A telephone call brought round David Herbert, the youngest son of the Pembrokes at Wilton.

"Miss Bankhead is in the bath with Mr Rex Whistler", Edie casually announced, letting him in. The bathroom door was open.

"I'm just trying to show Rex I'm definitely a blonde!" said the famous husky voice from the water. This brings to mind an observa-tion of Rex's based largely on his hours in the Life Room at the Slade: "I have never yet seen a blonde bush, have you?" Whether he was now convinced is not recorded – it is, after all, a matter of degree – but he must have made the same remark to Tallulah, with provocative intent, though the invitation to the bathroom came from her. Several new friends met her there for the first time. It is recorded that Dr Kinsey could not find a single case of female exhibitionism: he cannot have studied Tallulah. Anyway, she was glorious, with the delicious novelty of corn-blonde hair at shoulder-length, after the lean years of cloched bob and wasted waist.

Rex had not wasted time, that is evident, mindful of the competition there would be, and rather desperate by now, I should imagine. His engagements show, for 23 May, "Dine Tallulah", after which there is discreetly nothing. But another evening David Herbert was summoned at about half-past seven, to find that they had been in bed. Rex was in a dressing gown to stay the night, she in a kimono which was constantly allowed to fall open. Rex was in high spirits, and a match for his outrageous girl at that moment. He swept back the bed clothes, and for once the expostulation came from her. "Darling – darling! – *really*!" He knew that his homosexual friends always held that he was one of them, if only he would face it, and others thought he had no

physical desire for girls. How sweet to disabuse them and get even
with Cecil, by summoning as witness one who could be counted on to
cater for that very curiosity he had denounced, only months before.
But if Tallulah had just taken his virginity, as may possibly be true,
the gesture could hardly have been meant to reveal that he had taken
hers. There is pathos in the gesture. In the previous year she had had
a five-hour hysterectomy, and her life had been in danger for days. She
was hardly over it yet, and the result had been deep depression. For
she claimed that she had always wanted children, and if conceptions
had always meant abortions, that, in her view, was merely bad luck
with the timing. Contrary to popular opinion she was no expert on
the theory of sex, but full of mythical notions, unpractical and rather
helpless; also fertile; also promiscuous. From this ordeal she had
emerged looking like her portrait by Augustus John.

Rex will have known only of a serious illness, the reason very secret
and a source of shame, perhaps a cause of temporary revulsion from
sex. With a kind of amused distaste he described to me her careless-
ness, and her equanimity when he had to mention a spot on her dress.
"Oh! Ze dainty sing!" was all she said, before going to change. Her
frankness at once entertained and repelled, as when she spoke of "the
dreary conjuring trick" men produce – "not very romantic!", as he
said. Still, for him the snail horns of romantic love had been knocked
right back into the shell. As well as alluring she was good company,
with the style and manners of the lady she was by birth, and she was
witty, she was warm, and she was not intimidating. When he first told
me, "I have been having an affair with Tallulah Bankhead", I re-
marked, not without the twinge of venial envy that was requisite, and
looked for, "Wasn't that rather alarming?" – "It might have been –
but, do you know, the curious thing is, *she* was shy of *me*!"

This is credible, even if it seems paradoxical, as between one with
so much and one with so little sexual experience. Tallulah had deep
admiration for artists and poets. By nature she was the most intellec-
tual of his girls in the Thirties, though that was not difficult. Authentic
in her own way, she saluted authenticity, and was a merciless debunker
of pretentiousness. Then, she admired Englishmen. Her favourite lover
would always be Napier, Lord Alington, who had in her opinion
points in common with Rex, being charming and aloof, attractive and
maddening to somebody as positive as she. This made her pardon the
unpardonable: which was to keep her waiting. For when Rex arrived
hours late for dinner, one evening, he carried bouquets of white and
yellow tulips – so ordinary, he explained, that he had had to give black
stripes to the former and black dots to the latter, and the paint had

dried very slowly. Sex to her was conquest, it has been said: "She selected, seduced and disposed of", beginning with a ceremoniousness that will have been exciting to Rex in the careful preparation of neg-ligée, scent, drink and candles. And yet she had never been noted for self-confidence, and now had less than hitherto, neutered as she was, or felt she was. She may have feared that a man so refined in perception would think her obvious and unsubtle, and this may have been another cause of shyness. So she gave him confidence while lack-ing some herself, and talked all the while, and did not put him off. He never drew or painted her, there was never time. She was "Tallulah-Hula" in reminiscences to me. "Tallulah was just fun." Really, each was quite a prize to the other, and if she was a prize fairly widely awarded, that did not matter. A man appointed CB does not resent the thought of predecessors: those numerous standing Companions of the Bath.

This happened during my last term at Oxford while my own incon-spicuous and worthwhile love affair continued, and final Schools approached. Having changed from History to English and done hardly any work on Anglo-Saxon, I was apprehensive. That May my second book of verse was published, to make its own way without decora-tions, which it did before long rather well, too well for my true good. But no reviews had yet come when I placed on my desk in the Exam-ination Schools a small, green, model plough, to confront and pre-invalidate the worst. My watch being wrong, I had arrived early, gone back to my rooms in Long Wall, looked up a single Shakespeare note, and returned, to find a question on that very note. It was not with much surprise – more with an illusion of Providence, unwise to rely on, as I tend to do. In general I have often felt that things were on my side, while I was not. I scored a Second, to my great relief. I might claim to have scored a Double First, in the sense of unexampled, by having two books published in London while an undergraduate, and never even shaking hands with any luminary then in the ascendant at Oxford, such as Bowra, Coghill, C.S. Lewis, Kenneth Clark, Isaiah Berlin. If I had made any mark at all it was a cock-eyed one, like a child's magic lantern incurably directed at the ceiling, not the wall. And now I had no ambition except to write memorable poetry, a desperate ambition, since unmemorable poetry, alas, is worth nothing – unlike an unmemorable picture or tune, which may enliven a dull room or an idle five minutes.

In that June of 1934 Edith described Rex to herself as "so broken. ... His face has changed a little and is now a vizor." Three months later, "His youth is over, and his face in repose is still, sad, and very

*reserved* – a quiet mask." Mrs Landeryou saw it too, and commented, out of her trance with a duster at the studio window, "Mr Rex has maycher'd a lot in the last year. Reached his second adoldescent." Whatever the stage in life this denoted, he was not enjoying it much. So he gave himself a present. He exchanged his respectable saloon car for an open sports model, dashing and low-slung, a Swallow Special. Somebody was saying nasty things about him, that he talked maliciously, that he saw only Tallulah, that he was being put to bed drunk. But Tallulah on impulse had gone back to New York for another bad play, and as for Rex, he only wanted to be in Italy.

And this could be achieved. He was now painting a conversation piece for the poet Dorothy Wellesley, later Duchess of Wellington, to show her good-looking son and daughter in her natural rock garden, beside a dog that appears in a Yeats poem to its mistress –

> A Great Dane that cannot bay the moon
> And now lies sunk in sleep.

It looms as big as the one in the Van Dyck of the Stuart children, and almost on the scale of the rocks. Rex had of course made friends with the children, Valerian and Eliza. To her he wrote one of his rebus letters, all little pictures for words, which reads, in translation, "Last night when I jumped into bed to my rage I found a large piece of holly. As soon as I know who it was I shall have to thrash the offender." For her he also invented a secret code, to be used on the outside of envelopes, of which the only recorded use reveals the fact, when decoded, that ELIZAISANAUGHTYGIRL.

Dotty amused him with her intensity. One day she and Hilda Matheson, bosom friends, were inveighing against the English as philistines who produced nothing beautiful. There came a rap on the dinner table. "Dots! Remember the poets!" – "Yes. I had forgotten!" Two heads were bowed, repentantly. But now she was taking the castle at Aulla, and Rex and Kenneth Rae were invited. Unfortunately, our father had had a stroke. "I am in the deepest possible depression. ... He still lies in bed with the paralysis only slightly better, unable to sleep at the thought of my departure, so naturally my mother begs me to put off going. ... I ache for the woods and streams." This shows how fully they relied on him, and how negligible I was as a substitute, financially of course, but in general. However, it proved to be a mild first stroke, my mother was no spoil-sport, and Rex did go, after only a week's delay, into that life of picnicking and bathing and sleeping under the stars, where love and unfulfilment were forgotten. "I *do* so wish L were here", he wrote. Yet I never went abroad with him on any of his

thirteen excursions, chiefly because on eleven of them he was the guest of somebody unknown to me. Here, perhaps, was a chance, and I lost it through making a decision that seemed minor at the time, but was to alter my life. I went north to tutor a small boy whose mother was the sister of a client of Rex's, though in fact the proposal had come to me from Oxford. It was a happy autumn. Drives with her to Seaton Delaval and all the Vanbrugh houses of the North quickened my interest in his architecture. Then I wrote a sonnet for her birthday, and since it was addressed to the house itself I thought I would inscribe it on a window of her sitting-room, in the manner of Elizabethan couplets – not that I had seen one – and from somewhere I acquired a diamond pencil of industrial type. I had no interest in glass itself and no "designs" upon it, and might never have had any, but for the time and the place and the sonnet coinciding. Her father being Edwin Lutyens, this led to small commissions; and so began, I believe, the present revival of freelance engraving on glass.

That autumn, Rex designed for Sadler's Wells Opera a complete *Figaro*, both scenery and costumes, and because the company was poor took no fee; and because he was forgetful failed in what ought not to have been necessary, recovery of his originals; which, needless to say, have never come to light. This labour of love, postponed as always till the last moment, cost him the award of the Silver Jubilee postage stamp in a national competition. His design, drawn six times larger in accordance with the rules, was thought by Kenneth Clark, as judge, to be "incomparably better than any of the others", but, alas, it arrived a day too late, and lost him the equivalent of £2,300 in our money, together with a small boost to his reputation: incidentally, it is another drawing that has vanished. News of this set-back came just before the first night of *Figaro*, when he stayed at work on the scenery until two minutes before the curtain went up. In the first interval the lovely young Eliza Wellesley, there with her father Lord Gerald, hailed him to come down to their row, and, not succeeding, came up to his in the second. He went home with them. "I think he is stupid", Edith commented drily, knowing that Eliza thought he returned her schoolgirl passion. "I think she may at last *take* him – as Romola took Nijinsky."

It has been said that Rex could not resist a lighted candle. Nor could he resist a lovely face, when lit or lightable for him. And faces lovely or beginning to be so appeared quite frequently in the Daye House. There was Newbolt's granddaughter, Jill Furse, born at Netherhampton House, nearby, and observed from babyhood by Edith. Three years before, she had walked in, "tall and slender", fresh from

school at Montreux and resolved on acting. Some could not easily see her as an actress, but then, as Edith said, those were they who "did not see the imp in her". Two years later, when Rex was at the height and depth of his passion for Pempie, Jill had come out top at the Central School of Drama. "She has an enchanting personality, and ought to be a most captivating actress – if her charm is not too delicate to get across." Jill would have scoffed at that "delicate", and indeed at being described as "vivid and fairylike" in this year, 1934. It was mere chance that Rex had never met her, as yet, in all nine years of his visits to the Daye House.

Growing up into a grander world a little ahead, and simultaneously observed by Edith, was Caroline Paget, who at her coming-out ball in the Double Cube at Wilton had "looked an angel in shell colour". The Duke of Gloucester had been a house guest, "so we all wore orders and curtseyed about on the floor"; and Rex had been there, but with a vehemently suppressed toothache. Caroline, daughter of the Marquess of Anglesey, was the intended of Anthony Knebworth, son of the Earl of Lytton, who was attractive, dashing, athletic, a natural hero born out of his time; for he seemed to belong to the "lost generation", except that he was less arrogant. "My grouse about the war", he wrote, "is this – I missed it. It would have suited me." And surely he could not have failed of being killed in the skies of 1940, if in 1933 his fighter plane had not crashed at Hendon aerodrome. Caroline was distressed. But whether she would have married him is doubtful. To the Lyttons she was now virtually a widow of twenty, with an anniversary of his death to keep at Knebworth. This became a burden.

Both Anthony and Rex made everyone happy by entering a room. But very different was the means: the one outgoing, confident, quickly spreading infectious laughter, the other reserved, diffident, spreading laughter too, but not at once and for some subtler reason. Caroline was now "his chief friend", Edith reports being told in November 1934, with perhaps a touch of misgiving. "But he has lost his bearings sadly since Pempie. He has been painting her today 'from memory *of course*', as he said." And a month later, "I feel very unhappy about him. He *cannot* get to work. ... Pempie has broken him for the time being. He goes out at night much more than he did, and I think can't stay alone in his studio, but this makes him too tired to work next morning. What *can* be done for him?" There is no doubt that Rex rather fancied playing, for Edith, the part of desolated lover turning into disenchanted wastrel. "Des fleuves et des rivières de larmes have been more my lot than laughter recently", he told her and he painted two self-portraits in oils which show romantic self-awareness: one

against a Stowe pavilion under a stormy sky was bought by her and bequeathed to the Tate Gallery.

And so to 31 December and the last words in the bedside journal for 1934. "Seems now associating with a bad rowdy drunken set. O my darling, I must get him away."

Temple Bar. Drawn for Shell, 1933.

# ·XXI·

AT A BALL at the Austrian Legation Rex watched the Viennese waltz, then returning to fashion – determined to master it – and quickly did, with his adroitness. A whole room awhirl to those tunes, sensuous and ceremonious at once, was more to his taste than a heartbroken sax in a nightclub, advocating mutual support. I made some progress too, and we practised together, alternating as the girl – or practised with our flexible mother, whose thoughts turned wistfully to Brussels in the Eighties, until thoughts of her husband, gone to bed with no vestige of youthfulness remaining, caused the volume to be lowered. Equally, Rex practised with Edith at the Daye House, spending "every spare moment chasing valse tunes all over Europe, and when he catches one, he makes me dance. I nearly die of it."

She discussed him with David Cecil. "I do want him to have a happy *possible* love, as Pempie sent him all wrong." David saw the problem, when "his social world is that of expensive girls, and only an exceptional one would be happy giving up her fun". She reflected wistfully on David's own luck in winning Rachel, the daughter of the critic Desmond MacCarthy, a lovely girl used to "interesting society – not smart and rich". Rex was now saying that a big commission, if he got one, would mean "spoiling his summer", that is, the chance of some holiday abroad (doubtless pictured as free). "The temptation to *flâner* is very strong", reflected Edith, in a new mood of disapproval, "but he *must* feel that his art is an obligation, or it becomes a drawing-room accomplishment."

For some months our sister Jess had been at Bolebec with her little girl, Gillian, and now Rex drove them to the docks for their return to Africa. So, with mild fondness rather than devotion, she vanished from his life, except as one of his beneficiaries. At this time I sank to my lowest level before the war, constrained to take a second-rate job in Church Assembly as assistant secretary to the Press Board, and thus to start commuting from a room over Brunswick Square. It may not seem

desolation, but it was, to one so easily persuaded of failure, with a highly successful brother for comparison. Particularly that spring the sunlight of success seemed to glint from the family freelance. But he did not find it particularly warming.

He signed a contract for the Hans Andersen, foreseen in Rome, committing himself, in Kenneth Rae's words, to devise "with all the talent at his disposal" and deliver "with all the speed at his command" ten large and fifty smaller drawings (pp. 181, 247 and 258). As to number, he did better than that, providing over seventy. As to timing, he only defaulted by three months, which still allowed publication in 1935. Well before the deadline he went round to demonstrate the new, exciting technique he proposed to employ: white scraperboard, intended for commercial artists, on which you could paint with indian ink and then scrape off, for an effect like a wood engraving. "There's no *virtue* in a woodcut", he said to me, meaning that a technique is none the better for being laborious when a quicker one can give the same effect. The effect is not the same, as he soon saw, and presently he was using brushed ink in various tones to produce what may be roughly described as a painting with scratched highlights, his own invention, and very lively in his hands. Hans Andersen reveals his insight into children's imaginations, stirred, as they commonly are, by what is heart -rending, funny or frightening, by turns or simultaneously. As proof of that, the book has been in print for nearly fifty years. He could not resist throwing in, for no extra money, a more than usually elaborate title page, and a binding case, all over gilt Rococo on creamy buckram. It was a copy of this, assumed to be a splendid prayer book, that Liz Paget would carry instead of a bouquet to her wedding.

Tallulah gone, he was still "lost in idleness, parties and drink", saying he was a "hedonist", no longer a serious student of art, and provoking another poignant exclamation from Edith. "O my darling, how can I save him!" Even a year after his dismissal he confessed that he would go back to Pempie at any moment. This was the spring when he reminded Stephen that their good friendship had owed nothing to "unhappy destructive *sex*". Yet he pursued sex in this post-Tallulah mood, and told me with amusement how, watching an attractive girl at another table at Schmidt's, he had thought, why be so shy, so stuffily conventional, and had sent her a note to ask if she would care to have a drink with him and see his work. In his studio he had found her, within minutes, dreadfully boring; but since to end the interview would be unpardonably rude, had endured it for two hours, longing for his drawing-pad, his bed, for any other occupation. Then a girl in the chorus of some show had to some extent indulged him, allowing

him to go so far but no further. "Sex takes so much time, doesn't it?", he said to me. He was no instant seducer. His mind was like a subtle key which would not fit a simple lock, yet knew how very sweetly it might turn.

Unacknowledged, there had been a change in his friendship with Edith. Eight months had passed without a visit to the Daye House, though with numerous meetings in London, "which doesn't count", as she told herself. Guilt magnifies the faintest hint of reproof – even manufactures one. Now, as he was driving David Cecil down to Sussex, wind-blown in the fast new open sports car, he was saying that he had felt remorseful about Edith – then resentful – then remorseful again because of that. "Though he made no attempt to hide his feelings good and bad, I have never liked him better. He was too spontaneous and too generous to bother as to whether he was giving himself away." He was not, in fact, to any depth. For it was not only that Edith minded his absences and was felt to deprecate his goings on. There was the memory of that "cry for help", that caressing and clinging in the dark, like a child. Unfairly, we tend to shun the company of someone who has witnessed our humiliation, even if we chose them for witness and offered no alternative. Edith paid now for giving succour to "the man of my heart". But she was wise and she was patient.

One day, when I opened letters "on my way to the office" in Church House there was astounding news. I had won with my second book of verse what I had forgotten being entered for by Heinemann, the first award of the Royal Gold Medal for Poetry, given for the best book of the year by a writer under thirty-five. Later it was given to a leading poet regardless of age, and my award was retrospectively magnified. Rex was present on the day for this paperback version of his own success eight years before, and was involved in the publicity. "While up at Oxford", he told one interviewer, "my brother was concerned with very liberal ideas which he has since got rid of, to the benefit of his poetry, in my opinion." Really, it was very liberal ideas that had replaced undigested Marxist ones. A fortnight later I signed two contracts on the same day: one for another book of verse, the other with Kenneth Rae for a life of Vanbrugh. So the room over the square was given up, the Church Assembly hand-outs on Self-Denial Week and the Missionary Position were tossed aside, and I escaped from penury into freelance penury, staying mostly with Rex for the research, and at home for the slow writing.

Lady Caroline Paget coming out in the Double Cube at Wilton and Tallulah in the hotel suite on exhibition were not, as might be supposed, worlds apart. A link had been provided for Caroline, stage-

struck at seventeen, by her gay cousin at Wilton, David Herbert, the same who had witnessed Rex's brief enthronement at the Splendide. She became the life-long friend of Audry Carten who was already the life-long friend of Tallulah, after acting with her once. Rex by now was a warm friend of Duff and Diana Cooper, Caroline's aunt. Thus he was certain to keep meeting her in London or at Wilton or some other country house, and through her the whole Paget family. Edith described them in her journal: "Caroline and Liz each more beautiful than the other ... Rose ... Mary ... Kitty ... Henry very earnest and busy", the only son. And in the midst their mother Marjorie drawing portraits of them, "distrait and supreme, all those girls at her feet". At first it seemed that Rex, whose heart was almost a function of his eye, was more susceptible to Liz, thought by many the most beautiful. If Pempie looked startled at being such a picture to her looking glass, Liz looked surprised by the world she found herself inhabiting, as though intended for a previous generation. Her eyebrows seemed to be raised in deprecation of the way things happened, but also in amusement at herself for deprecating it. She was easy to tease, and he liked teasing. "The only comfort is", he wrote, while grousing about his work for Cochran, "there's a sweet girl in the chorus who looks like you. Haven't spoken to her yet." He was candid. "You are one of the very few people I really *love*, probably mostly on account of your looks and sense of humour." When she asked Kenneth Rae for advice about Rome, Rex "wrote her a *snorter*", because she knew perfectly well that "Rome belongs to me and that she'd never heard of it". But soon he was more attracted by the unpredictable mysterious Caroline.

His major work of this spring was for the theatre, and had distant origin in *Job*, the ballet put on in 1931 from Blake's designs, with choreography by Ninette de Valois, her first major success. To keep alive the young art of English ballet another famous sequence of pictures was looked for, and was found in *The Rake's Progress* by Hogarth, an artist no less English than Blake. Constant Lambert saw that Rex was indispensable. But "*why* did I say I would do it? I said I *could not*, but was *overpersuaded*." These were habitual second thoughts. Dame Ninette, as she afterwards became, was impressed by his practicality. He accepted that a scene must be changeable in one minute. He showed that with a different backcloth for each room – the Rake's home, the brothel, the madhouse, etc. – no one would notice if the side walls stayed the same. But to make them fit stylistically, each time, required the knowledge of a classical architect.

The act drop in grisaille was a Georgian street in perspective, with his favourite tower of St Martin's, nobody about, and only a skull

cartouched in mid-air, to point the pleasing, reckless, melancholy story. When he had to redraw it seven years later for a new production, he wrote in the margin that it was "meant to suggest a *faded Engraving* or Eighteenth-century wash drawing. But keep the engraved idea mostly in mind." This ballet is still in the repertory, and has proved equally successful on the big stage of the Bolshoi Theatre. It pleased Rex. He had not copied Hogarth, he had invented – in terms that would have seemed to Hogarth utterly authentic.

That huge "engraving" relates to Diana Cooper's drawing-room at 90 Gower Street, decorated at this time. Here his entirely original idea was to introduce small instances of *trompe-l'œil* painting, done on the plaster, among existing furniture and fittings; and she confidently left it to him, while abroad. "I do hope you won't hate the two 'classical mezzotints' which I've put on that wall", he wrote. When she hastened to look at them they proved to be a *tour de force* of mendacity. *Offrande à Diane* and *Diane Chasseresse* – one a Poussin, one a Claude, as I think – seemed to hang there unrolled. The joke was contrived with perfect taste and elegance, and up above were classical medallions hanging from cords that threw their own little shadows. "You will see", he had warned her, about a lofty antique jug, standing in a niche, "that a housemaid knocked it over one day, and the neck and handle got broken, but I got it well riveted, so I hope you won't notice it much. The silly girl tried to lift it by the handle, but of course it must *never* be lifted by the handle." Indeed, the handle was nothing but a slender serpent.

Equally classical was a chimneypiece this year for "Chips" – Henry Channon – at 5 Belgrave Square, with a feminine divinity in a gilded niche. Rex was in a mood of decorative purity in 1935, perhaps for no deeper reason than that after exuberance simplicity may appetize. "Creation does save life from crashing", as Edith had said – while noting with regret that he continued now and then, to no advantage, meeting Pempie – "who seems to me *nothing*, to have broken Rex's heart." Still, he was pretty well committed to Caroline by now, who was sweet in return though quite detached, and was not too jealous of Pempie. At a party at Ashcombe she and David Herbert "danced a mad fandango" with Rex "mooning about alone in brown corduroy trousers and enjoying every turn" in the cabaret. It is curious that he never took part in one himself, when he had, according to David Cecil, "an extraordinary gift for acting". This was revealed in charades at Hatfield House. "He could turn himself into an American film magnate or a pompous schoolmaster with subtle certainty ... his every movement and intonation and gesture altered to suit the personality. One

realized how very observant he was, and his humour and invention made his improvised dialogue as good." The explanation may be that since he never put himself forward Cecil Beaton and Edith were no more aware of this little-used ability than I was. It was what gave him full confidence for practical jokes, another of which came about in this way. Caroline had been taken on by the Oxford Repertory Company as Miss Bayly, in spite of failing to keep two auditions, perhaps more on account of who she was and how she looked than of anything she might do. Being reticent and never the show-off of the sisters, it aroused some wonder that she should have wanted to act at all, to live in digs and suffer lodging house high teas; but she needed to escape at intervals from wealth and pedigree, and from the scene where she might once have been typecast for life, as Viscountess Knebworth until Countess of Lytton. Thus she was delighted to play the black girl, Tulip, in an amateur filming of David Garnett's *The Sailor's Return* at Ashcombe, with Cecil Beaton as the sailor and John Betjeman as the clergyman, but was soon in high disgrace with her parents, for Cecil could not endure to keep it from the gossip column. "It is odd", thought Edith, "that she should do these *outré* things, and get her reputation, for she has that lovely dreamy aloof character, always seeming apart from what is going on, and without enthusiasm or ardour."

One afternoon when she and David Tree left their digs in Wellington Square for the Oxford Playhouse, they found a grubby character with several days' growth of beard sitting cross-legged at work on the flagstones. Propped against the railings were large pieces of cardboard, one with a lurid sunset; another, in pinks, mauves and greens, a marvellously seedy portrait of King George v, entitled *Happy and Glorious*. They were enough to catch the eye, if not to stay the foot. "Spare a copper for a poor man, lidy!" Two were bought, or given, and still survive.

From the artist's address book

# ·XXII·

PERSONAL INTEREST in the life of Queen Victoria increased as that period grew to seem less ridiculous and more prelapsarian. Laurence Housman had just published a dramatic chronicle of her reign, but the rule was that a century must elapse after accession before a monarch could be portrayed on the stage. This had no force in America, and in October 1935, Rex was hurriedly working up ideas to show the impressario, Gilbert Miller, the same day: scene designs, dress designs and little toy stages made of stiff paper by himself, placed all round the studio. Helen Hayes, who was to play the Queen, was astonished. Here was not the Victorian age of popular fancy, staid, reticent, demure. Here were silks, tartans, tentings, flowered wallpapers, full-blooded colours of a church at Harvest Festival – and all controlled by scholarship that had researched in books, fashionplates and paintings. Rex took her to see the very rooms in Kensington Palace and at Windsor.

Staying with David Herbert at Wilton, he worked on the model set which he had made to scale. "Rex adores Caroline", Edith noted. "She has a *tendresse* for him but at any moment leaves him." That weekend he painted for an exhibition a portrait of her in a new impressionistic manner. He had used it already in that little blurred oil done at home, and called *The Buckingham Road in the Rain*. But for commissioned work he could not bring himself to give up drawing precisely in paint, like a very Canaletto, though it sometimes caused him to despair. "It *is* very poor," he wrote of a *Wilton House and Bridge*, "a quite well *drawn* view, but it can't pretend to be a painting." When the new portrait of Caroline was shown in London it was quickly reproduced on paper as *Girl with a Red Rose* – any girl, not Caroline Paget (Pl. 32). Holding up her hair for the plain looking glass, she tries the Étoile d'Hollande on her yellow bodice. Lady Pembroke went specially to see it at Tooth's gallery, and shuddered. "That black glove!" It triggered the automatic response to decadence, Paris, the

197

demimonde; with connotations unwelcome where the eldest Anglesey daughter was concerned. And it is true there is a note of sophistication here, not found in the Dudley Ward portrait; this alluring face with the pout and the magnolia skin is brooding, sultry, self-absorbed. Now Pempie rang up to invite him to her latest film première: "Don't say you are engaged for Willie Walton's concert!" He had been. "But like a dog he must run if she whistles", noted Edith.

Either he found it easier to write to Liz than to Caroline, or she thought his letters more worth keeping.

I'm not feeling at all keen on going to America really, only rather terrified, because there are scarcely any Americans that I like much so far, and the thought of their terrific noisy speed and efficiency is definitely terrifying, isn't it? It's all right if you've the vitality of a David [Herbert] or a Cecil [Beaton] but I have hardly any, even for slow cosy old Angleterre.

I drove with him to Waterloo Station, quite calmly and in reasonable time, arriving a few minutes before departure, to find Edith and Kenneth Rae helplessly weighing the chances of an aeroplane. By good arrangement Stephen Tennant was a fellow-passenger in the *Aquitania*, eager to break out of his vexation at losing Siegfried; it was his second visit to the States. When he paid his first Rex had been concerned for him, fearing that he would seem very odd to the Americans, but to that he had been impervious. It was Rex who felt strange, for the first week. They telephoned between hotels, bedroom to bedroom, Rex half-way down in some canyon. "I'm surprised to find New York so squalid, every street reminds me of the Tottenham Court Road – old newspapers and drays. Oh, I'm so tired!" – "The view from my window is stupendous!", moaned Stephen, pillowed high up in the Saint Regis, cushioned as everywhere else, in hired cars and lovely homes and shops, from any contact with the harsh, uncaring city. When during breakfast in bed a sullen boy appeared with newspapers Rex greeted him courteously, and, what was worse, in English. The reply was terse: "Wadpaybrjawant." It had been taken for a pass. To Stephen, had this happened, it would not have happened: it would have been wiped from the record instantly. Rex wrote to Liz that he had never felt so homesick since returning to school.

Before any work could be done he was obliged to take the exam for membership of a union, and stay in some isolated room long after he had obeyed the orders to "draw a table" – "a running man" – "a hamburger". When Oliver Messel took it he was required to name three theatrical designers of history, could not think of one, and so failed.

"I'm really too tired to go and see Tallulah, aren't you?", had said the telephone on Stephen's pillow. But Rex was soon visiting that suite in the Gotham Hotel, with a copy of Hans Andersen inscribed for her. Years later she claimed that he had come to New York in order to see her, and it must have been one inducement. "Now he is with Tillulah", Edith wrote resignedly, spelling the name as always, "so I fear he will get drunk, and spend all he earns, and come back quite worn out." She knew – because they had telegraphed David Herbert at Wilton to say they were together, and to wish he was with them, as once in the recollected Splendide. Edith did not focus on the niceties of being together; whereas for David the message had excellent definition. So the affair was resumed in a light-hearted way for a while, accompanied by alcohol; and Rex did not have a very good head. On one occasion, he told me, she came out of her bedroom announcing, "Rex doesn't love me any more!", but he did not seem to have been much mortified. He was glamorous to her as she to him. Each was important to the other, she maintained after the war. And to another friend she said, "Rex was as serious about me as – in a different way – about Edith Olivier, and I adored him. If he hadn't died, who knows what would have happened!" She was taken to mean marriage. But that was mere daydream, and pathos reappears with the notion that he, who would have wished a wife to bring him youth, children, fidelity and health, could have settled down with a Tallulah of forty-three or more, sterile, incurably promiscuous, and drugged. Glamour she did keep until the peace, and great qualities, too – like some fabulous pre-war racing car, trackworthy still, if slightly battered, lacking only differentials.

The play opened in Washington "where it was less frightening and depressing", he told Liz; quite pleasant, in fact, in "a town very prettily laid out and very civilized". Then back to New York, and "I pray I shall like it more", partly blaming the great pressure of the work at first, "but I wish I was home again". The première on Boxing Day was a triumph for him, and for Helen Hayes too, though not in his eyes: he did not think her Queen authentic, and they sometimes sparred. Now there were celebrated people to meet: Cole Porter, Edna St Vincent Millay, Catherine Cornell the actress, and Elsa Maxwell the hostess, and for the last ten days he was the guest of Alice and Raimund von Hofmannsthal in their house on the Hudson. Raimund was the son of Hugo, the Austrian Jewish poet. An attractive extrovert, in youth he had followed Diana Cooper adoringly round in *The Miracle*. Thus "it was fun in little bits, more fun at the end", but his old, so-contradictory feelings for Americanism were resolved into a qualified dislike; though that did not involve the entirely likeable theatre-hands,

when it came to goodbye. "I do want to tell you about the misery of America", he wrote to Liz on return: misery that was still extending queues down Broadway for a spectacle which would have been nothing at all but for him – misery that enabled him to hand his mother a cheque for £1,000 (say £24,000 now), and be that much further from marriage – assuming there was ever any prospect of marriage.

Within days of his return we all came out of Cobden-Sanderson's to watch a gun-carriage roll through Russell Square, with four gaunt Princes staring straight ahead as they strode into a mounting constitutional crisis – and there in front of our eyes the top of the Imperial Crown sitting on the coffin, with its one sapphire and two hundred diamonds, tumbled into the street, to be scooped up neatly by an NCO of the escort and put in his pocket. "Christ, what's going to happen next?", said the new King apparently, and this was taken as a motto for the opening reign. Gratified by the success of one play Rex had taken on another, a dramatized version of *Pride and Prejudice*, with again a welcome chance to design the whole production, including now the poster and the programme. Slim high-waisted dresses were less challenging than crinolines, yet the period was closer to his heart. He would as happily have lived in any Longbourn, any Regency house, as he would unhappily in any pocket Balmoral. But to the décor of a Regency house he would have added touches of Empire, which he did more theatrically to the set for Rosings, for Lady Catherine de Bourgh. Now at the Daye House again, too tired to begin work until the evening, he still had fifteen dresses to design, which Edith's maid must despatch without fail at breakfast-time. Then the generator failed for two hours: Rex "angelically sweet and unruffled, but really in despair", and toying with recourse to a room in a hotel. It had been mere lack of fuel. At every hour of the night Edith woke to see his light still on, and at four she went down to him. At five they packed the fifteen perfectly explicit paintings, filled hot bottles, and got to their beds, where he slept until lunch-time; and in the evening decorated the visitors' book for 1936, and did a funny advertisement for Shell. This was fairly normal behaviour – so normal that he thought he must be lacking in vitality to feel exhausted so often. Edith was resigned to it by now; also relieved that he did not appear impoverished by debauchery, and was "not *at all* changed by America. In fact it made him love better all the cosy un-American things here." Even so, he would stay at the Daye House only twice this year; and not a letter survives, whereas a few years before he had written her fifteen, twenty, even thirty, in a year.

He liked to face an audience with a striking curtain: that street for

the *Rake*, The Round Tower in a vast brilliant wreath of roses for *Victoria Regina* (Pl. 39), and now a wide open book banked with flowers and fruit – on the title page, of course, "*Pride and Prejudice by Jane Austen*", and for the frontispiece a view of Rosings, with three graces. In the stalls on the first night, hardly able to whisper for the heavy cold brought on by fatigue, he had our mother beside him, enchanted by the visualizing of a favourite novel, and by Celia Johnson and Dot Hyson as Elizabeth and Jane. She supped at the Savoy Grill, and seemed to Edith, basking there too, "so pretty and darling", and not commonplace just then. Next day I took her to tea with my lady-love, unrecognized as such, but approved of as my frequent companion, being found "so appealing". All in all, with my father fairly recovered, the days of Rex's return were happy ones for her.

It was Rex's wish to take me on visits with him, and this was pleasant in inverse proportion to the sophistication to be faced. At Clovelly Court under the strict rule of Mrs Hamlyn, owner and empress of the village, the strictness only added spice to an old lady's genuine welcome of a younger brother. There was the pleasure of being there with the young Asquith girls, with one especially; of a private boating party all day to Lundy, and of bathing parties in the sunlit solitude of the Window Rock. With and without Rex I had several visits to Clovelly. But to Port Lympne, one. There, in a party with the Anthony Edens, Noel Coward and others, I felt myself to be again Rex's shadow; not that he asserted himself. When I asked if he liked Noel Coward he made a quick grimace – by way of comment on suburbanism faultlessly equipped with aplomb. Again I felt myself unable to say anything that came out right. In the garden one of Philip Sassoon's vistas plunged headlong into a small wood and there stopped. To contribute something more than mere superlatives, I wondered aloud, "You decided not to take it on through the wood", and was snubbed by Rex. The whole subtle point had been *not* to take it on through the wood. I still thought privately it would be more exciting to look right through and out of a green tunnel; or alternatively that something terminal was needed, like a statue, and not just an end-stop of trees as in a stretch of road-building abandoned; and I was relieved later on when I heard Lutyens say the same. I thought, if Sir Philip were not here, my brother might not find it such a stupid query, even if mistaken. As for a second slope, between two vast herbaceous borders, the fault here (assuming there was any fault) could not be ascribed to over-subtlety. For a social month in the year Flora trooped the colours. If you shut your left eye it was solid mauves from end to end, if you shut your right it was solid yellows. In the other Sassoon

garden, at Trent, Rex had once suggested touching up the lead statues with gold, for which there were good precedents. "I must say he has gone further with the idea than I should have dared!", he commented. "A vast lunging gladiator now has on his left arm what looks like a gleaming gold dish cover!"

Hannah Gubbay, Sassoon's cousin, acted as hostess for him. "I do wish", said Rex, "Hannah wouldn't say, 'I've been working like a black.' She *is* a black!" He could mock at a swarthy complexion; and had a reputation for mockery, not of the most caustic kind. But he did belong in the scenes of cultured affluence, whereas I floated outside – dodging in at times like an inexperienced bat through the window of a state room: radar-to-rococo. It made for social angularity. I despaired when I heard that somebody had described me as "a self-assured young man" to Desmond MacCarthy, whose interest in my efforts I coveted more than anyone else's; and he had replied, "I don't much care for self-assured young men", and in fact never showed any interest in this supposed example. In my case, a climb into literature was not helped by a hoist now and then into the 'Bohmord, fondly meant though it was. And the advice given was not always wise. Eddie Marsh, whose anthologies had established the term "Georgian Poetry", liked some of my verses but had been crushing about others, and Rex in his indignation incited me to write the kind of letter that Osbert Sitwell would have written – and he himself would never have written on his own behalf. I did, and received a graceful apology that made me wince. That week-end at Port Lympne, as we circled away from the front door after the tipping, Rex made a comment that stays in memory. A Whitman poem he had enjoyed reading to me once begins like this:

> We two boys together clinging,
> One the other never leaving,
> Up and down the roads going, North
> and South excursions making . . .

Sharing a bedroom in the far-off Farnham Common days, we used to pretend that we were poor clerks obliged to do so in some cheap lodging house. Now, because he knew that I knew that I had failed, he improvised –

> We two clerks together clerking,
> Up and down the roads larking,
> Week-ends staying, games playing . . .

It still keeps the power to touch of all tender words or actions that cannot be thanked for because they have to be taken as humorous.

To feel out-of-it was not an experience he never knew himself. Duncan Grant, living in the same street, invited him in for a drink, and he thought, I suppose, that it could not be wrong in that circle to arrive as he was, fresh from painting. But Virginia Woolf, arriving next, "found only steamy, grubby, inarticulate Rex Whistler". Such encounters drive you back to circles where you do talk the patois at least passably; one of which for him was the theatre. He found theatre people on the upper levels exasperating, but not more than they commonly did one another, and whatever he might say, enjoyed the work, and even the pressure. Cecil Beaton, a friendly rival, has said that Rex "could have done four productions a year had he so chosen". He did only two in the last three years of peace because mural painting was the stronger draw, and two chances of that arrived in this spring of 1936. First Lutyens wanted him to paint another staircase hall in Hill Street, at No. 36, the home of Mrs Porcelli. Round the upper part were eight large panels of various shapes, with plasterwork frames and Rococo pendants in between – panels of the kind conventionally provided for murals, but almost never so used. Lutyens knew they could be properly filled after nearly two centuries.

It was like opening eight windows into one romantic landscape, conceived as flowing on round the room – with such incidents revealed as horsemen under feathery trees, towers, clouds, mansions, rocks, boats, cascades: favourite properties re-invented. There were little touches of actual *trompe-l'œil* – like the bunch of flowers lolling on the plaster frame, and wound with string that seems to straggle down across it. He had here a customer happy to exploit his pliancy; but when he asked for an advance, she claimed, not trusting him, that she was – "Well, who isn't?" – overdrawn. "She (the old cat Porcelli) keeps thinking up new things for me to do and to alter." For example, she felt that the sawyers would never get through their fallen tree. And she would not have the human skull that nestled in the corner of another frame, a small cool hint of *et in Arcadia ego*, very characteristic: he never backed his modulating moods persuasively enough. But puss could rub her head against his kindness, when a large vase of flowers above a door, painted shedding a few petals, shed a great many more down the stairs for her daughter's wedding, all spirited away with a rag next morning. His wedding presents were a monogram for linen – and a simple design for a bookplate. True, these may have taken hardly more than an hour or two.

# ·XXIII·

IN APRIL 1936 Rex caught the sleeper with Caroline for a first long week-end at her home, Plas Newydd in Anglesey. He had last set foot on the island fourteen years before, when the family travelled in the open Ford up Watling Street to dismal lodgings in Bangor; and now a revived recollection of strait and bridge and a soldier on a column, and a fainter one of imposing stone lodges beside a road, brought again the lost feeling of that wet holiday when he had just been rejected by the Royal Academy Schools. Confronting the mountains on the mainland, stretched out in grey Gothic Revival ashlar on a site supremely picturesque in the original sense, Plas Newydd had been shaped by the father of "One Leg", the brilliant cavalry commander, made Marquess of Anglesey after Waterloo, who is commemorated on the column. The dining-room Rex was to think about painting was the last in a range of reception rooms, with a virgin wall fifty-eight feet long, confronting four windows. Through the windows was a view such as even Turner might find it hard to deflect a casual eye from; for in fresh weather lights and shadows feel their way along the whole of Snowdonia, caressing and erasing; while the water of the Straits clucks and silvers just under a steep-down lawn and a battlemented sea-wall.

Rex resolved to answer it as in a mirror – a mirror that transformed. He would answer it with another mountainscape-seascape, which could also be a townscape, the painted architecture breaking forward at the corners, on to the end walls. This great painted view would expand the back of a room that was too narrow for choice. And by painting to the very edge of the carpet he would make fact and fiction contiguous as never yet, so that you could simply, as he said, "walk into the picture" (Pls 36 and 37, and see note).

On return to London he received a cheque in advance for £200 from Lord Anglesey, before an inch of it was sketched. "I am rather flabbergasted at this huge unexpected profit which that lovely visit has

brought me!", he wrote. There would never be the slightest friction over money. It was agreed that he should be paid on the Hill Street ratio, area for area, but when, because of the vast extent of ceiling and end walls, he found that this worked out at "something just short of the National Debt", a round sum of £1,000 was substituted. He stipulated that he should keep all the preliminary drawings and paintings: "that is usual and I have always kept mine". It was a good contract letter, crisp and thoughtful.

His visit had already produced a design – but for something quite different: a Gothic loggia for the screen wall which Lord Anglesey intended on the entrance side of the house. "The painted hangings we could do in one afternoon and the gold stars on top the next day." It only had to be built, with flattened ogee dome, columns, finials, etc; and it seems to have been taken seriously at first, so persuasive was his coloured drawing. There was nothing of neo-Georgian timidity in any of his architectural proposals, as when he suggested a full-blooded Baroque centrepiece to Victorian Knebworth. He could invent whole-heartedly in a past style. Thus in architecture he was, what he was not in painting, a pure pasticheur – but then, he was not an architect. Of his many suggestions for the houses of his friends few were carried out, though some were. One that was not was a second wall at Plas Newydd, to make a forecourt, proposed because "nothing is lovelier than arriving anywhere in a very closed court, I think – (unless it happens to be Wormwood Scrubs)". He did embellish the first wall with the present rusticated arches, balls and grilles.

Trust, established at once with the Angleseys, ripened into mutual affection, so that soon he was writing to "My dear Charley", twitting him about his "exquisite perspective-plan – or should I say isometric section?" – also promising to take "the greatest care of Caroline and Liz" on a trip in several cars to the von Hofmannsthal's home in Austria; not to let a certain friend drive them; and not to be irresponsible himself. (Sketch of driverless car ejecting suitcase.) But even as a prospect the trip was not as rosy as it might appear. Caroline had not been kind to him, he wrote to her. She must not think that if she were he would have any claim. He had not exposed his love for her at Plas Newydd, had he? Nor would he while abroad. In the event, Austria was only "great fun – at times", and he "wanted to come back most of the time", but was persuaded into driving across Italy to the Riviera, and from there to London in two days, arriving "about dead". This he told the Angleseys, inviting himself to be a guest in a heavy guest-month, so as to make the preliminary design for the murals, and saying he could sleep in a boat. (Sketch of boat with iron bed, and self, frying

breakfast.) When the highly-finished water-colour was shown to them at last, months later, it was approved with delight. At the outset he had told Lord Anglesey that he thought the big task would be his happiest ever, and so it proved – but not to any great extent because of Caroline. To her he wrote.

> I feel rather extra unhappy because things are so wrong between us, aren't they. I suppose I have hoped for more affection from you than I have any right to expect … I do realize that this is not a case in which I can say: "I knew at the beginning that it wouldn't last long" because there hasn't really ever been a beginning, has there?

Cutting out printed phrases from somewhere (given in italics here) he pasted them into his letter. "Sez you, '*You've not had much experience of women, have you Rex!*' – Well, perhaps not, but '*I'll have to find ways and means*' said Rex. There are lots of *ways*, of course but it needs, unfortunately, so much *means* too." Under the flippancy there was a faint reminder that he might find comfort elsewhere.

Meanwhile at the Daye House the nubile came and went, and Edith took charge of a very beautiful girl with an unhappy background, little more than a child, who begged that her parents should not know where she was, but was told that her mother would have to. She stayed for some days, to be replaced by Jill Furse on a long visit to recuperate – "so exquisite, but it's a sad little face"; for illness had lost her the supreme chance at the Old Vic, playing Shakespeare's young heroines. My new book of poems arrived, and Edith read them aloud, she wrote to me, "straight through from end to end with a very delightful, sympathetic and poetic guest". Her name was not given, perhaps with the thought that if a meeting took place she would like it to be there, in her Long Room. She had forgotten, or forgiven, that four years before – and we had had no dealings since then – I was Red, and hateful.

Long afterwards Jill was to say, "I remember the shock, almost physical and almost prophetical that went through me when old EO read *The Emperor Heart*, I suppose that to the part of me which recognized you, all this [our life together] was *known* – had happened and was still happening. Otherwise it would not have made such a tremendous impression."

A few days later they parted at Waterloo Station, "both very sad. She is an exquisite guest. Lovely to see, perfect manners, very intelligent, sensitive and poetic, and great fun too." Edith had gone up to George Sassoon's christening, and returned with Rex. Being next to sign the visitors' book, he put two sprays of flowers under "Jill Furse",

merely on the strength of her report. He liked a lovely girl - liked the notion of a lovely girl. But he loitered in Edith's bedroom till midnight with some worry to confide, and never did. Unbosoming no longer came easy.

He was giving himself a good dinner in the Eiffel Tower on "Gloomy Sunday", while writing to Caroline who had "chucked" him again. He could see her standing in the hall with a bored expression, thinking – another invitation to dodge.

> But you'll be wrong, and what's more there ain't going to be no more, neither, so there. I've been thinking about you young lady ... and I consider you done me wrong – or rather, you never done me right. So you see, you aren't my girl-friend no longer. You never really were, were you? I've *loved you*, you see, Caroline, while you have never loved me at all, – only liked me.

That was why he had seemed such a bore, as he supposed, why she never *wanted* his company much, why she had been content, even glad, when work kept them apart. (Plump M. Stulik now stood waiting to turn out the lights on his last diner.) He was not so conceited as to think she *ought* to love him –

> I am still amazed that you should ever have *pretended* to do so. I only blame you, darling, slightly – but so very, very slightly, – for deceiving me a little. But very likely you deceived yourself.

Perhaps she had, yet the musing uncommitted face in another of his many portraits, tilted head on a cushion looking at him looking, does not lack self-knowledge. To more than one admirer – and who did not admire? – her symbol was a beautiful black cat that sometimes purred, but quite unreliably. So many wanted her it seemed that all should do so. The bowls of cream were requisite and unrequired at once. And yet she was capable of love of one kind.

For the truth is that Caroline was not single-mindedly attracted to men, either by predisposition or else through being influenced when still impressionably young, when twenty-one in fact, by the equivocal Tallulah and her friend, Audry Carten. "That was where it happened", she told one of her sisters, years later, as they passed 10 Albert Road, off Regent's Park, which Tallulah had briefly taken, just after her tumble at the Splendide with Rex. When Lord Lytton's memoir of his son Anthony appeared, and Caroline was touched again by his devotion to her, and by his phrase for her, "beautiful as the Milky Way", she inscribed a copy "To my darling *darling* Audry from *her* C". She never wrote like that to Rex, I surmise. So her heart was given before

he had a share in it; yet he did have a share in it, enough for hope; and she did respond physically, enough for him to feel he could discount the other tendency, if indeed he was much aware of it at first, in his lonely quarter of her compartmental life. They stopped meeting, without protest from her, and he found solace in other friendships – going to see Edith Evans in *As You Like It*, with Edith and the David Cecils and Jill Furse, and saying next day that he wanted to paint Jill because he "loved her profile and her primness", a characteristic more apparent than actual. But Caroline was in a nursing home and in pain, and he wrote –

> to ask humbly if we may be friends again? Sweet Caroline, I really *must* have you back in my life, it's so dreary otherwise. After all we were awfully good friends and happy being with each other (on the few occasions that we were) before I started being a nuisance to you ... so *please* darling sweet beautiful Caroline forgive me. Of course, it *was* a tiny bit your fault and in *one* way (the way you happen to look!) *all* your fault!
>
> You poor little girl, I can't bear to think of you being tortured – even though I have sometimes in the past wanted to torture you a bit myself!
>
> P.S. I'm prepared to do almost any penance – as here. [Sketch of figure crawling from John O'Groats to Land's End under sackcloth and ashes, and with lighted candle.]

Her prompt reply was "magnanimous", he declared, "even though there's more than a dash of sarcasm in it here and there". Then the old resentments were turned like mouldy hay, and written off, it was hoped.

The Abdication distracted a little, with Osbert Sitwell wanting a decorated copy of his satire on the Duke of Windsor's good friends, who all now confessed that they hardly knew Mrs Simpson. Though Sitwell was not Swift nor Pope, "National Rat Week" had a good circulation and did him no harm in the new reign. So back to the major task. Presently Rex told Charley Anglesey that the single vast roll for the mural, arriving from France, caused "in canvas and jute circles" proportionate amazement. "You *are* the most charming and kind employer that I ever had, the way you press me to accept payments on account!" He would be glad, rather later, of £200. No doubt he received it, rather earlier. Across Lambeth Bridge he had hired from Alick Johnstone's, the scene-painting firm, a studio large enough, with a frame that could easily be wound up and down. Two assistants were at work, the best being Vic Bowen who had helped to carry out his

stage designs, and who would stay with him for murals till the war. The invention of cellophane enabled Vic to square out the water-colour without spoiling it, and transfer the squares to the canvas, full-size in white chalk, then paint the groundwork in vague detail.

Across a restaurant table Rex was back in Edith's travelling confessional, though not as humblingly as once, merely brooding on the past as offering "gay *days*, but no period of sustained happiness" he could wish to return to, except perhaps at the Slade. That was before he knew love. Now he could not keep away from it, yet always seemed to be in love with two girls at once, Pempie and Angie, Caroline and Liz; and then there was that new one, of the narrow chin, broad brow and deliciously set eyes, who had preceded Jill Furse at the Daye House. After just one meeting at some party, rich friends were naughtily arranging that he and she should dine alone in their house, and very sumptuously too, both in fancy dress, for Rex to take her to the Austrian Ball; where he went on flirting with her, partly to make Caroline jealous. The glamour of his world, the glamour of his art and mind, were intoxicating after the deprivations of home. But he was not in love with her, and would not, as she begged him, be a fellow guest in Wiltshire for fear of going too far. Therefore, at the Daye House, she stared at his self-portrait, bit her nails, and could not sleep for thinking of him. Edith sympathized, but believed it would pass. Soon her bedroom was needed for another girl-guest.

But first I must return to the arrival of my book in the autumn. Edith had felt that there might be something to me after all, and had asked me for a weekend by myself. It was lucky – for me – that I accepted, and then was better liked than I had been when at Oxford, "very crude". But for passing that test I should not have been invited to meet Jill Furse, my fan, and Rex would have been there by himself. On St Valentine's Day he fetched her from Salisbury station for the one-night visit which was all that an actress in a play could manage. That night he talked late of his discontents to Edith. Next morning he generously lent me the car to drive Jill back to London, saying he was tired, and would prefer to go later by train; in fact he left within an hour or two. This was to promote my friendship with Jill, as I said in my story of our life together, *The Initials in the Heart*, but it is also true that he had no particular need at that moment to take on a third beauty, with the normal complement of two "on his books", and one of those as usual in his bad books.

# ·XXIV·

MORE JOY in work than love. "I hope you think I have done very little yet (and I believe you *do* think so)", he wrote to Charley Anglesey. Having sketched in a sumptuous sky he was moving from left to right across the scenery below, leaving only the people on the quay and in boats, and the rigging of the boats – "rather agonizing to do at first", he said, but he now considered he could "flick in a fine rope or the light down a pilaster with Canaletto!" Over the triumphal entry to the city he put a Latin inscription, provided by a Salisbury Canon after prolonged thought, to the effect that it had been founded by Lord Anglesey and designed by Rex. As painted it is not only in dog Latin but with a number of howlers.

A particular joy was the movable frame, illustrated for his client in several sketches. It meant that he could paint at the bottom of the canvas without getting apoplexy, and at the top without mounting ladders like a pirate, brushes in mouth. Osbert Sitwell called, and found a "Mandarin" sitting in the corner of the studio, "much more consciously oriental than anyone I had seen in China". In prosaic truth he was a Japanese scene-painter who in spare moments was studying Rex at work, but to have explained this would have spoilt an Osbertian story in the making. "I've never seen Rex *enjoy* a piece of work so ardently", Edith wrote. "His face lights when he speaks of it." And this was the day after he had spent all night there quite alone, between the huge shadows and his daylight-lamps, "like being in a dream-prison of Piranesi's". In the silence of one such night he heard a vaguely familiar sound: the self-starter of his open Swallow Special being tried. Two men ran when he burst from the door, and he ran after them, searching for a cry less old-fashioned than "stop thief!", but without success, and therefore running silently; not that anyone was likely to respond under the gaunt railway arches. Soon he found that he was *gaining* on the others, and thought best to slacken pace, and return to his painting.

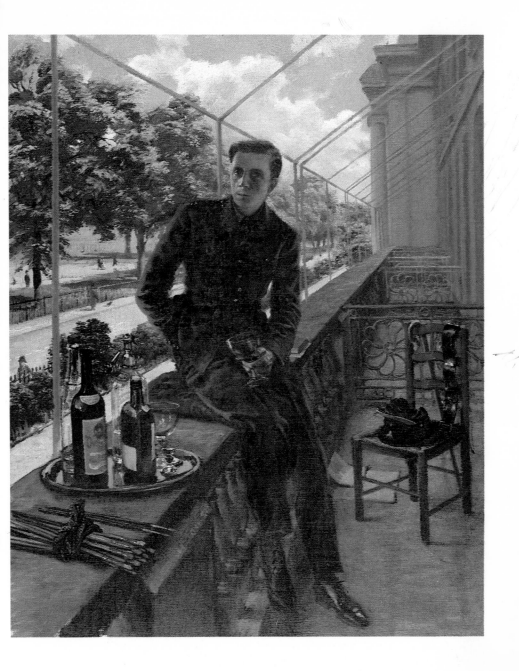

**26.** Self-portrait, over Regent's Park.
Painted the day his uniform arrived, in May 1940.

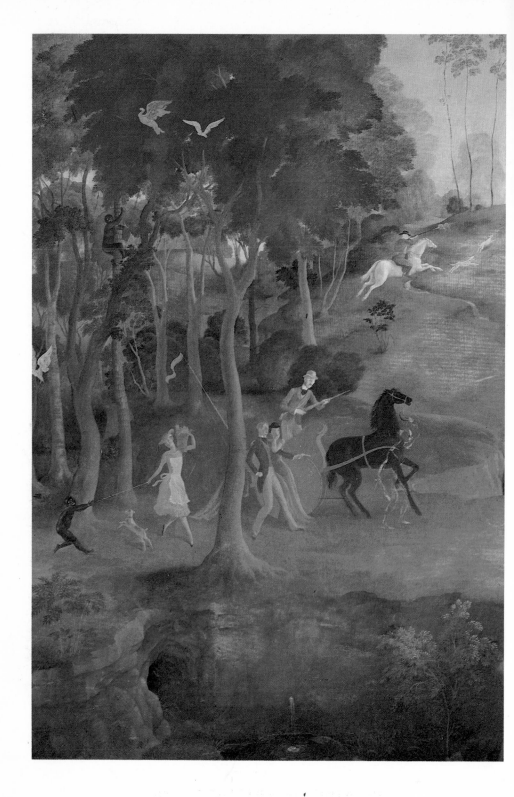

27. The Tate Gallery Restaurant mural, 1927. Detail.

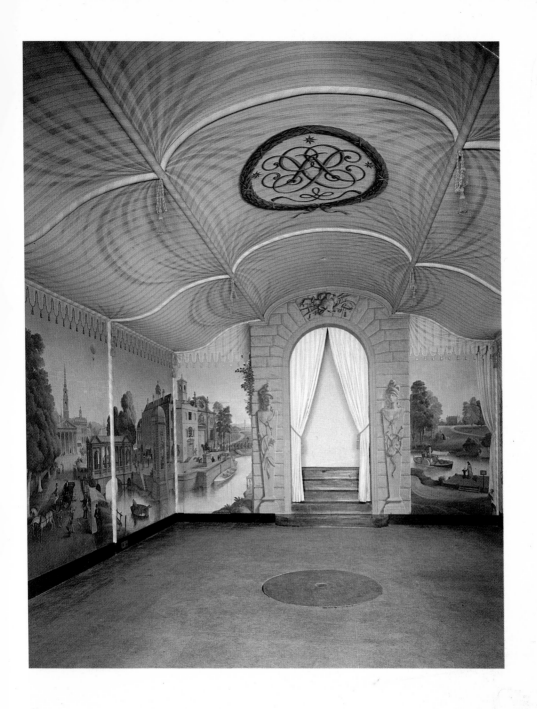

28. The painted room at Port Lympne, 1932.
The curtains are of recent date.

**29.** Bookplate for the Duchess of Westminster, 1930

30. (above) *The Vale of Aylesbury*.
A poster for Shell in 1932. The author is sitting under the tree.
31. (below) *East Mersea Church*, near Colchester.
The artist's first painting as a soldier, June 1940.

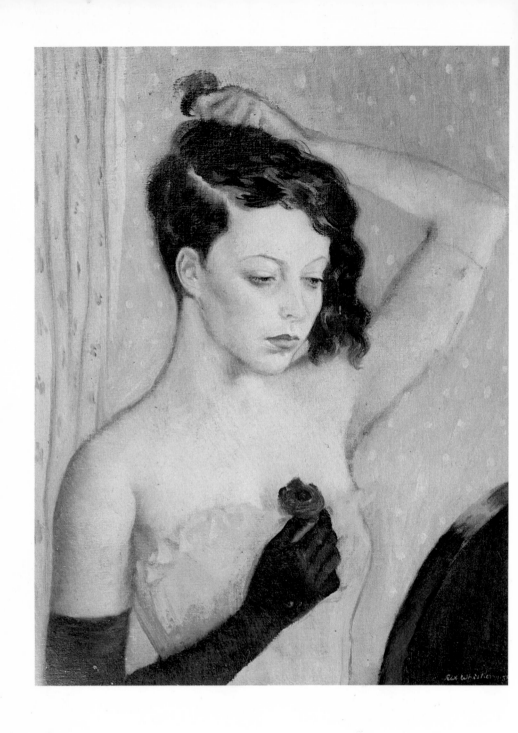

**32.** *Girl with a Red Rose.*
Caroline Paget in a fictional setting, 1935.

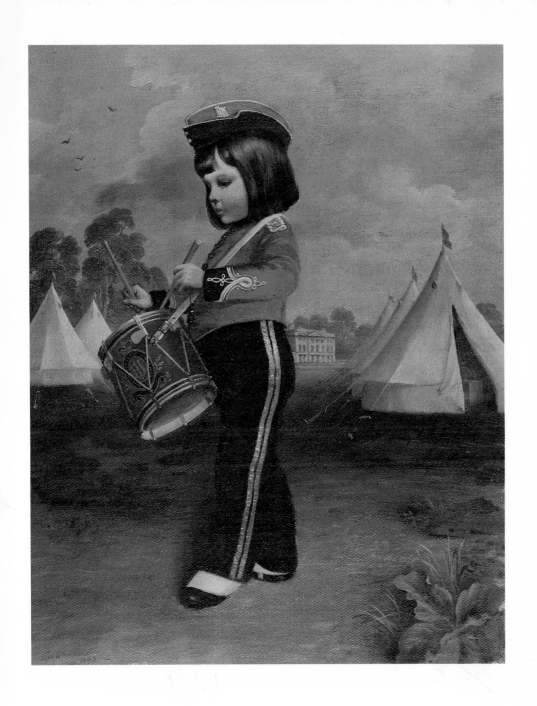

**33.** *Laura the Drummer*, 1940

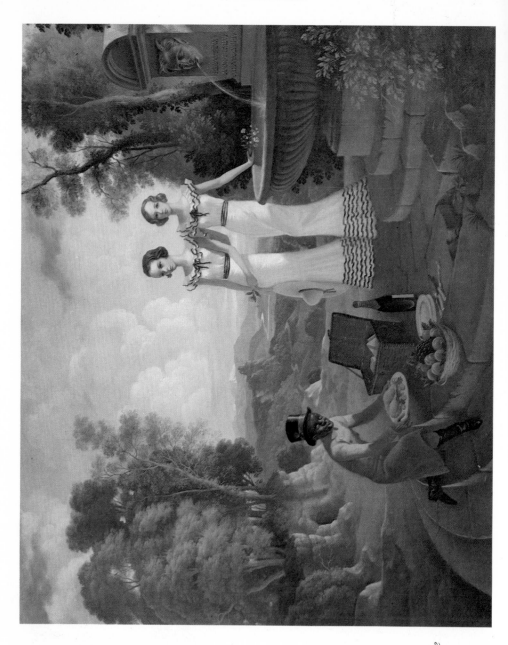

34. (right) Penelope and
Angela Dudley-Ward,
1933-4
35. (below) *Conversation Piece
at the Daye House*, 1937.
With Edith Olivier, Lord
David Cecil, Lady Ottoline
Morrell, and the artist.

36. (above) The dining-room
at Plas Newydd, 1936–8
37. (right) Detail of the
Plas Newydd murals

38. (above) A clavichord, painted for Tom Goff, who built it, 1939
39. (below) Curtain design for *Victoria Regina*, 1937

**40.** (right)
*An Ideal Husband.*
Design for
Acts II and IV, 1943.

**41.** (below)
*Love for Love.*
Design for
Act I, Scene 2, 1943.

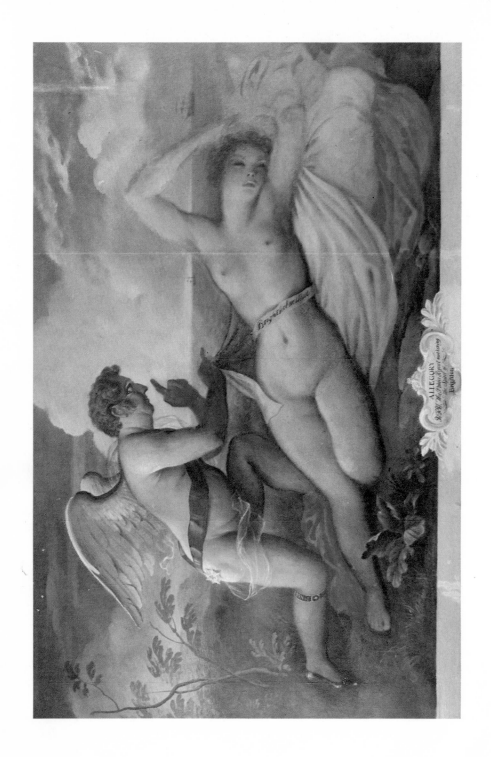

42. "Allegory. HRH The Prince Regent awakening the Spirit of Brighton", 1944

In June the canvases went up to Plas Newydd and were stuck to the wall, but not efficiently, nearly resulting in a law-suit until blisters were treated. Rex resumed painting before the family returned, and put workmen on to changes not more than provisionally agreed, such as stone-coloured walls, gold cornice, etc., and even modified the new forecourt entrance on his own initiative; in fact, "interfered left and right"; and was not rebuked. Then he had to go south for a new play called *Old Music*, and wrote that if the house was full by the time he returned he was quite ready to "shake down in one of the Gothic turrets", given a little straw. From now on the work became more interrupted and more enjoyable still because of his relations with the whole family, and especially with Henry, fifteen, and at Eton. Henry became like a second younger brother; and Rex was an education – in architecture, poetry, painting, design, and much else. When apart, they wrote for years more frequently than he and I did, exchanging jokes, insults, serious ideas, verses, rebus letters and nonsense.

His return north had also been delayed by the English production of *Victoria Regina*, opening at the Lyric Theatre one hundred years after her accession, to the day. This was far more to his liking than the American one, with the scenery reconstructed and improved, and Pamela Stanley a convincing Queen, both young and old. "In a few productions", he had reflected, "the scenery may be fully as important as the acting itself. But in no more than a few." *Victoria Regina* was obviously one. He dazzled with his sets – and took greater pains than anyone would ever notice to get them right. Thus is one scene there was a glimpse through a palace window of the Mall without Nelson on the skyline; for the scene took place in 1842, and a note on the drawing says, "Nelson's Column, 1843". Pedantic as it might be thought in that instance, it was the scholarly urge that gave a strength to his stage designs not found, for example, in Oliver Messel's, charming though they were.

There had been a first-night party at the Savoy, "Rex in a dream with Caroline, who for the first time seemed a part of his life – as if she shared his triumph. They are a perfect pair – both quite unfit for marriage. What can they make of it?" For a fancy-dress party at Ashcombe he brought to David Cecil, with whom he was staying, whiskers, spats and cravats, for them both to go as Victorian sportsmen, and for Caroline he had designed a Renoir costume: pink-and-white-striped dress, bustle, little sailor hat and tiny parasol. She looked ravishing – and hardly spoke to him or danced with him.

I remember him whispering to me, "David, you must come out and talk to me", and going outside into the dark summer night, and

how he poured out his frustration and his hopeless incurable love. Many friends I saw much more of would never have revealed themselves so naturally. He soon stopped and went back to make the best of it.

She was only flattered to be his in the hour of his success. When he and I called together on a young couple, cosy and serene in their flat, he burst out in envy as we emerged into the street, and was silent.

Edith put the problem to David, who thought, "Jill Furse would do!" – "*So she would,* but for Caroline. No one can eclipse that moonlike beauty." There was much to be said for it, otherwise: Jill's beauty (the prime requisite) and their common interest in the theatre, where her talent was not less than his – she illuminated the stage, someone wrote, while Caroline only smouldered. Presently Jill was wearing one of his crinolines, with ringlets, for "The Rose and the Thorn" episode in the play. Then there was their equal passion for poetry. Rex tried to induce that in his girl-friends, with readings aloud and handsomely-bound presents, and they responded like any upper-class girls of sensibility. Poetry did not count, say, like opera.

It might have come about. The loan of the car that Monday gave me eighty miles start, as he wished, and she lunched with me the next day. But a race was never on. He saw her occasionally, I more often, and after three months her diary read:

I had lunch with Rex at the Jardin des Gourmets and that was *lovely*. He is a darling, one of the most attractive and fascinating people in the world. But he has a sad face and his hair is going grey. ... He's a much more trustworthy person than Laurie I think and has far more fundamental goodness in his face. In lots of ways they're very alike – the same voice and hands and the same freakish sense of humour. I should love to know him really well. But then I always fall for sad people. I always think they are the kind I should like to marry and make happy for ever after.

As for Laurie, I'm much too fond of him without either trusting or being in love with him. I love his mind – one side of it, and we fit extraordinarily well. We're much too like each other, though.

So, had he competed quickly he must have succeeded, and there would then have been happiness enough for both, though not such as there was going to be, never tasted by him. If I had died of my abscessed appendix, in the previous year, in the end he would have married her, I fancy. When Edith recommended her he said he was attracted, but

I was in love, and he could not try. "O how I adore his exquisite being, so clear, so candid, so ideal."

A month later Edith was close to panic because the young girl who loved him rang up from Plas Newydd, voice quivering with emotion, "wildly happy", with "so *much* to tell!" Edith did not dare to ask if Rex was there, painting. He was. Could she conceivably mean marriage? "It would be like two children in a wild beast's cage." It would also be highly ironical, in Caroline's home. But it was not Rex, or not entirely. It was Caroline herself. They had become a kind of trio, to the mild extent of cuddling and kissing, and the unloved child felt accepted into love for the first time, and in a house imbued with high romance. On leaving, she wrote to Caroline ecstatically, pleading for more "lovely letters so that I may realize that you still love". When the answer came she wrote again. "Your letter was so miserably shallow, dear Caroline, I don't believe you love me at all. I hope you are happier than I." The affair had taken too serious a turn for the elder girl, who then went south herself, not without receiving a Rococo cartouche addressed to "Beautiful Darling Caroline" and begging her "to defer such departure until it should have (if ever) the approval of the undersigned – Henry – Rex." He was left alone with Henry, and his paints.

Still the young one was waiting to be claimed, though unaware of that, and in the end he claimed her, notwithstanding her innocence, drawing her into the bedroom at 20 Fitzroy Street. But guilt and misgiving are not as easily removed as clothes. He cried and said he felt sick, apologized abjectly, and took her home in a taxi, she as bewildered as he was disconsolate. No blissful morning telephone-call followed the first night, only silence. She felt in her ignorance that the fault must lie in her, that in some undisclosed way she, who could attract all men, was unattractive in bed. She had to be sure it was not so, presently became engaged to someone else, went to Paris with him on the quiet, and later broke it off. Thereafter, meeting her at balls and parties Rex kept her in unhappy suspense, never mentioning that night, but, with an impulse to confirm at least one power over beauty, flirted with her still. "It's been an extraordinary summer", he reflected.

Edith's financial anxiety was now handsomely allayed. Too exhausted to go without a car, and too poor to buy one, she bought one and relied on paying guests – and then Siegfried gave her £200 a year (say £4,400 now), out of gratitude. One of those guests, Lady Ottoline Morrell, had been specially rewarding, and it was an evening of good talk with her and the David Cecils that inspired Rex to provide for her autobiography his best-known water-colour, *Conversation Piece at*

*the Daye House*; where he included a good likeness of himself, if rather more youthful than he then appeared (Pl. 35), He was fonder of this than of any work of his. "If you die before me will you leave this picture to me", he wrote, "as I shall love it as a 'Long Room' souvenir. If I die first please bring it with you when you come."

If not Jill Furse, then Edith wanted him to marry "someone like that". What had she in mind? Not class: they were all ladies by birth and upbringing. Life-style, rather, which meant lack of riches, fundamentally. His girls might not all have large personal allowances; they did not need to. They enjoyed a luxurious society with high expectations of being entertained, as the young well-to-do always have. Edith wished him to find lasting love on a quieter and really more interesting level of society than Society, one where more serious ambitions were the rule, and less expensive habits. To me, for example, it was never a problem with Jill that it was Antoine's for lunch, rather than Le Jardin des Gourmets, Rules very occasionally after her play and never the Savoy, theatres only when free seats were going, and a train, not a car – except when Rex, always gladly promotive, offered his own, soon exchanged for a Hudson Terraplane, rounded and beefy as a beefburger – nor that sometimes she and I went shares, a good test of easy relations.

The fact is that Rex not only enjoyed to the full the perks of high life, but was attracted by the style that went with them, the spontaneity and lack of social inhibition. And if arrogance was sometimes a concomitant he did not then seem to be as riled as I was by the ineffable superiority of tone and expression. An intelligent young girl would not display it, anyway; and in that ambience her beauty would be enhanced – especially as she would have the leisure and the means to keep herself beautiful. In short he liked the atmosphere at the top. Why not, he thought, enjoy the best that is going in one's day, as artists used to do before it became suspect – the best always implying beauty, in one form or another? Writing from Belvoir Castle to his mother he drew a water-colour sketch of his great half-circle of a room – evening clothes laid out on the bed by the footman – in which hung a Le Nain, a Schidone, a Wouwerman and two Claudes. "There's grandeur for your bedroom walls!"

He repeated a current joke that the only sound throughout the Two Minutes Silence on Remembrance Day was that of Lady Colefax climbing. It occurred to me that some might think it quite a climb from Park Place, Eltham, to New Place, Anglesey; and then, how wrong they would be. A man carried up two thousand feet in a chair-lift is using less energy than one who strolls up a hillock, none

at all in fact, and is not accurately described as climbing. So it was with Rex, from those first conversations on the grass outside the Slade; and had they never taken place, it would only have delayed matters by a year or two; he was destined to be "taken up", for all the good or ill that that portended. So he jumped me into a chair beside him. But mine showed signs of stalling from the first, and I have been trudging downhill through the snow ever since.

He led me into some egregious adventures, like being presented at the first levee of the new reign, with a preliminary visit to a photographer, and hours of progressing through St James's Palace, which he thought worthwhile for a chance to see the state rooms, and just for the ceremonious and historic heck of it. Euan Wallace presented Rex, and Lutyens me, with remarkable benevolence. When we assembled in the architect's house and he came out very slowly, pompously and stiffly from behind a screen, an Edward Lear courtier in the same Moss Bros velvets and silver, we all burst out laughing. I reported to his favourite daughter: "It was very hot, and outside there was a band in the garden wheezing away softly like squeaky boots. The King looked very cross, so as Rex had a loose buckle that clattered at every step, and I had no gloves, perhaps it was as well that we didn't actually appear together."

This incident could be kept dark from fellow-poets; but not a white-tie dinner at Grosvenor House where I was photographed at table with Rex, David Cecil and others, looking particularly sleek and buttonholed. Later I met Auden, whose lyrical poems I reverenced. "I've seen you in the *Tatler*", was his only remark. I lacked the presence of mind to say, "Fancy reading the Tatler!", but I recalled that communists read it in order to exercise class-hatred; also that Auden had been in service to the rich as an usher at a prep school. So this brief exchange comes to mind.

"Please, sir, it wasn't my fault!"
"Why not? You didn't have to be there." (Too true.) "Stay in for ever and write a thousand less lines!"

I have often been tempted to stay in for ever, and have written many thousand less lines, from discouragement. Fortunately there were some in those days who encouraged, like de la Mare, Masefield, and Andrew Young. And I was dedicated; it was my life, succeed or fail. I persevered. Rex had again decorated my new book lavishly and for nothing, but the head-pieces, so delightful in themselves, tended to prettify and do me no good, as he himself said; for new verse when decorated is dismissed as merely decorative. On the other hand, his interest in my

glass-engraving, on which I was beginning to depend, with Lutyens as one customer, did me nothing but good, while I was learning my craft by executing Rex's designs, or designing in his manner – and then out of his manner, when adventurous. Demonstrating always on paper or black scraperboard, he never plied the scriber himself, so careful was he not to put me off by contrast; for though he denied this, he could have instantly outdistanced me, had he had the least wish to take up so laborious a technique.

The summit of the chair-lift was an invitation to Balmoral, Friday-to-Monday, which alarmed him as much as it excited, and sent him to Simpson's to buy shoes and splendid pyjamas, thankful that the urbane Osbert Sitwell would be the only other guest. Rex had known the King and Queen when they were the Yorks, and had written her a very warm letter on their accession, including an ironical wish that was genuine enough – "From my heart I wish that you may both enjoy the *happiest*, *longest* and *most peaceful* reign that England has ever had." He had regretted having failed to produce her bookplate, though that was now as well, and had promised to be prompt, if honoured with any other command; and she had quickly asked him for royal ciphers of "GRI" and "ER", and had received several variants. He was the only person she had recognized along the route back from the Abbey, watching, rather isolated, in the National Gallery portico.

Now he was describing the visit in five letters written in his bedroom at Balmoral. After dinner on the first night, with the thrill of the pipers "swaggering round the table (only three times, thank God!)", there was the Gillies' Ball where the King and Queen, having opened it, "hopped and skipped and capered in the wildest way the *entire* time we were there". He thought it must be like Elizabethan revelry: no pompous dignity, and no one taking particular notice of them among the "roars of laughter, in a sea of whirling arms and legs" [sketch]. Taking part himself in the simpler reels, he was lost, but it did not matter.

Though the King and Queen could not have been more charming to their only guests, it was still, he declared, "the most awful strain". Having no wrist watch, he had borrowed mine, a rather stylish one, but it was hardly required when at any moment one was summoned by a gentleman at the door: "it will be all right if you come down in five minutes". All was to give pleasure, yet it was "odd to have to be so obedient and prompt!" Because of this, and because of Osbert's car – at any rate the cause "*couldn't* be the King's wine!" – he felt extremely ill the second day, and had to ask leave to lie down behind curtains for the whole sunny afternoon, thus missing a picnic on the

moors with the Princesses, whom so far he had only heard running up and down the stairs in their nighties. For him, a big car bouncing had had a rather similar effect on social strain to a small one turning turtle, years before, for me.

Better by the evening, he sat next to the Queen for a showing of the film *Queen Victoria*. "*I* thought it absolutely ghastly and Anna Neagle the Bottom", he wrote, an opinion largely shared by the Castle staff, who bellowed with laughter at the way Hollywood supposed royal servants to behave. Sunday service at Crathie Church, where they sat in a pew behind the family, "wasn't quite such fun", he told Caroline, "though strange and interesting – with vast gaping crowds outside and extempore prayers bawled in Scotch inside – 'paradoxical as it may seem to Thee, O Lord' – and all that." In his view, the splendid cadences of Common Prayer were exchanged for mere wordiness, while the minister was working at his next sentence. "It sounded like the conversation of some middle-aged American *man*."

No doubt the Queen had seen his play and thought he would enjoy this glimpse of a house where she had allowed nothing of Queen Victoria's to be altered. The colourfulness of the rooms, multicoloured Victorian bouquets in vases, tartan carpets, gilt clocks, sunlight on satinwood and maple, together with the scarlet and gold of the flunkeys – all this "was not a bit less highly coloured" than his settings, he wrote to me. Rex's bedroom happened to be next to the King's dressing-room, whom he heard complaining after the ball, "I've never been so *tired* in all my life!" Repeating this, Osbert embellished it by adding, "It's these bloody guests!"

ALTERNATELY WITH Plas Newydd he was painting in 1937 a room at the top of Brook House in Park Lane for Edwina Mountbatten. By her grandfather's will she was obliged to have residence there: hence the penthouse on the new slab of flats, with a view across the tree tops of Hyde Park and a sitting-room consigned to Rex as soon as built. His treatment was novel, though suggested by his "mezzo-tints" for Diana Cooper. Judging that a room about seventeen feet by twenty-three was too small for a major flow of Arcadies, he divided up the walls into nearly sixty rectangles of various shapes and sizes, each containing a different scene, emblem or ornament, with countless allusions to his clients' active lives, and all done in grisaille on pale greyish-blue. It was as near as mural painting could be brought to book-illustration, and being drawn with as much finish – twice over in some areas, for his preliminary drawings are not rough – must have been laborious; but I do not recall any regret. "Begun in June and finished on the last day of December", we read, which was quick, bearing in mind the designs for a wall-clock, radiator-grilles, painted furniture, etc. The room breathed elegance with a faintly amorous air, given off by the likeness of Caroline as Ceres, several cupids, not fat putti here but slim Ganymedes, and a naked Venus with the features of Lady Louis herself,who reclines against the clock, watched by Father Time with the features of Lord Louis. As often, there is a certain ambiguity about his young masculine figures, which do not seem to be effeminate so much as vulnerable, in sharing some of the feminine attributes they tenderly respond to. Rex, indifferent to the obvious brevity of London flats, was for painting on the plaster direct, but Lady Louis insisted on canvas, and was justified in 1940, when a bomb wrecked the room; for by then the canvases had been removed to Broadlands. He has been lucky, so far, with all his major rooms preserved, and three now under National Trust ownership (see note).

"It's a little bit melancholy here in this dead quiet house," he wrote

from Plas Newydd, "after all the lovely noisy sweet beautiful company of the summer." And to Henry, "I have been growing a moustache for something to do between meals." On the other hand, "you can't think what progress has been made in the painting, entirely thanks to you – I mean thanks to you for not being here." Then he became quite seriously ill with an infected throat, even being ordered by Marjorie Anglesey a resident nurse for some days. Getting better, he had long talks with her about dying, whether some patients were frightened. "Some are very distressed", she said. " 'Distressed'!" He repeated the euphemism to me, imagination struggling with the experience of everyday death, as years before with execution. It was the same when he was given a lift up by air on one occasion, and the pilot made a detour to look at the *Thetis*, the doomed submarine, lying off the coast of Anglesey, one half submerged. The lifted end of the hull, with boats all round it, flashed silver in the sun like a parody of Hardy's poem about Barnes's coffin-plate, and left Rex, on his way to comfort and friendship, engrossed by the horror of men dying, panic-stricken in darkness, without oxygen.

Presently his younger love was married, only to greet him among the wedding guests with tears in his eyes – too obviously, her mother thought. The girl alleged years later that he shaped her life, inspired her love, did not really want it, and never let her go; none of which was clearly recognized by him. Having watched her go, he returned to solitary confinement at Plas Newydd, discontented with himself, and on the first night, with the wind howling round the big house and the "red-faced stupid useless fire" in his bedroom much too hot, he had an access of longing for Caroline, and wrote to her that his love had become more ardent and not less, as she supposed. "I think of you being angry and love you." (Here memory supplies me with a tableau from some party: Rex in exasperation twisting her arm behind her, Caroline with the expression of a smacked Siamese cat.) "I think of you being sulky and selfish and I love you much more ('Hey! How about yourself?': Caroline). And I think of you being loving and sweet and I would die for you." For the present the most he could hope for was the occasional holiday abroad. Love-in-ordinariness remained a day-dream. "Think of the white dusty roads, and delicious meals in little cafés and dancing and reading and painting. Goodnight my darling –

All my days are trances and all my nightly dreams
Are where thy bright eye glances and where thy footstep gleams."

A threat of trolley-buses with their overhead wires in Fitzroy Street had him seeking from Duff Cooper a letter of introduction to the

Minister of Transport. "It's the oldest painting quarter in London by a long, *long* way. If we can't be allowed to live peacefully and quietly in this drab old street where in the hell *may* we live? So sorry – I was carried away and thought I was addressing Mr Belisha."

The trolley-buses never came in fact, but they were sanctioned, and Rex had mentally outgrown the two rooms at No. 20, soaked in poignant memories of ten years though they were, and now found a delightful flat on two middle floors overlooking Fitzroy Square at No. 29, where unknown to him, Bernard Shaw had once lived, also Virginia Woolf; but they were costing him another £100 in rent. He had also outgrown Mrs Landeryou, when, among other lapses, he found that his dress trousers were in pawn, and he must pay to redeem them. Mrs Footsey took her place. One day, as she was guarding suitcases on the pavement Mrs Landeryou passed by with a concluding comment: "Still wants waiting on!"

At the same time he had a plan to bring the parents into Wiltshire, North Bucks being thought too cold for my father's chronic bronchitis, and almost at once a home was found of unsurpassable rightness, except that it was rather large. Having seen it in Salisbury Close Rex had to return to make a drawing. It was the Walton Canonry, No. 69, beyond the west front of the cathedral in a cul-de-sac – early Georgian of red brick stone, with a long garden running down to the Avon and the water meadows beyond; so that it seemed to be in Close and countryside at once, with familiar pictures by Constable on every side. After the sale of Bolebec House Rex felt it not too risky to sign a lease for this, and he foresaw giving up his new London flat in three years, to live there felicitously for ever. Most of every day he thought of Caroline, he told her, and quoted Charlotte Mew:

> My heart is lame with running after yours so fast
> Such a long way.

He still hoped it would catch up in the end, and hinted at these plans to his mother, who ardently wanted him to marry. But any pleasure in a son's marriage to a marquess's daughter was dissolved by discontent with the daughter. "I never admired her", she would say years later, speaking of her looks, but meaning the person they revealed. As for the girl's parents they had once wished for a more appropriate match, but Rex was well-beloved, and they approved – as they could not of Liz's sudden intention to marry Raimund von Hofmannsthal, then about to be divorced. Caroline was despatched by train to Austria with Rex for company, nothing loth, but she was already on the side of the unorthodox, and Rex's card from out there, designed to arouse

envy in Kenneth Rae, reads less like marriage guidance than a message in the Telegram Game. "Terrible confusions in the schloss lots of love hate tears fun and truckin at nights."

By now he was Caroline's lover, if intermittently, and perhaps long before, but it does not seem to have made a radical difference. His letters never speak of fulfilment, and it would be strange if she chose to keep only those of longing or of sad reproach. Years afterwards she said, as proof of understanding, that she had not minded the occasional failure that occurred, but she did not seem to have set much store by the success. One day to my surprise he said that he envied me in love, and I replied, "But you've had far more girls than I have!", and more beautiful, I might have added at that time. "More, perhaps, but not so successfully", he said. With my own drawbacks and making little progress where there was real beauty and not merely of the flesh, I did not think myself successful.

Taking train from Austria, they were met at Milan by Raimund's huge car, and toured the Veneto, all four. But as couples they were far from equal. Raimund had become a good friend and remained so, notwithstanding he was much that Rex was not. An amorist of confidence, uninhibited, endowed with "a Rococo spirit of pleasure", as David Cecil said of him, knowing "what the ladies liked" as Caroline would later put it, he was also cosmopolitan, and a linguist; thus the dominant male of a quartet on the move. More important than all this, Liz loved him. Rex felt the contrast both in circumstance and self, as between an impeded Anglo-Saxon and an outgoing foreigner. At some hotel Liz suggested to her sister that they too should share a room, to be told that Rex preferred to be separate: not a sign of harmony, but this may have been a temporary preference. That for imagination, wit, subtlety of mind and delicacy of heart, Raimund could not begin to compete with him was no compensation; indeed self-doubt now extended to his talent. Looking at Tintorettos he exclaimed in despair, "I shall never paint as well as that!". This was symptomatic; for when in good fettle it was enough to paint well. Now world events grew sombre round his discontents. In Venice Lady Juliet Duff had taken the Little Vendramin Palace for a party of her English friends, wishing joy especially to the two pairs of lovers. The climax was a ball given by Lady Castlerosse in a half-ruined palazzo on the Grand Canal, where there was waltzing till daybreak among broken columns, and gondolas to slide about in. At two in the morning report came of the imminence of war over Czechoslovakia, and Duff Cooper's mobilization of the British fleet. In sudden alarm that the frontiers might be closed and Raimund caught without a passport,

stateless and an Austrian Jew, the couples filled suitcases and left at once for Switzerland, the sisters still in their long dresses, and Juliet Duff talking excitedly about the Duchess of Richmond's ball, without bothering too much over similarities. Rex at the back of the car felt queasy all the way through the pass.

He had never been indifferent to politics, like many artists. A great reader of the papers, and especially of the *New Statesman* for a lively point-of-view he disagreed with often, he had been doubtful about international affairs, outraged first by Italy in Abyssinia, and sickened whenever the news-men came baying north out of Oxford Street, with news you could rely on to be bad. I now had John Constable's drawing-rooms in Charlotte Street, perfect for me; my life of Vanbrugh had come out to rather good reviews, and I was engraving glass full time, or versifying. I hear the double toot of the Terraplane *sotto voce*, purring outside, where Rex waits on the way to lunch at Schmidt's. Beside noodles and sauerkraut and lager, the Special Edition is divided and spread out. What answer now, for the free world to make while there is time? The right answer for us, we conclude, while there is time, is to take holy orders, but first to secure the offer of two livings in the West of England. There, so far from incurring the least *odium*, we should be praised for the *invaluable* work we were doing. How much invaluable work would be enough? Alternatively, a not-too-austere monastery was tempting, provided we took the tonsure together; there to be spoken of with a certain respect as "men who have sinned much".

Illusion held the country in a trance: the illusion of the left that war must be imperialistic war, the illusion of the right that Hitler only wished to be our friend. Had he previously been claiming, step by step, only what was fair? Rex could see that a German of good will like Walter Hirth might think so. He had not been sure if leading British politicians, and editors like Garvin, were right to see in Germany our main defence against Russia. Today some irony attaches to that view. But though to concentrate on traffic-lights two streets ahead may be far-seeing, it may prove fatal if you miss the ones immediately in front. Until now he would have agreed that Nazism might be preferable to communism as less threatening to our civilization; many Conservatives contrived to think this even until the summer of 1939. Osbert Sitwell did, privately, throughout the war, until in 1946 it was safe to sigh, "Oh for the German army to be in existence to help us!" Rex had long respected his sagacity, but increasingly he was drawn to the non-appeasers by his blend of the realistic and the chivalrous, and by his friendship with Duff and Diana Cooper. Very soon after the dash from

Italy he dined with them at Admiralty House. That night the towering bed he had recently designed for Lady Diana, using huge gilded dolphins from some source, the bed where he showed her in the margin of one letter fast asleep and the First Lord staggering drunkenly in with a candle, that "bed of beds" as she calls it, that last and fitting monument to the frivolity, nostalgia and exuberance of the Between Time, was not much in mind, for the Between Time was all but over. It was the night after Munich when Whitehall had been dizzy with deluded cheering. Duff had resigned as First Lord. Churchill was a smouldering, explosive fellow-guest. Mostly listening, needless to say, Rex surprised the company with an interjection when someone doubted if we were well enough armed to go to war. "Surely that's nothing to do with it! We should go to war if we think it right to do so – not because we're sure we're going to win." It caused a moment's silence. At another time he ventured on a comment less contradictory than it seems, if ingenuous. He may have felt that nothing could be lost, and something might be gained for oneself, by honestly examining a hostile point of view. I think his question was that if self-determination ruled might not the Sudeten-Deutsch, however hysterically whipped up, believe that it ought to be applying to them? The answer he might himself have found was that they might, but in seeking to advance a monster they had forfeited the right to it. Before he could do so, wrath against the years of fairmindedness was directed, in the thrust of a famous cigar, at him, its latest exponent, and so for a moment its arch-representative: "It is *you! – you* who are to blame! – *you* who have brought us to this pass!" Describing the incident to me, he dodged down in mock panic as if behind a table, eyes darting with injured innocence, finger pointing at himself: "Who? Me? Not *me*? What did *I* do? I didn't do anything! – Wasn't it dreadful!"

In a less alarming encounter at a country house he had gone out painting with Churchill, who gave him a continuous lecture on the way he did it – this to Rex's amusement – though Churchill's landscape of that day would now fetch a good deal more than his own.

To Henry at Eton he gave as an excuse for not writing that the Crisis had kept him unusually busy, putting in sometimes twenty-five hours a day. Chamberlain would ring up for his opinion, Duff had wanted names for new dreadnoughts, he would be summoned by the minister for the co-ordination of clandestine affairs, "not to mention long hours locked up in with the cabinet". Then – "an extraordinary thing has just happened: my front stud has fallen on to the paper here [sketch], and yet my tie and collar seem perfectly in order. What strange times we live in."

With various alterations wished by Rex himself, or sometimes by
the family, but never imposed on him against his will, the Plas Newydd
dining-room was not finished until this September of 1938, nor even
quite then. It was his masterpiece, stopping the visitor at the door with
the huge coolness of its sweep under towering cumulus; then calling
attention to a thousand freshly-glittering components, in architecture,
people, scenery, shipping, each with a meaning or reference that Rex
could divulge, if that was wanted, yet perfectly integrated into the
design (Pl. 36). A girl on the water may be Caroline. At the far end on
the return wall the pet dogs are about to eat their dinner. At the
opposite end, far down an arcade stands the artist as gardener, broom
in hand, aloof, solitary, with enigmatic expression; watchfully outside
the scene, like the attendant musician in *Fêtes Venitiennes*, who is
Watteau himself. There are many touches of humour, but they are not,
as ten years before at the Tate, selfconscious and whimsical. One
example may be given. Neptune is visiting this maritime kingdom,
though we do not see him. His crown and trident are propped against
the sea parapet, with wet foot-marks leading to the edge of the carpet:
he is somewhere in the house. The best sacred murals of the Between
Time in Britain are those in Stanley Spencer's Burghclere Chapel,
sacred because the meaning of the great *Resurrection* infuses all the
other panels; and surely the best secular mural is here.

Sending in his final bill for £400, as several times requested,
Rex feared that it was exorbitant, "but I *was* an immense amount
of time working on it, wasn't I? Of course there's such a bill you
could send in against me ... all those days of fun and bathing and
sunshine and moonlight and luxurious nights and enormous delicious
meals ... lovely, dear friends – and rows and rows of champagne
cocktails."

The offer of another room to paint came welcome, and he drove
over with Edith to Mottisfont Abbey near Romsey, to find one even
bigger than Plas Newydd's, with all four walls for his embellishment
(see note). Edith summed up Maud Russell (Mrs Gilbert Russell) in
the course of an hour as "a feeble little woman – afraid of her own
taste, and trying to be in the correct Art fashion". They were not
offered tea with much cordiality, and feeling "rather like the plumber
and his mate" drove home through sunlit woods that wore, this
autumn, a sinister greyness in their incandescence. Painted rooms are
bonny. But even if Maud Russell never did believe that we would find
ourselves at war, she deserves some credit for commissioning one a
fortnight after Munich, when the whole house of civilization appeared
to shudder.

On each occasion Rex looked for a quite new conception, and here, because Mottisfont had been an abbey and was still part-mediaeval and part-Georgian, he chose early Gothic Revival to take off from, a style he had not previously designed in, apart from that loggia for Plas Newydd, which may have given him a taste for it. Under a newly-coved ceiling, criss-crossed with painted groining, he would have a Gothic cornice over pairs of slender Gothic columns at wide intervals. Cornice and columns would be counterfeit, except at some points actually projecting in *trompe-l'œil*: all this architectural part to be grisaille on pink. For the important spaces in between the columns he put forward some alternative treatments. It was a pity he did (Pls 23 and 24).

For what he wanted was to show, through four wide arches, under looped crimson-velvet curtains in *trompe-l'œil*, four separate romantic distances. At other points there might be gilded statues in niches or trophies all of gold. In a corner might be glimpsed a spiral staircase descending to the undercroft or dungeons. One morning, on the chimneypiece, brilliantly pretending to be marble, a very tangible hour-glass appeared beside a skull – the skull that had been spurned by "the old cat Porcelli". These last were not seriously proposed, but the joke shows the tenor of his thoughts. He wanted the new drawing-room to be colourful, diverse and suggestively mysterious – suggesting, say, a Middle Ages viewed by Chatterton from Strawberry Hill. Mrs Russell thought otherwise. There must be no archways to beyond, no emphasis and nothing personal: all must be done as if in shallow plaster relief, which by Rex was intended for the framework only. Seizing on the trophies, but rejecting gold, she got him elaborating seven of the largest in that unobtrusive form, while heartily wishing he need never draw another. Really, she envisaged a superior kind of wallpaper. Thus Mottisfont became exceptional among his rooms. Between idea and execution all the others were enriched – and this was impoverished. The explanation may be found in her week-ends. She entertained sophisticated people who reassured her that it was quite all right to employ this decorator, provided he was kept to decoration. For he stumbled at the shibboleth of "meaning". At the drop of a torn-up letter, or a rose laid aside, he was apt to point a message, as in programme music. In every age there are critics who judge an artist not for what he does best, but for what he ought to do, or not to do, according to unquestionable canons that will be questioned in the next age. Mrs Russell found that he was charmingly compliant, and so with some misgivings the work began on countless sheets of paper in London.

Two floors over Fitzroy Square gave scope to entertain in a style that two rooms above the street had never sanctioned. For Liz Paget's birthday Rex proposed to Raimund that they should give a "lovers only" party, sharing the expense, and we were about twelve couples, all the girls attractive and mostly known to one another. We danced in soft lighting to a two-piece band which could play Viennese waltzes, and for cabaret had the frenzied pan-pipes of Faniker Luca from the Palladium, where Bud Flanagan the comedian claimed to know his brother, Filthy Luca. By this time Jill and I were growing close, so that Edith, who liked young love, seemed to like me for myself. Rex, though gay enough that night with Caroline, seldom saw her or knew whom she was with. She was mostly with Audry, confiding to a sister that a woman was far more satisfying in love. At the Daye House he complained again that she would neither have him nor release him – the complaint made of himself by his younger love – but Edith did not tune to his mind as easily as once, and cannot have liked reading in his thank-you letter a preamble that he always loved staying with her "as we are such good friends", only he had been too tired to explain himself.

> Your advice was based on a wrong supposition. The last thing in the world I want is just to marry for the *sake* of marriage. I have a very full life and a very busy one and so much of my unhappiness comes from the *accident* of most of my love being attracted to one person (and that second magnet is there as well) who doesn't return it.

The "accident" came from his invariable choice of a girl for supreme looks and grace without regard to any deeper quality, granted intelligence. He did have yearning love to bestow, and could hardly check himself if looks, grace and intelligence made even a feint at requiting it. "I was always very much loved", he could remark at the end of his life, and this was true, except that he was never much loved by the girl who really mattered. The youngest one had been too young for his conscience to be quiet, and now she was someone else's. Visiting the Daye House with her husband she gazed at Rex's work and murmured, "he is wonderful". Then Edith feared that "even yet some unhappiness may come. Beauty dazzles him." He continued, "But apart from all questions of this kind I do feel year by year an increase of melancholy, the result of an always increasing power of *loving* – this world and all the things in it that take me more and more by the heart." Such growth could have brought joy rather than melancholy, had it been answered and reflected in a girl's imagination. No longer could an adequate

answer be provided by a woman thirty-two years older. He was like that mountain shepherd in the Berlioz symphony whose solitary pipe is in the end replied to by nothing – or by nothing companionable: only by an ominous low roll of distant thunder.

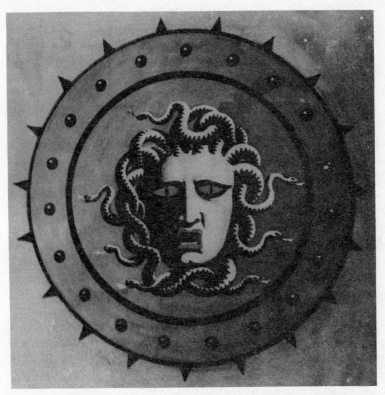

Medusa. For the Guards Armoured Division, 1941.

# · XXVI ·

HE WAS DEBATING what to do if there was war. Early in 1939 Caroline decided to volunteer for part-time training, as the excellent car-driver she was, and chose the fire service for its little blue cap, because Rex thought it was the most becoming when they saw it in a film. Now with her example to live up to he wrote to Henry, "I'm trying to get myself all mixed up in the Territorial Army. Isn't it mad? I had to be interviewed by a Colonel this evening. It was just like being 'sent for' for a swishing." Several regiments were tried, but no commissions were going.

At Mottisfont Maud Russell was not merely cramping imagination, she was busily frustrating it. She would adopt the minor suggestion of some week-end guest, unaware of its effect on the logic of design, and Rex would change the context, to make architectural sense again. That involved hours of extra work, for himself and his assistants. His well-tried method, of fertile invention most convincingly argued, could not work with a client too anxious for critical approval to have full faith in her artist. Then, she was in no hurry to pay by instalments, and this quarter he did not license his car. Diana Cooper on a visit to the work urged rebellion; but he wrote soon afterwards, "I don't think a talking-to would do at all, do you?" So he argued and gave way, discontented with himself as when long ago he had written, with his customary self-examination, "I know I have a weak character in many ways, I try to be nice to *everyone*, even when I *dislike* them, from a persistent need to be liked and smiled at." Thus when Diana herself had seemed cross on the telephone he hoped that it was not with him, could think of no reason why it should be, and wrote at once, "I can't bear you to be anything but affectionate to me, you are so *loved* ... one of the few people I love *all the time*." What lay deep in this hyperbole was genuine: a child's need for reassuring arms. In slighter relationships there was a touch of fawning, as in that phrase on a drawing, "to ingratiate himself". To ingratiate himself with Maud

Russell was distasteful. But he could not bring himself to do the opposite.

Vic Bowen sensed the difference between this job and the last. In Anglesey all had been fun, from the long drive up in good spirits, when Rex would show off the paces of the Hudson, getting Vic to watch the dial as he took it up to ninety-five on dead-straight, empty Watling Street. If passed somewhere, he repassed. On a humped bridge, once, paints and easels showered round them. Settled at Plas Newydd they might work away till even the pirate stations closed their music: at Mottisfont the same perhaps, but more in doggedness. Up there, the drink cupboard had been left for them unlocked, and Vic would tiptoe through the quiet house. Down here, no such concession; though, admittedly, why should there be? Vic perceived a tension, while never witnessing a tiff.

Although despised by Clive Bell, full illusion was not quite anathema to Mrs Russell, when it was purely decorative. At least she sanctioned sumptuous green curtains lined with ermine, that is, with spots painted on white material to look exactly like ermine; and, what is more, ermine pelmets above, entirely painted on wood so as to preserve ideal folds. But then in her absence during a week-end one muted wall did explode into realistic meanings. Here the drawing had shown an urn in relief. Returning, she found it swollen into *trompe*, billowing a cloud of incense, and banked up round the base with lute, books, rolled music, a purse, a packet of letters, a forgotten glove, etc: all tangible objects when viewed across the room. It was his most accomplished essay in deception, and his last of any size – and it belongs to the more eloquent, eventful room he wanted to have painted. Now his best hope was to appear ingenuous, and he brought her in at once to look at it. So pleased with it he was, she recollected, that she did not have the heart to say no. She even added the glimmer of her wedding ring to the congeries – but required him to paint out the twinkling rubies on the heart-shaped purse. To her they suggested vulgar wealth.

That May, while he wasted precious time repainting, I wasted it in Devon composing a long poem, when I might have been in London with my love. She was playing the lead in a Mauriac play, her best part ever, was being fêted every night, and soon was teasing me to reappear, which sensibly I did. Sometimes separation helps. Through it, unawares, all is made ready for the match's introduction to the touchpaper. Such radiance blossomed now as had never been forseen. And it needed only time, lavish time.

The toot of the car, re-licensed, brought us to the window of Constable's House. "Come up and have some tea!" But he declined. An

hour or two later this recurred. "You can't still be having tea! You're like a pair of old Russians!" Loving-kindness and sadness went on its way. An afternoon at the Close, with punting on the Avon, found place in Edith's journal only as it concerned us two, not Rex at all, for a wonder. Such is the power of happy love. "Jill in enchanting mood with long tangled hair and happy starlit eyes", she wrote, another time. "They move about together like married people." In those days, as between Rex and me, an extraordinary reversal of fortune had occurred.

In those days he accepted that Caroline did not love him, never would, yet he could not free himself. Cynicism resulted, and is felt in a comment on the clavichord he painted so richly for its maker, Tom Goff (Pl. 38). (It was stolen the day after Goff's death in 1975, and has not been seen again.) The naked wood proved too pimply, and he ordered a coat of spirit polish. Bowen protested that the paint would not stand it, and "You ought to paint for posterity!" – "I don't care about *posterity*", he said. "All I want is the dough!"

He was up a scaffold by the bay window at Mottisfont with his portable radio beside him. Dipping his brush, he wrote a message on the top of the cornice, and then left at once for Salisbury, to be with his parents on their way to the cathedral. The message was not found for many years. "I was painting this Ermine curtain", it reads, "when Britain declared war on the Nazi tyrants. Sunday, September 3rd, R.W." At that time, in a Devon farm, Jill and I left the family and paced round a little rain-wet kitchen garden where she asked if we could be married. No big decision could be simpler. The theatres would close, nobody would want a glass, there was no sort of dowry, but between us we had earned enough to live on perhaps, until my calling-up. Salisbury, it was found by my delighted mother, would grant a special licence, and nine days later we were married at the far end of a cathedral almost empty but for family, Edith, Sassoons and David Cecils.

We had walked across in sunlight – that is, Rex and I – he my best man, I in his best striped trousers, late in pawn, with his *short* black jacket, not tails, to give me, as he suggested, a measure of formality beside the bride. "Nothing went wrong", he wrote to Mrs Footsey, "except no ice for the champagne, and I did not lose the ring." Speeches were ruled out. A toast, and his duties were over, apart from rearranging the two drawing-rooms after we had driven away into the West, lent a car, and lent a cottage. He had never known and never would know the happiness that shone through that day and those before and after, as if they had been painted on glass. So for him the

sometimes-intimate companion, who had never yet been intimate enough, was gone.

That evening he drove to Edith for what turned into "a long agonizing talk". He looked very ill. Caroline now took everywhere a photograph of Anthony Knebworth, one man who could not pester, being dead. Painting was finished. He thought he might be bankrupted by Mottisfont. He wanted to go to the Front and be killed.

There was no Front to go to. A month or so passed, and then he wrote to Kenneth Rae, "I have been in great misery and perturbation since this horror began as to *what* I ought to do – while at the same time being tied hand and foot to this wretched job which drags on and on." He could not make up his mind if Kenneth Clark was right or wrong that artists were there to make art so that civilization be worth fighting for, a notion at once rational, alluring and distasteful; a notion that preserved Monet and Cézanne in 1870 when they went into hiding, to avoid the call-up. As great artists they might have been justified; and Wilhelm I was not Hitler. Any new work Rex could do seemed pathetically trivial. I was faced with no such dilemma, not enough of an artist to do otherwise than serve, when called on. Rex hoped he could do both, in some way – serve and draw – and took a letter from Duff Cooper to the General at Southern Command, who was all against his joining as a private, and thought he might be very valuable one day, "when the advance really begins", in Edith's words. What advance? From the Maginot Line of course, to rescue Poland. No one really believed in it here, let alone in France. How Rex would be very valuable was not gone into. He saw himself interpreting photographs perhaps, but he did not want to stay at home doing propaganda drawings like the one he had just done for the RAF leaflet raid on Berlin. Then Edith, with obvious intent, sent him on a stroll in Wilton Park with the next GOC, General Brooke, afterwards Lord Alanbrooke, who reported, "It's a question of conscience. I don't want to try and shake him."

All this time, Kenneth Clark, as Director of the National Gallery, was assembling a body of Official War Artists, on the model of those who had memorably recorded the First World War. His committee was approaching artists whom he knew and admired, and inviting others to apply. Here Rex was at a disadvantage. He could not bring himself to apply, though he might be persuaded. He could have the ear of the GOC through the influence of a past and future cabinet minister, but that was the wrong kind of influence, and misdirected. One friend there was who could have alerted Clark to his state of uncertainty: Osbert Sitwell. To him Rex had written in the spring,

"You were the one person I wanted to talk to", half hoping to be dissuaded from precipitate soldiering. But Osbert was preoccupied with his own weary discontents, and never thought of writing such a letter.

Clark, "who had many artists friends, was concerned by the likelihood that many of them would be thrown out of work, or called up and perhaps killed, unless some way were found of helping them". If that was the object no one needed help more than Rex – help against his own inclinations. The truth is, he did not come to mind. Always lacking serious critical acclaim, he never seemed to be a serious artist. Also he was "not of this age". It was hard to see him usefully in contact with a war.

At the first committee meeting in November 1939 Clark announced that "care was being taken that none who might reasonably have a claim for consideration were omitted". Fifty-one artists were listed, increased to eighty-six by Christmas, and with a Scottish contingent to about a hundred. Rex was not included so far. But in January 1940 his name appeared on a list of a hundred and eighteen more, with a "no" pencilled beside it. A month or so later, when seven hundred and fifty had been considered, he was one of those thought to be worth keeping in reserve. I doubt if he knew. It was too late, in any case. "When once in", he wrote wistfully of the Army, "perhaps my drawing *may* be used somehow, but I see it never will until I'm in." (See note.)

There was a double irony in this. With his rapid technique, superb visual memory, and enterprise, he would have made an excellent war artist; and the experience would undoubtedly have had some lasting good effects, as it did on the post-war work of Sutherland and Piper. Then, had he only known it, his war could have been much more adventurous than the one he chose – that is, until the last adventure. Such was Eric Ravilious's: spent on a destroyer in the Arctic Circle, recording the *Ark Royal* in action – in a diving submarine from Chatham – under shell-fire at Dover – then, by his own desire still, with the RAF in Iceland, where he vanished in a plane on a rescue mission – war pictures of value added to throughout. If Rex had to die, he might have harvested some aspects of the war no less eagerly. Ravilious may have been invited, but neither he nor Bawden had qualms about applying. Rex did, with a life-long need to prove himself. So persuasion was needed, and it had to be quick.

There were two considerations, he had told Kenneth Rae in October, when it still seemed that full-scale war might somehow be avoided. "I have had a strong feeling that if *anyone* has to go and

fight (so far no one has popped a gun) it is precisely people of *my* age, and not the young boys" – who were not to blame for the gross crime of ever letting it happen. "Also (between ourselves) I have an increasing dislike of the prospect of being in the ranks, and if the war develops there is the greatest possible likelihood of my age being called, I am told." Then it could be peeling potatoes for the duration, since he could never be sure of earning a commission from the ranks. And that was now the only route to one – except in the Brigade of Guards.

Thus a spoilt mural, a spoilt girl, a lost brother, critical neglect, rage at his generation, contempt for politicians, dread of the ranks – all this combined with a new sense of duty and an old sense of honour in pointing the way, the thoroughly alarming way to Birdcage Walk, time after time, with the buying of a bowler hat and "putting on hard collars and getting my hair cut (continually)". Friends tried to get him for a battery recruited from the arts, because it was "so unlike the army", but he did not think this much of a recommendation. If one had to be a soldier one might as well be with the best. He failed when recommended to the Grenadiers by the Queen's Treasurer; succeeded in the end with the Welsh Guards.

Col. Leatham (old Chicot Leatham as we used to call him in Poonah) has condescended to take me upon his list (I'm praying the war will stop).

I tried desperately for weeks – with *wonderful* letters from Duff Cooper etc: – to get an interesting staff job of some kind through my drawing, but all to no purpose, so I realised that the mention of drawing was only a *hindrance*. I was taken by Leatham on the ground of being a decent fellow and rather a *good cartoonist*! (I have never done a cartoon in my life.) I have kept it very dark about my drawing and painting, of which he has only the very faintest idea that I have some hobby of that kind! Hobby my foot. There was a blood-curdling moment when I heard he would take me on at once, in which case I should have been absolument dans la consommé.

He was telling lies, the only ones in a lifetime known to me, other than a moderate flow of white ones. Five days before, in thanking the Colonel, he had written,

I must confess that I am also extremely disappointed at the small hope you hold out to me, of my *ever* being needed – at any rate this year – and all the more for John Follett's mistakenly thinking you spoke of taking me on at once.

So much for the blood-curdling moment, but no doubt he wanted to show eagerness, with conscription catching up next year. (It would not have reached him in fact until 1941.)

If *only* I could show you that I had, in my drawing, some slight special qualification so that I could gain some advantage – fair or unfair – over those names that precede mine on the list! I do naturally realise that drawing – or painting – can be of very little use at such a time as this, but I had faintly hoped that there might be occasions – just now and again – in which I would be of more use than the man who couldn't draw at all. It is the *only* point I can urge in my favour – though naturally so small a one. *Of course* please do not think of troubling to answer this letter. I only beg you will not be annoyed at my having written it.

Half a page was then covered with detailed sketches of a rivery landscape, a classical yet modern street scene, and, for fun, an unrolled chart and a skull in a Jerry helmet.

I do hope you will not think it foolish – or impertinent – my having put in these few scribbles. They are of course only imaginary, and on a very niggly scale, of necessity, but with instruction I believe I *could* do accurate field survey sketching, etc?, if that sort of thing was ever wanted.

It hardly would be by an infantry regiment, but he was only using charm to promote himself. The moment he dropped the letter in the pillar box he was appalled. It was never mentioned. Since he had no family background the Colonel could only rely on Rex's unimpeachable friends, reinforced by keenness and a gentleman's accent. When Simon Elwes offered himself with ampler confidence and hair, saying "I'm a painter", Leatham is said to have told him that it need not matter.

"You say, why did I choose the w sort of Gs", Rex wrote to Charley Anglesey. He had no option, and acquaintances were joining. "I know I shall make an idiotic soldier, but then what else could I do? I expect I've been an awful fool." Characteristically he questioned his motives. Was it moral cowardice, a need to stand well with the Duffs and Charleys, which sent him to Wellington Barracks with short-back-and-sides? Would it have been moral courage to have forfeited their admiration, though not their understanding, by holding off until perhaps he figured in some list of Clark's?

"I am *just* finishing this wretched room", he told Henry. "The most arduous and most boring of any that I have done. Well, there will be no more, which will be pleasant." The Russells were grumbling about the slowness of completion, through nine months, which he courteously

defended on the score of extra work, in wall-lights, pelmets – and repaintings. Parting with Vic Bowen was warm. He gave him gold cuff-links with initials, and said their first task together after the war would be to finish the Tate Restaurant.

Plas Newydd and Mottisfont now belong to the National Trust. The later room surpasses the earlier in all-roundness of treatment, and might once have rivalled it in interest. It does not; it has a muted look. Yet it emerged from the muting as an exquisite whole, with scattered fingermarks of personality. Near his message to posterity on top of the cornice may be seen an illusory small pot with a brush in it, carelessly left up there by the artist.

Parting from Maud Russell was cool. Shortly afterwards, she riposted with an offer of £300 extra. His rejoinder, to "Darling Maud" was to decline this with thanks.

It was agreed between us that I should paint your room for a certain sum and the fact that, from foolishness, and idleness on my part, it has not proved so profitable as I had hoped, cannot possibly be a reason for allowing you to pay a still greater sum. Had the sum agreed upon at first been three times as great as it was I should have been only too keen to take it for the same work! but it would be very distasteful to me, our agreement being £1,100 to allow you to pay £1,400.

Well and good, as a gesture of dignified rebuff. But then he had to soften it. "I am deeply touched by your great generosity in wishing to pay me so *much* in excess. I know how true it is – your nature being what it is – that you would *much prefer* to pay me the larger sum." The prick of sarcasm became imperceptible when wrapped in cordiality. For he went on to wish that he had "taken a more affectionate farewell" and "thanked her more graciously for all the *great* kindness shown him". She could now feel serene. Her conscience had been eased. Her generosity had cost her not a penny. His quixotry could be dismissed with a shrug.

An extra £300 (say £6,400 today) was not easy to renounce, in this autumn of war and no commissions. He escaped from one big liability at once. "I have parted from my darling Fitzroy Square for ever and aye. It was agony seeing my lovely green carpets torn up and my busts and my easels, etc, bundled out." Then the agitations subsided. No news from the regiment "thank goodness, and the longer it's put off the better". Living now in the Walton Canonry, he was observed by Edith taking care of a father "completely unintelligible" and a mother "gibbering from living with him. It must be agony for a man who has

lived his free studio life to come back to be a nurse like this." For his part he was telling Henry that "life in the Close and idleness (only temporary) is being very delicious. Deep sleepy quiet all day long, with yellow leaves drifting down and an occasional bell tolling. Time for reading and for painting odds and ends (I have been touching up your papa in the Library), and time for going to bed early" – probably to read Trollope in the tranquillity of Barchester itself. The portrait of Lord Anglesey was one of the many undertaken this year, some for money, some not. Among the second was one of Jim, a refugee child from Portsmouth billeted on my parents. Painted for charity, it shows a naked boy contemplating a skull near a Roman ruin, and catches the mood of that November in Salisbury when all that had been sweet in English life, though likely to crumble soon, seemed timeless like the fragile spire itself (Pl. 22). This mood was caught again in twelve oil paintings quickly done for a commercial calendar. They are sentimental, but have their moments of sincerity. "February" shows a young bachelor, returned home, meditating by an open fire with shoes off, and tea placed beside him by his maid, who closes the curtains on another day. It is a kind of self-portrait, expressing what he largely dwelt on, that autumn: not achievement now, not love any more, just continuity, cosiness, security.

There was no melancholy, that Christmas, in my mother's big bedroom, given up to us on our return from a cottage by the sea, and now called a fun fair by Rex, because of paper bells and balls, dance music and bright clothes in perpetual disorder. At once Jill was beloved as the daughter of the house, lacked for most of twenty years, and all the more easily because there was no need for jealousy. My mother needed Rex more than me for support, both moral and financial. We needed only to remain together always, because the meaning of life had been revealed, even while it was obscured for Rex. He loved me more than he loved anyone, some friends have thought. And now my real attention was uncatchably elsewhere.

I told him that we had decided to await the call-up and enjoy the months remaining, and he agreed it would be folly not to do so, though he wondered at my unconcern about the ranks. He hoped that I should find my way to join him in the end.

In the New Year he went north to paint a portrait of the younger child in the house where I had tutored and scratched my first windowpane. Meeting Kenneth Rae in London he said,

"After the war, will you share a flat with me?"
"Of course, but I hope by then you'll be married."

"I shall never marry."

"Why not?"

"Because now I've seen real happiness I know for certain I could never find it."

The fault, he supposed, lay in himself.

# · XXVII ·

IT COULD NOT really matter now, but I rather wished he was not going to that house, to enter a scene that had been mine; but he had to, and there painted "the best portrait I've yet done", showing the little girl as a drummer-boy in the Hussars (Pl. 33). And for her he painted his best story book – about a "very handsome young man" who meets, out riding, a "most beautiful Nigger lady" on a bicycle, falls instantly in love, marries, and has three children divided down the middle, black and white. There was thick snow, to build an obelisk. There was skating on the canal, pegged out by Lutyens in my time. It led, he wrote, "from the house to a bronze Greek being bitten on the behind by a wolf, and the ice is perfection".

The children painted beside him round a glorious fire, while the mother read aloud and the snow turned legendary blue at lighting-up. And in the end the solitude at night, the huge uncertainty of war, long friendship and a mutual need for reassurance brought them together in a way quite unforeseen by either; so that years later she could write to me,

> Then he and I would sit up for hours talking in the firelight, talking until we went to bed – together. We were not either of us in love, and we were both making love to a dream or trying to lay a ghost: he of Caroline and I of you. We both wept a good deal – for ourselves and for each other. He wanted me to have a child by him, but I dare say it was as well that nothing happened.

In the "fun fair" over Christmas, Jill had conceived, but this was not announced as yet, to sharpen his own wish for children. The letter went on:

> Caroline kept him in an agony of unfulfilled desire – and yet I don't think he could ever have given real happiness to a woman. He was infinitely loving, but could neither find nor give the love he

longed for with his imagination, which was greater than his emotions, or desires could ever attain. He had such a strong streak of homosexuality in him, which his imagination wouldn't admit, but I am sure that speaking purely erotically he might have been happier.

He was like a child or another woman as a lover. I think the only reason I ever went to bed with him was to try to give him confidence and reassurance sexually. I knew he couldn't hurt me and I shouldn't mind it being sometimes a failure. But he was immature too, so that one can't be sure he mightn't have found the right person if he'd lived.

From there, he invited himself to North Wales to paint portraits for money of a charming and clever girl of twelve, Anne McLaren. Christabel, her mother, had been a friend for many years. Beautiful in youth and the daughter of the head of the CID, she combined in wealthy middle-age a mirror-polished poise with the steel-hard shrewdness of the sleuth, yet was genuinely fond of him, and he of her. Ten years after his death she published *The Story of Mr Korah*. It seems that one night, dipping into the Old Testament, she chanced to read "that appalling story of Korah, Dathan and Abiram", who with their wives and children were sent down "alive into the pit". She relates that when Rex came to lunch next day she made up impromptu a story for him to sketch while she talked. It is a sequence of grisly inventions so exactly of the kind that he himself had been inventing for twenty years that you marvel they could have a different authorship. Dead artists tell no tales.

So by way of Plas Newydd, to "dot the anchors and cross the masts", he returned to Salisbury Close where part of the house was now a small officers' mess, with well-mannered occupants. In a way it sweetened the prospect. Everyone was in it, had to be in it, even soberly wanted to be in it. And still there was nothing fearsome to be in, behind the Maginot Line. Therefore Rex suggested to Henry, doubtful what to do between Eton and the Household Cavalry, "Why not France! In the West it must be as safe and peaceful as anywhere in Europe."

For his last months of freedom the von Hofmannsthals were lending him as a studio their spacious drawing-room at 27 York Terrace, overlooking Regent's Park, and here he brought up enough furniture, and continued his unsuspected northern affair about which I had heard nothing. "He was terrified of Caroline finding out about me", she says. A friend who saw her portrait on the easel remarked, "Wasn't she

Laurie's girl?" He repeated this to her in vexation. "It was the only time I saw him angry."

We had arrived at the dissolution of the family. For he was sub-letting the Walton Canonry to the Commander-in-Chief – optimistically for only six months – our parents were going to relations, and the car would soon be put on blocks. I helped pack books and china, and we all took Communion in the cathedral for the last time. On the day when Hitler invaded Denmark and the war in the West became real, Jill and I disappeared into a combe in Devon, where a stream and a river ran the waters of comfort, of much more than comfort, and therefore we lacked nothing but continuance.

By contrast, Rex had to see to the stripping of the home that he had thought of as permanent, and also had to deal with a father of seventy-four whose mind became confused and suspicious. He thought Rex was his brother John, dead half a century, and was robbing him; and so he refused to say goodbye when put into the car.

Rex grieved for "the garden with the swans sailing gently past its foot", but still more painful was the feeling "of having once again no *home*, which – though you may not know it – is a terribly important feeling for me", he told Edith, who was always inclined to think that with the Daye House for home he could not deeply need another. "If it wasn't for the ghastly war, of course, I should feel it was only for a few months." By this he meant – if somehow the war had been defused before it had exploded in Norway, an irrational hope that had lingered in the West, so incredible another great war still appeared, so strong the illusion that the German economy could not support one. "Now the future is *completely* obscured, isn't it, and at present the likelihood of returning to peaceful days, all together there, seems as remote as anything could be."

He had designed a complete new ballet for Sadler's Wells, *The Wise Virgins*, asking nothing but expenses, and told Edith with uncalled for disparagement, "I fear the scenery and dresses are going to be intoler-ably hideous but we must all *face the music*, I suppose, or Constant [Lambert] will be offended – not to mention Willie [Walton]." Margot Fonteyn and Michael Soames were the Bride and Bridegroom. On the first night he was persuaded, looking shy, to take a curtain call by himself, and in ignorance came far forward – luckily too far to be buried by the plunging weight of it. With a momentary glance of panic he saw it was no good to fight his way back, and trusting to agility, jumped clear into the auditorium. But he was good at appearing to dismiss embarrassments, drank too much at the party, and suffered as so often from a hangover.

The lovers spent a last week-end at Brighton, walking and lying on the Downs, where he read Keats to her, and Kipling's "If", which he thought a fine poem, with sentiments both natural and sound. It was a happy or contented time. "I helped him buy his equipment", she told her mother, from a list all too like a school inventory. "He seemed so helpless and hopeless" – an impression he never gave to me, but indulged in with someone more practical than himself – "had no idea how to set about buying sheets and nailbrushes". Still, he had taken care to be in time with his uniform, from one of the recommended tailors. When it came he put it on at once, took easel and looking glass to the balcony above the Park, perched on the balustrade with a tray of gin and Dubonnet, and did his portrait, casual in posture, but pensive and a little tight-lipped, to prove firstly to himself, and afterwards to anyone who cared, that he was actually a second lieutenant (Pl. 26). To get the feel of it, he bicycled off on some errand, complete with Sam Browne belt, but carrying a parcel, and, what is more, bare-headed, an almost inconceivable *faux pas*. Even Liz knew better than this, and shouted to bring him back, "I'm sure you ought to be wearing your cap!"

The war news shocked, then astounded: the invasion of the Low Countries, the break-through at Sedan, the collapse. "The Blitziness of this Krieg really is pretty grim now, isn't it", he wrote to Henry.

> To look back means only to fill one's mind with a flood of bitter resentment against the dilatory obtuseness of our rulers in recent years. ... But there is one wonderful thrilling *fact*, which keeps me in great heart during this terrible present and for the future, and it is that the amount of *fight* in us is inexhaustible and unlimited – except by the limit of life itself, don't you feel that?

> It's not a possibility to be discussed, but in the privacy of one's own mind one cannot but say sometimes: suppose – just suppose that we were to be overcome and crushed by sheer weight of arms. Then comes that glorious thrilling realization that we shall go down fighting harder and longer than any race have ever before – that we should go out in such a blaze of glory that the Finnish resistance – perhaps even Leonidas and his boys at Thermopylae – will be but tiny candles in comparison for ever after. And that would be no less glorious than Victory. Still, bags I victory if the Gods give us the choice, and it's the "On dit" that they *have*, though their price has gone up considerably I gather in the last few days.

"Poor Rex went off to the Army like a boy to school," his love wrote to her mother, "I never saw anything like the confusion he got

into – rushing about in uniform with canvases under his arm." Even with a speeding taxi he only arrived a minute or so before the train left for Colchester – "to fall headlong into the carriage, gold braid askew over apoplectic face and my baggage on top of me, while hundreds of soldiers watched with disdain". One who watched without it was a fellow-novice in the same first-class compartment, Adrian Pryce-Jones. Together they went on in an ancient taxi to Roman Way Camp, "spirits at zero".

Yet four days later he was out with a canvas, wandering through Mersea Island to find a good site in the tiny village of East Mersea. It was not good by the picturesque standards of earlier years. There was a church tower bosomed high, it is true, but there was also an ugly red cottage, a tilted-over van, and then just etcetera, with a bush and a hen coop, all in blissful afternoon warmth (Pl. 31, and see note). In the foreground he introduced himself – not passively observing, as in earlier self-portraits often slyly introduced into pictures with sardonic amusement, but active in the shade, on his stool, at his easel, a soldier off-duty under the continuous, ironic blue of that disastrous June, and very consciously conveying his recurrent thought: this is nondescript England which I love like a mistress or a mother, and time may be short.

Within a few days he had perpetrated a solecism unique in the history of the Foot Guards. Almost late for Adjutant's Parade he was picked up at his billet by another new friend, David Vaughan, to finish dressing in the car; then discovered that he had no tie. They decided to hide themselves in the middle rank of subalterns. But to no avail. Lord Delamare could find no words until opposite that friend, the next man along, and it seemed to be he who was informed by those protruding eyeballs that he was not "a six-year-old-child" etc., etc.; while Rex, aged thirty-five, stood blanched and rigid, and once again in life saw himself (in retrospect) an apt subject for a Bateman cartoon. Otherwise he kept out of serious trouble by looking at his watch every quarter of an hour and doing what the others were doing, "but it's rather a strain".

Quoting verse to his recent love he wrote that Brighton was "a time to remember for years, to remember with tears". He wanted her to join him on leave from time to time, but she never could, or did, and afterwards was filled with remorse. "I have a sense of guilt because I didn't fall in love with him. I thought it was bound to happen and that I could begin again with him where I left off with you. But I couldn't. I was never really at ease with him." Three years before she had asked if I had told him of the end of our affair, and I had said,

"I haven't, as a matter of fact, because I never tell him anything. I have found that a hole made in our mutual reticence only closes up again like a film over a hen's eye and leaves the eye full of rather embarrassing confidences." This was written at a moment of impatience, and certainly there were mutual revelations, but they did not seem to expand mutuality for keeps, or they seemed to be followed for us both by a sense of recollected nakedness.

To the other new subalterns, many of them fifteen years younger, he was something of a celebrated man, and soon they saw him at work on a canvas of their dormitory hut, with scattered figures resting and himself shown patiently undoing an army boot. Then the training battalion moved to the racecourse at Sandown Park, Esher, and he found himself writing to Edith in the Royal Grandstand – "the first time I have ever been in such a place" – but not about the place.

> I feel more loathing and disgust for that little group of craven self-seeking traitors at Bordeaux than I do for Hitler himself – don't you? – though none at all for France and only admiration and pity for her. Not because they have found it necessary to give up in a desperate and overwhelming fight, but because these despicable creatures (without the smallest authority) are betraying their country without a thought or provision for the way in which it may be redeemed in the future, and without, apparently, any effort to hand over to us what little they *can* to help continue the struggle.

And when one recalled, he went on, that it was *they* who insisted that no separate peace should be made by either country!

> It really has been so curiously marked with almost *everyone*, this general sense of being stronger from now on, instead of weaker – as though the entire nation had started with a gasp of horror and ended with a great sigh of relief: thank God we have *at last* got rid of all our allies!, goes up the cry, which must seem madly funny to the rest of the world – and it does make me laugh too.

Otherwise, he told Maud Russell, "the army is hell". In a scathing attack for not answering a letter, she had called him "spoilt" and "capricious", and he now wasted a good hour on a far-too-elaborate rejoinder, half-submissive – "I have been so obtuse", and half-insubordinate – she did not gain anything "by writing angry letters to people like me". Still willing to wound and loath to alienate.

He was amused that each intake of new officers should be instructed in upper-class speech by his lordship – "terribly suburban himself, really" – as more than one of Rex's friends described him afterwards.

"In the Guards we don't say 'phone', we say 'telephone'. We don't say 'we are going to town', we say 'we are going to London'." The explanation is that in war-time the Brigade had to cast rather wide for officer recruits, and even across the minor public schools. This was in the heyday of the social shibboleth, long before the term "U talk" had been coined, or Betjeman had written "Phone for the fish knives, Norman", deftly designed for instant use as a test paper. It may be assumed that the aristocracy of the Thirties was the group least consciously concerned with these valuations, but I think the opposite is true: they were the most. In some great houses there was fascinated discussion on such themes as that "mirror" was bourgeois for "looking glass", and that you might just conceivably say "mantelpiece" for "chimneypiece", but of course never "mantelshelf". One day there was debate whether a ship at sea was in motion, that is, moving. "I think it's travelling", said Rex. "Oh Rex, how middle class of you!", laughed Caroline. Perhaps in a threatening period it was a comfort to remember that, while wealth and privilege might be appropriated, subtle class distinctions in language were inalienable.

He now had a platoon, and was despatched to protect Hampton waterworks from paratroops. Bombs fell every night, "and you know how one always thinks it's coming down on one's own knut". Going round on narrow paths between vast reservoirs, to make sure a sentry poked a bayonet in the darkness, "it's as much as I can do not to *fall* into the waterworks". And when the time bomb was removed from St Paul's he wrote, "I don't think I could bear that beloved favourite building being destroyed – though I suppose we must harden our hearts. Half the pleasure of victory will be gone if St Paul's and certain other churches have been destroyed." Ultimate victory was taken for granted, though hardly outside this island.

He was reading *Königsmark* by A. E. W. Mason, an historical romance of the early eighteenth century. The author had sent it, asking if he would like to do some illustrations, not for another edition but for private enjoyment, and offering the £100 in advance. It would need no research and Rex proposed ten drawings, once more relying on his speed, with the fee much too low and the date much too early. The cheque was paid in. It was acknowledged – but not for ten weeks. This did not ingratiate him with the drawer. There the matter rested.

Another task was to guard Heston aerodrome and be billeted again in empty Victorian villas, where a guardsman had committed suicide. Rex was not surprised, and painted the walls of his own platoon's billet with flags, emblems, etc. as "otherwise all our soldiers will commit suicide": he could not get used to calling them guardsmen. Here

he shared his villa with a subaltern, Andrew Graham, afterwards a full colonel, who had to leave earlier each morning to catch a train. Rex therefore pretended they were a married couple. (There was nothing sexual in this.) Another subaltern saw Graham call up from the gate, "Goodbye Mother!", whereupon Rex's head appeared at the bedroom window, "Goodbye, dear – Don't forget my blouse at Ponting's!"

Back at Sandown he was granted, for studio, the upper room of the grandstand, all arches and bastard Corinthian, from which he could see both Windsor Castle and Hampton Court Palace. Here he painted a plump master cook, one of his best portraits (Pl. 15); also a tough Jock Lewes with a bren-gun on his knee, then about to leave for Libya, where he would inspire David Stirling to create the SAS with him, and die too quickly on a raid ever to receive his share of credit. Also he painted a landscape target, over nine feet long, to practise street fighting at the miniature range, with three street vistas and a sniper here and there. The King, after a visit, left a message with the CO that he ought to put in "many more quislings". Rex was quite content for it to be shot to pieces, but obviously it could not be spoilt. For his platoon he drew out on roller-blinds the correct kit lay-out for two kinds of inspection, absolutely factual though bordered by palm leaves, etc. "I just mope about the mess and do a little desultory painting", he told Osbert Sitwell, while really grafting an old life on a new one with remarkable success. But the drawings for Mason were not desultory, and therefore were not started.

He now had to share his studio for a while with the other Welsh Guards artist, whom Rex described to Caroline as "that pompous lump of Elwes". In view of this they are unlikely to have mentioned the fact that they had shared Tallulah's favours, if indeed they knew. There came a moment when some art-work was needed, and thoughts turned first to Elwes, who had long since been in *Who's Who*, as Rex never was, earning more with one adroit portrait of a notable than his companion with a painted room. "We can't ask *him* – he's an artist!", said the second-in-command. "I expect Rex will do it." After mutual dislike had resulted in words and the throwing of a ham bone in the mess, Simon Elwes had the Colonel's approval to move on, and presently became a lieutenant-colonel in public relations.

The tempo of tremendous events now quickened. So did that of trivial, or private. I was called up into the Signals in Yorkshire. The Battle of Britain came to a climax. Down West the invasion was officially described as begun. Simon was born without fret or trouble among air raid alerts. My father lay dying of a hernia and old age.

I was in a quandary. If I sought "compassionate" leave on his

account, I should not get normal leave with Jill, when, if ever, that should be restored. My mother generously agreed that it was right to put the new life before the old, and felt no resentment. Again Rex was her one effective son, and stayed beside the deathbed, drawing a pencil portrait which he kept to himself (Pl. 11). She had loved her husband with an "extraordinary singleness of heart far beyond everything else in the world", he told Caroline. This may have been true in the sense of dedication, though by now the one who meant most to my mother was Rex himself. Soon Edith found him in Salisbury Cathedral, with the casket of ashes and the four candles, "quite alone – a rigid still figure in Guards uniform", waiting for the service to begin. He spoke of the "interment" at Oxford on the way down, "which showed the agony of these days with undertakers, and yet when he said it I could hardly stop a *fou rire*".

Caroline's little blue cap had been exchanged for a khaki one, but of similar shape. Throughout the Blitz she drove Light Rescue teams in London to their appalling "incidents", two days on and one day off, although apparently entitled to withdraw from the job; and would continue in it, off and on, for three years. He wrote:

> I think of you so continually with dread and anxiety and such admiration too. It *is* thrilling and magnificent and lovely to *know* you are being actually heroic, isn't is? That what you are doing is really fine and absolutely the top as a way of behaving, even though nobody *says* it (for so many are doing the same), still it must be a warm happy feeling.

Her example undoubtedly had some effect on his later decisions.

Eleven months had passed when we met again in Wiltshire, where I had come south to an officer-training unit at Bulford. I was putting in for the Rifle Brigade, and he begged me to try for the Welsh Guards. I said it would be too expensive, and he said not in time of war. I remember this with sadness; for on that decision of mine hung the alternatives: of being with him, constantly perhaps, for three years, or only at long intervals for a few hours at a time. With sadness always, but never doubting I was right. Soldiering was heavy enough without the gratuitous burden of being every day a brother's brother; and perhaps that fine intelligence perceived my need to make my own way into a war, behind this ultimate rebuff.

I was finding the OCTU more unpleasant than the ranks, because of the sense of competition. Rex told me I should meet with friendliness again when commissioned, and generally paid tribute to mess life, and the unexpected leisure; indeed he said he felt embarrassed by his

thoughts of Caroline, so often in danger. One remark impressed me, when I came to think it over. "The army has given me what I have always wanted and never been able to afford – a good manservant." He had not said, "it will give *you* what *you* have always wanted, etc.", for it was common knowledge that a good manservant had never been high on my list of requirements. In his mind unconsciously at that moment I was what I always had been, a younger brother on another level. And yet it was I who was established now, the family man, employing, as he never would again, a good maidservant – that is, if the girl from the village who took Simon out for an hour in the afternoon might qualify.

The battalion foresaw that a man of his age and particular qualities would soon be moving on. He would have been offered a job in Southern Command but for reorganization in the Guards, and presently was offered one in camouflage: "Rex not sure that he wants this." All the same he went for the interview, which suggests that he was not yet wholly committed at this period, and might still have agreed to a six-months engagement as official war artist in some area of excitement on land or sea – leaving open the choice of an extension or return to his regiment. It was the last moment for that.

Red Shoes. From *Hans Andersen*, 1935.

# ·XXVIII·

TO MEET A GERMAN INVASION still thought probable, new armoured divisions were required, and early in 1941 Alan Brooke boldly recommended forming one in the Brigade of Guards – traditional infantry. This had not reached Rex's ears when in March he wrote to Henry Uxbridge, now in the Household Cavalry,

> What fun if we ever found ourselves in Greece together or Palestine. But I suppose the dashing and elegant Horse Guards would never condescend to bivouac on the same front as the humble Foot or Mud Guards. Still, we might meet, as I suppose you are mostly mechanised now, so remember [sketch] if you hear a tapping at your chamber door, for *God's sake* let me in *quickly.*

The sketch was of a First War tank, such as he had been drawing at the age of twelve (which shows how few modern tanks were around, to be observed). It is seen under heavy fire, with a panic-stricken figure doubling towards it for shelter. The Household Cavalry had armoured cars, in point of fact.

Being given the choice himself now, he chose tanks – as less wearisome than endless foot slogging, more dashing and more interesting. The Welsh Guards were to have the lighter ones, for fast-moving reconnaissance, and accordingly he was posted to the Second Battalion, which, to his pleasure, now assembled at Codford St Mary, only a few miles from several of his earliest and closest friends. To Siegfried he wrote at once, asking to be allowed to interrupt the writing of memoirs for just "a walk one evening", or, if he were out riding, to meet him on a bicycle.

> There is no need to tell you how appalling the boredom is, and I am almost impatient for the horror and misery of *battle* to begin; though *you* better than most, will know the full idiocy of such a wish, which I half realise myself. But our tall strange Welshmen are

248

charming, nearly all of them, which helps a good deal, and come up to their well-known reputation for *singing divinely* whenever they can, and then I too am "filled with such delight, as prisoned birds must feel in freedom . . .".

The misquotation was generously overlooked. To Edith he wrote, after almost a year in the drab suburbs, "I don't remember ever having been so astounded by the beauty of Wiltshire. The ideal longed-for country one usually only sees clearly in dreams." This gratified. Also when he wrote of his mother, "I often feel that I understand and am closer to you than to her." She had just been staying for the first time at the Daye House, and he felt obliged to go into her character, since she and Edith "had so very little in common". He tried to think how it was that she seemed to have of wordly knowledge only fragments –

collected quite haphazard and without much sense or any selection, that anyway are of little use to her . . . like the dust and straws that collect on a trailing garment worn by someone who isn't interested in garments – not sufficiently even to keep them off the ground. . . . But what can it be that *holds her attention* as it were, and always has done (without her being aware of it) much more than *I* can, or anything I have done? She is possessed by a curiously strong spiritual force of some kind that I do not understand. I really believe her to be a most unusually pure and single minded person, but with very little idea of what the world is like anywhere in any part of it.

This did not gratify so much: rather implying that Rex still thought her more spiritual than Edith, which he did. It would not have gratified his mother either, who believed that her whole concern was for those whom she loved. Ill at ease that the one might think the other inane – which she did – he seemed to Edith to find his mother trying, and not to admit it. "But he *does*. She flows on in a treble voice rather sentimentally silly."

"The Whistlers very much a family party", she noted, when mother and sons were united for the first time since Salisbury. Left to themselves, the mother was content to sit silent while the sons exchanged military information of not too confidential a sort. Thus, in the Green-jackets, where riflemen were Londoners and short of stature, subalterns rose like bean poles. Quite the reverse in the Guards. "Some of the officers are *tiny*!", he said. No doubt he was thinking of the Runt, a cause of constant anxiety to one who set unusual value on looks: he had been almost relieved to hear from Andrew Graham that the runt-species was equally present in the Grenadiers, Coldstream and Scots, and replied,

I do, stupidly – or perhaps loyally (to the Regiment) – mind so much and all the time, about the really terrible appearances of some of our more recent acquisitions. I find it odd and am a little ashamed of it that I continue to mind privately (perhaps not always privately enough) when in most cases I have come to find them quite tolerably nice and unobjectionable as characters.

These thoughts are rather distasteful even in a private letter, but the subject was entirely unaware of them and liked him. Rex cruelly altered two photographs and posted them to Graham as Nos 1 and 2 of "The Troglodyte Series of Art Postcards". They showed "Runt fishing from tank" and "Runt being obscene about two-pounder gun". Of the genus as a whole, he went on – in a vein that shows how consciously he gave himself to taking pride in a great regiment, by way of acclimatizing to the uncongenial –

I dread to see that the Adjutant has chosen one of them for a Court Martial in another Battalion; and in these big gatherings of officers of the Division which take place in cinemas from time to time I watch them (our runts) uneasily, as they always seem to choose the most conspicuous chair, and I note with irritation how they have invariably chosen to wear berets when Service Dress caps would have made them a *little* better, or vice versa, and I only just resist the longing to put my overcoat right over them – as though by mistake of course. Have you shared that feeling sometimes?

A sketch showed a runt seated on the edge of a chair with dangling legs – mouth agape in helpless misery at imminent snuffing – some nearby officers alarmed – Rex himself striding forward with coat, elegant enough. Elegant he was, especially in his "blues" at night, with the brilliant brass buttons and the bright red stripe down the legs, worn one week-end for Edith's benefit. In contrast, meeting some of my friends one evening, he found the total dark green with black buttons of the Rifle Brigade immensely distinguished; and at once gave me a set of "greens", to be made by our expensive regimental tailor.

Months passed before he even began work on *Königsmark*, and Mason wrote to Christabel Aberconway that he had given him up. "A man, artist or not, who doesn't acknowledge a cheque for two and a half months isn't very likely to do any more." He guessed that even then it had only been a friend's hint which produced "a letter redolent with charm". This is more than possible. "I bet he has forgotten the story and all about it by now. I used to think that dog didn't eat dog" – but Rex was "not the only instance" of dog doing so, and liking it.

A second hint, from Christabel this time, got Rex to work; which was all the more desirable in that he had just agreed to illustrate *The Last of Uptake*, an amusing fantasy by Simon Harcourt-Smith in the old, precious, Between Time manner, written presumably with him in mind. Apart from Gulliver and Hans Andersen, none of Rex's books are important in a literary sense, unfortunately, but these latest two are among his very best, and he produced them in army huts between fatiguing days of training. The Baroque inventions for *Königsmark* are in sepia with delicate touches of pink. When they were sent off, after nine months, not five weeks, he could safely employ for this latest customer his old trope about sackcloth and ashes; which was not suitable wear in the heat of June, "but I am *spiritually* grey with ashes" (p. xiv).

Got for £10 a piece by Mason, they were left to the Tate Gallery, and reproduced by me in a book later on. In vigorous freedom they correspond to his new style in oils; nevertheless to Diana Cooper he wrote that some "were rather dreary and like *Strand Magazine* illustrations". Perhaps it was a mistake to have drawn them, unrequested, as big as the *Gullivers*, twelve inches by nine, when he could not possibly put into them the same care, wit or humour. In point of fact they are without wit or humour, which is rare in his work, but right for this tale of brutality and passion, appealing as it did to two sides of his mind, the grotesque and the erotic. Evidently he identified with the charming young lovers, in drawings nearer to his private ones than any made public hitherto: she so childlike and diffident, both so eager and defenceless.

His youngest love, now in her middle twenties, had taken her baby to America in the perils of 1940, and was paying a brief visit to be with her husband in his final months before embarkation; but they were not in harmony, though fond. One evening in June she met Rex at the Daye House, and was seen by Edith to be "lovelier than ever", as she watched him at work on *Königsmark*. In his contradictory nature he could be described as a flawed cavalier. He had scruples about deflowering a young virgin, but thought that "if she had been married it would be another thing", that is, if she were emotionally free for one reason or another; for he would never conceivably have wished or allowed himself to break up happiness. "Yah, Cuckold!", I heard him exclaim with odd vehemence, when looking with Siegfried at some eminent Victorian instance. Dispossession had a certain appeal. He knew that he succeeded easily with women, as with Tallulah who had had more passionate lovers, yet tormentingly he was still not at ease with himself.

In October 1941 they were together again at the Daye House, prob-
ably on his initiative, not Edith's. His commanding officer had said,
"I should like to see Rex with a moustache!" So with one he arrived,
and Edith did not find it greatly altering. The girl was booked to
return to her baby in America within days, and there were strong
financial reasons for that. But she was not as yet compulsively drawn
to the baby, and suddenly she rebelled, saying she disliked America,
her friends were in England, she would forfeit the passage-money. Rex,
whose leave was just due, was "all against her going. Thinks she will
be drowned." This put Edith, her one and only adviser, into acute
uncertainty, though still advising her to go. Not to "might smash their
marriage", she reflected. "Rex sees it differently. I think he thinks that
if it *was* smashed he would comfort and marry her!" There was never
any great censoriousness.

She decided to go, and at once the appeal of the Last Chance became
irresistible, its rejection too poignant to face living with, in view of
what had once before not happened, and all that had ensued from
that. She moved for the last week to Claridge's, where Rex came to
see her, released by common sense from his old antipathy to that hotel.
Indeed he came to stay, without taking a room, living in hers and
slightly apprehensive of managerial disapproval, but undiscovered or
at least undisturbed. Disillusionment with life, or simply growing
older, had relaxed inhibition. With a few outings in her car, to walk
in Windsor Great Park or elsewhere, they spent the days largely in
bed, and perhaps with the same future in her mind as Edith had
imagined in his: remarriage. If only she could have waited, he sighed,
for this was the best he had known. After his death she had a letter
from him, written before going into action and wishing that she had
conceived. Many such were written after war-time affairs. Nevertheless
she felt, diversely, these things: that without knowing it he was homo-
sexual (here agreeing with his recent mistress whom she never met);
that he did not greatly need the physical, being "all love but no life";
or else that some special need never found expression. I wonder. It
could be that his feminine aspect obtruded because his masculine was
held in check. At any rate I guess that somewhere, but never where he
bent his attention, there did live the "not impossible she" who could
have answered all that his imaginings asked, and been rewarded by a
charge of co-ordinated loving that was never brought to bear. In elec-
tricity an imperfect contact gives a flickering light, and built-in resist-
ances a dim one, though the voltage may be more than adequate. She
took ship to America and they never met again.

There had to be a symbol for the new armoured division and the

GOC consulted Rex (p. 227). "So now I am thinking hard about mailed fists, iron bludgeons, etc, to find something suitable." In the end the Eye of the Guards Division in the First World War was revived, and Rex painted a different sample eyeball on each of twelve tanks, but the original version seems from photographs to have been chosen, as easier to reproduce. He was making a lieutenant's humble presence felt, in those minced meadows. The huts of Codford for the dining-room and anteroom (or sitting-room) were needlessly uncomfortable, he thought, because of top lighting; so he made "Before and After" drawings for the suggestion book, showing on the one hand misery and mishaps between half-blinded officers and servants, and, on the other, elegance and "service with a smile" among table lamps. The dining table was too narrow, for another thing; and there was nothing whimsical about his remedy: "If *the table were widened* (by a 6″ plank run down each side supported by a cross batten at intervals) and the *lighting confined to the table*, (with possibly a serving light or two) the result would undoubtedly be better nourished, more efficient, and happier officers and staff." A dinner party with guests from outside convinced the CO that Rex was right. So he called in a painterly Guardsman, and for ten days eating was elsewhere. Walls and ceilings became a tent, striped red and white, in the Port Lympne manner. Along the walls were hung "a set of *portrait plaques* of Squadron Leaders and other notables, to assist new officers in Recognition", as he had put it. Each was an oval of wood with a subtly-caricatured Roman head in relief, and the first was of his own commander, entitled "Timotheus Consett – Dux Squadronis III". Then for the anteroom he brought out old properties – but new to this audience – deceptive gilt frames hung on fictional silk cords. A visiting officer found him "surrounded by the boys, jacket off, sleeves up, cap on head, grasping his ash walking stick as a rest for his right hand", and seeming more engaged in discussion than painting. *Mutatis mutandis*, so it had been from the first day at his preparatory school. He painted what was asked for: a regimental Blimp, a Henry VIII, signed "Hans Holbein pinxit – costume by Clarkson", a Dali, in which, unevasive as always, he included a tank far-off in flames. It was known that British tanks were no match for a Tiger or a Panther confronted head-on, though the Government persistently lied about this, and that when a tank "brewed up" the crew were very lucky to escape. Consett had airily told him he could go on leave when all the frames were filled, and he had taken up the challenge. Filled they were by dinner time, and he was gone.

In a similar mood, or in a daydream during some weary lecture, he

had doodled a Renaissance tank, with swags, flags and even urns. And when asked to draw German tanks for instruction he did this accurately, concluding with a Rococo model. War was a drink too sharp not to soften it with humour. He was now very much a part of the battalion, greatly liked; and he painted several portraits, one of his particular young friend, Dick Whiskard, who would be the second officer to die in action, as he himself would be the first. Years later I wrote a poem about this, reproduced on p. 301. One task was to redraw the backdrop for *The Rake's Progress*, lost in the invasion of Holland, and make a little money. The new one was the only stage design he ever willingly parted with, he afterwards wrote, but by no means the only one that was never handed back.

In July Jill stayed at the Daye House to convalesce, after relinquishing the lead in *Rebecca* through severe illness on the very night that Rex was taking Caroline to see her; and I began catching late buses to Wilton, and very early ones to Tidworth. We were a shade too involved in each other to be perfect guests, and aroused a corresponding shade of irritation in our hostess, who thought, "he adores her dumbly – like a dog. She is fond, but not so doting." Probably Jill thought the doting was elsewhere. Rex came from Codford one afternoon, and there seemed to be a subtler alteration than the new moustache, a further remove from the civilian. Dignified in chair, with head on cushion, pondering the reprehensible behaviour of somebody or other, while drawing at a cigarette with lofty critical disdain, he was very much the officer – and one of a rank more befitting his age: not at all the kind of Englishman that an American girl might expect to burst into tears if the skin of the milk got into his mouth. And yet it was the devil of a wearisome task, as more than one ex-civilian found. Passing the drinks cupboard, we saw him inside it, tossing down a private brandy. It seemed strange for a moment, when drinks were painfully no longer on offer. "What *are* you doing?" – "Obviously, I'm having a drink!", he snapped. No doubt it was on Edith's insistence.

He talked to me of the Sassoons, how Hester appeared to be in love with him; though the marriage was not failing on this account. Later Siegfried bluntly told him that she was, and of his own lack of interest, with an obvious deduction to be drawn. "Rex isn't in love", Edith notes, "but is fascinated by her femininity, and would make love to her if it made things happier for her. I beg him not to. She would ask him to take her away ... for life. This R. couldn't stand. He is still in love with Caroline." Last year's successful adventure at Claridge's, quite concealed from Edith, only added to the stress. "He says he'd rather marry —— than anyone, and now wishes he had."

Thoughts inevitably turned to the convalescent at the Daye House, who was, in Edith's words, "a dream of beauty. Rex thinks her beauty complete." David Cecil came to lunch. "He loves Jill and she him. – How he agrees with me that we wish Rex had married her instead of Laurie!" This wish was natural enough, and also reasonable, on the evidence. To the world they would have seemed ideally matched in character as in theatrical interests. Now a marriage came as a surprise: my mother's to a retired Indian Civil Servant, of moderate means. "May God bless you, my darling," Rex wrote before meeting him, "as I am sure you deserve to be blest, after all these years of loving devotion and unselfishness to darling Daddy and all of us." Soon he could guardedly describe him in a letter to me, now in Yorkshire, as "direct and honest and a little more unpolished in manner than I personally like, but if he loves and values her as he ought to do – as he surely must do – I shall be overjoyed, even if I never come to like him very much." He guessed that I should think much the same, and begged us to be there in the church. But Jill was too sick on the morning. War would now divide him and me. I watched him give our mother away, and never saw him again.

He made a new will, leaving everything to me, including about £1,800 in investments. Though this marriage to a man at once better educated and duller than our father depressed him, it relieved him of anxiety for her future. He told Edith, as she records, that "he himself must expect to be killed. Oh GOD." He was only trying to acclimatize her, but anxiety increased in the Daye House, and she took it to share with Hester Sassoon; for she had heard that "the Guards Armoured Division will be the spearhead of the Second Front. This is Rex. He will be killed. *I cannot look on at all.* R. is destined for doom."

*The Last of Uptake* appeared and shows by the sheer number of vignettes that he still could be absorbed in decorating a book where the main characters were buildings and statues, in variety of moods. In the following year *Night Thoughts of a Country Landlady* appeared, Edith's quite amusing account of her war-time lodgers, for which Rex invented a fictional Edith, skinny and spinsterish, with the unfortunate result that the public has assumed that so she was. This was his final book, and a drudgery endured as of benefit to her, since Batsford would not otherwise have published it. He felt that such work always tended to renew the trivial reputation he had won, chiefly as the illustrator of three best-selling books by Beverley Nichols. His mind was elsewhere. During this summer of 1942 he developed his new style in oils, freer but not vaguer, unmistakably his own, in several small canvases round about the Daye House. He was beginning to

learn, he said, to paint. The subjects were themselves indicative. Although he had cherished the little Victorian dairy from the first, he had never thought it merited a picture; his Wiltshire subjects had always been beautiful in themselves and romantically presented. Now he was painting what was there at hand, with the thought as well that he had better do so while he had the chance – painting it from different sides, generally with Edith in the picture, to whom each was given in turn, token after token of gratitude for seventeen years. Once he included the shiny round back of his car, a novelty in his work, and a portent. There was a changing palette. The reticent, cool grey-greens of his long-extended youth had been replaced by tousled sunlight, summer warmth. In him it was like slow maturing, which may well have been advanced by the experience of love, tantalizing though it was, and even by soldiering. He himself thought that this was good for him, although on other grounds than these. He told me that through all those boring and uncomfortable hours of the day and night he had come to see the value of the ordinary man's view of life, shared in many desultory conversations around billy cans and bivvies. He was now commander of a troop of fifteen or so, with three Crusader tanks. He had taken along with him from Sandown his servant Williams, to remain with him in mutual affection as front gunner in his own tank, until the end. Not that the "good manservant" was incapable of error, as when Rex was irritated to hear that some of his linen had been packed in Andrew Graham's luggage. "I flogged Idris unmercifully." Tim Consett, his squadron commander, was a regular, older than nearly all the troop commanders, but still seven years younger than Rex, whom he looked up to as "the most wonderful person I had ever met". He only once had to reprimand him, and frankly admitted this was difficult to do. They were already firm friends the year before, when sent with a party of guardsmen to sort the Christmas mail at Earls Court, an unmilitary task. The men were almost mutinous, and the sergeant who reported this surprised the couple drinking port, a quite irregular indulgence on duty. Rex made a drawing of this, now lost, entitled "The Gauleiter of Earl's Court", showing NCOs in the background whipping guardsmen to fill mail bags.

Consett, a favourite with the engaging second-in-command, Jim Windsor Lewis, secured for his squadron the most engaging subalterns. Consequently it was soon being called "that clique", or "effing Three Squadron" by Douglas Greenacre, their dominating CO, known throughout the division as "the Boomer". Wealthy scion of several food stores in South Africa – had those stores formed a landmark of Doncaster or Derby instead of Durban, he would hardly have been

picked for equerry by the Prince of Wales, or by now be in command of a Guards battlion. Rex's name for him was "CO Bottle", the name of a piece of tank apparatus containing oxygen under high compression. For he exploded: at waiters in the mess, at anyone on the parade ground. But there was another side to it, and Rex was mature enough to ponder this. At a private luncheon some of his fellow subalterns were saying how intolerable he was. "He's ghastly in the mess, I agree," said Rex. "But he's a very fine soldier. He knows his job. I know I'd be only too glad to be near him when we went into action." This silenced them, but was not intended as a snub, being heartfelt. He would never be convinced that he made much of a soldier.

There were countless courses in different parts of the South, and at the end of one it fell to Rex to give a lecture on the Lubrication of the Covenanter Tank. "It was quite a humorous affair", remembers the sergeant instructor, who received a drawing done in a few minutes after the last lecture, and entitled "Sgt Bolam in a spot of trouble with the lubricating system". A Laocoön effect is suggested. Many years later P. T. Bolam would be writing that he met him only for a week, yet his death seemed "very much a personal loss – it was a great pleasure to have known him."

"There is a very strong impression of being *at sea* (lit. – not met!)", he told Brian Howard, "with this pounding of powerful machinery beneath one and charging in formation over the limitless Plain, keeping in touch by wireless." At such times there was a dash in soldiering that appealed. "If you wake at four, say", he bade Edith, "think of me looking out of my little iron tower rolling along through the darkness." A summer's dawn could make the tedium seem worth while. "The beauty and *strangeness* of everything (even the scenes really quite familiar) never fails to fill one with wonder and glorious delight – almost as though one had seen God's face for a fleeting moment."

He would not have been writing to Brian Howard but for a chance meeting that began well, and ended in a "drunk and swinish" quarrel about the war. Brian, intellectual weathercock, who had once been praised by Thomas Mann's daughter Erika as the first Englishman to recognize the full peril of Nazism, was now – in 1942 – a pacifist. Rex anyway despised the irresponsible and futile intellectualism he purveyed. "I don't know that I was any worse than you," he wrote, "but certainly no better." He felt ashamed, especially as Caroline had listened to it all in boredom, and a rare evening with her had been spoilt. Not that it had promised much. But being given unexpected

leave another time, he still begged for at least "one waltz – some-where – even if we're both cross" (sketch of furious dancers).

He supposed it was no good. "It's rather late to suck up to you. Oh, well, Hey, Ho, etc, etc."

The Real Princess. From *Hans Andersen, 1935.*

# ·XXIX·

THERE WAS A FAREWELL SERVICE on St David's Day 1943, perfect marching through the Close, and several thousand Welsh voices in the nave. For they were leaving on exercise "Spartan", which Edith believed, with misgivings, to be really mobilization, when Rex drove two car-loads of possessions to the Daye House, gave her his petrol coupons and laid up the big Terraplane again. For forty years it would stay like that, with hardly more than his thirty-four thousand miles on the clock. He was to flash a little torch as his tanks passed her gate at ten, but then they went by a different route. "I know it means abroad after this – it tears my heart."

But it only meant that the west half of the island was being emptied, to make room for an occupying army that at last brought the substance of full hope: the Americans. Rex had felt a renewal of his first warm feelings for them, when at Christmas 1942 he helped to entertain an advance party of their officers, courteous and at first rather shy, for what ended in a "riotously funny, wildly drunken welcome to the New Year", and for him a tooth broken in the ragging. "But how *awful* I felt on Jan 1st!" Undulating over Salisbury Plain he had to stop for a few moments and be sick. His three halted crews were sympathetic.

When he was picket officer word would go round, "It's OK – Whistler's on tonight." Yet he kept a fair standard of discipline and neatness, and humanly speaking nothing ever went wrong with No. 15 Troop; it was the happiest in the squadron, perhaps in the battalion. His methods were not always orthodox. A friend from Division, who asked to be attached to his troop during battle practice in Wales, as certain to be more fun than any other, found him underneath a tank with the crew standing round, and fetched him out. "What were you doing?", he asked privately. "Oh, I was just cleaning it – the men get so dirty." The rest of the morning he spent in chat, relying on his crew to do things right. In the mess he referred to his own driver Dolphin as "the Dauphin", and to his troop-sergeant Sherlock, an outstandingly

good one, as "Shirley". He was given in fact two of the best sergeants, though in other troops the third tank was commanded by a corporal.

As with all who become legendary, truth is inextricable from myth. Were his tanks, through dilatoriness, really camouflaged on one side only for an inspection, in the mistaken belief that the General would not ask them to roll back the other way? Shades of Haileybury OTC! Did his Welsh dragon truly breathe so much smoke one end and have so many undulations the other that it had to be repainted from the stencil he had scorned? The divisional commander, Major-General Allan Adair, a man of charm and a friend of the Angleseys, observed with amusement his concentration on mastering the machine, and had him several times to dine. To his young friends Rex seemed to consort naturally with seniors because of age and eminence; yet he would never be more than a lieutenant, whereas I, by the chance of a battalion job I could manage, and the inherent injustice of the Army, had become a captain. But no one, high or low, knew about his private life. Going on leave he disappeared, with no magnet as obvious as wife, mistress or family, to draw him. In truth he was sometimes at a loss where to stay, and in great embarrassment invited himself – he who for years had had a problem declining invitations. It seemed to him "another proof of how *coarsening* the army life must be".

"Spartan" took them to Snarehill Camp near Thetford in Norfolk, remote from Wessex friends. But there was another friend now within range: Venetia Montagu was welcoming the Guards in East Anglia, with a dance of really pre-war quality in the great hall at Breccles, probably on Rex's suggestion, and he was writing to Caroline begging her to stay the week-end there, as he was free to do himself, taking Idris.

> We can have lovely waltzes, and walks under the stars, and Venetia's delicious food next day and reading aloud. How glorious if you could find that striped dress I loved so much, do you remember it? The one you wore at the Court Ball, something like I have drawn here. If you come I will paint another head of you on Sunday much better than the previous ones. If not, it will *have* to be Judy Montagu!

The sketch showed them revolving, not in dudgeon this time. But she could not get leave from her squad.

Then there was Sandringham. When the King and Queen came to inspect the division, thundering forward in mock advance with live ammunition, they could follow the action on Rex's lucid explanatory drawing. Unfortunately shells began to fall too close, and had them

all ducking behind the parapet – Rex furious, when told, that his battle plan had been made to look silly. This gaffe he did not mention to his mother in telling her about the royal visit: he went straight on to describe the dinner in the following week to which he, his Colonel, the General, and one or two others from Brigade were summoned in their splendid "blues", but "all very informal and pleasant". He sat on the right of Princess Elizabeth "and we had a great deal of talk throughout dinner, (she had a rather dumb Grenadier on her left)". Now seventeen, the Princess was, he found,

> gentle and a little demure from shyness but not *too* shy, and a delicious way of gazing – very serious and solemn – into your eyes while talking, but all breaking up into enchanting laughter if we came to anything funny. After dinner I had a most enjoyable talk with the Queen about paintings she had bought – and painters – and books – and poets – and that fantastic *Poetry-reading orgy*, and we bellowed with laughter. The K. in very good form, and all as though they hadn't a care in the world!

There was the usual flow of *jeux d'esprit* into a new neighbourhood, including a sham window at Pakenham Vicarage with an eighteenth-century divine reading by a candle inside it. Two scene designs for a successful revival of Congreve's *Love for Love* he could do out of his head. Sir John Gielgud remembers their being first "sketched on the backs of envelopes during an hour's talk over dinner at the Ivy, and completed by a wash of light water-colour and a few tiny figures to suggest proportions". Finished drawings followed (Pl. 41). Rex was unable to oversee the scene-painters, and feared again that the costumes would be credited to him.

On arrival at Thetford Sergeant Sherlock had taken note of four trees of the genus bushy-topped, by army designation. They were in the form of a perfect square, and could provide a useful shed. He got boards and corrugated iron, hacked and hammered, wedged the beams deep into the trunks, and had it up satisfactorily within an hour or two; only to be dressed down by Rex for philistine behaviour. "He is the most sensitive man in the world", thought "Shirley". But it did not matter; their accord was too good. Many glimpses I had from him, years later, of Rex in those days. "For the battalion dances he always drew a comical poster or two. Whenever he was picket officer he was favourite in the Sergeant's Mess, and one evening drew on the wall by the bar the face of a man peering round at the barrels." But he hated beer, and would secretly and quite irregularly buy the bottle of whisky that "Shirley" was entitled to, now and then, saying he could always

pass it off as turpentine. "Sometimes, when the weather was wet, he would take us into a hut and give us a lecture, or make me give one: then he would sit and draw as he was listening – invariably such things as fountains, country mansions, and always a gargoyle of the most hideous features." Graces and grimaces. Anodyne applied or rebellion sublimated. Invention free-wheeling in a trance of boredom, through the waste of precious youth for all of them. He would lend money against pay day; and was quick to sense trouble at home, bringing a man to Consett for immediate leave, and sending a very long telegram to a wife. "He hated any young officer taking over the troop for a few days' experience. We hated it as much as he did, we thought so much of him." This was to belong, and know the warmth of that support.

Rumours of his doings were of mild interest to other artists. Alfred Munnings wrote to Laura Knight, "Rex Whistler is just for fun painting framed pictures in mess halls, and stuffed salmon. He's in the Army almost for fun, not a job." Here was a faint whiff of the same Munnings-malice that was bent on getting Stanley Spencer, a fellow RA, prosecuted for obscenity; it was proper to Munnings. Nevertheless the remark has some bearing on a general notion that wherever Rex aimed to go it was surely as a funster. Thus in the world of art he had been overlooked. But in the world of the theatre there was concern. A pressing invitation came when he happened to be sitting in the mess. Returning from the telephone, "That was Oliver Messel", he reported to Tim Consett, with laughter and a show of indignation. "He wants me to join him at the School of Camouflage!"

Perhaps it would hardly have been possible for anyone in the position he had reached by this time, committed for two years to training with the same group of men for the same single purpose, and to looking after them. Impossible for Rex, who relied on such personal commitment to justify his presence in a first-class regiment. His superiors had a sense of worry nonetheless, and there might be regimental opportunities of change, carrying the promotion he obviously should have. This was a delicate subject, and Tim broached it one day with diffidence.

"You don't think it would be a good idea if you got a job?"
"What do you mean?"
"Well, thirty-nine is rather old for a troop leader."
"So you mean I'm no good?"

On the contrary, he was extremely good. The paradox was, he might be less so, higher up.

"All right! If I'm not allowed to go to France and fight with my troop, I promise you I shall never paint again! I shall kill myself!"

But there was still a conspiracy to find work he would accept and could accomplish, and finally General Adair appointed him to a vacancy at Divisional Headquarters, where he should at least be slightly safer. He was summoned to the Orderly Room and informed by the CO. Strictly speaking, he had no choice; but he knew his General and was on very strong ground. R. J. A. Watt, the adjutant, sat observing this verbal exchange. It may have been the most enjoyable moment of Rex's whole army career. With correct bearing and full respect, he could answer the "CO Bottle" forcibly for once, in his own language.

"Well, I'm bloody well not going – Sir! I'm going to stay with my troop!"

I am sure he would have faced court martial. The Colonel could only say that he would ring the General and see what could be done. Thus Rex was given chance after chance to avoid fighting, and, such was his loyalty, conviction and need to prove himself, rejected them all. The idea was dropped, and never revived.

Afterwards, some believed that Rex had had a premonition, and it seems that he may have thought so himself; though it would be like him anyway to keep the chance of death well out in the open. Going on leave he remarked to a fellow-officer in the train, "Of course I think I shall be killed. No, Nigel, I mean it." Nigel Fisher, who had seen action in 1940 and survived, did not press him to say why, and the topic was dropped, as embarrassing. About the chance of existence after death he more than once had used that curious term "fifty-fifty", but agnostic is too negative a word for his position. I think he strongly sensed at times that there was a meaning, and at others, being influenced by the intellectual climate, concluded there was not; knew eternity while doubting its existence.

They moved north for final training on the Yorkshire moors, and Rex found himself billeted at Windrush, a little modern house on high ground above Pickering. He jumped out of the army car, looking cross to find himself so far from the mess, and said courteously he would not be staying for more than one night. However, when he opened his bedroom window, on that golden afternoon, a great view, round from castle to steeple and the moors behind, made him think again; and there could be other advantages.

At once they were out on tiresome exercises for two or three days and nights at a time, sleeping by their tanks – only back for a day's maintenance – and out again.

The moors are all that I ever imagined they might be, but I prefer the *wolds*, full of cozy prosperous villages and farms, exquisite rivers, and all surrounded by wonderfully "Biblical" valleys and hills of golden corn. But oh Edith how my heart *aches* for peace and I really loathe the endless roar of engines, and stink of petrol, and the coarse loutishness of the soldiers.

His own were excepted, because he also said he loved them and they him.

Mrs Chadwick, the wife of an officer prisoner-of-war, formed the opinion that Rex was quite a solitary. In all those ten months, she says, he only went out about five times in the evening; he changed into corduroys and stayed in his bed-sitting-room – by a huge coal fire, later on – where Idris would put on a card table the supper he had cooked. Once he could give a friend roast chicken "with two bottles of excellent port at the end (I hope we shall only kill one)". By himself "he had very simple tastes – a fried herring with mustard sauce was a favourite. All he seemed to want was peace and quiet, and we hadn't a cross word."

Few in the mess were aware of what exactly was keeping him secluded in these evenings, by permission of the Colonel. It was the designing in sequence of a play, a ballet, a film and a calendar, and first he was posting off, scene after scene, his designs for *An Ideal Husband* – "a fearful labour with no books for research and no materials to study for dresses". Long explanatory letters were a poor substitute for being there in London. It would be better not to paint the curtains – "if he didn't bring it off it would be very bad, and he probably *wouldn't* without my being at hand to help paint. Silver tea tray with a lot of bright silver junk on it, in *particular* large very ornamented bright silver kettle with spirit lamp below – you know the sort of thing." He was not released for the first night, but was allowed up to London for two dress rehearsals, which were more important, and saw the difficulty in wartime of "finding actors and actresses who have reached puberty and not yet become octogenarians". So the surroundings and bric-à-brac of Oscar Wilde's West End had all to be discovered in his own visual memory, then be given just the heightening of form and colour that would carry them beyond the factual to sing of their period (Pl. 40).

He had to admit that while thus complaining he had taken a few days off in the North Sea, with Idris. Such trips were smiled on by authority to promote inter-service fellowship before the invasion. HMS *Pytcheley* was a Hunt Class destroyer commanded by Hugh Hodgkin-

son, the brother of a Welsh Guards officer. Introduced to the Operations Room on shore, where a Wren was plotting movements, Rex presented his testimonials in the form of a spouting dolphin in the centre of her chart (a smaller version of one for the bathroom at Windrush). They set off from Immingham at high speed for Orkney, and returned with a convoy to Sheerness, uncomfortably slow. Rex spent a good deal of time on the bridge, called the funnels chimneys, saw a distant engagement, and drew for the wardroom a vast coloured head of Neptune crunching up an E Boat, probably his biggest grotesque ever. By way of return, many of the crew were given trips in the tanks round the moors. This may have suggested to him that Mrs Chadwick's son, ten years old, could do the same. Heavily disguised one night in beret and denims, he bicycled with Rex to the castle park, was slipped into his tank at the last moment, and given headphones to keep in touch with him on the intercom, through a five-hour outing. "They sailed away towards Whitby", his mother says, "and a wall and tree just got in the way", for a bonus. A less welcome demolition occurred another night, when Rex, against the rules again, had his tank come to fetch him. Turning in the cul-de-sac "the Dauphin" knocked down the dry stone wall with a tremendous din. Rex rushed out in dismay, and early next morning was there in shirt sleeves, trying to rebuild it. "I explained it was a skilled job and we should have to get a man."

# ·XXX·

"IS DARLING GILL again acting in London? She and Laurie are nearly as bad correspondents as I am." Jill lunched with him in Greek Street happily, and then took him home to meet his nephew and godson for the first and only time. Simon, aged three, behaved well, sitting on his knee while a tank at full tilt with gun at full blast was drawn for him, and acquired in those minutes, or more probably by inheritance, his uncle's odd way of holding a pencil, not mine. That afternoon brought home a sense of being left behind in life more sharply than any event since he had waved us farewell from the steps of the Walton Canonry. A Donne, a Vaughan and a Marvell, richly bound with tooled and gilt cartouche, were his christening present.

Over lunch he had put forward an idea that came from Edith, who pondering his expressed need of a home had often worried that neither she nor his mother could expect to live long, and after the war he would be far too solitary. He had got from the Cathedral Chapter a seven-year extension of his lease, hoping that our mother would return to Salisbury with her husband. Now Edith proposed that Jill and I should share the house with him – quite divided into two in his own version, though not perhaps in hers; she will have pictured a freer, more supportive arrangement. The rent for either party would be modest. Jill was taken by this, saw herself returning from the theatre at week-ends, with our own room somewhere in London, and in her absence a "capable body" to look after what was strangely foreseeable as "the children"; "though I realise that you may feel difficulties that I don't". These difficulties might have dwindled, and sexually she knew by now there was no jealousy. Of course Rex had to embroider the plan for me, with a "Whistler's Academy" for small children, under a versatile staff of three, well-equipped to teach French and Dramatics; English and History; Drawing and Painting – the main attraction being "a little crockadile to the Cathedral on Sundays".

266

He had been asked by Sadler's Wells to redesign the ballet, *Le Spectre de la Rose*. To recreate Nijinsky's part,

> they have a very fine new young dancer, Ninette de Valois tells me, about whom they are excited [Alexis Rassine], and Margot Fonteyn will be the young girl. The original setting (by Bakst) was not very remarkable, from photographs – and the awful repetitions of it I have seen in London. So to redesign it would not be the sacrilege of redesigning say the *Boutique*. I had a fascinating discussion with beloved Karsavina – still entrancingly beautiful – and she told me about the original production at Monte Carlo in 1911, but she also thought nothing of the set. But shall I have time? There are only a few hours every evening – and some of that goes to hot bathing.

Quite a measurable part, in fact; for it had always been a time for meditation, as when lying supine under the old round geyser at 20 Fitzroy Street, his body hairless and fine-skinned like a girl's, yet taut and agile like an athlete's without being specially muscular; gently stirring the hot gratefulness, then leaning forward to inject some more.

A great event in the battalion stopped progress. After two years, "CO Bottle" was gone, promoted to brigadier, "to everyone's intense relief. No one, I think, had a word to say against him as CO. But to live with and see socially every day (and he *never* went away) he was Hell." Jim Windsor Lewis, the second-in-command, took over; less effective, though brave enough in 1940, and much liked.

> This change called for a great dinner party, free champagne and a general "blind", as we old-time soldiers call 'em. Then like an idiot I suggested that we should give a big Christmas Party to the infants of Pickering. So now I find myself mostly responsible for preparations to entertain about 250 little troglodytes on Christmas Eve, aged six to nine. I must collapse into bed now as I have to be up in the icy dark to go to a distant moor, Fylingdale, to fire our guns. Oh the misery of it – and on Saturday too.

For each child there was a personal invitation written out by Rex or a friend, to which he added a sprig of instant holly in green and red ink. Logistics were put into the hands of the quartermaster, with a search of towns and villages, all about. Rex was still at work on one of the decorations round the room, a snow-scene, when the children began to form a circle, in momentary wonder at a thirty-nine-year military man. In the outcome he would write to his mother –

Our Christmas party here was a great success, I gather, and we "clocked-in" 294 children, not counting a fair sprinkling of others who came in with their mothers – children of the Regiment, etc, too young to come alone, so we had well over 300 to tea in all.

The hall certainly did look very gay. There is a big stage at one end, on either side of which I painted an enormous Guardsman (10 or 11 feet high) in full dress, bearskin and all, then on the stage curtain, which was kept lowered, we contrived a vast Regimental device with a glittering crown and a huge leek in green shining tinsel. There were great festoons of evergreens and the whole ceiling a dizzy mass of flags and bunting.

The tables were arranged like an E but with four arms instead of three, and all lit with candles and covered with *crackers*! (which we were lucky enough to find). At one side there was a huge Christmas Tree blazing with lights, and at another the Battalion dance band bellowed away with carols and popular songs – to all of which the children sang at the tops of their voices, which was charming, wasn't it, and it made the party "go".

"Shirley" had marshalled the children, and Rex had cotton-wooled or painted up another sergeant.

During tea, to *deafening* shrieks of excitement, Father C was seen descending a high stairway from the room above in a cloud of falling snow (Don't tell the paper-salvage authorities), and gave out a packet of sweets etc to each brat. (Bang went our weeks ration.) After tea a Punch and Judy arrived, and that was followed by a conjurer, then a general melée and after God Save the King, hat-and-coat-finding for about an hour! But there were no casualties and *no* one was spotted blubbing – a miracle surely!

Not even perhaps the child who was in bed, and received his bag of sweets with a quick ideogram from Rex. Another had a leek painted on his bicycle.

For me in early years the approach to Christmas had been raised by our festival-loving mother to such a rapture of anticipation that the day sometimes ended in desolate, humiliating tears of disappointment. For Rex himself this final Christmas was also utterly unlike the ones of old, always kept in the family, self-sufficient and curiously ingrown as it was, with an equal reluctance to go out or ask in. Yet it now occurs to me that "the family" was not a term we ever used, nor did we visualize it much. It was there as a condition of being, and for Rex it was there to be looked after financially without question, sometimes with heaviness and always with a limiting effect on his career. In short,

though romantic, he was no rebel, as artists have been supposed to be since the start of the Romantic Movement. He did not want one value (art) to be destructive of another (loyalty) – or vice versa, of course. He wished all things to work together for good, and this involved some measure of renunciation. Certainly if art is all that matters, rebel-artists have the best of it.

So back to *Spectre* on which before Christmas he had "wasted a whole evening trying endless ideas". This is unexpected, because of all his main theatre productions it had the note of simple inevitability; but then the simple is not always the easy. For £75, he would provide the girl's bedroom, two costumes and a front cloth (Pls 18–20). When on 1 February the theatre curtain lifted to the Weber waltz, a sigh could be heard round the audience, faced by one enormous deep-pink rose, splashed with rain, and seen against blue sky and scattered stars beyond other roses; while in the centre of its convoluted petals could be discerned the spirit, still asleep. This rose was the most trenchant and deliberate affirmation he could make of a grace and a beauty that were viewed by intellectuals as pure escapism from actuality. And he grew it from the mud of the tank park.

So also was the set: a warm, moonlit room with wide-open, rose-fringed door, where the girl asleep was to dream she was awake, and dancing, dancing with the spirit of the rose she had been wearing at the ball. Incurably escapist as he seemed, how could he hope for a place among the serious critics and promoters of our civilization, weighed down as they were by understanding what a war really meant? In truth, he had not hoped for such a place.

He was allowed two days in London to see to the last touches, and to the lighting, no less important, and was there for the first night, and at a party afterwards with the Duchess of Kent, to whom presently he wrote that he had been "particularly dull and stupid" through tiredness, and shyness. "How useless shyness is, but if I haven't got rid of it by now, I suppose I never shall. This remote army life too, I think, tends to make one more of a Yahoo." There was no need to eschew a pinch of pathos:

> The cold is almost unendurable, but it is somehow laughable, to find oneself trundling over the English countryside with streaming eyes and nose and one's head stuck through a little trap door [sketch]. Today in church we had the 147th psalm.

> He casteth forth his ice like morsels:
> Who is able to abide his frost?

Certainly, I feel, not I, if it gets one degree colder, in spite of being clothed from neck to knee in chamois leather. Madam, when all this ghastly nightmare is eventually over ...

Would she remember her promise to share a model in his studio? But it could not now, he explained, be in the same studio. He drew a sketch of Fitzroy Street, with No. 20 taken out from the rest by a bomb. For as though by conscious intent it had been quite expunged, with all that cosiness of work, that anguish over Pempie. The Duchess replied gracefully, and having no special girl now to spend his time with, he asked if she would accompany him with two friends to his other production still running, *An Ideal Husband*, and to supper afterwards. But this was not achieved.

With his men now even farther from Welsh homes, he got Lady Juliet Duff to send twenty books, which he thought quite excellent except perhaps a prosy Fenimore Cooper, since some guardsmen "can only read very slowly, one word at a time – but even that might be tackled", if the winter got worse. And it did; with constant exercises on the moors and wolds, to harden them for battle. When Mrs Chadwick and her neighbours heard the massed rumble of the tanks far off, they stoked up for hot water. "Mr Whistler used to come in frozen, saying, 'I have been standing up for the last two miles thinking, Oh for a sight of my little church tower'."

The death of Lutyens that winter was a sadness to Rex, as to me, who had seen more of him. "I loved him", he wrote to Lady Emily, "but who did not who had the wonderful luck of being numbered among his friends? I treasure the thought of him in my heart with *delight*. I pray God to bless him, but if ever a man was and is blessed I feel sure it is he." (See p. 47.) He was wholly on Lutyens's side about the replanning of bombed London, telling Juliet Duff, who had sent him a letter in *The Times* by Lord Quickswood,

> No you *mustn't* agree. ... It is just this sloppy *highly sentimental* uneducated attitude (to the Arts – however highly cultured and informed he is on other things) that has been responsible for all our disgracefully hideous and unplanned cities. "At least often" he says, "the natural is more impressive than the self-conscious ... obvious ... commonplace ... appropriateness of a planned design." Surely (while never saying that this is impossible) the exact reverse is far truer. At *least* often, the appropriately planned is more beautiful, successful, impressive, than the natural. Anyway I put *my* shirt on my friend Sir Christopher's opinion, rather than upon my lord Quickswood's –

who cared so strongly that he wrote twice to *The Times*, asserting that the crowded chaos round St Paul's quite admirably reflected, not the callousness of competition, but the "wealth of Empire". And so the chance was lost of a ceremonial way right up from river to cathedral, when only one worthless commercial block stood ungutted between them.

Now Robert Donat wanted a single scene for a play which

> is quite appalling in *my* opinion. It is by a young writer and actor not known to me, Peter Ustinov, and he has written about something which clearly – to my mind – he knows *nothing* about ... an ancient county family in a "Stately Home" – as it were, Wilton. [*The Banbury Nose*] There is rather surprisingly a golf-course just outside the window and the old gentlemen play chess in their "pink" coats and riding boots, etc.

Edith would appreciate absurdities which would not have occurred in Chekhov. This went no further.

On leave, driving down the King's Road in Chelsea, he saw and hailed Osbert Sitwell, out of touch for years, and left the party he was with to join him. Together they strolled across the river to look at Battersea Old Church, while Osbert persuaded him to do the designs for a film of his Edwardian story, *A Place of One's Own*. "I hoped that this might mean – since it was the policy of the Government to release artists for such work – that he would be obliged to stay in England." Osbert's solicitude came five years too late. Did he seriously suppose that this could be achieved on the brink of liberating Europe, with the Guards in the forefront, for the filming of a ghost story? He may have.

Rex had strong views about the war, but did not dispute much with older or more knowledgeable friends. As an officer he had recently begged a bed in London from "Chips" Channon, a former client and an out-and-out appeaser of the kind he blamed vehemently for the war. Sitwell, defeatist from the first, by indulging lofty contempt for both Hitler and Churchill impartially, had arrived at virtual incomprehension of the issues involved. No doubt, if war had been funked in 1939, the later Forties would have found him still at Renishaw, morosely sipping brandy with Gauleiter Tom, while remembering the Jews they had liked.

Rex went round Scarborough, I think, with the film in mind, filling many pages of a sketchbook I possess with details of Victorian mansions. But nothing resulted, until agitated telegrams arrived, when he produced a number of evocative designs throughout a single night

Letter from Rex to Edith Olivier, 21 February 1944

without sleep, while his kindly fellow troop-commander, Richard Sawrey-Cookson, read Jane Austen aloud until daylight.

"I am established with my troop along a low wind-cropped thorn hedge." They had been out for eight days, sleeping rough, and were approaching the climax of "Eagle", which was itself the climax of all training, a mock battle involving the whole of VIII Corps, in rehearsal for France. In February the Wolds had lost their biblical and Palmerish beauty. "*Nothing* is lacking except physical danger, and possibly *that* would make one feel more warm. There is a howling wind from due north, rain and sleet." This to relieve feelings, and to tell Edith that some leave was due, and he must, positively, spend two days at the Daye House. For the first time he implored her to get rid, if she possibly could, of her perpetual war-guest, who always jarred, and never volunteered to be absent. She could not. However, this guest was at the cinema that Saturday, so the two old friends could share the fire in the Long Room for the last time, as it turned out.

He had chosen to be centred on the Guards Club for the greater part of leave. A few days later Hester Sassoon paid Edith a visit, as if on purpose to hint that she was having an affair with Rex, but adding that he did not wish to play the part of co-respondent in divorce. This was to reassure Edith, who was inclined anyway to disbelieve her innuendo. "Oh dear, how little I know about people!", she reflected sadly – who had once read his heart as no one else could. But Rex, back in the battalion, would neither confirm nor deny. Hester would have answered several of his requirements as he ranged about among the fair, conscious that he might perhaps deserve them now, and of time running out.

To review the Guards Armoured Division surging past, came at different times, General Marshall, Churchill, the King and Queen, then Field-Marshal Montgomery, who had originally opposed the putting of the Guards into armour as out of character, but was now, as commander of the land forces for invasion, infecting every man lined up on Driffield aerodrome with his total and convincing confidence.

# · XXXI ·

THEY WERE LEAVING for the south in their Cromwell tanks – of thirty tons, but still capable of fifty miles an hour and more – to three of which, allotted the letter o, Rex had given the names Olympus, Orion and Orpheus; and by chance they arrived in the village of Weston, where Sacheverell Sitwell saw a slim moustached officer wave at him, and throw out, it is said, this message: "Would to God I could stop this mad rush round England and see you. Passing through in my Juggernaut ('bigger and better'). Written on the move." The words in single quotes referred to what Sachie had said about Rex's sequence of cars. Luckily the battalion harboured not far off, and Rex took his CO, Jim Windsor Lewis, for a meal. So they arrived at their destination, which proved to be Brighton, no bad one for Rex. The squadron mess was at 39 Preston Park Avenue, where the room they were to have for an anteroom showed a dingy brown wallpaper, not endurable for long.

During a recent leave he had discussed an important project with John Gielgud, who afterwards wrote of "two memorable evenings with him while he filled a sketchbook with little vignettes and projects, creating and discarding by the hour an unending flow of witty and beautiful ideas". These were for *A Midsummer Night's Dream*, a play that to Rex meant falling for Pempie in a twilight near Oxford; and he had never before been asked to do a whole Shakespeare production – only the costumes for *The Tempest*. Hence his enthusiasm. The "fixed woodland" of convention, he told Gielgud, was surely boring. He would use modern theatre techniques to bring great fans of leaves dipping across the stage from either side, to cross one another for a few seconds, and then sweep back, revealing quite a different scene. It would be, he said, like walking through a beech wood, branches parting before you and closing after. As for the architecture: "Classical – not bogus Baroque classic, but à la Claude and Poussin. Or a little earlier still and plum contemporary with author William himself." And he could have done it, but for Sitwell's now-long-forgotten film.

Arrived on the south coast, he felt obliged to write to Hugh Beaumont, the promoter.

> John will tell you that I never felt at all certain – I only *hoped* that I would be able to build up a collection of designs during these spring and summer months for him to work on. You will understand that I am not free to discuss my present engagements or what is likely to happen to me and when. I can definitely say that you must count me out for some time to come – unless the very unforeseen occurs.

The disappointment was as real to him as to them. "Nothing I would have loved more to do for the theatre, and feel I would have done nothing else so well. So if you haven't done it by the time I am free again, remember." Although he could not foresee it, there would still in fact have been ample time to do a memorable *Dream* in the six idle weeks he spent in Brighton.

With a free twenty-four hours he called his mother to London for a busy, contenting day of just the old kind – lunch, a cinema, tea and shopping in Selfridge's, then sitting in the sunlight in the park before seeing her off at Paddington; events of the commonplace kind that seem most of all to hurt the memory in recollection. "The best job done was the purchasing of your new green hat! Which I thought charming and very becoming to you. I certainly advise you to get a *well cut* medium-to-dark grey suit and that hat would look very pretty with it." He had given her power of attorney, but hoped that in official documents, "you will not any more refer to me as 'Rex J. Whistler', as though I was some Yankee." (He had forgotten it was once his signature.) "What is the matter with 'John'?" He was trying to find the small Bible she wanted to give him. "It is *most* lovely here, [the weather, that is – more especially after Exercise "Eagle"], and we are all very well and gay."

So they seemed to Sussex friends. Lady Cynthia Asquith had not seen him since the days of peace, and could not picture him in uniform, but there he was in bronzed and supple health, arriving with his young friend, Bobby Cleveland-Stevens, and not wearing it "with a difference". More mature certainly, but still himself. He talked little of the war, except to say that a "blood bath", in politician's jargon, was surely a repellent image. It was a superlative spring evening at Sullington, under the bright-and-dark polish of the Downs, and they could not take themselves indoors until the sun had long set. He observed everything, was full of practical suggestions for felling or planting, when peace returned. "As I noticed the peculiar intentness of his gaze

it struck me with a pang he was consciously memorizing what he saw, and the words, 'Eyes, look your last', stabbed into my mind." Late at night he asked for "The Lotus Eaters" and "The Scholar Gipsy", and while they were being read, two pages of the visitors' book received the contents of the old cornucopia that always flowed fresh for a thank-you: shells, sheaves, garlands, birds, columns. The two soldiers left early next morning. "I don't know that I'm exactly looking for-ward to the blood bath", he said, "but at least it will be *going abroad*!"

Another Sussex friend, Imogen Gage whose home was at Firle, wrote to me, "it may appear that I regarded myself as nearer to Rex than perhaps I was. I always knew and accepted that I was fonder of him than he was of me." He had written to her, "What I most need is peace in my heart at this time", the peace of requited love which he had never more than glimpsed. Now the girl in America was no more remote in body than Caroline in spirit. In chance talk with Cecil Beaton, and having no reason any longer to fear that gossiping tongue, he was matter-of-fact about Caroline. "No hope. She's a lesbian, and that's that." He was half-understood to be on his way to some other liaison.

It was after an evening at Firle, lost in reminiscences of earlier visits, that he forced himself out of a chair, exclaiming, "I had *forgotten* about the war!" And it was to Moggy Gage that he wrote about a final party "filled with real laughter and affection and friendship, yet, for me, somehow grief-stricken". In these last days she was in truth the nearest.

"When *is* this war going to start!" Rex was writing to his mother – two days before it did. "It had better get going soon or I shall be broke. Champagne suppers and a great deal of gaiety are the order here." He wrote to her frequently now, and always in a vein to re-assure, if he could, though not evasive.

The vast Armadas that sail over our heads are really the most *beautiful* sight, often shining like constellations when the sun catches them. Their deep-throated, awe-inspiring roar continues inexorably hour after hour – not loud, they usually cross us at a great height – but filling the whole sky with echoing sound as though they were beneath a great dome.

He described in great detail, for her to identify and remember, a white rose on a neighbouring house which he wanted to see all over the garden front in Salisbury.

A military policeman took two guardsmen back to their billets, not

wanting to charge them with drunkenness so near to the event. He was visited next day by their officer with a drawing, as a token of thanks. There was little for them all to do, except waterproof the tanks for what might prove to be total immersion before they struggled up the sand into France.

A friend in the regiment, Francis Portal, lunched in the squadron mess when the afternoon set in for rain. Rex said, "Shall we decorate the sitting-room?" Its dullness had been a weight on his spirits from the beginning, not much relieved by the jagged hole in the window that took everyone in, as once long ago in the sanatorium at Hailey-bury. Also he wanted to paint a regimental farewell to Brighton, even though Brighton would be none the wiser. It was a little late, but there was no sense of urgency. He claimed he was the fastest painter going, would take on any other, and guarantee to win. Painted direct on the wallpaper in only a few hours, with pauses, the main decoration to emerge was soon inviting the question, who would be sued, the War Office, the regiment, or Rex himself? For it was not likely to appeal to the owner, and certainly nobody foresaw an actual dispute over owner-ship. (See note.) It showed, very large, a corpulent "Prinny" as Cupid, nude but for the Garter Ribbon and the Star that lolled on his right buttock – about to arouse from sleep a seductive Psyche, nude too, but with a wispier ribbon, bearing the word "Brighthelmstone". His lifted finger warned against interruption, and wherever the be-holder went in the room a lewd and sidelong glance would follow him, though on the plump calf the garter said, "*Honi soit ...*" At last the title – "Allegory. HRH The Prince Regent awakening the Spirit of Brighton." Warm as a Titian in its crimson, blue and flesh colour, it held satirical and classical in balance, being funny and beautiful at once (Pl 42). While this progressed, the rest of the room was under-taken: a plaque of George IV over the chimneypiece; the regimental leek, very bright and large, elsewhere; then chinoiserie trees all round, skilfully redeeming the villa-wallpaper frieze of fruit and flowers. The result was a painted room, signed and carefully dated, "June 5th-7th, 1944" – as if to say, done while the world held its breath over D Day. For this was a second quiet message to posterity, recollecting the first, of five summers before, the one not yet discovered at Mottisfont: "I was painting this Ermine curtain when. ..."

Soon the room brought misgivings. Yet he did not deprecate a visit from Moggy. Knowing she would make one anyway, he wanted it to be as soon as possible; for he feared that the next unit might turn the indelicate into the crudely indecent; and then she would bring her mother, Lady Desborough, who would suppose that he had played a

practical joke in quite deplorable taste, or at least would think him largely responsible for it.

Moggy did go there quickly after his departure, even forcing a window, and hoping to be alone with his imagination: only to find "two horrid little men looking down over the banisters", amused by her zeal, and leeringly ready to conduct her. "To my dismay they showed me darling Rex's rather horrifying picture, for which I was totally unprepared" – and probably not least by a resemblance to herself in the features of that tempting girl, or "that enormous nymph", as she described her. However, she forgave him, in all the circumstances.

He was resolved and ready, though inwardly aghast and doubtful of his value, like many another peace-hungry soldier. "He said he was a useless officer, even a menace to the men he commanded, but we came to the conclusion he was just as good as the average civilian turned soldier." Better, said others; for the devotion of his men and the support of outstanding NCO's produced a troop of high efficiency. "He wasn't frightened of being killed, but was terrified of losing his right hand or sight."

Rex and I had been corresponding, as we hardly ever did, and first about the unplanned pregnancy which lost Jill an ideal part in a play. Sympathizing, he thought the gain outweighed the loss. "I *used* to think once that being poor made it unwise to have a family." The poverty that had ruled out marriage to Pempie would have seemed opulence to us, who never had any money at all unearned, and very little earned. "I did love him so", he went on to say of Simon. "And then, remember, you have got to have the children I ought to have had, and to produce my share of little Whistlers, which I shall love, just as much as if they were my own." Finally, he sent me the drawing he had made, unknown to me, of our father lying dead. "I took about an hour over it, and it was *very* accurate. The profile was like that. I meant it for Mother but never felt I dared give it to her. If you feel she might now care for it, will you offer it to her some time? If not, please keep it to yourself if you would like it." Old faces look younger in death, and somehow this recalled to me the oddly eloquent letters my father continued to write to his girl, long after he had ceased to talk to her like that. Rex was passing to me a decision that until now he would have kept for himself. I knew I could not show the portrait.

All this brought an indication of farewell, and moved me. Bearing in mind that I expected to be presently abroad myself and we might never meet again, I wrote to him as I had never written yet, and hardly spoken, laying fully bare my love for him and gratitude, and trying to

explain that I knew I had always seemed cold, or at best reserved, and how this came about far back in childhood because our personalities were so alike and our characters and gifts so very unequal – then, knowing his delight in children and his wish for a good marriage, and reminding him how suddenly and how very easily marrying had come to us, I asked why he had to rule it out for ever, even now.

Silence followed. I did not mind. What ought in a lifetime once to be said, had been said. But I felt after a month or so that I might have put it too emotionally and left him with a weight on his conscience, so I wrote a brief note, affectionately saying that of course no answer was needed. He replied,

> I am really miserable about not having answered your loving and generous letter before now. If ever there was a letter which *had* to have a prompt response.... Your second brief note gave me agony as I knew you would be bound to feel that and would not have felt it for a moment if you had been answered in the way I wished to answer, and indeed in the way I *did* respond in my heart immediately.

This was the language he had used for twenty years about a mere social misdemeanour. I knew well that he now meant it; but I have a sense that in general he was made too uneasy by his fine perceptions, his subtle registering of mental intercourse, to give spontaneously the simple answer that is sometimes the right one.

> You hoped I would not and I did not feel any embarrassment at anything you wrote about the close bonds of the love we have for each other and strange similarity of feeling and sensibility. (The more I think of it and of other brothers – a *very* strange similarity.) I did feel a qualm of embarrassment at your unfair and alas only too inaccurate comparision of some aspects of your character and mine – because I knew at once you were wrong, just as one feels a certain embarrassment when some of one's work is praised far beyond what one knows to be due. Mock modesty does not enter into this (though too often into much of one's life!) There cannot be any mock modesty in the intimate secrecy of one's own heart, can there? One knows only too well what praise is undeserved and one cannot fool one's own sternly uncorruptible heart. But oh what pleasure one can feel (though slightly ashamed of feeling it) from unjust praise from someone one loves.
>
> I am sorry if my last letter had a gloomy world-and-life renouncing tone – I cannot remember what I wrote. I am certainly not resolved against marriage, and *might* of course marry, but frankly

I think now that I shall probably never do so. It is rather late in the day, and you know the person whom I have loved for many years now, I know very well now I should never make happy. However, who knows?

"News coming in all day," Edith wrote in her journal on 7 June, imagining him in the assault, "O Rex." But he was still at Brighton with his paints, where the pilotless aircraft, the "doodlebugs", were becoming a nuisance. It was not for ten days after D Day that he sent Edith the coded message he had devised. "Tomorrow I dine with Charlie. . . . Goodbye my sweet darling Edith, and may God grant that I shall have the great joy of seeing you again before a great while." And the same to his mother, but not with a prayer so poignantly explicit. However, as all was going well in France according to reports, she was now more buoyant in her constant exchanges with Edith. Again both supposed the Welsh Guards to be across, when in fact rough seas kept them waiting near the Hamble River "shut up in a frightful camp like German prisoners for a *fortnight*", he afterwards wrote, "with no contact with the outside world." On the last two nights this was relaxed, their Brigadier illegally giving them permission to visit the Old Ship Club at Bosham.

Like the joke-ending of some Haydn symphony, Rex's last murals up north, as the audience thought, were succeeded by his very last down south, as every one was sure, and by his absolutely last, done on two highly jovial nights at the Old Ship. Taking a red and blue pencil from Mrs Trevor Moorhouse's desk, and his own stick of charcoal, he first drew a gross Bacchus or Silenus seated on a barrel, adding, on suggestions from the crowd, a glass of champagne and the Club's name on a ribbon. The next night he drew a naked girl – agreed to tie her to a stake – then put in a guardsman in comic-strip style to ogle her. Next day they embarked – disembarked – and were back that night, when he was asked to draw a fawn, but misunderstood and drew a charming boy-satyr, offering her a bunch of grapes. On the third night – if there was one – he was to do the third wall. But at last they had sailed.

# ·XXXII·

THROUGHOUT DARKNESS they crossed on a sea that had a good deal of swell from the departing storm, one complete squadron to a landing craft, and at first light Rex could gaze at "abroad" again, the low factual skyline of a piece already freed, now sixty miles long if only eighteen miles deep, it was said. Ahead was evidence of the greatest amphibious invasion ever launched, ships, wrecks, a littered shore, and the balloons above them. Disembarking near Arromanches was expeditious, No. 3 Squadron being quickest.

They mounted the bulldozed ramps to the marshalling area, where vehicles and men appeared to be milling in the utmost confusion, and were presently directed to an orchard two miles to the east of Bayeux, near the River Seulles – approached through a flowering countryside, surprisingly undamaged. In this neighbourhood the whole of the division would be bivouacked for a fortnight, to the sombre sound of Allied bombardments farther south, themselves unengaged. All would indeed have been different had the Germans been in strength hereabouts, but history's biggest martial secret had been kept, as we know, and Hitler still supposed that the main attack would be delivered on the Pas de Calais. One of Rex's young friends in another battalion of the Guards Division had known the truth for three months, having had it from the lips of a very high authority, Montgomery himself. He was on leave in March when Monty, a close friend of his father's, revealed the whole plan in outline: the deception up the Channel, the landing points in Normandy, the British to draw the enemy around Caen and break east, the Americans to deliver the right hook. Justifiable trust, in this instance. But only extend the human chain along which trust could have been placed with equal confidence and the risk incurred by that initial act of vanity can be gauged.

So, for the time being, life under the apple trees was a curious mixture of the strange and the familiar, and for hours at a time not unenjoyable. The passion for sight-seeing was impossible to slake, and

281

four days after landing on French soil, which was also four days after
Cherbourg fell to the Americans, Rex was on the way north in Mickey
Renshaw's jeep, ninety miles or more, seeking wine and spirits for the
mess along the route, and finding the remains of the city boarded up
and deserted, with still some firing in the western suburbs. Of about
Rex's age or a little younger, Major Renshaw was Deputy Assistant
Provost Marshal for the Guards Armoured Division, which is to say,
second-in-command of its military police, and thus equipped with his
own vehicle. After a sunny picnic by the river they had an impulse to
inspect the harbour, all its basins mined and full of rubble. Mickey
told Rex to puff himself up like a general, as, sounding a peremptory
horn, they swept in past the huge and menacing No Entry signs, Rex
nonchalantly answering the coloured sentries' salute; and so spent a
happy, irresponsible hour in underground passages, ammunition
dumps, gun sites, barrack rooms – opening drawers, looting pieces of
German equipment, in fact doing "everything we had been lectured,
taught and trained not to do", as Renshaw afterwards admitted; then
loaded the jeep and went to sleep in the sun; and later examined an
underground fort somewhere else, to similar effect. Had they been put
under close arrest, the chances are that the issue would not have
achieved international importance, and neither of them might have
suffered more than a stiff reprimand on the eve of battle; a likelier
chance was being blown to pieces by an overlooked booby trap. On
the way back, buying Calvados from likely farms, they were welcomed
by a whole family as the first Englishmen it had seen. There was a
giving of chocolate and cigarettes, and a toasting of France and Eng-
land in eau-de-vie, till Rex noticed one lady who seemed to be rather
out of it. On his courteous inquiry she flung her arms round his neck
and burst into sobs. It was quite a while before he could disengage
from the embrace and take it in that her son had been killed by a stray
shell the day before. "Never again", he vowed, while waving goodbye
from the jeep, "will I question why anyone isn't looking cheerful!"
The last outing with Mickey would be to an exquisite château where
the two officers were allowed to see everything, and then surprised the
gentleman-farmer by asking if he would sell it to them.

"Till now nothing much has happened", he told Edith after a fort-
night. "Only the continuous thunder of the guns has disturbed our
overgrown countryside where we lie hidden." In this area war had
passed over the country people too quickly to stun them, and they
were still at work and more than well disposed. Also there were an-
cient copper baths full of glorious hot water, in cubicles all round a
courtyard in Bayeux, which town had been spared in its centre by the

bombers for the sake of the cathedral. Rex and a friend or two went to dine there occasionally. He took "Shirley" to see the cathedral and explained the phases of the architecture; then took him to a lace-making factory and contrived to talk about the lace with Madame. For an hour or two the peace and beauty of a cathedral town en-thralled him, as they always had, and now especially for the French-ness, the foreignness recovered after years, and he showed great re-luctance to return to the war. To friends he seemed perhaps quieter than before, less quick to cause laughter, and less ready to paint or make sketches on demand. But then he set up a canvas in the orchard and began a war picture which has never come to light, a Gothic cathedral rising stark above a blaze of burning houses.

With the confidence of his years and status he soon did what no one else in the battalion had yet thought of: he took his troop, all fifteen, on a truck-tour of Bayeux and the country round about, and especially to view the scenes of tank action, and so prepare themselves a little for what lay ahead. Quite suddenly they were out of tranquillity and into devastation – savaged, eyeless villages, wrecked trees, and the nauseating sweet stink of rotting animals in a landscape once full of livestock. They passed a number of shattered Cromwells assembled in a park; then beside a road, and on its own, a knocked-out enemy Panther tank. They stopped in curiosity, and climbed up to inspect.

Inside they were startled to find the driver and co-driver, still sitting there regardless and overlooked, crouching down in their seats, but reduced by fire to mere bone-structure without offensive smell, their skulls thin as egg-shells and brittle as parchment. For a first illustration it was vivid. "When we got back", says Sergeant Sherlock, "we sat down and he talked for ages on the awful destruction. I could see he was deeply affected."

Officers' letters are not censored, but censoring the men's was now the task of the subalterns, accounting for each other's troops, not their own; and in the last snapshot to be taken of him (cameras were forbidden), Rex is seen in a row of them on sunlit grass, among the bivouacs tied to tanks, and the drying clothes, wearing the formal cap he much preferred to the beret, and the wellingtons that were trimmer and less bother than laced boots, for feet never sweaty (Pl. 10). Among companions lolling unselfconsciously, and fifteen years or so his junior, he sits erect, consciously the officer, with the moustache he might by now have given up, but chose to keep. Censoring was an uncongenial task, so that great care had to be taken not to show the least amuse-ment if the wording was funny, as at times it was. On one occasion loud laughter did break out because Rex found he had been given a

letter of his own by mistake, and began expostulating at the indiscretions it contained. The men overheard and took offence, and the squadron commander's driver complained. When assured of the truth he seemed not appeased – not wholly believing it. If they wrote in Welsh there could be no censoring. But few could write Welsh.

This passably comfortable existence resulted of course from a sky kept virtually spotless of enemy planes. Some shelling and mortaring occurred here and there, and the Welsh Guards Infantry lost a number by that means. The weather now being "hellish", Rex wrote, it was "on some days impossible to keep anything dry, in our little bivouacs, which are only waterproof sheets fixed up over holes dug in the ground. – I'm writing outside my bivvy in an old overgrown apple orchard", he told Moggy Gage. "Today has been silent but the noise of the guns most of the time is fantastic, the rapidity of the fire quite unbelievable if one had not heard it: from a fast tatoo at kettle drum speed it finally reaches one deafening *continuous* roll of explosions."

Apart from being discreetly ornamental, Rex's own tank was unique, since only he at first was allowed to travel with some outside luggage – a metal box wrapped in a groundsheet just behind the turret, holding paints and small canvases, etc: he had had it made to measure by the village blacksmith at Codford. Now that he was appointed battalion burial officer, as befitting, no doubt, the oldest and most thoughtful subaltern, Olympus would have to carry as well about twenty white crosses; and "the Dauphin" was not happy. "Oh, you don't want to bother about that!", said Rex, with little regard for superstition. "If anything happens to anybody we just stick one in and I paint the name on." His tank was therefore well-provided for obsequies, since he had in his kit the prayer book given to him by his mother that spring, and marked by her at the twenty-third psalm, "October 1940", for his father's death. After asking Lewis Sherlock's opinion, that psalm was what Rex decided to read over the grave. Its few words are as likely to start tears as anything ever written: "Though I walk through the valley of the shadow of death ... thy loving-kindness and mercy shall follow me all the days of my life ...."

On a stroll one evening, glad to get away from all the metal in the orchard, he passed with Mickey Renshaw the grave of an airman recently shot down, and said that he wanted to be left just so, where he was killed, not taken to an enormous cemetery. With his old blend of the romantic and self-mocking, he enlarged on this: it would mean so much more to anyone who visited the grave, not that anyone would, to find a beret with its tarnished leek hanging from a little cross, just where it had happened; to see the same bit of landscape, and perhaps

have the same thoughts about it. The two friends exchanged a promise to visit each other's grave. He supposed one would feel lonely in the process of dying. Vaguely in his mind, I think, there was a voice-from-the-grave kind of poem – by Christina Rossetti or Hardy or Poe or de la Mare – a poem he could not create himself but would rather have created than a picture. Then one evening, on his way back in good spirits from supper at the Lion d'Or with a friend, he noticed the white wall of a ruined chapel, found in his pocket the stick of charcoal and the red and blue pencils from the Old Ship Club, and did a quick Madonna and Child. The mural symphony had now really ended, on a faint minor chord that no audience ever noticed.

Why Rex found himself where he did was primarily a matter of global geography. America lying to the west of Britain, her ground forces had landed in France on the right, to be supplied in due course through the Atlantic ports, while the British on the left would be supplied across the Channel, and the lines would not cross. But in the area chosen for invasion the only good tank country was on the ex-treme left, or east bank of the River Orne. Hence the capture of a bridgehead there by the British Airborne on D Day, the tenacious holding on to it, and the building of three bridges behind a minefield by the engineers. It was obvious enough to Rommel that the attack would break from here, wheeling south at once down a corridor of open fields just east of Caen, because a few miles east again there was a maze of watercourses, impassable by tanks. To meet it, he had posted seven of his nine Panzer divisions.

Now it was to be made, by three British armoured divisions, the 7th who had fought already in North Africa, and the Guards and the 11th who had not, though the latter had already been blooded. To what extent Montgomery believed that the cencentrated fire power of these three divisions, attacking on a one-division front with overwhelming support from air and sea, could break right through the enemy posi-tions and so open the way at once to the Seine and Paris, is unknown. Obviously he hoped so, while careful not to promise so much. What he had announced in St Paul's School on 15 May, to the King, Chur-chill, Cabinet and Eisenhower, was that having taken Caen he intended "to penetrate quickly and deeply into enemy territory". This plan would now be put into effect, with the important qualification that Caen had not been taken. And that same afternoon before the climax of the battle had been reached he would give the waiting world, most unwisely, the exhilarating words "broken through", "a complete suc-cess".

"The trial of my faith has come", my mother wrote to Edith. There

was still that uneasy feeling that faith for her did not mean accepting the worst that could happen as God's will, but "moving mountains", to prevent it happening at all. Well, Rex had done the little that he could in that context. Now it was 16 July, and he was writing to her, partly about a brief visit I had paid to the Lake District, under canvas, with a tramp in glorious light along Striding Edge to the top of Helvellyn – this on Midsummer Day, his own birthday. Once it had been he who escaped to the sun and I who was hemmed in, but this reversal would not have occurred to him. However, the contrast in our lots, for the moment anyway, can only have been pointed. Still the old sweet fantasy-habit was kept up, to bring cheer to her, if with a sense of irony by now.

> Wouldn't it be lovely if he and Jill could have a cottage there for him to work in. – Then you and I could sometimes go and stay with them!
> That *idiot* Parker. Will you ask him what the Hell he means by questioning the Power of Attorney. It was precisely for this purpose that I had it made out. I am *sure* the Old Pickering lawyer cannot have bogged it.
> Darling we seem at last to be on the verge of battle. Please do not worry if you do not hear from me for some time now. It may not be possible for a bit.... Much, much love my darling, I am always thinking of you.
> I enclose a bit of mistletoe from the tree above my bivvy!

At the same time he wrote another last letter to someone who had always, in some senses, matched her in importance, one who was his dearest, longest-lasting and most helpful friend; and here he gave pleasure by putting into words a request that would have been too poignant for his mother – while certainly not needing to be asked of either woman:

> Now my darling we are on the very verge of battle from what I understand. I know you will pray for me and for my particular little troop too, and it will be a comfort to me to think you are doing so.... It may be a long period now – I cannot tell. God bless you darling Edith my fondest love,

> Rex

To her, too, the last words of valediction were written round a sprig of mistletoe, picked from just above him where he sat. A third went to Moggy Gage, but none to Caroline. The three "Y"s of green, unfaded to this day, remain threaded through the tops of those letters.

Later that morning, a lovely summer one at last, General Adair gathered all his officers together and gave them Monty's message, in a confident speech that issued from the heart and deeply moved them, as they faced their first action together. "Goodwood" was about to begin. They would cross the river at dawn with the two other armoured divisions, and swing south. Airfields would be established on the high ground south-east of the city. Driving on towards Falaise they would presently link up with the Americans coming in from the west and the break out into eastern France would be achieved.

At dusk on 17 July Francis Portal talked to Rex while his tanks were revving up for the start. Forty miles away, Rommel had just been desperately wounded in a staff car – the assassination of Hitler was in hand – encouraging news, had it reached them. At parting, Portal said cheerfully, "So we'll probably meet tomorrow evening!" Rex was flushed and unusually quiet, and "gave a wistful answer: 'I hope so!'" Portal felt afterwards there was a sense of premonition, though it might have been merely the effect of anxiety.

By midnight the battalion was in column with engines ticking over, despatch riders astride their machines, opening and closing their throttles in concert. By one they were on the move, swaying out of a field into narrow lanes between enveloping hedges, well marked by Michael Renshaw's police.

Every road junction we came to was beautifully signposted with illuminated arrows and boards, lit by electric torches with directions for "tracks" and "wheels" in black lettering. It was not possible to go wrong, and the heat of the engine, combined with the hypnotic winking of the next vehicle's convoy-light, soon sent one into a fitful doze; there is no room for excitement in the coma induced by a night drive in convoy.

It was a hot night, and at the frequent halts some people got out, to stretch, not knowing or caring where they were, maps not being needed. After sixteen miles, when the hedges began to grow slightly distinct, they came to a stop on a kind of long ridge: below which was the river.

The sky was clear and the air cool and very still. It was going to be hot later on. One by one the vehicles shut off their engines. Apart from the drone of a motor cycle diminishing as it passed up the column, and the snoring and coughs of the men in vehicles, complete silence settled on us.

High in the sky and away to our left a faint and steady hum caught our attention and grew into an insistent throbbing roar.

It was 5 a.m. and they were coming over from England, the first of two thousand, and first the Lancasters, then the Flying Fortresses, flying in revue formation with a terrible dignity, unloading, wheeling, glassing the sun for an instant where it melted the horizon, all as if indifferent to the sudden black balls that appeared among them; though one and then another would slip out and sidle down like a leaf into its dreadful autumn; then it was the fighter-bombers taking off from an airstrip close beside the column; and then the Navy's guns and the artillery. Everyone was out of his vehicle long since, gazing and listening in simple awe; for the whole sky had been full, and now the earth to southward was hidden by a rising mist of dust. At once jaded and exhilarated, Rex watched it with a friend, and is reported to have been "in great spirits". It seemed to everyone from the GOC downwards that nobody could stay alive in the obliterated landscape they now had to cross, towards what the map revealed as low, wooded hills, far off. "Someone produced something to eat, and since the sun was now well up in the sky we dragged our valises out and lay down to sleep on the edge of a cornfield."

A perfect summer's day was opening for "Goodwood" when the order came to move again; and wireless silence broke along the column. The leading tanks began their slow descent towards the Orne – between innumerable gliders that had brought the Airborne – who had reinforced the parachutists – who had captured it on D Day. Since then, two miles or so from the sea, three Bailey bridges had been built across canal and river by the Engineers, one each for an armoured division, and to these they gradually descended. On the other side only a few rough single-file tracks across the dense minefield could be cleared; thus there were many halts, and halts reflected backwards were magnified. Air Marshal Coningham and his staff were getting restive. They thought rightly that the huge advantage they had gained was being frittered away, and they wanted those new airfields south and east of Caen, which had been a priority of Monty's. Top-level impatience was reflected right down to a point by the roadside where a cross staff officer, pulling up his scout car, found Rex and the squadron commander playing piquet in the grass, under orders not to stir until their petrol tanks had been replenished. "You're holding up the whole war!", he shouted, and sped on. Obviously it occurred to many that the enemy were getting ample time to recover or to bring in reinforcements. Over their girder bridge at last, it was nose to tail along the carefully taped track, and with military policemen all the way, waving down or waving on; there was no sense of danger whatever in the fog of petrol fumes and dust.

The division was conscious of the fact that the 7th and 11th had both seen action by now, and that they had not. There was a tendency to compensate by showing some indifference to danger. One officer would imperturbably keep his head above the turret and be killed by a shell-burst; one, wandering at night, was shot dead by a British sentry; one strolled through a clearly-marked minefield. Rex and Mickey Renshaw, visiting a local airfield (to have some Camembert flown home), had sat sipping whisky with a fine sense of composure – after their hosts had plunged under tables, or vanished with weapons, bringing down the raider. Especially on this sunlit morning war seemed unreal. It was like cars crawling back to London from the coast on a summer Sunday, stationary as far as one could see, then shrugging forward; it was like one of those contradictory dreams where somehow the contradiction seems to be the point: a scenario altogether too familiar to be so intrinsically different.

Such a concentration of armour, supremely well protected from above, had not been seen before in action, nor is likely to be seen again. Then, suddenly as it seemed, this evaporated, and you were out into wide country, twelve tanks moving southward in line abreast, and now, as they opened out, with a distinct sense of loneliness, and perhaps with only two of them still visible, and not always them, without turning the turret. A certain sense of unreality was anyway endemic in a vehicle cramped like a spacecraft and detached from the scene outside – into which it was refreshing to debouch with head-phones off, when offered any excuse, and to run a comb through your hair, Thermopylaewise. On the move the commander was close to his companions and yet isolated always behind headphones by sheer noise, which in the end could damage hearing, communicating only on the intercom; or with his other tanks on one crackling radio channel; or with the squadron on another. Once out on the ground you could only climb up and yell. Since the commander had to be out first himself, from his place in the turret, it seems strange that no long lead to his radio was provided; and this was something the Grenadiers improvised later on.

The 11th and some units of the Guards had advanced three miles towards Cagny and run into a strong anti-tank screen, which produced at one point the dire spectacle of nine Grenadier Shermans burning together. But this was only smoke in the distance, and well ahead of No. 3 Squadron, whose lighter and quicker-moving Cromwells had been given the job of supporting Infantry in mopping up resistance on the flanks, if any still survived. As deployed, Rex's No. 15 Troop was on the right of his squadron with the troops of his three friends, Ward,

Mildmay and Cleveland-Stevens, lined up to his left; and the first small village on his particular route would be Giberville, two miles out from the bridgehead. He had therefore been instructed to liaise and keep in radio-touch with the Canadian platoon commander of motorized infantry whose task was to examine the village on foot, ready to support him if need be: this was Rex's first task. Other villages would then receive the same attention on the way to Vimont, five miles or so farther on.

Cornfields succeeded one another, and through these they slowly ploughed, under a sun now misted over from the risen dust, but for this troop at least there were few signs of devastation. The bombardment, they knew, had been of a novel kind on such a scale, entirely anti-personnel, so as not to put craters in their path. Anyway the brunt of it perhaps had fallen farther south. Was anyone left alive in this shell-shocked countryside – or how many had returned in the long hours that followed? There was no opposition so far. But everyone was tense. At one moment two of Rex's friends exchanged shots, while their vision was impaired by bushes, but luckily to no effect.

It was early afternoon when the remains of Giberville came in sight, and the plan was for Rex's troop to pass closely on the left of the village, then wheel right, in readiness, if wanted, to bring fire to bear from the far end, and cut off an enemy retreat. His map board showed a single-line railway running straight across in front, where it emerged from the houses. On arrival it was found, at just this point, to lie between hedges in a cutting only six feet deep but with very steep sides, and with a tangle of telephone wires brought down along the opposite bank. It was crossable, and had probably given no trouble to the Shermans. He ordered his other two to open out slightly and cross to left and right, which they did. Between them Dolphin plunged into the hollow and bumped across the rails, revving up for the opposite ascent, failed to make it, slid back in a track-skid and halted, unable to move either way. Telling Sherlock to position himself where he could fire into the silent village if need be, and give cover, Rex was quickly out on the ground. The offside driving sprocket, he saw, was gripped by a scribble of wire.

When this happens there is nothing for it but to settle patiently with wire-cutters and pliers, extracting short piece after piece. In the enthusiasm of the moment he shouted for them all to dismount, and went to work with them, probably siting one man below the lip with the sten gun, but the feeling was that no enemy remained thereabouts. They toiled for several minutes, when suddenly from some point in the enigmatic village a burst of automatic fire, the first they had encoun-

tered, flashed against the side of the tank and removed all possibility of re-entering it. More followed in occasional bursts, but no movement otherwise of any kind. The two tanks in the open stayed put, bullet-proof, their commanders unaware of what had happened behind them – exempt, now, from being told. Rex's anxiety as time passed can be conceived. By a cruel chance he had lost control of his troop in his very first minutes under fire, and so endangered his crew – all three crews, perhaps, if an anti-tank gun was brought to bear: stationary vehicles were an invitation.

"I think one stuck to one's tank!" reflected one of his friends, in the light of later experience; but all agreed that they might well have done the same on that first afternoon, and in the absence so far of an enemy. Faced at that moment with a problem not specifically foreseen in training, Rex had in truth done the wrong thing; and the cruelty of chance lay in the timing. Earlier it would not have mattered. Later he would have known better, once action had been joined. Crossing the railway immediately to his left at that time, out of sight, was Philip Ward, now Major-General Sir Philip Ward, who has put things to me like this. If an instructor had posed the same problem to you exactly, you would have got no marks for saying you would evacuate the tank. And in practice two men were as many as could work on one sprocket simultaneously. Rex could have left gunner and wireless operator inside. By turning the turret they could have heard and seen his directions, called up the sergeant, and had fire from two tanks, or protective smoke, put down as required.

As it was, Sergeant Sherlock did not know exactly what had happened, and the tilted tank which he could watch remained silent to his questions. Aware now of fire from the ruined village, he did not like to move back without orders, risking two tanks close together, and stayed where he was for a long while, or for what only seemed to Rex a long while. Sense of time faded under concentration; but it was now about three o'clock. Behind the village was a piece of battered woodland, and now mortar fire began to come from that area and to get the range. It might not damage tanks themselves, but one better-placed bomb could wipe out a whole crew when dismounted. So Rex perceived. Peeping over the lip he tried with his observant eyes to pinpoint the source of the small arms fire. Through what must have seemed long minutes of willing Sherlock to put down fire himself or return within call, he came to think that he would not act without an order, or would not act quickly enough. It was up to himself.

Sherlock was about to change his position and perhaps drive back to investigate, when he saw Rex dive into the cutting, move along it

in dead ground to shorten the distance; then emerge and sprint out towards him over fifty or sixty yards of open ground, no doubt relying on his one-time speed as wing three-quarter, and feeling fit in these last years, though thirty-nine. Sherlock did not think he could make it, but Rex evidently took the machine-gunner by surprise. Climbing up on the lee-side, he told his sergeant what had happened, told him where the fire was coming from, told him to call the other tank, enter the village and "have a go at them"; he was returning to his crew. He jumped down, shouting, "Go ahead!"

It did not occur to either, in the stress of the moment, that it would take only seconds for Rex, first, to ride back to the cutting on the tank – on the blind side – as infantry often enough had ridden under training. That he might safely return on foot, in the way he came, would not have seemed likely, on reflection. But this did not need to be tested. As he jumped and reached the turf a mortar bomb fell near his feet and he was blown about ten feet up into the air. His neck had been broken.

In that instant after the violent flash Sherlock knew that Rex was dead, knew it from the way he was flung up and fell. The mortaring was now heavy, with possibly some shelling from the south. Quite deaf in his left ear, he moved away, while the news was given to his shocked crew on the intercom, and then extended to the other tank as he called it in, now himself troop commander; later to the squadron, and so to the battalion – news the more notable for being their first casualty of any kind. Together the two sergeants wheeled and shelled the little wood at the points Rex had indicated, evidently causing a withdrawal. Then they closed in and completed the order by machine-gunning the area that was pinning down his crew; all of which was a novel undertaking executed with zest. "We had the satisfaction of making a good kill, but I am afraid I was dazed and numb from the horrible incident."

In the local tranquillity that followed, he pulled out of the ruins and returned to Rex, searched him, took all his personal belongings, and carried him to the hedge next to the café; searched his body for wounds, but found none. He was quite unmarked. "It hurt me more than I can say to have to leave him, but I had to return to his crew and see how they were." They were safe, but they had no notion of what had happened during this long time since their officer vanished, telling them to keep their heads down and wait. Under cover of the guns they cleared the wire at last and got back into their tank, having been the best part of an hour in the cutting.

"Williams, your brother's servant, was almost distraught, and I had

to prevent him from going to have a final look at his master, as the sniping had started once again." At that moment a Canadian runner appeared – said about half a company of Germans had counter-attacked and his platoon was trapped. Sherlock took the troop back into the village. "I enjoyed that shelling, sir, and the Canadians got back out of it." Still, "it was our first day in action and can you imagine how awful it was for me?" By dusk Giberville was in our hands for good, with two hundred prisoners. Then orders came to rejoin the squadron who were moving forward to another strong-point.

Later that evening they were back in harbour, close by, and Sherlock sought out his squadron leader, who agreed with his request to take a scout car and bring Rex back for burial. "I could not rest until I knew he had been attended to." But in the interval a motor battalion had come up, and already he was a few feet down in an army blanket, anonymously buried – because he never wore his identity disk, perhaps with a romantic wish for anonymity – and buried, as it strangely happened, by a fellow-officer of mine in the Rifle Brigade, who had found him lying by the hedge in shirt sleeves and wellington boots, quite undisfigured and looking as though he were asleep. Not liking to leave him so, he had read a short service over him and had a crude cross made from boxwood, on which he had just written, "An un-known officer". So Lewis Sherlock never saw Rex's body again – no one in the regiment saw it – and had to be content with substituting his name in red wax pencil. And Rex did not get till later the more formal kind of cross which he carried on his tank. Idris Williams, asked by another officer if he would be his servant, replied with dignity that he could never be anyone else's servant.

Today the steep sides of that insignificant cutting can still be de-tected under the brambles and dense thorns that have long since choked it, and modern Caen, a big industrial city, has extended its haphazard factories almost to the edge of the village.

Rex had to be reburied, as he foresaw, with others in the regiment, but only two miles down the road and in a fairly small British cemetery at Banneville-la-Campagne, charmingly designed and now surrounded by tall trees, one of eighteen in Normandy. Where the other party lie, who were stopped by "a good kill" on his direction, is unknown. His very brief battle of a few minutes, after four years of training, was nothing more than a skirmish, and for the Welsh Guards the serious fighting began on the following day.

Now in temporary command of the troop, Sherlock understood the responsibility. On the first night he "could not sleep for thinking of

him", and years later could write, "I don't think I shall ever stop
thinking of it. Lieutenant Whistler was in a class of his own as far as
his troop was concerned.... He was a friend to us, a splendid man,
and no-one could replace him." None the less, someone had to do that
difficult thing, a young subaltern who had hardly got the feel of it
when his tank received a "panzerfaust" which killed both him and
Corporal Jones, Rex's wireless operator, and burnt or injured the other
three. It does not follow that it would have been just there at just that
moment with Rex in command, but on the whole, if he could have
had a preview, he might have thought himself in luck. "Another lucky
person", he had written many years before, at news of a friend's
sudden death in his early forties, and this rational view he retained.
Thus it came about that the process of dying was not lonely for him
after all, because he had no experience of dying; and though we all
cling to life instinctively, I have shown that to him it had lost, for the
time being, some of its savour, its primal enchantment.

It is now history that for lack of indispensable support from the
infantry, left behind through bad planning and congestion in the
bridgehead, "Goodwood" came to a halt with the loss of four hundred
tanks, thirty-six per cent of British armour in France, and over five
thousand casualties. We had only the three armoured divisions, none
to follow, and though tanks were replaceable trained crews were not,
and they could not be expended as a battering ram. They had broken
out, but they had not broken through. So, leaving troops to hold the
ground, Montgomery withdrew the three divisions by night, the Welsh
Guards to the very orchards they had left, east of Bayeux; from where
they were soon rolling forward again in unison with the American
breakout. One object had been achieved. During the first days that
followed seven enemy armoured divisions out of nine, depleted but the
finest troops they had, took no part while awaiting a resumption of
"Goodwood" that was not intended.

On the war maps the line is long that stretches from the Calvados
coast to Luneburg Heath and 5 May 1945. Also shown is a short line
that forms a quadrant round Caen. Roughly where it stops the two
thousand headstones at Banneville-la-Campagne stand in ranks.

# ·XXXIII·

WHEN EDITH, who was Mayor of Wilton, came home in the late evening, too tired to put the car away, it was her sister who had to give the news, and did so with delicacy she felt, if with some elaboration. She provided several cups of extra-sweet tea, then remarked how terrible it must be to be told that some dear one had been killed, when really he was still alive, perhaps a prisoner. Edith was too intelligent to wait on this, and "remained as she was – staring in front of her. She seemed to be peering into another world. She continued to sit, wild-eyed, staring and quite silent, utterly white. Then suddenly she started to become red around the neck." The sister now said that they must put the car away, and they went together; then that she must lie on her bed and be left alone for an hour, and so it was. She lay gazing in front of her, and did not cry until returned to. "Since Mildred died he has been the whole happiness of my life. Everything I like to do he likes. Everything I would like to do he *can* do. He creates enjoyment of life. He is always aware of God, though not conventionally." She was writing in the present tense without noticing it, as only this was tolerable. And next day: "There's a deep darkness over the house – and yet I do not realise that Rex will never come into it again. Blessed am I to be so old. I *must* die soon. Worked at my lecture, and went to a long welfare meeting about refugees."

I read the news in a train at Waterloo Station on my way to leave, having just bought a mid-day paper. The picture reproduced on the Diary page of bowler-hatted bandsmen in a garden looked familiar in style, and had the caption, "One of Rex Whistler's last sketches. Art and the stage suffer a considerable loss. . . ." A wave of heat brimmed up in me from chest to scalp, and a decision seemed to be made for me that instant to say nothing, show nothing, to the others in the compartment. It was too intimate to be told, too enormous to be made visible. So, while opposite to me a handbag was fingered, or a head nodded agreement, the world changed irreversibly, and no one was the wiser.

The familiar train ran by the same significant places: fields beyond Basingstoke tilting up to our landscape of origin, Salisbury spire, a moment of Wilton Park wall, and again and again out of a dozing trance my thoughts went to two women, and especially to my mother, both at that very moment helplessly enduring the bleak gaze of finality. How it was going to be for us two down in Devon, wonderfully reunited at this moment after long months, I have described in another book.

A few days later Edith had to give a small dinner party, which "was strangely a success. Sieg put his arm round me and said, 'I am always and ever your friend. Be brave. You *are* so.' Everyone seems to know what R and I are to each other." She clung for comfort to this recognition, but the stare of finality is not to be dodged. Following *The Times* obituary, the editor received more letters than about anyone killed in the war, but found room only for Gielgud's. "O that it should have come to this – 'Personal tribute to the *late Lieut. Rex Whistler'* – and that's the end."

It was midnight when I opened her gate, and found her there waiting for me, silent in the yew tree tunnel, and told her it was worse for her than for me because I had Jill. Even under smoothing moonlight she looked years older. My mother had asked for a memorial service in the cathedral, but could not face the journey herself. So I escorted Edith alone to a seat in the choir among about a hundred others – she would have liked a thousand – and I can see why she wrote, that night, "The first words filled me with emotion and made me cry the rest of the time – 'Let us remember Rex Whistler.' It was said very gravely and solemnly like the Recording Angel's Voice." Silently she cried until the beauty of the words brought peace by the end.

The permanent war-guest had a more astringent notion of comfort. This was to impart a sense of proportion by pointing out that men were being killed every day, that Rex was not a great man, and that someone else's memorial service in the Guards Chapel had drawn larger numbers. In the cathedral, the numbers had not been added to by Siegfried Sassoon: true to self, he told me he would have found it "too painful". I overheard the companion referred-to ask, "What will happen to her, do you think? Will she go mad?" At that moment the isolation of a human being in distress felt to me as cold as Arctic night. Agatha Bodenham went mad at the end of Edith's novel, *The Love Child*. But she herself, with her faith, her gratitude, her mental energy and stamina, would not go mad.

On purely personal grounds this death was perhaps the most widely regretted of the war; even *The Times* correspondent mentioned it in

despatches from the battlefield, and not exactly because of Rex's reputation in art. There was a certain similarity to Rupert Brooke's death, with the same risk that if a myth were substituted for a man, some harm might be done, by reaction, to the true assessment of a talent. But Rex did not have such eminent champions as Dean Inge of St Paul's or Eddie Marsh. He had Edith Olivier, or rather she had him. Unfortunately she was writing a book on Wiltshire, but it was at once agreed that a memorial volume would be a solace, and she must compile it when she could, and meanwhile I should help her to sort papers and pictures, and Siegfried would supervise. "To the end he glowed with perpetual youth", she wrote of Rex in her journal, forgetting that nine years earlier she had written, "his youth is now over." There was a certain uneasiness when her article on him in *Country Life* applied to him words evoked by Philip Sidney's death: "What perfection he has grown into, and how able to serve Her Majesty and his country, all men have almost wondered at." No doubt it was hard for a friend, clearly more than a friend, but in the eyes of the world of unclassified status, neither mother, wife nor mistress, not to falsify slightly. She recorded Hester Sassoon talking "as if she and Rex had been lovers. Says she wanted him to come home blinded so that she could do everything for him!" This was a cruel distortion of a maternal woman's wish to cherish, if the very worst should happen. When my mother met Edith she said, "I think of you as a piece of Rex." Accepting it as her due, Edith could find no graceful answer to one who had never seemed more than a tiresome and unlikely background. So "I said 'a broken piece', and couldn't help crying." On the last night of 1944, in the clamour of bells and music from St Paul's, and from liberated Paris, "how unbroken is the silence of the dead", she thought. "This is the devil tempting us to believe that death is a reality. Yet the silence is here. No response. None."

Obliged to complete her other book, she had not gone far with the book about Rex when in 1948 she drove to Wilsford to relive, by exchanging happy memories, those early hopeful days that had brought them all together. There she was gratuitously told that Siegfried and I feared the book would not be good, and was "asked if we could find someone else to do it". Depressed, but characteristically undaunted, she worked on for a few weeks, then had strokes, and died, aged seventy-five.

My mother got the news by War Office telegram, opened by her husband who guessed what it contained, and but for being on a journey at that moment I should have gone to her first. This and her wish

for the cathedral service, and her wish for me to be with Jill, disturbingly unwell, meant that several days passed before I reached her, during which she had been, to begin with, not hysterical, but prostrated. Again her faith had been stunned, as by the death of Denny in childhood. "There seemed nothing left to pray for", she said later. But this time, it was only for a few days. This time she could not think herself to blame, and perhaps in some recess of her mind had faced the chance. She had the benefit of more experience, being one of those who tend to grow in stature rather than diminish. I found her as well as I had begun to hope, from a telephone talk and a letter: as full now of gratitude as grief, not crying much nor stoically refraining, able to laugh at foolish jokes, and jokes made by Rex. To see her straighten his photographs on her dressing table, not as if they were icons in the service of self-pity, but unconsciously frowning a little, moved me, because she seemed by some small but detectable distinction to be thinking of him, not of herself. She talked of him and of his work in a practical way, and showed no sign of tending to propagate a legend; nor would she in the nineteen years ahead, that would bring her to the age of ninety-three. It was a very long evening she would know and a fairly sunlit one, and it was blessed by good health and clear senses until near the end.

Nineteen years after his death, on an afternoon in late May, I turned off the road to London and drove by lanes to where this story began – to my father's parish of Sherborne St John, neighbouring my mother's of Wootton St Lawrence, both country villages still, unaffected as yet by the spread of Basingstoke. In Sherborne I looked down the garden path to Wellington Villas, where the firm of Whistler had expressed in humble style the last of Georgianism, where my father had been born, where he had said goodbye one day, and virtually for ever, to go and get married. In Wootton churchyard his little oak cross for Denny had vanished with the grave-plot itself. In the church a tortoiseshell butterfly was rattling at the west window. I got it down intact and out of the door with a curious, long, wavering lath, and recognized this as the last of six specially ordered by Parson Ward eighty years before, to brace the Christmas evergreens against the soffits of the arches, an ingenious idea of a man who cared for such things. His Basil Champneys Vicarage was now Wootton House, his trees mature all about it.

I drove out to Rook's Down, more or less between the two villages, and stopped where a straight track led away into the distance, one of the ox droves beloved by my mother in girlhood, and took the small heavy box from the floor of the car. It had been her wish to be

cremated rather than buried, so as not to cause trouble, and she had paid for it in advance. I walked along the ox drove to where it bordered a field of late-sown corn. From here one could see the squat tower of Wootton Church, and among my grandfather's beeches and limes something of his chimneys and gables. The sky was masked in grey from very high cloud. The flat skyline was remote or broken by long woods. It was a water-colour landscape of cool blues, greys and greens, fresh-eyed in clear light, where peewits cried and stirred about, and a lark or two came down and slid sideways: a commonplace of England. It was about six o'clock. No car or tractor happened to cross the view. There was nothing that would be wonderfully strange to eyes of seventy years ago.

Here I was certain they had strolled, where the landscape was wide enough for solitude, with hedges thick enough for concealment; had advanced through a courtship that strangely remained undetected, because it was so unlikely. The Wootton shopkeeper and postmistress was the centrepoint of local gossip, yet exclaimed "I don't believe it!", when the news came out. Here was the beginning and true origin of Rex, a child of promise only partly fulfilled; christened Rex to be kingly, and at least regal in generosity; equipped to succeed so easily, except in love, where unsuccess in his own eyes at last vitiated everything else; and for me a brother to whom indirectly and often directly I owed almost every good chance that had come my way in life – for whose reputation I write this book out of gratitude, though in the end he had arrived at a cynical view of reputation.

It was here that half a story began, or less than half: say, twenty years of adult work and life. I wondered what the other thirty would have added, in plays, books, walls and canvases. Slowly evolving, like his character when viewed in depth, his art would have grown different. Would he in murals have escaped from the logic of illusion and the stranglehold of *trompe-l'œil*, to paint, say on a single wall night and day, or life and death? Would the modern scene have grown acceptable to a romanticism just beginning to look up from its absorption with the past? Far back when I was young I thought Rex went to Rococo for elegance and grace, to me then rather frivolous qualities, but the age called him more seductively than that, as I have shown, and not only in the visual arts but through Mozart in whom it came to consummation, and especially through Watteau who began it all. Where love is seen as tender and attainable, and the lovers are like children, naughty perhaps but never nasty, sensitive if teasing, divinely happy for an hour near the all-too-human stone divinity, or perhaps only for a moment under the forgotten urn. Could he ever have out-

grown that sense of the unattainable which kept him helplessly alone inside so much of pure enjoyment, so much of friendliness and laughter?

> Here Incompletion lies, a man for whom
> The music broke out from a distant room.
> Often to hear, and not quite reach, his doom.
>
> And still he heard that music, it was meant
> Strongly for him, though in the obscure event
> Dreamlike denied. Sleep, on that much, content!

Easier to picture a young couple, with the starched collar and full moustache, the long skirt and blouse of the Nineties, strolling discreetly between these very thorn bushes. How did a builder's son and a parson's daughter come to invent such a man? How, Edith wondered, do ordinary people ever invent extraordinary? For myself I had never thought of all three as either one or the other. Here anyway was the end of it, the matrix now crumbled like the gem. I put my hand into the box, took out a handful of the curious, rough crumbs, and lobbed it into the young corn, then another and another, changing the direction, following its course. Each time it glanced for the fraction of a moment in the breeze, making as it seemed to me a secret sign, but never twice the same, a faint hieroglyphic which I failed each time to decipher.

# A Portrait in the Guards

So these two faced each other there,
The artist and his model – both
In uniform, years back, in training.
Not combatant yet, but both aware
Of what the word meant. Not complaining,
But inwardly how loth.

They talked of this, perhaps. Each knew
The other, or himself, might be
Unlucky. But each knew this true
Of anyone at all; and so
There was no thrill in it. A knee
Jigged to the hit-tune of some show.

Each scrutinized the other frankly,
As only painter and sitter do:
Objectively and at leisure. Face
That must not, please, relax too blankly
Into repose; and face that threw
Glances, the brush being poised in space.

So both, it may be, had the sense
Of seeing suddenly very plain
A very obvious thing, the immense
Thereness of someone else, a man
Once only, since the world began.
Never before. Never again.

It could be, while a cigarette
Hung grey, each recognized the other
As valid utterly and brother.
It should be so; because, of all
Who in that mess-tent shortly met,
These would be first to fall.

# Notes

For individual works mentioned in the text, see the index to the catalogue raisonné in *The Work of Rex Whistler*, 1960.

My brother's letters are referred to below with a date. In quotations, his spelling has been kept.

Throughout the book the words of Edith Olivier are from her MS journal, when not from an identified letter. The abbreviation EO is used, with EO(J) for the journal.

My brother kept an occasional diary, referred to in the text, but only for short periods.

p. 2 *J. McNeill Whistler*. The connection, however, must be very remote in any case. His grandfather settled in the USA in 1777, and is shown by Hugh Whistler, the family historian of this century, to be descended from Ralph Whistler of Fowlescourt near Didcot, who died in about 1558. Another line of descent from Ralph was not explored further than John, a plumber and glazier of Doncaster who expressed in his will the wish that his son John, born *c.* 1775, should continue the business.

Our earliest recorded Whistler ancestor was John, born 1775/6, who was employed as a plumber and glazier in Aldermaston, and died by the fall from a damaged ladder, as described on pp. 1-2. My father, his great-grandson, who was unaware of Hugh Whistler's researches, had been told in childhood that the family had come from the north.

*John Whistler's photography*. Fifty-nine of his prints are now in the Victoria and Albert Museum, some on paper watermarked 1854. A few appear in an album of William Tollemache, dated 23 November 1859; others in one that belonged to James Clarke Hook. (Sotheby's, Belgravia, 19 March 1976.)

p. 4 *Paul Storr*, the silversmith, 1771-1844, married Elizabeth Beyer, the daughter of Adam Beyer of Soho, builder of musical instruments, who had probably left Saxony as a result of the Seven Years War. Storr's elder son, Paul, married Susan Utterton; it was their daughter Jessy

303

who married Charles Ward, the grandfather of Rex Whistler. Thus the artist was the great-great-grandson of the silversmith. (See N. M. Penzer, *Paul Storr*, 1954.)

D. M. Dolben, *Poems*, ed. R. Bridges, 1915, p. 108, "Song".

*Basil Champneys*, 1842–1935, was a grandson of Paul Storr by a daughter.

p. 32 *Ronald Fuller.* Unpublished recollections.

p. 52 *Caricature of Tonks. Daily Express*, 2 November 1959.

p. 58 *Paul Storr.* See note to p. 4 above.

p. 66 *To Stephen Tennant.* 15 October (?) 1924. *An Anthology of Mine* had however been begun in 1923, the year on the title page. It was published facsimile in 1981.

p. 67 *To Ronald Fuller.* 13 June.

p. 68 *To Ronald Fuller.* 24 September.

p. 70 *To Archie Balfour.* 19 October.

p. 73 *To Stephen Tennant.* (?) 7 October.
*To Stephen Tennant.* 15 October.

p. 74 *To Ronald Fuller.* 31 October.

p. 77 *To his mother.* 4 March 1925.

p. 78 *"Rex Whistler".* First mention in EO(J): 29 March.

p. 82 *Tonks grumbling.* To Mary Adshead, 24 and 26 April.

p. 83 *Rima.* R to EO, 9 January, 18 November.

p. 86 *"Unattainable bridegrooms".* EO, *Mildred*, pp. 11–12; *Without Knowing Mr Walkley*, pp. 25, 294.

p. 89 *Apotheosis of Tonks.* Tonks to Augustus Daniel, December.
*George Moore.* 9 March 1926. Unpublished letter in my possession.

p. 91 The restaurant has been refurbished in 1985 and the lighting improved, though failing to achieve that evenness of tone across the canvas which was intended.
*Sickert.* See Wendy Brown, Sotheby's *Art at Auction*, 1980.

p. 92 *Tonks on the royal visit.* For this and other quotations from Tonks's letters to Augustus Daniel, see J. Hone, *The Life of Henry Tonks*, 1939.

p. 93 *Monomark.* Extracts from a MS diary.

p. 95 *Palladian Bridge, etc.* Rex could never bring himself to give sufficient depth to an entablature and in his first sketches for the Tate showed a pediment resting on capitals, a solecism pointed out by the architect for the room, Lionel Pearson.

p. 96 *Osbert Sitwell*, describing the murals in the *Architectural Review*, July 1928.

p. 97 *"How can I thank you".* R to EO, 27 November 1926.

p. 100 *Lytton Strachey.* See Michael Holroyd's biography, Vol. II, pp. 558–9 and 695.

# Notes

p. 109 *"I am disgusted"*. R to EO, 14 September 1927.

p. 111 *Ravilious and Bawden*. R to EO, 10 February 1930.
*J. McN. Whistler*. See note to p. 2.

p. 112 *R to Ronald Fuller*. December 1927.

p. 113 *Siegfried Sassoon*. Unpublished diary, 17 and 25 October, 3 December.
*R to Osbert Sitwell*. January 1928.

p. 114 *Tricking up a studio*. R to EO, 2 February.
*Tonks as Dr Knots*. A painted bust beside the door into the kitchen.
*The British School at Rome*. R to EO, 8 December 1927.
*Samson in the Temple of Dagon*. Now at the Ashmolean Museum,
Oxford.

p. 115 *"The incredible beauty"*. R to EO, 25 April 1928.

p. 116 *"Well, if you're right"*. R to EO, 10 June.

p. 117 *Capri*. R to EO, 10 June; to his mother, 4 June.

p. 118 *Le Corbusier*. R to EO, 20 May.

p. 119 *Bored with the "New Architecture"*. R to EO, 7 January 1930.
*A Hell Room*. R to EO, 1 August.

p. 120 *"I have been painting"*. R to EO, 17 June.
*"Some spell on me"*. R to Tonks, 1 July.

p. 121 *Lord Berners*. R to EO, 10 June.
*Aulla*. To his mother, 16 July. R to EO, 22 July.

p. 122 *Bill Montagu-Pollock*. R to EO, 1 August.

p. 123 *"I too like Osbert"*. R to EO, 17 June.

p. 127 *Lutyens*. R to EO, 28 November.

p. 129 *Dorneywood*. Photographs in *Country Life*, 7 December 1951.
*¡OHO!*, 1947. AHA, 1978.

p. 131 *Frank Pakenham*. Afterwards Lord Longford.

p. 135 *Pencil portraits*. The one of Sassoon, intended for *Everyman's* but
disapproved of by Edith Sitwell, was given to Stephen Tennant, and
may not have survived. Arthur Waley told me that he was unaware of
being drawn by Rex, during talks in his studio, until the finished
drawing was shown to him.

p. 136 *The lost sketchbook*. It was returned to me in 1959 after the death of
one who had held on to it. I like to compare this with J. R. Cozens's
discovery of his father Alexander's lost portfolio on a stall in Florence,
also after thirty years.

p. 138 *The dead nanny*. The identification is now confirmed, which was only
guessed in *The Work of Rex Whistler*, no. 174.

p. 141 *Unusual method*. Flat-bed photogravure on copper, plate-sunk and
printed in sepia to resemble engravings.
*Watched from his sleeper*. R to his mother, 23 June 1929.

p. 142 *St Peter's illuminated*. R to EO, 2 July.

p. 143 *The Grottoes*. R to Stephen Tennant, 16 July.

p. 143 *The key letter.* R to EO, 2 July.

p. 145 *Longing to be a poet.* R to EO, ibid.

p. 147 *The "frightful sentimentality" of Gothic.* R to EO, 10 March 1928.

p. 152 *"Which reminds me, Edith".* R to EO, 13 October 1930.
*Nellie Wallace, Beatrice Lillie, Sophie Tucker.* Popular as stage, cabaret and music hall stars.
*David Cecil.* This and later extracts are from an unpublished essay on Rex Whistler, generously written for my benefit.

p. 154 *Gulliver's Travels.* In a number of copies, and more than I recognized when compiling *The Work of Rex Whistler* (1960), the central part of the full-plate drawings and the maps was hand-coloured by my brother, or by the copyist employed. His first sketch reveals that colour had been the original intention. Nevertheless he did not paint his own copies and came to the conclusion that, on balance, colour detracted more than it enhanced, by destroying the unity of the design. This is obviously true of the Lagado illustration.

The drawings alone, without the text, were republished from the surviving copper plates in 1970. This was a breach of copyright, afterwards acknowledged.

The full set, slightly reduced in size for a reader's edition of Swift's masterpiece, was reproduced in 1984 by the Herbert Press, London, working from the original drawings.

p. 155 *Siegfried Sassoon.* Diary, 15 July 1930, and later.

p. 157 *"Such fun painting again".* R to Stephen Tennant, 30 August 1931.

p. 159 *"His Majesty has".* R to EO, 10 September 1930.
*Sert.* A. Gold and R. Fizdale, *Misia*, 1980, p. 220.

p. 160 *Mural at Port Lympne.* Disfigured by some very bad retouching since the War.
*"I am still so miserable".* R to Sir Philip Sassoon, 10 November 1931, also EO(J), 9 November 1930.

p. 162 *A thirty-minute water-colour.* N.d. See Brian North Lee, *The Bookplates of Rex Whistler.*

p. 163 *"The most awful correspondence".* R to EO, 2 January 1932.
*"May the New Year".* R to EO, 16 January 1932.

p. 166 *Max Beerbohm* to RW, 7 October 1931. Original letter in my possession.

p. 167 *"This is the first summer".* R to EO, 10 June 1932.
*R to Sassoon.* N.d. (1932).

p. 168 *Betjeman.* EO(J), 1 August 1935.

p. 170 *Professor Buchanan.* Quoted in the *Daily Telegraph*, 28 June 1971.
*Alton Barnes visited.* EO(J), 8 August 1932.

p. 171 *R to EO.* 1 April 1932.
*Pempie Dudley Ward.* R to EO. Letters, 14 June 1933 to 24 June 1934.

p. 175 *Money equivalents in 1985.* For a rough guide multiply by twenty-

# Notes

four. Eg: Port Lympne – £19,200. The sisters' portrait – £4,800. Book wrappers – between £430 and £600.

p. 178  *To his mother from Rome.* N.d., but April 1934.

p. 179  *"I find the pain is still".* R to EO, 12 April 1934.

p. 182  *"Problems of a Stage Designer"* in *Footnotes to the Theatre*, ed. R. D. Charques, 1938. In my earlier brief biography I disparaged this article without bothering to re-read it, as if largely concocted by myself – who had put his thoughts on to paper. But the ideas were his, and are revealing.

p. 183  *"Francis D[oble]".* R to EO, 12 October 1933. Sheet diary, 13 March 1934.

p. 187  *"Deepest possible depression".* R to Kenneth Rae, August 1934.

p. 188  *Kenneth Clark.* His opinion mentioned, EO(J), 27 and 29 October 1934.
*Jill Furse.* EO(J), 20 July 1931, 19 July 1933, 5 August 1934.

p. 189  *Caroline Paget.* EO(J), 1 May 1931.
*Pempie Dudley Ward.* EO(J), 8 November, 14 December, 1934.

p. 195  *Decorations for Lady Diana Cooper.* The relevant pieces of plaster were carefully removed to University College, London, after the war, but since all it acquired was travesties of repainting, I have used the past tense.

p. 197  *Wilton House and Bridge.* R to EO, 4 October 1935.

p. 198  *"I'm not feeling at all keen"* etc. R to Elizabeth Paget about America, 17 October, November 1935, 25 January 1936.

p. 202  *Sassoon's garden, the gladiator.* R to EO, 14 June 1933.

p. 203  *Virginia Woolf.* Diary, 1 June 1932.
*Murals at 36 Hill St.* Dismantled after the war, the eight diverse panels were re-assembled, as well as possible, at Parbold Hall in Lancashire.
*"She (the old cat)".* R to Caroline Paget, 4 February 1937.
*Design for a bookplate for Mrs Porcelli's daughter.* Whether used is unknown.

p. 204  *The Mural at Plas Newydd.* A different design for the main wall has recently been offered at Sotheby's (1985), showing statues in niches alternating with two open porticos on to a townscape – similar to his first sketch for the Tate Gallery Restaurant eleven years before. As at the Tate he soon dispensed with the solid parts altogether, "dissolving" the whole wall into scenery. Though a finished watercolour, this early proposal seems never to have reached Lord Anglesey, and was unknown to me.

The gold centrepiece on the table in Pl. 36 was made by Paul Storr, Rex Whistler's great-great-grandfather, to be given to the first Lord Anglesey after Waterloo.
*Cheque in advance.* R to Charley Anglesey, 16 April 1936.

p. 205  *Architectural proposals.* Those mentioned, and others, are illustrated

# Notes

in my article "Rex Whistler's Architecture", in *House and Gardens*, April 1961.
"*Wormwood Scrubs*". R to Charley Anglesey, late summer 1936.

p. 206 "*Rather extra unhappy*". R to Caroline Paget, 10 October.

p. 207 "*But you'll be wrong*". R to Caroline Paget, c. October.

p. 208 "*To ask humbly*". R to Caroline Paget, 2 February 1937.
"*The most charming ... employer*". R to Charley Anglesey, February 1937.

p. 210 "*I hope you think*". R to Charley Anglesey, (?) April 1937.
*Osbertian story.* The Japanese painter who was to Sitwell "an old Chinese gentleman" is described by him in *Noble Essences*, 1950, Chapter x, p. 281.

p. 211 "*Shake down in one of the turrets*". R to Charley Anglesey, July/August 1937.
*Scenery as important as acting.* See note to p. 182 above.
"*I remember him*". Unpublished essay on RW.

p. 214 *Conversation Piece.* R to EO, c. 8 March 1937.

p. 216 *Letter to the Queen.* 21 January 1937; concerning ciphers, 17 September 1937.

p. 218 *National Trust ownership.* Plas Newydd, Isle of Anglesey; Mottisfont Abbey, near Romsey, Hants; Dorneywood, near Burnham, Bucks. The Brook House murals were re-erected skilfully at Britwell House, Britwell Salome, Oxon: lacking one vertical section. More noticeably, the loss of the silver cornice, with its pattern of "E"s and "M"s, makes for an abrupt junction of walls and ceiling. The decoration of ceiling and radiator grille are lost.
"*A little bit melancholy*". R to EO, 15 October 1937.

p. 219 *Longing for Caroline.* R to Caroline Paget, 17 February 1938.
*Trolley-buses.* R to Duff Cooper, February 1937.

p. 220 *Walton Canonry leased.* 18 July 1938.

p. 221 *Card to Kenneth Rae.* September 1938.

p. 222 "*Oh for the German army*". John Pearson, *Facades*, 1978, p. 382.

p. 223 "*Bed of beds*". Diana Cooper, *The Light of Common Day*, 1959, p. 195.

p. 224 *Final bill for £400.* R to Charley Anglesey, 11 December 1938.
*Mottisfont.* EO(J), 17 October 1938. The house is now owned by the National Trust, and the painted room may be compared with the original designs displayed in it.

p. 226 "*Your advice*". R to EO, 27 January 1939. Quotation continued below.
"*Very much loved*". To Moggy Gage, before D-Day, 1944.

p. 228 "*Territorial Army*". To Henry Uxbridge, late January 1939.
"*I don't think a talking-to*". May 1939.
"*A weak character*". To EO, 12 October 1933.

# Notes

p. 229 *Mauriac play.* Jill was in *The Intruder*, the translated version of *Asmodée*.

p. 231 *To Kenneth Rae.* 24 October 1939.
*Stroll with General Brooke.* Recorded by EO in her unfinished book on Rex.

p. 232 *"When once in".* R to Charley Anglesey, late 1939.
*Clark and the Official War Artists.* See Julian Andrews, preface to *Sutherland, the Official War Drawings*, Imperial War Museum, 1982, p. 11. Also the *Minutes of the Artists' Advisory Committee*, at the Imperial War Museum, vols covering 23 November, 6 and 20 December 1939; 3, 17 and 31 January, 21 February 1940, with a list, following the last-named date, of twenty-seven artists held in reserve: "Whistler, Rex. Book illustrator."
*"He always seemed to be fully employed"* was how Clark explained his lack of interest in Rex, years later. KC to me, 21 July 1959.

p. 233 *"Col. Leatham".* R to Kenneth Rae, 24 October 1939, with quotation preceding.
*"I must confess".* R to Col. Leatham, 19 October 1939.

p. 234 *"Why did I choose the W sort of Gs".* R to Charley Anglesey. N.d. (autumn 1939).
*"I am just finishing".* R to Henry Uxbridge, October 1939.

p. 235 *"It was agreed between us".* R to Maud Russell, 21 November 1939.
*"I have parted from".* R to Kenneth Rae, 24 October 1939.

p. 236 *"Life in the Close".* To Henry Uxbridge, late October 1939.

p. 239 *The Story of Mr Korah.* Christabel Aberconway evidently misread his final sketch, where the shouts of the sleeping Mr Korah have brought in a male character from real life, probably one of his partners, not, anyway, the nanny of his dream.
*"Why not France!"* R to Henry Uxbridge, c. 12 March 1940.

p. 240 *"Once again no home".* R to EO, 18 April 1940.

p. 241 *"To look back".* To Henry Uxbridge, (?) 26 May 1940.

p. 242 *East Mersea Church.* Endorsed on the back: "June 9 1940. 1st painting done in the Army from Colchester Roman Way Camp."
*"It's rather a strain."* R to Osbert Sitwell. (?) July 1940.

p. 243 *"I feel more loathing".* R to EO, 26 June 1940.
*To Maud Russell.* 12 August 1940.

p. 244 *"On one's own knut".* R to A. E. W. Mason, late August 1940.
*The waterworks.* R to Christabel Aberconway, 30 August 1940.
*"I don't think I could bear".* R to Maud Russell, 1 September 1940.

p. 245 *"I just mope about".* R to Osbert Sitwell, (?) July 1940.

p. 246 *Portrait of his father.* R to Caroline Paget, 17 October 1940.
*"I think of you".* R to Caroline Paget, 17 October 1940.

p. 247 *"Not sure that he wants this".* EO(J), 27 December 1940.

p. 248 *"What fun if we ever".* R to Henry Anglesey, 26 March 1941.

# Notes

p. 248 *To Sassoon. c.* 20 September 1941.

p. 249 *"The beauty of Wiltshire".* To EO, 19 May 1941, and following passage about his mother.

p. 250 *The Runts.* R to Andrew Graham, late October 1942, and following passage.
*Königsmark sent off.* R to A. E. W. Mason, late June 1941.

p. 253 *"Surrounded by the boys".* The Codford paintings seem to have been done at intervals during the summer of 1942. They and other productions hang at the Regimental HQ in Birdcage Walk, London.

p. 254 *Backdrop for "The Rake's Progress" repainted.* He complained to Janet Leeper on 28 February 1944: "No scene designs are *ever* returned until one has written at least 24 letters."

p. 255 *Mother's remarriage.* R to me, late September 1942.

p. 257 *R to Brian Howard.* (?) August 1942.
*"If you wake at four".* R to EO, 13 January 1943.

p. 258 *"One waltz – somewhere".* R to Caroline Paget, 24 February 1942.

p. 260 *Dance at Breccles.* R to Caroline Paget, July 1943.

p. 261 *Dinner at Sandringham.* R to his mother, 2 May 1943. Also to EO that day.

p. 262 *Malice of Munnings.* See Maurice Collis, *Stanley Spencer,* 1962, for this discreditable episode.

p. 264 *The moors.* R to EO, 1 August 1943.
*An Ideal Husband.* To EO, 18 November 1843. To the scenery manager Ferguson, 23 October.

p. 266 *"Darling Gill"* (sic). R to EO 18 November 1943. We had been married for four years.

p. 267 *Le Spectre.* R to EO, 3 December 1943.
co *Bottle's departure.* To EO, 18 December 1943.

p. 268 *Christmas party.* To his mother, 12 January 1944.

p. 269 *Designs for "Le Spectre".* They were burnt in a house-fire in 1952. Both are reproduced in colour in *The Masque,* no. 4, "Designs by RW, part two", Curtain Press, 1947.
*To the Duchess of Kent.* 6 February 1944.

p. 270 *Lutyens.* R to Lady Emily, 8 January 1944.
*"No, you mustn't agree".* R to Juliet Duff, 12 December 1941. Lord Quickswood in *The Times,* 29 November and 6 December.

p. 271 *Ustinov.* R to EO, 25 January 1944.
*Osbert Sitwell. Noble Essences,* 1950, p. 284.

p. 273 *Exercise "Eagle".* R to EO, 21 February 1944.

p. 274 *John Gielgud.* Letter to *The Times,* 28 July 1944.
*Scenery classical not baroque.* R to Hugh Beaumont, 29 May 1944.

p. 275 *To his mother.* 10 May 1944.

p. 276 *To Imogen Gage (Moggy).* 24 June 1944.

# Notes

p. 276 *To his mother.* 4 June, 16 June 1944.

p. 277 *The Brighton murals.* Subsequent history: Brighton wanted "Allegory" for the Pavilion as a memento of the Welsh Guards visit, the Regiment wanted them to have it, my mother and I waived a possible claim, the Government were under obligation to renovate, anyway. A graceful if sad ending to the painted room was in sight until the owner claimed that it was her property, and the murals (already removed) must be paid for. This might well have been disputed; but not wanting a squalid wrangle to overshadow the artist's death in battle the Regiment bought "Allegory" and gave it to Brighton, who bought the painted leek and gave it to the Regiment, while the *Brighton and Hove Herald* bought and gave the plaque of George IV to Brighton. In each case the wallpaper was taken off with an inch or so of plaster and transferred successfully to canvas. The chinoiserie trees were left to their fate. "Allegory" and the plaque are on view in the Pavilion. The leek hangs in the Regimental HQ.

p. 278 *"I used to think".* R to me, 10 April 1944.

p. 279 *"I am really miserable".* R to me, *c.* 10 May 1944.

p. 280 *"Shut up in a frightful camp".* R to EO, 16 July 1944.

p. 282 *To EO.* 16 July 1944.

p. 284 *The weather "hellish".* R to Moggy Gage, 15 July 1944.

p. 286 *"Wouldn't it be lovely".* R to his mother, 16 July. Also to EO, the same day.

p. 293 *The cemetery.* Rex's regulation headstone is on the farthest side from the entrance, marking grave 22, in row F, of plot III.

p. 295 *Since Mildred died.* EO(J), 25 July 1944. Her reception of the news was described by her sister Mamie in a letter quoted by Cecil Beaton in *The Years Between*, p. 350.
*I read the news.* In the *Evening Standard*, "Londoners Diary", 27 July.

p. 296 *Edith's dinner party.* EO(J), 29 July.
*The Times.* Obituary, 28 July; Gielgud's letter, 31 July.

p. 297 *Article in Country Life.* "Memories of Rex Whistler", 1 September 1944.

# Bibliography

## Books on the artist

I   Laurence Whistler, *Rex Whistler, His Life and His Drawings* (1948)
II  Laurence Whistler and Ronald Fuller, *The Work of Rex Whistler* (1960). With a catalogue raisonné.

## Books illustrated by the artist

A complete list up to 1959 is included in the catalogue of II above. Later publications:

*The Bookplate Designs of Rex Whistler.* Ed. Brian North Lee for the Private Libraries Association (1973)

*AHA.* Collected Reversible Faces, with verses by LW, (1978)

*An Anthology of Mine.* Facsimile of an illustrated MS book of verse, 1923–4 (1981)

*The Story of a Boy and Man.* Sketches for Julia Nissen as a child in 1944, with her words (1984)

## Articles and Essays on the artist

See II above, p. 114

# Index

Titles and ranks are generally those held during the period of the biography.

Abbots Langley, Hertfordshire, 24-5, 35-6
Aberconway, Christabel McLaren, Lady, 81, 110, 153, 158, 239, 250-1; *The Story of Mr Korah*, 239, 309n
Abercrombie, Patrick, 110
Ablett, T. R., 21, 61
Acton, Harold, 103-4
Adair, Major-General Allan (*later* 6th Bt), 260, 263, 287
Adshead, Mary (*later* Mrs Stephen Bone), 62, 69-71, 115
*AHA* (publication), 129
Aitken, Charles, 69-70, 89, 90, 94, 109, 122
Alanbrooke, Field-Marshal Alan Brooke, Viscount, 231, 248
Alington, Napier Sturt, 3rd Baron, 185
Allenby, Field-Marshal Edmund Hynman, 1st Viscount, 33
Alton Barnes, 170
Andersen, Hans: illustrations to, 67, 192, 251
Anglesey, Charles Paget, 6th Marquess of, 204-6, 208, 210, 234, 236
Anglesey, Henry Paget, 1st Marquess of, 204
Anglesey, Marjorie Paget, Marchioness of, 194, 197, 219
*Arabian Nights*: illustrations to, 36
Arran, "Boofie" Gore, Earl of, 167
Arromanches, 281
Ashcombe (house), 153-4, 195-6, 211
Ashmole, Professor Bernard, 117
Asquith, Lady Cynthia, 275
Auden, W. H., 215
Austria, 205, 220
Avon Valley, 170

Bakst, Leon, 267
Balfour, Archie, 69-71, 80, 82, 113
Balfour, Betty, 100
*Ballerina* (play), 183
Balliol College, Oxford, 166, 176, 186
Balmoral, 216-17
Bankhead, Tallulah: relations with RW, 183-7, 192-4, 251; RW sees in USA, 199; and

Caroline Paget, 207; and Simon Elwes, 245
Banneville-la-Campagne, 293-4
Baring, Daphne, 62
Bartlett School, London, 58
Batsford (publishers), 255
Bavaria, 130, 136-8
Bawden, Edward, 111, 140, 232
Bax, Clifford, 61
Bayeux, 282-3
Beaton, Cecil: friendship with RW, 99-102, 110, 113, 123, 153, 196; on RW's indifference to sex, 133; and Edith Olivier, 151-2; in Ashcombe, 153-4; and RW's fee for Sassoon room, 160; in USA, 162, 198; affairs with women, 171; return from USA, 172; on RW's passion for Penelope Dudley Ward, 173, 179; prosperity, 176; and Tallulah Bankhead, 183-5; on RW's theatre designs, 203
Beau monde, le *see* Lebohmord
Beaumont, Hugh, 275
Beckford, William, 144-6
Beddington, Jack, 61
Beecham, Sir Thomas, 183
Beerbohm, Max, 166
Belgrave Square: no. 5, 195
Bell, Clive, 229
Belloc, Hilaire: *Cautionary Tales*, 96
Bentley, Richard, 139
Berners, Gerald Tyrwhitt-Wilson, 14th Baron, 121-3, 141, 146, 160
Betjeman, (Sir) John, 166, 196, 244; *Mount Zion*, 168
Bett, John, 35
Birrell, Francis, 85
Bismarck, Ruppert von, 154
Blake, William, 105, 194
Bloomfield, Reginald, 48
Blow, Detmar, 65
Blunden, Edmund, 135, 167; *Collected Poems*, 168
Bodilly, Vera, 48
Bohmord *see* Lebohmord

# Index

Bolam, P. T., 257

Bolebec House, Whitchurch, 169–71, 174, 176, 220

Bone, Stephen, 53–4

Booth, William (Salvation Army General), 5

Bosham: Old Ship Club murals, 280

Bowen, Vic, 208–9, 229–30, 235

Brangwyn, Frank, 48

Brighton, 274; wall painting, 277–8, 280, 311n

British Empire Exhibition, Wembley, 1924, 67

Britwell House, Oxfordshire, 308n

Brompton Oratory: altarpiece, 20

Brook House, Park Lane: decorations, 218, 308n

Brooke, General Alan see Alanbrooke, Field-Marshal

Brooke, Rupert, 297

Brown, Frederick, 69

Buchanan, Professor Colin D., 170

Buckle, Katy, 41–2, 67

Bullock, Malcolm, 162–3

Burghclere Chapel, 62, 124, 224

Burn, Rodney, 69

Byam Shaw, Glencairn A., 155

Byron, Robert, 103

Caen, 285, 288, 294

Caetani, Princess, 141

Calvert, Edward, 145

Cameron, D.Y., 48

Canaletto, 197, 210

Cap Ferrat, 99–100

Carten, Audry, 194, 207, 226

Castlerosse, Lady, 221

Cecil, Lord David: friendship with RW, 85, 152, 191, 195, 208, 211, 215; on Hofmannsthal, 221; at Laurence Whistler's marriage, 230; on Jill Furse, 255

Cecil, Rachel (née MacCarthy; Lady David Cecil), 152, 191, 198, 230

Cenerentola, La (opera), 182

Cézanne, Paul, 221

Chadwick, Mrs (of Windrush, Pickering), 264–5, 270

Chamberlain, Neville, 223

Champneys, Basil, 4, 10, 24

Champneys, Sir Francis, 88

Channon, Sir Henry ("Chips"), 195, 271

Charlton, George, 49, 58, 61

Chingford Green, Essex, 12

Chu Chin Chow (musical show), 36

Church Assembly, 191, 193

Churchill, Winston S., 223, 273

Chute, Mrs (Chaloner's sister-in-law), 3, 11

Chute, Chaloner, 3

Clark, Kenneth, 188, 231–2, 234, 309n; The Gothic Revival, 139

Clarke, Terry, 32, 34

Claude Lorrain, 95, 121, 142, 157, 163, 179, 195, 274

Cleveland-Stevens, Bobby, 275, 290

Clovelly, 201

Cobden-Sanderson, Richard, 135, 167, 200

Cochran, Sir Charles B., 56, 129, 194

Codford St Mary, 248, 253, 310n

Cohen, Dennis, 139, 141, 146, 154

Coldstream, William, 62, 94

Colefax, Sibyl, Lady, 153, 214

Coleridge, Samuel Taylor, 37

Comus (masque), 127

Congreve, William: Love for Love, 261

Coningham, Air Marshal Sir Arthur, 288

Connell, Amyas, 117

Consett, Timothy, 253, 256, 262

Constable, John, 105

Constable, W. G., 53

Conversation Piece at the Daye House (RW watercolour), 213–14

Cooper, Alfred Duff (later 1st Viscount Norwich), 194, 219, 221–3, 233

Cooper, Lady Diana: and "swoop" parties, 151; and Mrs Landeryou, 165; friendship with RW, 194; RW decorates drawing-room, 195, 218; in The Miracle, 199; and impending war, 222–3; bed designed by RW, 223; on Mottisfont designs, 228; and RW's illustrations for A. E. W. Mason, 251

Country Life, 297

Coward, Noel, 201

Cozens, John Robert, 75, 144, 146, 305n

Cremieux, Mlle, 75

Cresset Press, 139

Cublington, 169–70

Cunard, Emerald (Maud Alice), Lady, 153, 183

Cunard, Nancy, 157

Curtius, Professor, 117

D'Abernon, Edgar Vincent, 1st Viscount, 110–11

Daily Mail: RW wins prize, 41

Daniel, Sir Augustus M., 52, 61, 69–70, 92, 105, 114

Daumier, Honoré, 53

Daye House, Wilton Park, 82, 85–7, 102, 104, 124, 130, 135, 149, 153–4, 172, 188, 191, 200, 226, 240, 255, 273; see also Olivier, Edith

de Bourgh, Lady Catherine, 200

de la Mare, Walter, 37, 64, 65–7, 85, 144–5, 153, 215; Come Hither (ed.), 108

Delamere, Thomas Cholmondeley, 4th Baron, 242–3

Delhi: Viceroy's House, 127

Delvaux, Paul, 127

Desborough, Ethel, Lady, 153, 277

Dewe, Joan, 45–6

Doble, Frances ('Bunny'), 183

# Index

Doernberg, Princess Imma, 148, 174
Dolben, Digby Macworth, 4
Dolphin, Guardsman, 259
Donat, Robert, 271
Dorneywood, Buckinghamshire, 114, 127, 129, 308n
Driberg, Tom, 160-1
Dudley Ward, Angela, 171, 177, 180-1
Dudley Ward, Penelope ("Pempie"), 171-5, 177, 179-81, 183, 189, 192
Dudley Ward, Mrs William (Freda), 171, 181
Duff, Lady Juliet, 221-2, 270
Duveen, Joseph, Baron, 71, 90, 92, 109-10

Eden, Anthony, 201
Edward VIII, King (later Duke of Windsor), 200, 208
Elizabeth, Queen of George VI, 216-17, 260-1, 273
Elizabeth, Princess (later Queen Elizabeth II), 261
Eltham, Kent, 12-14, 18, 24, 40
Elwes, Simon, 234, 245
Epstein, Jacob: Rima, 83
Erhardt-Ehrenhaus, Otto Martin, 182
Esher, Reginald Brett, 2nd Viscount, 114
Ethel (Haileybury maid), 38
Evans, Charles (of Heinemann), 89
Evans, Edith, 208

Farnham Common, 68, 169, 202
Farrell, Gwen (later Ann Martelli), 131-2
Fidelio (opera), 182
Figaro (opera), 188
Firbank, Ronald, 96
Firle, Sussex, 276
Fisher, (Sir) Nigel, 263
Fitzroy Square, London, 220, 226, 235
Fitzroy Street, London, 219-20, 270
Flanagan, Bud, 226
Follett, John, 233
Fonteyn, Margot, 240, 267
Footsey, Mrs (charwoman), 220, 230
Forster, E. M., 101, 155
Fortnum and Mason (store): RW's advertisements for, 137
France, 147; see also Normandy
Fraser, Lovat, 36
Fry, Roger, 62
Fuller, Ronald: friendship with RW, 32, 36-7, 39, 55-6, 64, 68, 83-4, 101; poetry, 37; RW bookplate, 83; career, 83; misses Tate opening day, 112; at Oxford, 168
Furse, Jill (later Mrs Laurence Whistler): friendship with RW, 188-9, 206, 208-9, 212, 214, 255, 266; and Laurence, 209, 212, 214, 226, 229; acting, 229, 254; and Caroline Paget, 212-13; marriage, 230, 240, 255; in

Whistler family, 236; children, 238, 245, 266, 278; illness, 254-5; and RW's death, 296, 298

Gadebridge Park, Hemel Hempstead (school), 28-9, 31, 38
Gage, Imogen ("Moggy"), Viscountess, 276-8, 284, 286
Garmisch see Bavaria
Garnett, David: Lady into Fox, 108; The Sailor's Return, 196
Garvin, J.L., 222
Gatty, Hester see Sassoon, Hester
Gay, John: Fables, 140
Gaynor, Janet, 177
General Strike, 1926, 94
George V, King, 200
George VI, King, 216, 245, 260-1, 273
Gerrard, A.H., 50, 58
Gershwin, George: An American in Paris, 132-3
Giberville, Normandy, 290, 293
Gielgud, (Sir) John, 261, 274-5, 296
Gill, Eric, 42
Glenconner, Christopher Tennant, 2nd Baron, 75-6
Glenconner, Edward Tennant, 1st Baron, 65
Goetheanum, Basle, 58
Goff, Thomas, 230
"Goodwood", Operation, 287-8, 294
Gower Street, London: no. 90, 195
Goya, Francisco, 20, 91
Graham, Andrew, 245, 249-50, 256
Grandville (J.I.I. Gérard), 140
Grant, Duncan, 98, 203
Gray, Thomas, 97; Elegy: illustrations to, 139
Greenacre, Douglas ("CO Bottle"), 256-7, 263, 267
Grey of Falloden, Sir Edward, Viscount, 64-5, 72, 84
Grey, Pamela, Viscountess, 65, 76, 78, 84, 95, 99-100; death, 130
Grosz, George, 96
Guards Armoured Division, 248, 252, 255, 273, 281-2, 288, 294
Gubbay, Hannah, 202
Guinness: RW's advertisements for, 137
Guthrie, Robin, 62, 69

Haddon Hall, Derbyshire, 169
Haileybury (school): RW attends, 31-5, 38-9, 45, 75; homosexuality at, 132
Halliday, Edward, 117
Hamlyn, Mrs (of Clovelly), 201
Hammersley Heenan family, 49
Hammersley Heenan, Eileen, 49, 56
Harcourt-Smith, Simon: The Last of Uptake, 251, 255

# Index

Hardy, Thomas, 6, 10, 43, 101
Hayes, Helen, 197, 199
Heinemann (publishers), 89, 114
Herbert Press, London, 306n
Herbert, David, 102, 184, 194-5, 197-9
Herbert, George, 171
Herbert, Tony, 102
Hesse, Prince of, 137
Highway Clubs, London, 69; see also Shadwell
Hill Street, Mayfair: no. 19, 157; no. 36, 203, 205
Hirth, Johanna and Walter, 136-8, 222
Hitler, Adolf, 222, 243
Hodgkinson, Hugh, 264-5
Hofmannsthal, Alice, 199, 205
Hofmannsthal, Raimund, 199, 205, 220-2, 226, 239
Hogarth, William, 53, 129, 140; The Rake's Progress, 194-5
Hook, James Clarke, 303n
Hopkins, Gerard Manley, 106
Housman, Laurence, 197
Howard, Brian, 55, 103-4, 106-7, 119, 257
Hutchinson, Colonel (of Monomark), 94
Hyson, Dorothy, 201

Ibert, Jacques: Divertissement, 96
Ideal Husband, An (Wilde play), 264, 270
Importance of Being Earnest, The (Wilde play), 33
Inge, W. R., Dean of St Paul's, 297
Ingres, Jean-Auguste Dominique, 135
Irwin, Edward Wood, Baron (later 1st Earl of Halifax), 127
Italy, 76-81; see also Rome

James, Edward, 175; The Next Volume, 168
Job (ballet), 194-5
John, Augustus, 61, 70, 98, 185
Johnson, Celia, 201
Johnstone, Alick, 208
Jones, Corporal, 294
Jones, Allan Gwynne, 62
Jones, Glyn, 116
Jones, Inigo, 58, 183

Karsavina, Tamara, 267
Kennington, Eric, 38
Kent, Princess Marina, Duchess of, 269-70
Kent, William, 140
Kindersley, Dick (boyhood friend), 30
Kinsey, Dr Alfred C., 184
Knebworth (house), 205
Knebworth, Anthony, Viscount, 189, 207, 231
Knight, Dame Laura, 262
Knight, Winefred, 62

Lamb, Henry, 151
Lambert, Constant, 194, 240

Lamont, Gillian (RW's niece), 191
Landeryou, Mrs (charwoman), 165, 187, 220
Last Supper (RW's painting), 88, 114
Lavery, Hazel, Lady, 110
Lawrence, T. E., 174
Leatham, Colonel R. E. K., 233-4
Leavis, F. R., 112
Lebohmord (le beau monde), 102, 161, 202
Le Corbusier, 118-19
Lehmann, Rosamond, 100
Lemprière, Dr L. R., 34-5, 37
Lewes, Jock, 245
Lewis, Jim Windsor, 256, 267, 274
Lewis, Katy, 112
Lewis, Sydney, 48
Lillie, Beatrice, 152
Lines, G. C., 22
Lister, Sir William, 84
Livingstone, Dame Adelaide, 178
Llewellyn, William, 48
London County Council: County Hall, 69
Longford, Edward Pakenham, 6th Earl of, and Christine, Countess of, 131; see also Pakenham, Frank
Louise, Princess, 100, 129
Luca, Faniker, 226
Luton, 30, 44, 64
Lutyens, Sir Edwin, 47-8, 127, 188, 201, 203, 215-16; death, 270
Lytton, Bulwer, 1st Baron: Eugene Aram, 57
Lytton, Victor Bulwer-Lytton, 2nd Earl, 207

MacCarthy, Desmond, 191, 202
MacColl, D. S., 122
Macfie, Dr Ronald, 74, 76-8, 80
McLaren, Anne, 239
MacLaughlin, Martin, 112, 165
Mann, Erika, 257
Marriott, Charles, 71
Marsh, Sir Edward, 202, 297
Marshall, General George, 273
Masefield, John, 215
Mason, A. E. W.: Königsmark: illustrations for, 244-5, 250-1
Matheson, Hilda, 187
Maxwell, Elsa, 199
Mendelssohn, Felix, 96
Merchant of Venice, The (Shakespeare): RW competition prize, 88
Merton Court (school), 22
Messel, Oliver, 56, 58, 153, 169, 198, 211, 262
Mew, Charlotte, 220
Meynell, Alice, 179
Midsummer Night's Dream, A 172, 274-5
Mildmay, Anthony, 2nd Baron, 290
Millay, Edna St Vincent, 199
Miller, Gilbert, 197
Monet, Claude, 221

# Index

Monnington, Thomas, 62
Monomark (company), 93
Montagu, Judy, 260
Montagu, Venetia, 260
Montagu-Pollock, (Sir) William, 122, 167
Montgomery, Field-Marshal Bernard (*later* 1st Viscount), 273, 281, 285, 288, 294
Moore, George, 93; *Peronnik the Fool*: illustrations for, 89
Moorhouse, Mrs Trevor, 280
Morison, Lady Mary, 97
Morley College, London, 111
Morrell, Lady Ottoline, 153, 213
Motte (publisher), 140
Mottisfont Abbey, near Romsey, 224-5, 228-31, 234-5, 277, 308*n*
Mountbatten, Edwina (Lady Louis), 218
Mountbatten, Lord Louis, 218
Mozart, W. A., 299; *Coronation Mass*, 139; see also *Figaro*
Munnings, Sir Alfred, 262
Mussolini, Benito, 119, 178

National Trust, 235, 308*n*
Neagle, Anna, 217
Newbolt, Sir Henry, 85, 104, 108
*New Forget-Me-Not, The*, 135-6, 138, 166
*New Keepsake, The*, 166
Normandy, 281-90

¡*OHO!* (publication), 129
*Old Music* (play), 211
Olivier, Edith: and RW at Academy, 45; on Wilsford, 65; in Italy, 76, 78-80; friendship with RW, 82-7, 97, 102-7, 110, 124, 130, 136, 162-3, 166, 191, 193, 196, 200, 207-9, 226-7; and Mildred's tribute book, 85; writing, 85-6, 108, 119, 255, 296; and religion, 85-6, 105; and RW's parents, 87, 125, 127, 235, 249, 300; at Cap Ferrat, 99-100; and unusual dress, 102; and Laurence Whistler, 103, 166, 168, 209, 226, 229; book with RW, 108-9, 114; and Tate flood, 113; and RW in Rome, 116-17, 120; RW designs palace for, 119; visits Sitwells with RW, 123; visits Whistler family, 125, 127; social judgments, 125; in Bavaria, 136, 138; letters from RW in Rome, 143, 146; on William Walton, 148-9; motoring, 151; social life with RW and Cecil Beaton, 151-2; RW portrait of, 152; made up for Tomlin, 153; and Sassoon's concern for Stephen Tennant, 154-6, 164; and RW's painting, 158; excursions with RW, 170; and RW's infatuation with Penelope Dudley Ward, 172-3, 175, 177, 180, 189, 195; and Sassoon's love for Hester Gatty, 174; and RW's finances, 176; on RW's *Fidelio* scenery, 182; on RW's face, 186; on Jill Furse, 188-9, 206, 254-5; on

Paget girls, 194, 196-7; on RW in USA, 199; on RW's work at Plas Newydd, 210; on RW and Caroline Paget, 212-13; Sassoon gives allowance to, 213; at Laurence Whistler's marriage, 230; and RW's loss of Salisbury house, 240; and RW's army service, 249, 252, 257, 259; and RW's mother at Daye House, 249; in RW's paintings, 256; illustrated letter from RW, 272; and Hester Sassoon, 273; and RW's departure for action in France, 280; and RW in France, 282, 285-6; and RW's death, 295-7; own death, 297; *As Far As Jane's Grandmother's*, 86, 119; *The Love Child*, 85, 108, 296; *Night Thoughts of a Country Landlady*, 255
Olivier, Mildred, 79, 82, 84-5, 295
Ormerod, Frank, 55
Orpen, William, 48

Paget, Lady Caroline: relations with RW, 154, 183, 189, 193-5, 197, 204-9, 211-13, 219-21, 226, 230, 238, 246-7, 254, 257-8, 260, 278; acting, 196; portraits of, 197-8, 207, 218, 224, 239; illness, 208; and Jill Furse, 213; and women, 213, 226; war service, 228, 246-7
Paget, Lady Elizabeth, 154, 192, 194, 198-200, 205, 220-1, 225
Paget, Henry, Earl of Uxbridge, 211, 213, 219, 223, 234, 236, 239, 248
Pakenham, Frank (*later* 7th Earl of Longford), 131
Palmer, Samuel, 105, 145, 160
Parbold Hall, Lancashire, 307*n*
Paris, 162
Pater, Walter, 79
Pearson, Lionel, 90, 109, 304*n*
Pembroke, Reginald Herbert, 15th Earl of, 103
Phear, S. G., 4
Pickering, Yorkshire, 263-5, 267
Pinner Wood House, Middlesex, 57, 60, 67
Piper, John, 232
Piranesi, Giovanni Battista, 210
*Planters* (RW drawing), 64
Plas Newydd, Anglesey: RW's decorations, 204-6, 208, 210-11, 218-19, 224, 229, 235, 239, 307*n*, 308*n*
*Playbox Annual*, 21
Poe, Edgar Allan, 37, 57, 64, 134
Pope, Alexander, 140
Porcelli, Mrs Ernest, 203, 225
Portal, Sir Francis, 277, 287
Porter, Cole, 199
Port Lympne, Kent: RW's decorations, 158-60, 162, 166, 175; RW takes Penelope Dudley Ward to, 173; Laurence Whistler visits, 201-2
Post-Impressionism, 62

Poulenc, Francis: *Les Biches*, 96
Poussin, Nicolas, 178–9, 195, 274
Price, Harry (spiritualist), 84
*Pride and Prejudice* (play), 200–1
Primavera, La (house, Cap Ferrat), 99
Prix de Rome, 90
Pryce-Jones, Adrian, 242
*Punch* (magazine), 30
*Pursuit of Rare Meats, The* (Tate Gallery mural), 91, 108, 129; *see also* Tate Gallery
*Pytcheley,* HMS (destroyer), 264

*Queen Victoria* (film), 217
Quennell, Peter, 173
Quickswood, Hugh Gascoyne-Cecil, 1st Baron, 270

Rackham, Arthur, 35–6
Rae, Kenneth: and RW's book illustrations, 135, 167, 192; in Rome with RW, 177–9; friendship with RW, 187, 236; contract with Laurence Whistler, 193; and Elizabeth Paget, 194; and RW's trip to USA, 198; and RW in Austria, 221; and RW at beginning of war, 231–2
*Rainbow* (comic paper), 20
*Rake's Progress, The* (ballet), 201, 254
Rassine, Alexis, 267
Ravilious, Eric, 111, 232
*Rebecca* (play), 254
Reinhardt, Max, 172
Rembrandt van Rijn, 91
Renishaw (Sitwell house), 123
Renshaw, Michael, 282, 284, 287, 289
*Revolution* (RW drawing), 63
Reynolds, Michael: "The Slade" (unpublished), 132
Richardson, Sir Albert, 58
Richmond, Ian, 117
Robert, Hubert, 142
Robertson, Nan (*née* West), 61
Rodgers, Claude, 94, 109
Rome, 80–1; RW at British School, 114–22, 123; RW revisits, 141–3, 146; Kenneth Rae and RW in, 178–9
Rommel, Field-Marshal Erwin, 285
Ronald, C.A., 33
Rothenstein, William, 110
Rousseau, Henri (Douanier), 147
Roxburgh, J. F., 88
Royal Academy: RW attends schools, 45–6, 48, 55; 1934 Summer Exhibition, 180
Royal Drawing Society, 21, 30, 45
Russell, Maud, 224–5, 228–9, 234–5, 243

Sackville-West, Edward, 100
Sadlers Wells: Opera, 188; Ballet, 240, 267
St Albans: Abbey, 42

Salisbury: Walton Canonry, 69 The Close; 220, 230, 235–6, 239–40, 266
Sandown Park, Esher, 243, 245
Sandrart, Joachim von, 121
Sandringham, Norfolk, 260
Sassoon, George, 206
Sassoon, Hester (*née* Gatty), 174, 254–5, 273, 297
Sassoon, Sir Philip, 91–2, 158–60, 162, 201–2
Sassoon, Siegfried: and Edith Olivier, 85; protests at World War I, 97; introduces Stephen Tennant to Hardy, 101; friendship with RW, 113, 130–2, 134–6, 149, 155, 251; relations with Stephen Tennant, 130–1, 135, 137, 149, 154, 163–4; RW portrait of, 135, 305*n*; in Bavaria, 137–8; letter to RW in Rome, 146; and Sitwells, 149; falls from favour with Stephen Tennant, 155–6; meets Sir Philip Sassoon, 158–9; poem for *New Keepsake*, 166; RW sends Laurence Whistler's *Armed October* to, 167; dismissed by Stephen Tennant, 171; at Port Lympne, 173; marriage to Hester, 174, 254; gives allowance to Edith Olivier, 213; at Laurence Whistler's marriage, 230; and RW in army, 248; and RW's death, 296–7
Sawrey-Cookson, Richard, 273
Secker, Martin (publisher), 114, 119, 163
Sert, J. M., 92–3, 159, 175
Shadwell: RW's murals at Highway Club, 69–72, 76, 82
Shaw, George Bernard, 110–12, 220
Shell company: RW's reversible faces for, 128; RW's drawings for, 129; advertisements for, 169, 200
Shelley, Percy Bysshe, 144
Sherborne St John, Hampshire, 1–2, 298
Sherlock, Sergeant Lewis ("Shirley"), 259, 261, 267, 283–4, 290–3
Sickert, Walter, 91, 98
Sidney, Sir Philip, 297
Simpson, Mrs Wallis (*later* Duchess of Windsor), 208
Sims, Charles, 45, 48, 50
Sitwell, (Dame) Edith: and low life, 70; at Tate Gallery opening day, 110; Edith Olivier visits, 124; Siegfried Sassoon on, 149–50; "Colonel Fantock", 96; *Façade*, 96; "Gold Coast Customs", 124; *The Sleeping Beauty*, 79
Sitwell, Sir George, 123
Sitwell, Georgia (Mrs Sacheverell Sitwell), 150
Sitwell, Lady Ida, 124
Sitwell, Sir Osbert: Tonks praises RW to, 61; and low life, 70; on RW and Stephen Tennant, 81; on Tate mural, 96; war service, 97; photographed with RW, 100; at Tate Gallery opening day, 110; requests bookplate, 114; RW visits, 123; and Sassoons, 158; let-

ter style, 161-2; on Abdication, 208; sees murals for Plas Newydd, 210; at Balmoral, 216-17; political views, 222, 271; and RW in war, 231-2, 245, 271; *A Place of One's Own* (film), 271, 274
Sitwell, (Sir) Sacheverell, 100, 150, 166, 274
Sketch Club, 61, 88
Slade School of Art, London: RW attends, 49-55, 57-8, 61-4, 88, 92-3; competition, 60-1; Centenary Fund, 92; sex at, 132
Smith, Edie, 184
Smith, Isabel, 19, 21
Soames, Michael, 240
*Spectre de la Rose, Le* (ballet), 267, 269, 310*n*
Spencer, Stanley: Burghclere Chapel (*Resurrection*), 62, 109, 124, 224; characteristic shapes, 158; Munnings persecutes, 262
Stanley, Pamela, 211
Steer, Philip Wilson, 58, 61-2, 121
Stein, Gertrude, 104
Steiner, Rudolf, 58
Stirling, David, 245
Stokes, Adrian, 48
Stonehenge, 101
Storr, Fanny, 10
Storr, Rev. Frank, 4
Storr, Elizabeth (*née* Beyer), 303*n*
Storr, Paul, 4, 58, 303*n*
Storr, Paul (son of above), 303*n*
Storr, Susan (*née* Utterton), 303*n*
Stowe school: Laurence Whistler climbs Cobham Monument, 41; Laurence Whistler attends, 88, 95, 102, 112; in Tate mural, 95
Strachey, Lytton, 100; *Eminent Victorians*, 96
Strong, Mrs (in Rome), 117, 121
Stulik, M. (restaurateur), 160, 207
*Sunday Times*, 180
Sutherland, Graham, 232
Swettenham, Sir Frank: *Arabella in Africa*: illustrations to, 72
Swift, Jonathan: "Cassinus and Peter", 140; *Gulliver's Travels*: illustrations to, 139-41, 146, 148, 154, 251, 306*n*
Swinburne, Algernon Charles, 101
Switzerland, 72-6

Tashman, Lylian, 171
Tate Gallery: Refreshment Room mural, 48, 90-1, 97, 108-10, 129; painting and design of, 93-5; figures in, 95-6; visitors to, 109; opening day, 110-13; flooded, 113, 129
*Tempest, The* (Shakespeare), 183, 274
Tennant, David, 68
Tennant, Stephen ("Napier"): friendship with RW, 57, 62, 64-6, 81, 101-2, 113, 116, 130, 134-5, 150, 154-5, 164, 192; illnesses, 72-6, 82, 102, 130, 136-7, 149, 154-5, 163-4; convalesces in Switzerland, 72-6; in Italy, 78,

80; RW paints likeness in Shadwell mural, 82; at Cap Ferrat, 99; photograph of, 100; and Osbert Sitwell, 123; relations with Sassoon, 130-1, 135, 137, 154-6, 163-4, 171; in Bavaria, 130, 136-8; infatuation with USA, 132; letter to RW in Rome, 146; returns to Wilsford, 149; letter from RW, 161; offers to illustrate Edith Olivier's book, 163; and RW's relations with Penelope Dudley Ward, 173; travels to USA with RW, 198
Tennyson, Alfred, Lord, 144
*Thetis*, HMS (submarine), 219
Thomson, Sir Courtauld, 113, 129
*Times, The* (newspaper): and Shadwell murals, 71-2; and Tate murals, 112; and replanning London, 270-1; and RW's obituary, 296
Tollemache, William, 303*n*
Tomlin, Stephen, 153
Tonks, Henry: at Slade, 49-53, 55, 93; and oil painting, 57-8; and RW's facility, 61-2; anti-modernism, 62; and RW's fairground bill, 63; and Shadwell mural, 69-70, 82; agrees to RW's absence in Switzerland, 72, 76; relations with RW, 88-9; and Tate murals, 90, 92, 109-11; and royal visits, 92; on unworthy living ("the Pit"), 99; on art as religion, 105; retirement, 111; and RW's success, 113-14; and RW in Rome, 120-2; and RW's painting, 158
Towne, Francis, 75
Tree, David, 196
Trent (house), 202
Tucker, Sophie, 152
Turner, J. M. W., 75, 91, 113, 142

United States of America, 197-200
University College, London, 49-50, 307*n*; *see also* Slade School of Art
Urquhart, Francis Fortescue ("Sligger"), 165
Ustinov, Peter, 271
Utterton family, 40
Utterton, Edwin (RW's great-uncle), 31
Uxbridge, Lord *see* Paget, Henry

Valois, Dame Ninette de, 194, 267
Vanbrugh, Sir John, 188; Laurence Whistler writes biography of, 193, 222
Vaughan, David, 242
Venice, 221
Victoria, Queen, 197, 217
*Victoria Regina* (play), 201, 211
Villars, Switzerland, 74, 77
Vyne, The (house), 3

Waley, Arthur, 85, 101; RW portrait of, 135, 305*n*
Wallace, Billy, 158
Wallace, Captain Euan and Barbara (*née* Lutyens), 157-8, 215

# Index

Wallace, John, 158

Wallace, Nellie, 152

Walsham-le-Willows, Suffolk, 13

Walton Canonry see Salisbury

Walton, Sir William: sets *Facade*, 96; at Wilsford, 100-1; at Renishaw, 123; RW portrait of, 135; in Bavaria, 136-7; visits Edith Olivier, 148; affair with Princess Imma Doernberg, 148, 174; ease with women, 149; tricks RW, 154; and RW's ballet designs, 240

Ward, Basil (RW's uncle), 14

Ward, Rev. Charles Slegg (RW's maternal grandfather), 3-5, 7, 9-11, 13-15

Ward, Denis (RW's uncle), 8, 14

Ward, Dorothy (RW's aunt), 18

Ward, Henrietta (*née* Shute; Charles Ward's 2nd wife), 7, 11

Ward, Jessy (*née* Storr; RW's maternal grandmother), 4-5, 7, 304*n*

Ward, Major-General Sir Philip, 289, 291

Warren Lodge, Farnham Common, Buckinghamshire, 68

Waterfield, Aubrey, 121

Watt, R. J. A., 263

Watteau, Antoine, 224, 299

Waugh, Evelyn, 168

Webb, Aston, 48

Wellesley, Dorothy (*later* Duchess of Wellington), 187

Wellesley, Elizabeth, 187-8

Wellesley, Lord Gerald (*later* 7th Duke of Wellington), 188

Wellesley, Valerian, 187

West, Nan, 93-4, 109, 115

Whiskard, Dick, 254

Whistler (surname and family), 2-3, 303*n*

Whistler, Denis (Denny; RW's brother): born, 13; relations with mother, 17; relations with RW, 17-18, 86; character, 17, 22; schooling, 19, 22; early drawing, 20-1, 24; death, 22-4, 26, 106, 298

Whistler, Hector (RW's cousin), 88

Whistler, Henry (Harry; RW's father): character, 6, 14-15, 27; in Argentine, 6-7; courtship, 8-10; marriage, 10-11, 15, 27; business enterprises and activities, 10, 12-13, 44, 57, 125; relations with father-in-law, 13-14; relations with children, 16, 27; work in World War I, 19, 25, 30, 44; faith at Denny's death, 23; memorial cross, 23, 109; children's education, 27; on outings, 42; sensitivities, reflections and habits, 42-4; and Pinner house, 57, 67; politics, 64; place in family, 87-8; at Tate opening day, 110, 112; Edith Olivier on, 125, 127, 235; woodcarving, 169; stroke, 187; recovers, 201; in old age, 240; death, 245-6; portrait of, 246, 277

Whistler, Hugh, 303*n*

Whistler, James McNeill, 2, 98, 111-12, 303*n*

Whistler, Jess (RW's sister), 12, 14, 27, 57, 72, 191

Whistler, Jill *see* Furse, Jill

Whistler, John (RW's great-great-grandfather), 1-2, 303*n*

Whistler, John (RW's grandfather), 1-3, 10

Whistler, John (RW's uncle), 6-7

Whistler, Laurence (RW's brother): born, 16; and parents, 16-17; anxieties about accidents, 40-1; childhood, 40-3; schooling, 45, 88, 95, 112; bronchitis, 67; poetry, 95, 148, 166-7, 186, 193, 206; accompanies RW, 102-3, 124; in car crashes, 124-5, 150; at Oxford, 165, 168, 174, 176, 186; socialism, 168; painted by RW, 169; first love, 174, 186; relations with RW, 179-80, 187, 201, 215, 236, 243; glass engraving, 188, 216; works with Church Assembly, 191; wins Royal Gold Medal for Poetry, 193; Vanbrugh book, 193, 222; and Jill Furse, 209, 212, 214, 226, 229; at levee, 215; marriage to Jill, 230, 236, 240, 255; army service, 245, 250; wartime correspondence with RW, 278-9; and RW's death, 295-8; and mother's death and cremation, 298-300; *Armed October*, 167; *The Initials in the Heart*, 209

Whistler, Nell (*née* Ward; RW's mother): childhood and character, 5-6; comes out, 7; and father's second wife, 7-8; courtship, 8-10; marriage, 10-11, 15-16, 27; relations with father, 10, 15; children, 12-13, 16-18, 40-3; and Denny's death, 22-3, 40, 298; in Abbots Langley, 24-5; anxieties, 40-1; love of outings, 42; and social class, 43-4; music, 60; politics, 64; leaves Pinner, 67; approves RW's trip to Switzerland, 72; faith, 86, 285-6, 298; Edith Olivier and, 87, 125, 127, 235, 249; reading, 87; at Tate opening day, 110, 112; in RW's car crash, 150; broken leg, 169, 174; at *Pride and Prejudice* performance, 202; and husband's death, 246; RW on, 249; remarries, 255; wartime London meeting with RW, 275; and RW in action, 285; and RW's death, 296-8; own death and cremation, 298-300

Whistler, Rex (Reginald John): mural painting, 3; born, 13; and parents, 16-17, 43; relations with Denny, 17-18; character, 17-18, 22, 29; early drawing, 18-22, 24, 28-30; schooling, 18-19, 22, 26, 28-9, 31-5, 38-9, 45; grip in drawing, 19, 29, 53; horror themes, 20; rebus letters, 21; and Denny's death, 23-4, 26; illnesses, 23-4, 26, 28-9, 34-5; kisses school maids, 29, 38; and use of colour, 30, 36; school stage designs, 33-4; practical jokes, 35; and Georgian art, 35-6; illustrations for Ronald Fuller, 37; rugby-playing,

# Index

37-8, 132; breaks nose, 37; career in art, 38, 45; wins *Daily Mail* prize, 41; at Royal Academy schools, 45-6, 48; marginal embellishments to art studies, 46, 53; oil paintings, 46, 57, 197; fails at R.A., 48, 55; at Slade, 49-59, 61-4, 88, 92-3; mimicry, 52; memory drawing, 53; fantasy cars, 54; appearance, habits and style, 54-5; architectural fantasies, 58; Slade scholarship, 59, 75-6; draughtsmanship praised, 61; physical power, 63; politics, 63-4, 222-3; love of poetry, 64-7, 212; sexual inclinations and reserve, 65, 117, 132-4, 148-9, 163, 184-5, 239, 252; Shadwell murals, 69-72, 82; book illustrations, 72, 85, 89, 135, 138-41, 146, 148, 154, 167-8, 192, 215, 244, 250-1, 255; trip to Switzerland, 72-6; dress, 73-4; spoken French, 75, 142; first trip to Italy, 76-81; bookplates, 83; relations with Edith Olivier, 82-7, 102-3, 105-7, 124, 130, 136, 152, 162-3, 166, 191, 193, 207-9, 226-7; eyesight, 84; religious faith, 86, 105-6; reading, 87; competition prizes, 88; paints Tate Gallery murals, 90-1, 93-7, 108-10; spirit of mockery, 96-7; L. Strachey describes, 96, 101, 104; cash gift from Lady Mary Morison, 97; London rooms, 98; Riviera holiday, 98-9; photographed, 100-1; social life, 100-5, 114, 123-4, 151-3, 214-15; book with Edith Olivier, 108-9; payments for Tate murals, 109-10; at Tate opening day, 110-12; success and commissions, 113-14; Dorneywood mural, 114, 127, 129; at British School in Rome, 115-22; on lack of concentration, 116; letter-writing, 116, 161; in car-crashes, 124-6, 130, 150; reversible faces, 129, 154, 158; (illustration), 128; headstone for Lady Grey, 130; flirtation with Gwen Farrell, 131-2; boxing lessons, 132; dreams and fantasies, 132-3; erotic drawings, 133-4; portraits, 135, 146, 152, 168-9, 171, 180, 197-8, 236, 238-9, 245-6; in Bavaria, 136-8; loses Rome sketchbook, 136; revisits Rome, 141-3, 146; romantic melancholy, 143-6; cars and motoring, 150-1, 187, 214, 228-9, 259; as conversationalist, 152-3; payments and earnings, 154, 160, 175-6, 204, 208, 224, 235, 244, 269, 307*n*; 19 Hill Street murals, 157-8; skiing, 158; anti-Semitism, 159; decorates room for Sir Philip Sassoon (Port Lympne), 158-60, 162; in Paris with Bullock, 162-3; painting for Bullock, 163; letter to Laurence Whistler, 167; landscapes, 169-70; posters, 169-70; plays Inigo Jones, 171-2; and Penelope Dudley Ward, 171-7, 179-80, 189, 192; poverty and liberality, 175-6; in Rome with K. Rae, 178-9; exhibits at

R.A., 180; stage designs, 182-3, 188, 194, 200, 203, 211, 240, 254, 261, 264, 267, 269, 274; relations with Tallulah Bankhead, 183-7, 192, 199; appearance changes, 186-7; self-portraits, 190, 214, 241; ballroom dancing, 191; casual romances, 192-3, 206; and Caroline Paget, 193-5, 197-8, 204-9, 211-13, 219-21, 226, 230, 238, 246-7, 254, 257-8, 260; decorates Lady Diana Cooper's drawing-room, 195; "Chips" Channon's chimneypiece, 195; acting talent, 195; in USA, 198-200; advertisements, 200; visits to Austria, 205, 220; relations with unnamed "youngest love", 213-14, 219, 226, 238-41, 251-2, 254; attracted to high life, 214-15; invited to Balmoral, 216-17; moustache, 219, 252; tries for Territorial Army, 228; at outbreak of war, 230-3; at Laurence Whistler's marriage, 230; wartime service in Welsh Guards, 233, 241-2, 246-50, 253-4, 256-7, 259, 261-5, 267, 274; calendar paintings, 236; rejects marriage, 237, 280; painting while in army, 242-3, 245, 253, 262, 264, 277, 283; at father's death, 246; designs Guards Armoured Division symbol, 252-3; and mother's second marriage, 255; will, 255; commands tank troop, 256, 259-60; army lecture, 257; arranges wartime Christmas party in Pickering, 267-8; embarks for Normandy, 281-7; in action, 288-91; killed, 292; buried, 293; memorial service, 296; "An Anthology of Mine", 66-7

Whistler, Robin (Laurence's daughter), 41
Whistler, Simon (Laurence's son), 245, 266, 278
Whitchurch *see* Bolebec House
Whitman, Walt, 202
Wilenski, R.H., 110
William, Guardsman Idris (soldier servant), 256, 264, 292-3
Wilsford, Wiltshire (house), 65-6, 100-1, 113, 149, 154
Wilton House, 82, 95, 102-3, 171
Windrush *see* Pickering, Yorkshire
Wingfield, Lucy Evelyn, 116
*Wise Virgins, The* (ballet), 240
Wood, Christopher, 129
Woolf, Virginia, 123, 152, 203, 220; "Pictures", 91
Wootton St Lawrence, Hampshire, 3, 7, 298-9
Wootton, John, 140
Worge, Lewis, 12-13
Wylie, Elinor, 100

Yeats, W.B., 144
Young, Andrew, 215

14